D1055689

THE
NEW ORLEANS
MUSEUM of ART

THE
NEW ORLEANS
MUSEUM of ART

The First Seventy-Five Years

PRESCOTT N. DUNBAR

Louisiana State University Press
Baton Rouge and London

Copyright © 1990 by Louisiana State University Press
All rights reserved
Manufactured in the United States of America
First printing
99 98 97 96 95 94 93 92 91 90 1 2 3 4 5
Designer: Albert Crochet
Typeface: Linotron Palatino
Typesetter: G&S Typesetters, Inc.
Printer and binder: Thomson-Shore, Inc.

Library of Congress Cataloging-in-Publication Data
Dunbar, Prescott N.
 The New Orleans Museum of Art : the first seventy-five years /
Prescott N. Dunbar.
 p. cm.
 Includes bibliographical references.
 ISBN 0-8071-1604-1 (alk. paper)
 1. New Orleans Museum of Art—History. I. Title.
N598.D86 1990
708.163'35'09—dc20 90-6002
 CIP

To my wife, Sarah, who
like so many volunteers in this book has made
the impossible a reality for this city

Contents

Illustrations

Foreword

The New Orleans Museum of Art (known locally as NOMA) could scarcely be more deeply rooted in the Crescent City. It stands a few hundred yards from the brackish Bayou St. John, which as a shortcut from the Gulf coast to the Mississippi accounts for the location of the French colonial town of La Nouvelle Orleans. At the head of the boulevard linking the bayou and the Museum is the equestrian statue of General P. G. T. Beauregard, the Confederate hero who lived a few dozen blocks away in the French Quarter. A stone's throw from the NOMA loom the ancient "dueling oaks," beneath which old scores were settled by pistol a century and a half ago.

However local and regional the moorings of the Museum, it is also cosmopolitan to the core, and this is clearly manifest in the architecture of both its original neoclassical building and the recent addition. The earlier section, dating from 1911, recalls the great Roman-style museums in London, Berlin, Washington, and Paris. The new addition embodies the worldwide modernist style of architecture to be found at museums in Los Angeles, New York, Kuwait, and Tokyo. Thus, aspects of the building and its site reveal both the cosmopolitan and the regionalist urges that suffuse NOMA's entire history.

The artists' names emblazoned above the entrance of the neoclassical section reflect the rootedness of NOMA in the city of New Orleans and the South, as well as in the United States. All but one of the twenty-two artists were Americans, the exception being the sculptor Canova, who had a younger relative working in New Orleans. Three of the group were themselves New Orleanians, and a fourth—John James Audubon—lived and worked there.

Founded in 1910, NOMA belongs to the third wave of American museums to be established. It was preceded by pre–Civil War collections in Philadelphia, Hartford, and Charleston, and also by the im-

portant post–Civil War galleries opened in many cities in the Northeast and Midwest. New Orleans was a latecomer to the museum world, but the city boasted a lively tradition in portraiture, landscape painting, and the decorative arts. NOMA's founders had to consider this as they asked how their new institution would serve the Muse. Should NOMA be a temple in the South to the highest achievements of world art, or should it instead serve as a magnet and incubator for the best of local and regional talent?

Prescott Dunbar, in his engrossing history of NOMA, shows how New Orleanians addressed this "schism in their cultural identity" as they built their museum. Although Nathaniel Burt mentions NOMA only briefly in *Palaces for the People,* his history of American art museums, the Museum's story provides rich insights into how Americans everywhere seek to embrace both the particular and the universal in their heritage. Dunbar's story is intensely local, but its implications are universal.

The convolutions of the tension between the regional and the cosmopolitan are endlessly intriguing. Dunbar, whose family has deep roots in Louisiana life, does not hide his sympathy for the more cosmopolitan strain in NOMA's history. With a raised eyebrow he recounts the biography of Ellsworth Woodward (1861–1939), the Massachusetts-born painter who championed regional art during his fourteen years as NOMA's acting director. Dunbar disdains Woodward's dismissal of modern art as "insanity," and takes pleasure in reporting the success of the Picasso show mounted immediately after Woodward's death in 1939. Yet Dunbar also shows how it was an enthusiasm for regional art that led members of the local Art Association to conceive the idea of a museum for New Orleans in the first place.

Eventually, the schism between regionalism and cosmopolitanism was resolved in favor of the wider preference, but with a deep bow to the localist tradition. Dunbar puts the moment of resolution in 1964, when the entire city mobilized to purchase Edgar Degas' *Portrait of Estelle Musson Degas Arranging Flowers.* Painted in New Orleans, this masterpiece depicts the artist's New Orleans–born sister-in-law, Estelle Musson, who was abandoned by her Parisian cousin and husband, René Degas, the artist's brother. By reclaiming Degas' splendid portrait, New Orleanians not only avenged a wounded local pride but symbolically united their local and cosmopolitan aspirations in art.

It was one thing to affirm New Orleans' old links with Paris, New York, and other art centers and quite another to build a great collec-

tion. Back in the booming 1840s a local banker, James Robb, had conceived the idea of opening a national gallery of art in New Orleans. He assembled several local leaders who shared his vision, found quarters for exhibitions, and even mounted a number of temporary shows. But he failed in his effort to establish a permanent collection of masterpieces. The economic eclipse of the Crescent City in the later nineteenth century meant there were no great collectors, hoarders, and marauders there comparable to the Havemeyers in Manhattan, the Mellons in Pittsburgh, or the obscure Jacob S. Rogers, whose $5-million gift set New York's Metropolitan Museum on its road to fame. The one great New Orleans collection of the robber-baron era—that of Hunt Henderson—got away, denying NOMA a priceless store of Whistlers, Renoirs, Degas, and Monets. When the classical building given by the West Indies–born sugar magnate Isaac Delgado opened its doors in 1911, its collection consisted, in Dunbar's words, of "curios, casts, and castoffs," and its annual budget was barely 1 percent of that of the Metropolitan Museum. It is no wonder that nearly all the purchases in the 1920s were inexpensive works by southern artists.

Only with the appearance in the past thirty years of such major collectors as Muriel B. Francis, Felix H. Kuntz, Mrs. Richard B. Kaufmann, Mr. and Mrs. P. Roussel Norman, Dr. Kurt A. Gitter, and Mr. and Mrs. Frederick M. Stafford has New Orleans gained the base of cognoscenti needed to build a major art museum. The appointment of E. John Bullard, previously of the National Gallery of Art, in Washington, D.C., to the directorship in 1973 brought the expertise and national outlook needed to crystallize a major development effort. Since then, success has followed success.

Dunbar's narrative is rich in the problems and conflicts inevitable in the formation of any American museum. Indeed, NOMA's history is a veritable textbook of how museums are created. First, there was the tension between advocates of high art and the crafts tradition. Should NOMA be a repository mainly for paintings and sculpture, or for crafts and objets de virtu as well? Second, there was the tension between those who viewed art as an object of sensual delight and those who saw in it a means of education and "uplift." To what degree should the needs of the education program, introduced in the 1960s, influence acquisitions policy? Third, there was the question of curatorial focus. Should the Museum's program and financing be built around lucrative blockbuster exhibitions brought from elsewhere, or

should its energies be bent instead toward creating more modest shows that more directly tap local concerns and build up the capacities of NOMA's own staff? Fourth, there was the matter of how one balances the necessity of forming a professionally qualified staff with the need to engage the energies of knowledgeable private collectors and volunteers. Only in 1948 did NOMA gain a full-time and professionally trained director, so the resolution of this issue, too, has occurred only during the most recent decades. Finally, there was the conflict between the Museum's sense of purpose and community expectations about its role. How does a handsome gallery, which inevitably becomes a sought-after venue for public and private events having little or nothing to do with art, maintain its integrity as a museum without rudely rebuffing the social pressures placed upon it by the community?

In most European countries and in Japan such questions would be decided at the government level, by commissions and committees within a national ministry of culture. Happily, the United States lacks such a centralized and bureaucratic source of patronage, although its absence places exceptional demands on local leadership and local resources. The story of cultural institutions in this country is the story of how successfully private and civic interest is mobilized locally in support of the museum, orchestra, ballet company, zoo, or opera. There exist a few museums—notably those in New York, Cleveland, Chicago, Fort Worth, and Los Angeles—that boast large endowments that enable them to undertake bold initiatives with relative ease. Most, however, are more like NOMA, in that they must exercise extraordinary care and at the same time expend vast energies merely to meet the high expectations placed upon them by their many publics. Hence, the history of NOMA, for all its distinctive New Orleans flavor, is more representative of how culture works in America than is the history of the few large and better-known national institutions.

The story of New Orleans' museum is as engaging as it is instructive. There is suspense, as when a potential major benefactor, Victor Kiam, died only hours before he was to sign documents leaving his outstanding collection to NOMA. There is high intrigue, as when one of the most generous donors decided the entire Museum should be given over to her pet interest in Latin American art, notwithstanding the obvious disinclination of the director, the public, and most of the board toward so exclusive a focus. There is glitter, especially with the arrival of such blockbuster shows as The Treasures of Tutankhamun,

The Fabergé Collection, and Peru's Golden Treasures. And there is enough hardball politics and outright scandal to titillate the most exacting connoisseur of social mores in one of America's most colorful cities. Through it all, one can follow the emergence of a fine museum that is well managed, loyally supported, and much loved by tens of thousands of people in New Orleans and elsewhere.

Dunbar knows the story intimately. The following pages are informed by his exhaustive research in the archives and by his extensive interviews with participants. They are enriched, too, by his personal involvement with the Museum over many years as an active trustee. He is thus the ideal chronicler of a major cultural resource for the city of New Orleans, the region, and the nation.

S. FREDERICK STARR

Oberlin, Ohio

Acknowledgments

Oftentimes my task of writing a history of the Isaac Delgado Museum of Art/New Orleans Museum of Art has been difficult at best, because of the scarcity of the records in easily accessible files. There are "Minutes of the Regular Meetings of the Board of Trustees of the Isaac Delgado/New Orleans Museum of Art" from 1910 to 1985, and scrapbooks of newspaper clippings and memorabilia pertaining to the Museum, in the Felix J. Dreyfous Library of the Museum. These provide the skeletal structure for the research of this history. Board minutes for the early years, however, are brief and handwritten, and often clippings in the scrapbooks have no datelines or chronological sequence. To endow the skeleton with flesh and blood and body and soul, an archives had to be assembled. Of invaluable assistance in this was the late Gladys Landry, who for many years tirelessly stuffed filing cabinets with documents concerning the Museum and filled shelves with old Museum catalogs, annual reports, and the like. As a guide through this labyrinth, no one could be better than she. Mrs. Landry also contributed many a lead by her generous gift of time in interviews.

Thanks are likewise due the late Alberta Collier, a newspaper reporter and art critic for the *Times-Picayune,* who helped me with newspaper files and gave me much assistance in interviews. For many hours of interviews, I would especially also like to thank Morgan Whitney, Janet and Charles Kohlmeyer, Alice Godbold, Clarence John Laughlin, Elizabeth Catlett, Muriel B. Francis, Shirley Latter Kaufmann, Sunny Norman, Tina Freeman, Margo Logan, Jim Byrnes, Bill Fagaly, and Barbara N. Pate. For access to the written records that form the basis of factual history, I am indebted to Doris Antin, archivist of Tulane University; Kathryn Davis, assistant to the president of Tulane; Bill Cullison, of the Special Collections of the Tilton Library,

at Tulane; and Shirley Shea, assistant to the board of governors of Tulane.

I am extremely grateful to S. Frederick Starr, president of Oberlin College and a former trustee of the New Orleans Museum of Art, for his insightful review of my manuscript and for writing the foreword to this volume. I am happy to acknowledge the excellent work of Lyn B. Boone, of Granville, Ohio, who made editorial revisions in the original manuscript. Special thanks are owed all those museum staff members and volunteers who assisted in the production of the book, from typing to copying. In particular, I appreciate the efforts of Winston Lill, coordinator for the seventy-fifth anniversary of the Museum, who aided in finding photographs and identifying the personages in them, and to Nan Goodson, who composed the chronology for the book. Special thanks go also to the staff of the Louisiana State University Press, particularly my editor, Barry L. Blose, for professional assistance in seeing the history through the long process to completion. Finally, I must acknowledge the support of the Museum trustees, who first agreed to let me undertake this project, and of John Bullard, the Museum director, without whose willingly given time I could not have completed it.

THE
NEW ORLEANS
MUSEUM of ART

I

Founding the Museum

It also shows how vital the whole idea of the museum had become after the Civil War. Suddenly it was imperative that a proper city should have a proper art museum as a sign of cultural maturity. If the older cities of the Eastern Seaboard could do it, so could the new cities of the central valley. They could and they did—on the usual hopeless but successful American basis of no art, no artists, no collections, no buildings. Nothing but grit, taste (steadily improving) and lots and lots of money.

—Nathaniel Burt, *Palaces for the People*

The New Orleans Museum of Art, like most successful institutions, is a reflection of its times. The ideas and tastes that shaped its development over the first seventy-five years have been those of particular men and women living in New Orleans. This unique city of Anglo-Latin origin, built below sea level on the banks of the Mississippi River, strongly influenced the character of those founders, trustees, collectors, curators, and art lovers who have so untiringly directed the growth of the Museum.

In 1910, the founding year of the Museum, New Orleans was a highly prosperous city. With 339,075 inhabitants, it was one of the three busiest seaports in the United States, and its fortunes depended largely upon importing and exporting, shipping, cotton factoring, shipbuilding, finance and banking, and the growing, manufacturing, and selling of sugar products. Railroad building and consolidation between 1880 and 1900, one historian writes, "was to put New Orleans in touch with a more vast territory than that reached by the direct rail connections of any other American city. Railroad tonnage at the port of New Orleans increased 691.9 percent between 1880 and 1896. . . . The Gulf ports increased the value of their exports 142.7 percent between 1880 and 1900. New Orleans alone showed a gain in value of only 72.6 percent in 1898–99 over its exports. . . . It still managed to

1

stay ahead of South Atlantic ports which increased the value of their exports only 56.9 percent in this twenty year period. It also ranked second in overall commerce, second in foreign exports, and fifth in imports in the United States in 1892."[1]

At long last, New Orleans had recovered from the crippling effects of the Civil War and the subsequent long occupation that ended in 1877. Called the Queen City of the South, New Orleans was the most cosmopolitan center in the region, with the oldest opera in the country, ten theaters, eight newspapers (two of which were German and one French), two race tracks, numerous men's clubs, world-famous restaurants, and a highly organized social season centered on Mardi Gras. Storyville was in its prime, and jazz had just been born. The city's public library, university, and free-care medical complexes were among the finest in the South. In the city there was an outstanding literary circle whose ranks were led by the nationally acclaimed George Washington Cable, Grace King, Dorothy Dix, and Lyle Saxon. There was also the internationally recognized School of Art at Newcomb College, as well as the Arts and Crafts Club, the Fine Arts Club of New Orleans, and the Art Association of New Orleans, all dedicated to the advancement of the fine arts.[2]

The Art Association of New Orleans was one of the strongest artistic influences upon the cultural life of New Orleans. It was formed as the result of a merger in 1904 of the Artists' Association, founded in 1885 by a group of professional and amateur artists, and the Arts and Exhibition Club, founded in 1901 by another group of artists in affiliation with laymen who were to help with finances. The Art Association annuals, a juried competition of artists' works and their exhibition, attracted artist participants of impressive national, even international, stature, such as Thomas P. Anshutz, Mary Cassatt, William Merritt Chase, William Glackens, Childe Hassam, Charles Hawthorne, Robert Henri, Winslow Homer, Claude Monet, Maurice Prendergast, Frederick J. Waugh, and J. Alden Weir. The Art Association of New Orleans had a policy of exhibiting work by local artists as well as presenting traveling exhibitions from throughout the United States and Europe. Its shows were held in the Atheneum since the city's only public art galleries were small ones in the School of Art

1. Joy J. Jackson, *New Orleans in the Gilded Age: Politics and Urban Progress, 1880–1896* (Baton Rouge, 1969), 210–11.

2. The school was awarded a medal at the Paris Exposition in 1900 for its pottery arts and won the grand prize for art exhibits in 1915 at the Panama-Pacific Exposition.

at Newcomb College and in the Tilton Library of Tulane University. Indeed, at that time in the eleven states that had formed the Confederacy there were only two fine-arts museums: Charleston's Gibbes Memorial Art Gallery, founded in 1858, and the Telfair Academy of Arts and Sciences, in Savannah, established in a private mansion in 1875. At the turn of the century there were only twenty-five art museums in the entire United States.[3] The years between 1918 and 1940, however, saw the establishment of over three hundred new museums.

According to one of New Orleans' historians, "it is a fact not generally known that prior to the Civil War New Orleans was one of the principal art centers of the United States. The wealth and culture of the inhabitants attracted to the city many of the leading American painters"—painters like John James Audubon, Edmund Brewster, Ralph E. W. Earl, Henry Inman, John Wesley Jarvis, Matthew Harris Jouett, Elias Metcalfe, Samuel F. B. Morse, and John Vanderlyn. Painting portraits of the wealthy planter and merchant proved very lucrative to the struggling artist. Jarvis, who took up residence in New Orleans in the winter of 1816, "boasted that he used frequently to earn $60,000—of which $30,000 he spent in New Orleans and the remainder he took away with him."[4] Many European artists, particularly French, likewise flocked to the profitable banks of the Mississippi, settling in New Orleans. Among them were Jacques Amans, Louis Collas, Adolph D. Rinck, and Jean Joseph Vaudechamp.

During the 1840s an attempt was made to establish a permanent museum or gallery of art in the Crescent City in order to encourage an interest in art. A society, formed to encourage the exhibition of works of art, included among its members Glendy Burke, J. M. Dick, John Hagan, H. R. W. Hill, J. M. Kennedy, S. J. Peters, James Robb, and R. D. Shepard. The organization was first housed at 13 St. Charles Street, near Canal. In 1844, George Cooke, an artist whom Robb had commissioned in England "to do a copy of Gericault's dramatic and tragic *Raft of the Medusa,*" settled in New Orleans.[5] He brought with him over thirty paintings he had copied from the old masters in Europe. These paintings quickly became the focus of the fledgling art society's efforts.

Robb and Cooke prevailed upon Daniel Pratt, who was at that time

3. Calvin Tomkins, *Merchants and Masterpieces* (New York, 1970), 21.
4. J. S. Kendall, *History of New Orleans* (2 vols.; Chicago, 1922), II, 649, 653.
5. Jessie Poesch, *The Art of the Old South* (New York, 1983), 280.

building a huge warehouse for his cotton gin, to outfit the third and fourth floors as a studio for Cooke. There he displayed the copies of the old masters, as well as his own recent works and those of other Americans such as John Gadsby Chapman, Thomas Cole, Thomas Doughty, and Thomas Sully. This establishment, it is written, "was given the rather magniloquent name of National Gallery of Paintings."[6] Robb was the principal behind the project and often lent paintings from his own collection to exhibitions there.

Robb, one of the nation's earliest art collectors and connoisseurs, bears comparison with a few eastern collectors of the era like William Wilson Corcoran, Robert Gilmore, Jr., James Jackson Jarves, and Luman Reed, whose collections eventually formed the nuclei of some of the country's earliest museums. Born in Brownville, Pennsylvania, on April 2, 1814, Robb left home at the age of thirteen "to seek his fortune, walking in the snow to Morgantown, Virginia where he was employed in a bank."[7] He worked his way up to become its cashier, but after the financial crash of 1837, he moved to New Orleans. There he became involved in several financial projects, including the construction of the first gasworks in the Cuban city of Havana and the establishment of eight banking houses and commercial firms, with branches in Liverpool, New York, Philadelphia, and San Francisco. As president of the New Orleans, Jackson and Great Northern Railway, he built the first railroad that connected the Crescent City with the North. He also found time during this period to serve as a Louisiana state senator and as a regent of the University of Louisiana, now known as Tulane University of Louisiana.

During the 1840s, Robb sought to create a major art collection. On September 17 and 18, 1845, he personally attended the famous sale at Bordentown, New Jersey, of the collection of Joseph Bonaparte, former king of the Kingdom of the Two Sicilies. That sale included over one hundred old-master works by artists such as Abraham Bloemaert, Luca Giordano, Cornelius de Heem, Nicolas Poussin, Rembrandt, Peter Paul Rubens, Jacob van Ruisdael, and David Teniers. Robb purchased fifteen canvases at the auction. Among them were works by Charles Joseph Natoire, Salvator Rosa, and Joseph Vernet. But Robb appreciated contemporary American art as well, and he acquired a number of works by members of the Hudson River school.

6. Kendall, *History of New Orleans*, II, 649.
7. *Appleton's Cyclopedia of American Biography* (N.s.; 20 vols.; New York, 1888), V, 269.

In 1847, Robb participated in a grandiose scheme to have 380 pictures offered for sale in the United States from the collections of thirty-nine Italian noblemen. He hoped the United States government would purchase them as the nucleus of a National Gallery of Art, to be located, of course, in New Orleans. When the public monies for that were not advanced, an auction was held in the ballroom of the St. Louis Hotel.

The catalog of the sale enumerates works by Correggio, Jacques Louis David, Claude Lorrain, Nicolas Poussin, Raphael, Rembrandt, Guido Reni, Salvator Rosa, Peter Paul Rubens, Andrea del Sarto, David Teniers, Titian, Anthony Van Dyke, Velázquez, Joseph Vernet, and Leonardo da Vinci. Records do not indicate whether Robb or anyone else in New Orleans purchased works. The auction was a success, however, and there were many buyers from other parts of the United States. Indeed, a number of works found their way into American museums, several of them into the Cincinnati Art Museum.[8] One painting remains in New Orleans—a portrait of Marie of Austria attributed to Van Dyke.

A historian of the city has written, "The authenticity of the pictures disposed of at this sale may possibly not pass unchallenged by students of art; the significance of the event for our present purposes, however, is that it occurred in New Orleans at a comparatively early date, and is, therefore, presumptive proof of the existence in the community of a real interest in art at a time when most American communities were acutely indifferent to such matters."[9] The significance of a collector of the stature of Robb at such an early date must not be overlooked either.

As Robb's collection grew, he felt it necessary to build a proper mansion to house it. In 1852, he purchased the entire block on Washington Avenue bounded by Camp, Sixth, and Chestnut streets, in the Garden District, and began construction of an Italianate villa. But misfortune, both domestic and financial, plagued him from the outset of the venture, and he was frustrated in his plan "to build the biggest and fanciest showplace in New Orleans."[10] In the end, the house had only a basement and one floor with a pedimented balcony around the top. The most spectacular room was the so-called Mirror Room,

8. Kendall, *History of New Orleans*, II, 651.
9. *Ibid.*
10. "The House Robb Built," New Orleans *Times-Picayune States, Dixie Roto*, June 14, 1953.

which boasted an ornate black onyx mantelpiece, paneled doors of tooled Honduran mahogany, and fine enormous silver-backed mirrors whose frames were covered in gold. Such a setting befitted Robb's collection of over one hundred works of art.

Unfortunately, Robb's finances continued their slide, and the panic of 1857 drained him of his reserves. It is therefore not surprising that in 1859, he sold his home to John Burnside, a "merchant of New Orleans," for fifty-five thousand dollars and auctioned off many of his art treasures to meet his obligations.[11] At this sale all the Joseph Bonaparte paintings came under the auctioneer's hammer as well as 149 other works. Burnside purchased six of the paintings that had belonged to Joseph Bonaparte, including *The Toilette of Psyche*, by Charles Joseph Natoire, which Robb had purchased for $325 in 1845. This magnificent painting had been in the French royal collection, which during the chaos of the Revolution was sold to a Spanish nobleman of Madrid who placed it in a gallery he founded. When Napoleon entered Madrid in 1808, he seized the collection and sent the objects to Paris, giving his brother Joseph *The Toilette of Psyche*.[12]

Besides the Natoire, Burnside bought five other paintings that had belonged to the former king, including two Joseph Vernets and a Salvator Rosa. In addition, he purchased ten other of Robb's paintings, among which was Luca Giordano's *Bacchus and Ariadne*, which Robb may have bought at the famous sale at the St. Louis Hotel in 1847.

In 1881, Burnside died and his vast estate was inventoried in the *Daily Picayune*. Robb's former mansion was valued at $75,000, and the paintings at $17,037. The Vernet seascape of a calm morning at sea was valued at $5,000, Natoire's *Toilette of Psyche* at $500. Burnside had purchased the Natoire for $950.[13] The Vernet, as well as another and the Salvator Rosa, which Robb owned, found their way into the Boston Athenaeum, according to J. S. Kendall. In 1897, Randolph Newman, of New Orleans, purchased the Natoire from Burnside's estate. It was exhibited at the Delgado Museum when it first opened and for many years remained there on long-term loan. The Museum purchased it in 1940 in memory of Judge Charles F. Claiborne, whose $10,000 bequest made the acquisition possible.

Prior to Robb's efforts to found an art museum in New Orleans,

11. *Ibid.*
12. A. Hawkins, *Creole Art Gallery Catalogue*, no. 13 (1892).
13. New Orleans *Time-Picayune*, August 4, 1881; New Orleans *Daily Tropic*, October 8, 1845.

something called Plough's Museum had existed. A notice indicates that it was launched by thirty-one subscribers, among them Antonio Mondelli, who worked as a scenic artist at the St. Charles Theatre. Plough's Museum must have been short-lived, for the only other mention of it appears seven months after it opened, in February, 1838, when there was an announcement of the showing of a "marble likeness of Pope by Canova." Thus for many years there had existed in New Orleans the desire for a public art museum not only to accommodate permanent and traveling exhibitions of art but also to serve, as a *City Item* editorial stated, "a community that is really alive today." [14]

How was this desire communicated to Isaac Delgado, and why did he donate $150,000 for the erection of an art museum for the citizens of New Orleans? Delgado was a self-made man who worked diligently in amassing a fortune. He had been born on November 23, 1839, in Kingston, Jamaica, of Spanish-Portuguese-Jewish descent, the oldest of twelve children. Delgado's grandfather, also named Isaac Delgado, was known as one of the "great merchant princes" on Port Royal Street in Kingston. A partner in Naar and Delgado, the grandfather was a direct descendant of Abraham Moreno Delgado, who was the first of his family to settle in Jamaica and was granted a patent of naturalization in 1750.

The most outstanding Delgado was Grandfather Isaac's brother, Moses. He was an astute businessman like his brother, with whom he was in partnership. He was, as well, the leading political activist of his day, fighting for the cause of Jewish political emancipation. Through his leadership the Jews of Jamaica were granted full political freedom in 1831. That occurred twenty-seven years before it did in England. For this the grateful congregation of the Sephardic synagogue of Kaal Kadosh Shangar Hashamayim presented him on December 13, 1831, with a sterling silver tankard inscribed in recognition of the work he had done in their behalf.

The elder Isaac Delgado served the Jewish community in Kingston faithfully. He was president of the synagogue there in 1831, and both president and chairman twelve years later. In 1812, he married Clara Melhado and from that union seventeen children were born. So many children diminished the family fortune. The younger Isaac's father,

14. New Orleans *City Item*, December 15, 1911.

7

Henry Delgado, who for twenty-one years supplemented his income by serving as a justice of the peace, inherited only a pittance and was a planter of modest means with twelve children to feed. So it was necessary for Isaac to support himself. He emigrated to New Orleans in 1853 at the age of fourteen and went to live with his uncle, Samuel Delgado (1829–1905), a cashier in a banking firm, who secured for him the position of clerk in a steamboat agency. Later Samuel decided to enter the sugar and molasses business. Taking his nephew with him, he established the house of Delgado and Company. Upon the uncle's death on October 14, 1905, Isaac incorporated the firm, giving several trusted employees interests in it. Through his years in New Orleans he accumulated a fortune in excess of one million dollars. In addition, he became a prominent social leader. He was a member of the Boston Club and of several carnival organizations, and he was one of the original members of the Chess, Checkers and Whist Club. He was president of the New Orleans Convalescent Home, a director of the Eye, Ear, Nose and Throat Hospital, and a member of the board of commissioners of the City Park Improvement Association. He was a founder of the Louisiana Sugar Exchange and a director of the United States Safe Deposit and Savings Bank.

The scope of Delgado's business and civic activities is evident but tells little of the motivation behind his gift of an art museum. He was not an artist or active in art circles, nor did he collect art in any form. Oral tradition, the distance of years, and Delgado's laconic personality have shrouded his impulses in mystery. On March 3, 1910, he himself commented in a report in the *Daily Picayune*, "The gift speaks for itself and further than that I have no inclination to say anything." The documents pertaining to his remarkable donation give little insight. In the letter of February 26, 1910, informing the board of commissioners of City Park of his offer, he wrote simply,

> From an informal conversation held with my friend Mr. Lelong, and some members of your Executive Committee, I have been led to believe that you would willingly donate in the Park, the site for a building I propose erecting to be known as Isaac Delgado Museum of Art.
> My desire is to give to the citizens of New Orleans a fire-proof building where works of art may be collected through gifts or loans, and where exhibits would be held from time to time, by the Art Association of New Orleans.[15]

15. Letter attached to Minutes of the Board of Administrators, Isaac Delgado Museum of Art, 1910.

Did a member of the Art Association persuade him to make this princely gift? Could it have been his own desire to be remembered by posterity, since, as a bachelor, he had no heirs? Or was it a simple matter of generosity on the part of one of the city's great philanthropists? In a speech in 1925, Samuel Adams Trufant, then secretary-treasurer of the Museum's board, seemed to agree with the last view when he stated that "Mr. Delgado was in no sense an art critic, nor was he an art connoisseur, but a good citizen deeply loyal to his adopted city [and] interested in the future of her youth."[16]

Perhaps the story written in the 1930s by Ethel Hutson, a newspaper reporter and the longtime secretary to the first director of the Museum, sheds light more clearly on the matter. She wrote, "As to the person who suggested to Mr. Delgado that he should give the museum to the city, I did not know there had ever been any question but that it was Miss Ellenora E. Moss, the friend of his aunt, Mrs. S[amuel] Delgado."[17] It seems that this aunt, knowing she was dying, was worried about her nephew, who was suffering from cataracts that made him practically blind. Because of her concern, she appealed to Miss Moss to become a friend to Isaac as she had been to her. Ellenora, unable to refuse so dear a friend, made it a practice to read to Isaac, to go driving with him every day, and to help him however she could. A fast bond developed despite "one of his life-long obsessions, a dislike of girls. The only two women to whom he vouchsafed his friendship were his aunt and Miss Moss," whom he consulted on many matters near to his heart. According to the story, one of the chief worries he confided to her involved the fate of the "objets d'art" that his aunt, whom he had lived with since his arrival in New Orleans, had so lovingly collected over the years.

Virginia McRae Delgado, who had been born in Virginia, was a seventeen-year-old divorcée living in New Orleans at the time of her marriage to Samuel Delgado. She loved beautiful things, and Delgado indulged his young bride in collecting them. She frequented auctions, where she often bought furniture, paintings, and porcelains. Many of the objects she acquired had belonged to friends who had fallen into

16. Transcript attached to Minutes of the Board of Administrators, Isaac Delgado Museum of Art, 1925. Previously Delgado had given $180,000 to Charity Hospital in honor of his uncle, and upon his death he left $800,000 for the construction of the Delgado Trades School, after having made special bequests of $335,000. The Museum gift brought the total amount of his generosity to $1,475,000.
17. New Orleans *States-Item*, August 9, 1960.

financial straits after the Civil War, and she could not bear the thought of these much-loved objects' falling into strangers' hands.

As her own death neared, she had worried about her beautiful possessions. Miss Moss, conscious of this fear of her "dear departed friend" and hearing Isaac express his concern over his aunt's possessions while they were driving past the New Orleans Public Library and the Howard Library at Lee Circle one afternoon, suggested to him that the city needed a museum. She pointed out that if he gave the money to build one, it could care for Virginia Delgado's collection and for many other "fine things owned by New Orleanians" as well. Her suggestion seemed to meet with his approval; Miss Hutson wrote that "he went right to work, with characteristic energy to put it into effect without delay."

At the time of his deed of donation, Delgado nowhere made provisions for giving his aunt's collection to the Museum or for housing it there. But his will lends some credence to Miss Hutson's story. By it the Museum received numerous articles, valued at $29,430, from Virginia Delgado's home. The *Daily Picayune* of January 6, 1912, spoke of "many beautiful and costly articles," of which none was of "extraordinary value that might be pointed to with the pride of a parvenue in displaying lavish wealth." Among the most outstanding of the objects was a "Sevres vase appraised at only $5,000, the value of which could be discerned only by a connoisseur." Late-nineteenth-century Sèvres and Imari porcelains and a few paintings entitled *Bacchantes, Cupid, Rebecca at the Well,* and *Diana with Dog* were in the collection. So minor were the painters that the newspaper reporters failed to mention their names. Most of the objects were finally deaccessioned and sold at auction in 1965, because they were judged not of the standard that first-class museums have established—though for over thirty years they had been displayed in the Delgado Room, which the Museum board had set aside as a testimony to Virginia Delgado's taste.[18]

A significant fact frequently overshadowed by Delgado's $150,000 gift is that he owned no land upon which to build the proposed museum. Delgado's friend Pierre Antoine Lelong, a member of the board of commissioners of City Park, was instrumental in securing from that board the promise of a site for the Museum. An editorial in the *Daily Picayune* of February 10, 1913, however, detailed another story: "For

18. Arthur Feitel wrote in his unpublished memoir that the Delgado Room was a "terrible hodgepodge of copies of furniture, bric-a-brac and paintings" ("Confessions of a Frustrated Museum Enthusiast" [1967; typescript in archives, NOMA]).

long years Mr. Lelong nursed a dream of an art museum in the city, but was unable to interest any philanthropist in this scheme. Finally, in connection with Major B. M. Harrod, he approached Isaac Delgado with the plans of the project. After many attempts the two finally succeeded in getting him to furnish the building on the site in City Park where it now stands." According to Louise Westfeldt McIlhenny, it was because of her father, Gustave R. Westfeldt, that Delgado "gave the money to the art association of which my father was president." Westfeldt went to Delgado to ask him to leave money for the art museum. "He said he would. He then wrote that he wished to give it so that it could be completed during his lifetime, and it was." Whatever version is correct, it is possible that without the aid of Lelong, whose name is memorialized by the avenue in City Park that leads to the Museum, no museum would have been built. The foresight and generosity of the City Park commissioners should be as well remembered as Delgado's gift.[19]

City Park was a tract designated on earlier maps as the Allard Plantation; the tomb standing in the park once held the remains of Robert Allard, who died in 1824. Records of 1845 show that the tract was sold by a sheriff of the parish of Orleans to satisfy a mortgage in favor of the Consolidated Association of Planters in Louisiana. John McDonogh, who was one of the city's greatest philanthropists, bought the parcel and at his death in 1850 bequeathed it to the cities of Baltimore and New Orleans. The city of New Orleans bought Baltimore's share for twenty thousand dollars in 1852.

Records of the city council predating the Civil War show frequent declarations concerning the need for a park. In 1859, a fence was built along Metairie Road, now called City Park Avenue, a keeper's cottage was erected, and a few benches placed around some of the trees. During the Civil War those first improvements fell into decay, and finally cows roamed over the tract. During Reconstruction, the state legislature took the park from the city and placed it under the control of a state-appointed board. In 1875, the legislative act was re-

19. New Orleans *States-Item*, August 20, 1960. The members of the board of commissioners of City Park at the time were H. F. Baldwin, A. Blais, V. J. Bottom, Paul Capdevielle, J. B. Ceflou, Charles F. Claiborne, C. Dittman, Felix J. Dreyfous, H. L. Franz, J. Garcia, G. S. Gibbons, A. Gloudot, Jr., Benjamin M. Harrod, I. G. Kitterage, J. Koch, J. H. Lafaye, V. Lambore, D. Lanoux, Pierre Antoine Lelong, W. L. Miltenberger, A. P. Noll, Felix J. Puig, A. Pujol, E. J. Reiss, P. M. Schneidau, P. J. Schoen, E. W. Smith, J. Steckler, S. Story, P. Torre, and J. J. Weinfurter. Six of these eventually served on the Museum board as well.

pealed and the park was given back to the city. Concerned citizens in that section of New Orleans, impressed by the beauty of the spot, recognized the possibility of developing the tract for the benefit of the populace. And so the original City Park Improvement Association was formed in 1891 for the purpose of doing what the city had failed to do, namely, developing the spot into a place of beauty for New Orleanians.

The association drew up a charter and elected a president, Judge A. L. Tessot. It obtained an ordinance from the city giving it control of the tract, with "full powers to govern, manage, and direct the park." In 1896, a legislative act confirmed the grant made by the city council. The act constituted the association a state agency, but with the provision that city funds continue to support the park. Roads and lagoons were laid out, and bridges built. Since the tract was of insufficient size for the ambitious plans drawn by George H. Grandjean, adjacent land was acquired, extending the grounds first to Bayou St. John and later to Lake Pontchartrain. By 1910, the park measured 1200 acres.

The site given for the Museum was in a circle with a diameter of 315 feet, placed at the end of a palm-lined avenue one thousand feet long leading from the Esplanade Avenue entrance of the park.[20] The circle had been filled and graded up to eight feet above mean level at the center, using earth excavated from the nearby lagoons. Delgado approved of the location, and the wheels went into motion to implement his project. In a letter written to the City Park commissioners on April 26, 1910, Delgado provided for the formation of a board of administrators made up of representatives of both the City Park board of commissioners and the Art Association of New Orleans. "But," he also wrote, "I wish it to be understood that nothing in this letter contained shall be construed as preventing the organization of an art association having in view the preservation of the Isaac Delgado Museum of Art and the securing of funds for its maintenance and development."[21]

Nevertheless, the more rigid guideline was followed, and a board of administrators was formed from representatives of the two organizations specifically mentioned in Delgado's letter. This board governed the Museum for over forty-five years. The first board consisted of

20. The palms eventually succumbed to weather and old age, giving way to the present alley of magnolias and white oaks, the latter having a lifespan of about sixty years.

21. Letter attached to Minutes of the Board of Administrators, Isaac Delgado Museum of Art, 1910.

Pierre Antoine Lelong, chairman; Joseph Bernard, secretary; Paul Cap-
devielle, member ex officio; Charles F. Claiborne; Felix J. Dreyfous;
Major Benjamin M. Harrod; E. W. Smith; Gustave R. Westfeldt; Ells-
worth Woodward; and Charles Wellington Boyle, curator. Of this
number, five of the original members—Lelong, Westfeldt, Claiborne,
Woodward, and Dreyfous—served in sequence as president, direct-
ing the growth of the Museum until Dreyfous' death on November 15,
1946. The Museum's founders were all outstanding business and so-
cial leaders of their day, but not one of them was an art collector. Only
one was vastly knowledgeable about art, and that was Ellsworth
Woodward, professor of art history and dean of the School of Art at
Newcomb College. Charles W. Boyle, himself an artist, was not as cu-
rator considered a voting member of the board. It was Woodward
who became the leading spokesman for the Museum, serving on the
board for more than twenty-eight years, as acting director from 1925
to 1939, and as president from 1934 to 1939.

Born in Seekonk, Massachusetts, in 1861, Woodward was gradu-
ated from the Rhode Island School of Design, and he studied in the
studios of Carl Marr, Samuel Richards, and Richard Fehr, in Munich.
At the age of twenty-four he was elected assistant professor of draw-
ing and painting at Tulane University. In 1887, he became professor of
art in the newly founded H. Sophie Newcomb Memorial College for
Women. As chairman of Newcomb's School of Art from 1890 to 1931,
he was responsible for initiating the courses for women in drawing
and painting as well as in pottery, needlework, silversmithing, and
bookbinding. The idea was that the sale of decorative pieces produced
by the women would help defray the costs of their art supplies. So
successful was this program that for many years the sale of artwork
brought in an average of a thousand dollars a month.

Woodward believed that the basis and justification for the Mu-
seum's existence lay in its educational role, and the board followed his
beliefs. The acquisition of original masterpieces of European painting
or from antiquity was a secondary goal. Woodward may have been
aware of a report by J. Elliot Cabot, a trustee of the Boston Museum of
Fine Arts, who in 1886 wrote, "Original works will generally be be-
yond our reach . . . but through casts we can acquaint ourselves with
the best . . . at a very moderate cost." The Museum, like its predeces-
sors in New York, Boston, and Washington, D.C., was to be a place
where primary emphasis was on education, moral uplift, and social
betterment. Thus, it was felt, "everyone may freely come [to the Mu-

seum], and it will be kept open not only during the daylight hours, but at night, when thousands of those who are busy in the daytime may visit it; and, let us hope, during at least part of Sunday, for surely there is no better service an art museum can do than give the working man and woman a peaceful, restful and elevating time and place to spend their Sunday afternoons." [22] The objects on display were to teach students and artisans the standards of form and color, exhibiting the accomplishments of the past for the present to imitate and excel.

The board also felt a fierce regional pride in the economic development of the South and agreed with the editor of the *City Item*, who wrote on February 12, 1911, that the gift of the museum "will mark also, the beginning of a new era in the life of this city." According to Woodward, the "habit of poverty" had held the region in its grip ever since the war. But, he believed, the situation had changed and the South was no longer dependent on agriculture alone; as the wealth of the area grew, so would its ability to develop centers of culture:

> We must get out of the habit of looking to other cities alone for our own culture. In our own community we must build up a center for each of the fine arts, and though we may, and should bring to that center whatever the rest of the world may offer that is worthy, it must be here that our artistic life shall be at home. As long as we feel—as we have felt with reason heretofore—that we must turn to New York, Boston, Cincinnati, Pittsburgh and Chicago, or to European centers for first class opportunities in music, literature and art, what chance have we to develop a strong community interest in these things? Foreign art may stimulate and influence artists, but it is native art alone that moves and guides the people.

He concluded,

> The significance of the gift lies in the situation—in our great need for just such a stimulus to a bigger and broader cultural life. It comes at what the slang of the day calls "the psychological moment," when its influence should be multiplied many times by the circumstances, both within and without the city. To a community just awakening, as ours is, from a time of prosperity and expansion of commercial and manufacturing interests, the chance to gather treasures that shall belong to the entire community that shall make the whole people sharers in the large cosmopolitan life of culture is surely the best of all possible blessings. [23]

The Museum of Art was not only socially desirable but also an object of civic pride. And the good businessmen and professional men who

22. Nathaniel Burt, *Palaces for the People* (Boston, 1977), 121; New Orleans *Daily Picayune*, February 12, 1911.
23. *Ibid.*

had made their fortunes in New Orleans, who were the New South, could do no better for their city or themselves than by serving on the Museum board. The careers of a few of those founding fathers gives an insight into the course of the Museum's development in the early years.

The first president of the board was Lelong, who was born in Poinsat, France, on February 21, 1853. At the age of seventeen he emigrated to New Orleans, leaving his widowed mother and a sister behind, in order to learn a business profession. His brother-in-law, D. A. Chaffraix, was a partner in the New Orleans sugar firm of Chaffraix and Agar. After working for the firm for over twenty years, Lelong became a partner. The company's name was as a result changed, first, to Agar and Lelong, and then, in 1903, to Lelong and Company. His brother, General G. M. Lelong, also came to New Orleans and became first vice-president of the Citizens' Bank. P. A. Lelong was not only an outstanding businessman but also an active participant in community affairs. He served on the original board of commissioners of City Park and on the board of the Fisk Free Library, and he was secretary and treasurer of the Carnegie Library Board. He was one of the founders of the Louisiana Club, a member of the Boston Club and of the Chess, Checkers and Whist Club, and a founder of the Sugar Exchange. He served as chairman of the building committee of the Museum and was instrumental in persuading A. Monteleone to donate five thousand dollars to erect the Esplanade Avenue entrance gates to City Park.

The first curator of the Museum, like its first president, was not a native New Orleanian. Boyle was born in 1861 in the small town of Lewisburg, in St. Tammany Parish on the shores of Lake Pontchartrain. The native landscapes he knew as a young boy substantially influenced his style as a painter. One newspaper wrote, "Mr. Boyle is a living refutation of the theory that talent in art must be cultivated in Europe, or it will never amount to anything. During the whole of his career, he spent but three months of training outside of this city, and those were spent in New York where Robert Henri and Frank Vincent DuMond advised him, rather than taught."[24] He studied in New Orleans under Paul Poincy and Andres Molinary, both locally well known artists at the turn of the century. For over fourteen years as curator, Boyle advised on the Museum's collection and exhibitions. In

24. New Orleans *Times-Picayune*, March 16, 1919.

1915 and 1919, he held one-man shows of his works at the Museum. At the *Times-Picayune* editor wrote at the time of Boyle's death on February 9, 1925, "he was one who without rushing to modernistic extremes in his selections, was free from possible accusations of remaining dry-as-dust in his art views."

Westfeldt, who was the second president of the board, was likewise not a native Louisianian, having been born in New York City in 1852. Educated at Rugby School in England, he entered the coffee-importing business and founded a firm with offices in Mobile and New Orleans. He eventually became a director of the Hibernia Bank, D. H. Holmes, Ltd., and the Liverpool, London and Globe Insurance Company. He also served on the State Board of Prisons and Asylums and on the board of administrators of Tulane University. For several years he was active in the Art Association and served as its president.

The oldest member of the first board was Major Harrod, who was born in New Orleans in 1837. He graduated from Harvard with an A.B. in 1856 and an A.M. in 1859. Upon the outbreak of the Civil War he enlisted in the Crescent Rifles. He was promoted to second lieutenant in the 2nd Louisiana Regular Artillery and later served in the 2nd Regiment of Engineers. At surrender he returned to New Orleans and took up the engineering profession. He was chief engineer of the state of Louisiana from 1877 to 1880 and was appointed a member of the Mississippi River Commission in 1879. He served on that body until 1904, by then having become president of the commission. He was the only member appointed to both Panama Canal commissions by President Theodore Roosevelt. Among his engineering achievements were the Roosevelt Dam, in Arizona, and Metairie Cemetery, Christ Church Cathedral, and the old campus of Tulane University, locally. Of national reputation, he was also active in New Orleans on the board of City Park and as a member of the Pickwick Club and the Round Table Club. He was an ardent original supporter of the Audubon Society, and "one of the late aspirations of Major Harrod's was to convert the island [Ship] which he owned off Bay St. Louis and near Henderson's Point into a bird refuge." [25]

Another of the distinguished members of the Museum's board was Dreyfous, who was born in New Orleans on February 17, 1857, above the soap factory operated by his immigrant parents, Abel Dreyfous and Caroline Kaufman Dreyfous. In 1862, he attended public school,

25. *Ibid.*, September 8, 1912.

but he left shortly thereafter because he refused to sing the "Star-Spangled Banner" as proof of his loyalty to the federal government, which had just captured the city from the Confederates. He attended private schools until 1871, when he entered his father's notarial office. In 1888, he received his LL.B., and he followed the law profession throughout his life. In 1888, he was elected a representative to the Louisiana legislature, where he wrote the bill creating levees throughout the state. He was the first president of the Orleans Levee Board, from 1890 to 1896, and from 1896 to 1900 he was a member of the New Orleans City Council. He was a director of several banks, a second vice-president of Temple Sinai, a director of the Jewish Orphans' Home, the president of both the Milne Asylum for Destitute Orphan Boys and the board of City Park, and a member of the Harmony Club.

Claiborne, another of the original board members to serve as president, was the grandson of Louisiana's first American governor. Born in New Orleans on February 2, 1848, to the banker William C. C. Claiborne and Louise de Balathier Claiborne, he was educated at the Christian Brothers School and the University of Louisiana, from which he graduated with top honors. Thereafter he entered the law offices of Chief Justice Bermudez, and in 1869, at the age of twenty-one, he was admitted to the bar. Claiborne took part in the battle of September 14, 1874, when the White League broke the control of the metropolitan police in the city. Practicing law for many years, he ran for the city council in 1888 and was elected to a four-year term. He also served on the council from 1896 to 1900. During the latter period he was credited with proposing the formation of the Sewerage and Water Board.

In 1912, Claiborne ran for mayor but was defeated by Martin Behrman. In the following year he was appointed a judge of the court of appeals, from which he retired in 1928. He served as a delegate to the constitutional convention of 1921, as a member of the board of City Park, and as the president of the New Orleans Public Library.

Another member of the founding board active in politics, Capdevielle, as president of the City Park Improvement Association for two decades, served on the Museum board in an ex officio capacity. He acquired his interest in politics from his father, who had become politically active after emigrating from France to New Orleans at age twenty. Born in the city in 1842, Capdevielle was educated at Jesuit College. Upon graduation, he enlisted in Boone's Battery. He sustained wounds at the siege of Port Hudson and after the fall of the fort

was exchanged as a war prisoner in New Orleans. He then served the remainder of the war in Le Gardeur's Battery in Charleston.

With the surrender at Appomattox, Capdevielle returned to New Orleans and entered business as a clerk, studying law at night. He graduated from the University of Louisiana in 1868 and practiced law until 1885, when he became president of the Merchants Insurance Company, a position he held for sixteen years. He was also president of the Orleans Railroad. His first political office was as a member of the State School Board in 1877. He was on the Orleans Levee Board and was elected mayor of New Orleans in 1899. An obituary tribute remarked, "His administration as mayor was noted for two events both connected with the beginnings of New Orleans' industrial and port development; the installation of the modern sewerage system and the organization of the Public Belt railroad."[26]

Capdevielle was appointed state auditor by the governor in 1904, and he was elected to that post in 1908, 1912, 1916, and 1920. He was still the state auditor when, at the age of eighty, he died at his summer home in Bay St. Louis on August 13, 1922. He had served as president of the Pickwick Club and as vice-president of the Opera Club, and was a member of the Mystic Krewe of Comus and a director of the Charity Organizations Association. He was made a chevalier of the Legion d'Honneur, and a commander of the Order of St. Olaf by King Oscar of Sweden.

26. *Ibid.*, August 14, 1922.

II

Laying Foundations and Opening the Museum

The board of administrators of the Isaac Delgado Museum of Art, having been duly constituted with Pierre Antoine Lelong its president, held an open competition in 1910 for the design of the building the Museum would occupy. The announcement of the competition specified that the cost of the structure was not to exceed $125,000. The building was to be fireproof and two stories high, with a basement. The broadside specified, "In the lower story may be offices for the Board of Administrators and Curator, a Statuary Hall, rooms for the display of one special exhibit, with not less than 800 square feet of floor space, and for bronzes, pottery, and metal, textile, and other craft work." It continued that there should "be a room for lectures and meetings and special exhibits, but in any case, it will be considered a merit in any design if provision is made for future extension of the building, for this or other purpose, in a manner that will not detract."[1] The instructions to the vying architects spelled out a broad concept for the Museum and required that plans be completed by July 1, 1910. In addition to awarding the project to the successful architect, the board offered two runner-up prizes in the amounts of $500 and $250.

A committee composed of Ellsworth Woodward and Major Benjamin M. Harrod selected the winning design from a total of seventeen entries. The plans chosen were the entry of young Samuel A. Marx, a native of Natchez, Mississippi, who had just become a partner in the Chicago firm of Lebenbaum and Marx.[2] The second prize

1. Instructions for Architects in Competition for the Isaac Delgado Museum of Art (1910; archives, NOMA).
2. Curiously enough, Marx became a noted collector of the school of Paris. His collection consisted of major works by artists like Georges Braque, Juan Gris, Fernand Léger, Henri Matisse, Joan Miró, and Pablo Picasso. He served as a member of the board of the Art Institute of Chicago for many years.

went to Emilio Levy, of New York City, and the third to Brune and Kasbaum, of New Orleans. The contract for the erection of the Museum was awarded to Julius Koch, of New Orleans, at a bid of $113,600. The contract for the heating, plumbing, drainage, and ventilation went to the C. C. Hartwell Company for $7,697. Thus the unfurnished building was to cost $121,297. The contractors were given six months to complete their work.

A cornerstone dedication was conducted without public fanfare on March 22, 1911, with Isaac Delgado, Ellenora E. Moss, and the board members present. Delgado made no formal address at the dedication, but afterward, seated in his automobile, he was heard to say, "This building will be for rich and poor alike, and I understand that there will be park carriages operated to take visitors from the entrance of the park out here. There could have been no better place than City Park for this structure."[3] The newspaper reported that Joseph Bernard, secretary of the Museum's board, marked the occasion by placing within the cornerstone a copper box containing copies of the daily papers, Mr. Delgado's letter offering to donate the Museum, his letter specifying the manner of electing the board, a picture of workmen on the building, reports of the board of commissioners of City Park for 1900–1910, a one-cent and a two-cent stamp, a copper penny, a blank application to the City Park Improvement Association, a copy of specifications and bids for the building and the report of the meeting at which they were received, Mr. Delgado's photograph, and a twenty-five-cent piece and two five-cent pieces of 1910.

Construction moved apace. The building soon took on the aspect envisioned by Marx: one "inspired by the Greek [but] sufficiently modified to give a subtropical appearance." Marx, according to the *Daily Picayune* of February 12, 1911, explained that the desired effect was to be "accomplished by the introduction of certain features into the cornice, the wide projection of which gives a deep shadow below; the open portico with seats at both ends, and the tile roof."

If Delgado and the board were pleased with Marx's renderings of

3. New Orleans *Times-Picayune*, July 5, 1911. The latter part of this statement may have been provoked by an editorial that appeared in another paper: "Possibly some regret may be felt in some quarters at the report that the location of the Art Gallery is to be Lower City Park, for reason that the proposed situation was virtually out of town. . . . It is worth-while to note that the location in Lower City Park was eagerly offered, while one in Audubon Park was not tendered. It would be a handsome act if a site were graciously offered nearer the settled sections of the city."

the Museum, there certainly were those in the city who were not. In an editorial, the New Orleans *Item* asked,

> Being on the eve of getting the Panama Exposition would it not be preferable to postpone the erection of the museum building, and follow the example of Philadelphia, Chicago, St. Louis and Paris, . . . to build an Art Museum on a larger style of like material, and one that suits its purposes for this exposition, and to stay thereafter as a permanent ornament to the city? The $150,000 so generously donated by Mr. Delgado could then be used for buying paintings. Other art objects to be housed in this building under the name of Delgado Collection, and so to perpetuate his name as it is done in many of the world's art galleries.

On the surface this suggestion had merit. New Orleans had been selected as the site of the Panama Exposition. The architectural firm of Stevens and Nelson, losers in the museum contest, had won the competition for designing the grounds and buildings of the exposition. Several buildings were under construction, and the board of the Museum might have considered taking over an exposition building after the close of the event and retaining Delgado's $150,000 for the purchase of a fine permanent collection. It is fortunate, however, that the editorial's suggestion fell on deaf ears, for the money allocated for the Panama Exposition ran out. Work had to be abandoned, and the Panama Exposition was never held in New Orleans.

Marx's building had a front portico of buff Bedford ashlar. The architect designed a frieze around the entire building, upon which the board ordered inscribed the names of men who they felt had distinguished themselves in the three great arts of architecture, sculpture, and painting. Ethel Hutson wrote of their choices, "Though guided somewhat, as was most proper, by local considerations and selecting several artists whose work achieved only local reputation, the majority of the names chosen would be found in any list of the best twenty-two artists of the country who have passed away." The names inscribed were St. Gaudens, Whistler, Richardson, La Farge, West, Powers, Audubon, Allston, McKim, Johnson, Wikstrom, Homer, Copley, Inness, Ward, Church, Hunt, Remington, Clague, Canova, Perelli, and Poincy. "Such a list," Miss Hutson continued, "will . . . always be made up differently by each person, according to his taste and predilections; but this list is one which has had few criticisms made of it, either as to those left out or those included."[4]

4. New Orleans *Daily Picayune*, February 12, 1911.

Still, William Woodward disagreed in an open letter to the editor of the *Daily Picayune*. He wrote, "The name of Audubon would seem to be properly recognized elsewhere in our city in his proper sphere as a naturalist and lover of birds. The fact that he was enough of an artist to make acceptable colored drawings of birds, etc., hardly warrants his name to be inscribed with such men as St. Gaudens, La Farge and other artists of that class."[5] Woodward also objected to the inclusion of Perelli, Clague, and Wikstrom in the list, all of whom painted in and around New Orleans for many years. But despite his criticism, the names remain to this day just as the board decided.

If there was some disagreement concerning the names on the frieze, there certainly was none concerning the purpose of the interior entrance hall. That was to be a grand space for sculpture. Planned to be the largest and most prominent area of the Museum, it received the greatest amount of light and produced the imposing effect of being lit by a skylight. A similar arrangement was used in the Luxembourg Palace, in Paris, and in the Corcoran Gallery of Art, in Washington, D.C. Statuary Hall was to contain plaster casts of antique statues from Greek and Roman times, since they would serve, as they did in the Boston Museum of Fine Arts and the Metropolitan Museum of Art, to advance the education of students, who could scrutinize and sketch them.[6]

Several articles appeared in the newspapers announcing intended gifts for Statuary Hall. These generated much enthusiasm. The Museum received a statue of Praxiteles from the Butchers' Protective and Social Union, the *Nike of Samothrace* from Robert L. Farish, and an *Apollo* and a *Venus* from Felix J. Dreyfous. Major Allison Owen, of the Washington Artillery, gave a cast of Michelangelo's *Madonna and Child*, and Lelong donated a cast of *Jeanne d'Arc*. In 1913, the Fine Arts Club presented the *Diana of Versailles* to the Museum. Arthur Feitel has described the Museum's custody of the statues: "Some of these casts were protected from having a protruding arm or leg knocked off by low wooden railings. Plaster fig leaves had been applied to such statues as Hercules and Apollo in order not to shock the Victorian morals of the visitors."[7]

5. *Ibid.*, February 14, 1911.
6. By this date the Boston Museum of Fine Arts and the Metropolitan Museum of Art had begun replacing their replicas with original statues from Greek and Roman antiquity. See Tomkins, *Merchants and Masterpieces,* 121–25.
7. Feitel, "Confessions," 10.

On the ground floor, Marx designed an office for the curator and a room for the board of administrators. There were four exhibition rooms, one of which came to house Virginia McRae Delgado's collection. The others, according to Miss Hutson, were intended "for textiles, bronzes, and other metal works, terra cotta, ceramics and all sorts of craftsmanship." The desired lecture hall was dropped from the plans because of insufficient funds.

On the second floor there was a balcony gallery around three sides of Statuary Hall, two long exhibition rooms, and four square exhibition rooms. The Delgado building remains much the same today. All the woodwork was of birch with a mahogany stain, and the walls and ceilings were of plaster colored and jointed in imitation of Caen stone.

The Museum opened to the public on Saturday, December 16, 1911, at two o'clock in the afternoon—"under most auspicious circumstances, not withstanding the cold and threatening weather," according to a reporter of the *Times-Democrat*. Several hundred people were present to hear Mayor Martin Behrman officially accept the Isaac Delgado Museum of Art "in the name of the people of this great city of New Orleans." Ten days earlier the city council had by ordinance officially accepted the gift. The mayor spoke of the sincere appreciation of the city and referred to the promptness with which the city council had acted to provide funds for the Museum's maintenance. The only unfortunate note in the joyous event was that Delgado himself could not be present, for he was gravely ill.

After the speeches, everyone present was invited to enter. "Inside the building the throngs of people gave little gasps of surprise and admiration as the beauties of the building's interior and the rare quality of the paintings and exhibits were viewed," it was reported. Two of the exhibition galleries on the ground floor offered displays of "exquisite ceramics, bronzes, vases, pottery and metal work and Japanese carved ivories, many of great antiquity. Here was shown one of the finest collections of French medals, collected by Mrs. Emory Clapp and loaned to the Museum for its opening."[8] The public also could find there a large French china vase handmade by Jean Ponyat, of the Limoges china factory, and presented to John Gauche in consideration of his large purchases from the factory.

On the second floor some four hundred paintings were exhibited, with one room set aside for the twenty-eight paintings and single wa-

8. New Orleans *Times-Democrat*, December 17, 1911.

tercolor lent by Chapman H. Hyams and valued at $100,000 or more. Among other paintings displayed at the opening were *Morning on Bayou Boeuf,* by Charles Wellington Boyle, donated by the Home Institute Alumnae, and a landscape, *Snow and Flood in Flanders,* by Modeste Huys, donated by the Quarante Club of New Orleans. These two paintings and seven other works accessioned in 1911 made up the entire permanent collection of the Museum at the time of its opening. The small number of holdings was not unusual for a new American art museum. When the Metropolitan Museum of Art opened in 1870, it did not own a single work of art.[9]

Among the other notable paintings on view at the Delgado were Robert Henri's *Blue Kimono* (purchased by the Museum in 1971) and Irving Wiles's *Spanish Girl,* both lent by the American Federation of Art; Ballard Williams' *Vivacetto,* lent by the Buffalo Fine Arts Academy; Charles Joseph Natoire's *The Toilette of Psyche,* lent by Hart D. Newman; Seymour Thomas' *Thistle Down,* lent by Mrs. Emory Clapp; J. L. Gerome's *Eastern Scene,* lent by Morgan Whitney; and two Jean Jacques Henner heads, lent by J. K. Newman and Morgan Whitney. The Musuem's opening was reported in all the papers in glowing terms, and the three thousand who attended must have enjoyed reading the newspaper accounts.

The enthusiasm did not diminish after Delgado's death on January 4, 1912, for numerous exhibitions opened at the Museum that year. One of the first was an impressionist show lent by the world-renowned art dealer Durand-Ruel in February, 1912. Shown were Georges d'Espagnot's *Myringen suisse,* Edouard Manet's *La Femme au soulier rose,* Claude Monet's *Maison de pecheur au Petit-Ailly* and *Le Parlement: Effet de Brouillard,* Henri Moret's *Port Donnant—Belle Isle en mer,* and Auguste Renoir's *Environs de Cannet, Jeunne Fille au fichu blanc,* and *La Ravaudeuse à la fenêtre.* At the close of the show, Durand-Ruel gave the Monet to the Museum for its permanent collection. That year Mayor Behrman allowed the Museum to exhibit portraits of General Winfield Scott and Anne of Austria that hung in his parlor at City Hall. This was announced in the newspapers in March, 1912, along with the information that visitors to the Museum on Mondays, Wednesdays, and Fridays would have to pay an admission charge of twenty-five cents, in order to "assist in maintaining the institu-

9. Tomkins, *Merchants and Masterpieces,* 35.

tion." [10] In May, a large exhibition of Augustus Koopman's paintings went on display, and the newspapers announced that it was the intention of the Art Association of New Orleans to buy one of his works for the Museum's permanent collection. Closing out the Museum's successful first year of exhibitions was a show it sponsored, under the auspices of the Art Association, of forty-five paintings by members of the American Federation of Arts. Among the more popular paintings were Bruce Crane's *Autumnal Hills*, C. W. Hawthorne's *Mother and Child*, Robert Henri's *Blue Kimono*, and Robert Reid's *Against the Sky*.

The approach toward exhibitions in the first year was that of the "academy show." But the particularly strong emphasis on the crafts at the Museum's opening indicates the influence Ellsworth Woodward had on his fellow board members. That a show of the French impressionists took place at all is surprising. In the years that followed there would be little variety in the exhibitions mounted. They would be limited to shows of the American Federation of Arts, to the Art Association of New Orleans' presentation of local artists, and to a few large one-man exhibits of artists adjudged academically proper: artists like Charles W. Boyle, Charles W. Dahlgreen, Luis Graner, and Paul Philippoteaux, who are now seldom seen in institutional collections.

The Museum's academic approach is clearly illustrated in the 1913 roster of shows: in February, pictures by American mural painters; in October, C. A. Fries's works; in November, forty-two paintings by various members of the American Federation of Art; and in December, works from the Chicago Society of Etchers. Throughout the period prior to 1920 the exhibition policy followed the same pattern. The Museum offered shows of Augustus Koopman, Harry B. Lachman, Edward W. Redfield, and William Woodward, all of whose works were tendered not only for inspection but also for sale.

An article that ran in the New Orleans *Item* in March, 1916, typified the artistic taste of many New Orleanians in the first years of this century. Harry B. Lachman, a young artist who had studied in Paris and who had recently returned to the United States, was given a one-man show at the Museum at the invitation of the Art Association of New Orleans. He was a landscapist who, according to one reporter, "with-

10. The New Orleans *Times-Democrat* of June 4, 1913, stated that the first acquisition purchased with paid admissions was *Frozen River*, by Charles Rosen. The painting was described as "simple in composition . . . with all the convincing elements of winter."

out having fallen into worship of the false gods of Post Impressionism, Futurism, etc., has carried the more reasonable qualities of modern art to their extreme development." [11] In the words of another reporter, Lachman's pictures were "sincere, wholesome, vivid representations of reality." The collectors of New Orleans agreed, for in less than two weeks he had sold eleven paintings to S. T. Alcus; H. F. Baldwin, later the president of the Museum board; I. M. Cline, a well-known art dealer and collector; Mrs. Leon Gilbert; Mrs. William Mason-Smith; J. K. Newman, a noted New Orleans collector of the French salon school of painting; Mrs. J. B. Richardson; and Samuel Weis, president of the Art Association and later a member of the board of the Museum. The reporter who extolled Lachman's sincerity and wholesomeness concluded that the painter's work appealed to the city's solid citizens because he was "not one of the revolutionary group of painters who have been turning the art world upside down with theories and practices of Cubist, Post Impressionistic, Futurist, or Symbolic art. He frankly rejects these radical ideas of modern art as 'crazy' and is bold enough to declare that Paris has also rejected them. 'The insanity of war,' Mr. Lachman concludes, 'has cured the insanity of art.'" [12] Alas, there was no Gertrude Stein or Duncan Phillips among the members of the Art Association or the board of the Museum.

The Museum's first nine years also saw loans of works that New Orleanians had collected. Walter Keiffer lent 149 gem cameos, comprising early Greek and Roman and seventeenth-century French specimens of amethyst, onyx, coral, sardonyx, and the like. J. K. Newman lent his collection of twenty-six French salon and Barbizon school paintings. On display were works by Eugène Louis Boudin, Henri Harpignies, Jean Jacques Henner, Léon Augustin Lhermitte, Adolf Schreyer, and Félix Ziem. The large collection of bronze Indian and Chinese Buddhas assembled by I. M. Cline, the federal weather forecaster for southeastern Louisiana, was another popular exhibit. In 1917, Hunt Henderson lent 116 etchings, lithographs, paintings, and drawings by James McNeill Whistler. The numismatic collection that Charles L. Lawhorn lent included 360 ancient Greek coins. These shows were of importance to the community not only for the public interest they aroused in the Museum but also because they exempli-

11. New Orleans *Times-Picayune*, March 9, 1916; New Orleans *Item*, March 16, 1916.
12. *Ibid.*

fied the variety of local collections and the presence of artistic commitment in the community. That commitment came into view the more fully as prominent citizens began, even in the first decade, to bequeath their private collections to the young museum.

III

The First Benefactors

In donating the money to build the Museum, Isaac Delgado provided no endowment for its operation or for establishing a permanent art collection. From the outset the Museum became a ward of the city of New Orleans, which in the beginning provided only modest sums for maintenance and operations. The annual appropriation of the city in the first decade of the Museum's existence was $5,500. That amount covered the salaries of the curator, the custodian, a janitor, two guards, a night watchman, an assistant secretary, and the treasurer, as well as heating and electricity bills, repair costs, the price of display pedestals, printing disbursements, moving charges, and petty expenses. This can be compared with the Metropolitan Museum of Art, the largest art museum in the nation then as now, which had an operating budget in 1911 of $338,864.41, and a professional staff of twenty-seven.[1]

American art museums generally fall into two categories. First, there is the museum formed by a group of public-spirited citizens out of civic pride and a belief in the educational and cultural benefits of the kind of institution they are setting up. Usually, a museum of this sort begins with the building of an edifice. The formation of an art collection follows, through the generosity of many donors. Second, there is the museum formed by a single active art collector who desires a permanent home for his or her treasures. In the second category are the Isabella Stewart Gardner Museum, in Boston; the Walters Art Gallery, in Baltimore; the Frick Collection, in New York; and the Phillips Collection, in Washington, D.C. The Isaac Delgado Museum, although built with funds from but one patron and originally carrying the benefactor's name, falls into the first category. Since Delgado had

1. "Annual Report, for the Year Ending December 31, 1911, of the Metropolitan Museum of Art" (1912), 3.

no personal art collection to display in his museum, the founding trustees hoped that a handsome new building would attract art works from private collectors, as well as funds that enabled important art purchases. A key to the success of any art museum that must depend on multiple donors is the presence of serious art collectors in the museum's city or region. The South was at a distinct disadvantage in this regard, compared with the Northeast and the Midwest. The long economic devastation following the Civil War meant that no great industrial fortunes were formed in the South in the late nineteenth century which were capable of supporting the formation of great art collections. There were no J. P. Morgans, Andrew Mellons, or Henry Clay Fricks in the South.

In 1911, New Orleans, owing in part to its historical and cultural ties to France and its long urban cosmopolitanism, was more artistically engaged than any other city in the South. The city's long-established opera houses and the School of Art at Newcomb College were indicators of the cultural environment the city afforded. At the time of the Museum's founding, New Orleans had several art collectors who took an active interest in the new institution. Two of the city's three most important collections—the Morgan Whitney collection of Chinese jades and the Chapman H. Hyams collection of salon paintings—were bequeathed to the Museum in its first five years. The third collection, by far the most distinguished in New Orleans and the only one in the South of truly national stature, was Hunt Henderson's of French impressionists and Whistler. Henderson lent many works to the Delgado during its first decades, but his collection was finally lost to the museum. No other collectors of the stature of Hyams, Whitney, or Henderson were to arise in New Orleans until after World War II. The effect was disastrous on the formation of the museum's permanent holdings.

For its exhibition program during the first forty years, the Delgado depended on the generosity of the Art Association of New Orleans, the New Orleans Art League, and the Southern States Art League. These groups selected loan shows, rented them, and paid hanging and shipping costs. On such groups the Museum also relied in building its permanent collection during the first decade. In 1911, the Art Association of New Orleans gave on long-term loan a fine oil painting by the American realist Robert Henri, *Spanish Gypsy Girl*, which was converted to a gift in 1960. A large landscape of 1847, *Forenoon*, by Asher B. Durand, one of the pioneers of the Hudson River school,

was given to the Museum in 1916 by the Fine Arts Club of New Orleans. The board of the Museum did in these years manage to purchase several works of art with small cash donations and with the funds realized from paid admission. Charles Rosen's *Frozen River* was bought in 1913 with admissions money, and Frederick J. Waugh's *Oncoming Wave* in 1914. Accessions secured in this way were doubtless beneficial, but they were also minimal. Bequests and donations by local art collectors and art lovers had to be the Museum's principal source in building its permanent art collection in the first decade.

The first benefactor of the Museum was Major Benjamin M. Harrod, who died in September, 1912, leaving his landscape paintings to it. According to a newspaper article of March 11, 1913, "the late Major Harrod expressed the wish that his pictures go to the Museum after the death of his wife, and Mrs. Harrod decided it would be best to give the collection to the institution in her lifetime." In the gift were eleven oils and one watercolor, including works by the finest landscapists working in New Orleans in the post–Civil War period. Among the paintings were Richard Clague's *Back of Algiers* and *Fisherman's Camp;* Achille Perelli's *Deer's Head;* and Bror Anders Wikstrom's *Miami, Florida* and *Morning on the Banks.*

The following year, Mrs. Harrod gave the Museum a collection of fifty-six pieces of English, French, and American silver, along with numerous items representing the decorative arts. A booklet compiled in 1936 under the auspices of the Federal Art Project of the Works Progress Administration describes the Harrod silver and notes several remarkable pieces. Among them are a small English cream jug dated 1754–1755 that was made by Ed. Doweal, and an American tea strainer by Amos Doolittle, of New Haven, Connecticut, *circa* 1775. There were also numerous American pieces engraved with the monogram of Benjamin Morgan, Major Harrod's grandfather, which were produced in Philadelphia about 1815 by Fletcher and Gardner, and a number of pieces made after 1830 by the New Orleans firm of Hyde and Goodrich.

The generosity of Mrs. Harrod was also evidenced by her bequest of five thousand dollars in October, 1917. That was the first monetary bequest the Museum had received, and it was set up as a fund the income from which would be used for the acquisition of American paintings. Until 1949, it was the only endowment the Museum could draw on to purchase works of art. In 1919, the Museum acquired the

first of the paintings it was to buy with money generated by Mrs. Harrod's bequest. It was an oil, *Afternoon Light*, by Charles Wellington Boyle, then curator of the Museum. Among the other oil paintings the Harrod Fund secured during the 1920s, 1930s, and 1940s were *Portrait of Grace King*, by Wayman Adams; *Mysteries*, by Arthur B. Davies; *Our Daily Bread*, by John McCrady; and *Alice by the Sea*, by Mary B. Sawsell.

In 1913, the first truly important donation of art came to the Museum through the bequest of Morgan Whitney, who on July 19 had died unexpectedly of a heart aneurysm at age forty-four. He had been visiting the home of his sister-in-law, Mrs. George Q. Whitney, who was summering in Newport at the time. The bequest he left is known as the Whitney jades, though it comprises his collection of 145 pieces of Chinese jades and porcelains of the Ch'ing dynasty, Japanese ceramics, objects of amber, amethyst, aquamarine, and rock crystal, and some shell and coral ornaments. In the *Times-Democrat* of September 1, 1913, A. H. Griffith, a "noted connoisseur, and for twenty-two years resident curator of the Detroit Public Museum of Art," pronounced the collection "one of the finest in the country." He also said "that $50,000 would be a conservative estimate of the collection's value." "Indeed," he continued, "I consider the collection to be the most valuable that I have ever seen." But that exaggerates the quality of the Whitney collection. Though certainly distinguished, what Whitney gave does not equal in size or breadth the great oriental collections presented to the Boston and New York museums during the period.

A man of great taste, Morgan Whitney had dedicated his life to aesthetic pursuits that allowed him to follow his artistic inclinations. The *Times-Picayune* stated at the time of his death that he was a "scion of one of the wealthiest families in the state." Indeed, he was from one of the wealthiest families in the nation. Whitney's grandfather, Charles Morgan, had made a fortune in the lucrative nineteenth-century steamship and railroad businesses, and he saw to it that his heirs were well provided for. His daughter, Maria Louise Morgan Whitney, was devoted to him. She had "turned out to fulfill his fondest hopes,"[2] as had his son-in-law, Charles A. Whitney, who collaborated successfully with his father-in-law in shipping and railway ven-

2. Wesley Towner, *The Elegant Auctioneers* (New York, 1970), 86.

tures, assuming the presidency of the business when Morgan died in 1878. "An intense Episcopalian of portly physique and sporting enormous mutton-chop whiskers,"[3] Charles Whitney was a capable administrator in an era of cutthroat competition. Unfortunately, he himself died a short four years after Morgan. He left a considerable fortune, and his son's share of it was variously estimated by the New Orleans papers at between $1 million and $1.5 million.

At the time of his father's death, Morgan Whitney was only thirteen years old. The young Whitney spent his school days in New Orleans and summers in the East with his mother, brother, cousins, grandfather, and stepgrandmother, Mary Jane Sexton Morgan. A short, quiet woman, she was a frustrated collector. Long interested in art, she was never allowed by her husband, a man of austere taste, to buy any paintings, porcelains, or crystal. Upon Morgan's death, however, she fell to collecting with a passion. At the time of her own death in July, 1885, Mary Jane Morgan had over 240 paintings and her estate was estimated at about four million dollars. Included in the collection, which was sold at auction by her heirs, was a Chinese peachbloom vase, eight inches high, for which she had paid twelve thousand dollars. For weeks before the auction the newspaper reporters had played up the high cost of such a small object. The New York *Times* editorialized that the vase "is in the nature of a monster or other spectacular object and is regarded with open mouth by the public solely because it cost the price of a New York house." Authorities were brought in to authenticate its age and origin. More controversy was stimulated by the newspapermen, many of whom felt Mrs. Morgan had been duped into paying so much for such a small thing. At auction, however, the vase brought eighteen thousand dollars. It was sold to William J. Walters, of the Walters Art Gallery, in Baltimore, to be displayed within the priceless Chinese collection there. Because of the scandal, the public flocked to the gallery to see the object that had brought the world's record auction price for a piece of Chinese porcelain. "They clamored in vain," however, for Mr. Walters "was so infuriated by the publicity that he withdrew the vase from the exhibition."[4] After the death of his son in 1931 the vase was again shown among the Chinese porcelains, and now one can "gaze upon Mrs.

3. James P. Boughman, *Charles Morgan and the Development of Southern Transportation* (Nashville, 1968), 233.
4. Towner, *The Elegant Auctioneers*, 113.

Morgan's much maligned bottle, shedding—in the words of the Museum catalogue—the delicate play of color of a ripening peach splashed with apple green."[5]

Indeed, one wonders how this controversy concerning his step-grandmother's vase and collection must have affected the young and artistically inclined seventeen-year-old Morgan Whitney. Although it is hard to determine how much influence Mrs. Morgan exerted on the young man, it cannot be doubted, that he had come to appreciate objets d'art. Indeed, in his own later collection were two pieces of peachbloom porcelain. The *Daily Picayune* of February 17, 1914, reported the size and cost of Mrs. Morgan's vase and estimated that the large peachbloom porcelain in the Morgan Whitney Collection was "worth more in view of its size." An article in the *Times-Democrat* on September 1, 1913, however, reported that George N. Gallup, of New Orleans, "a close friend of Mr. Whitney and an expert in the classification of art objects," stated that Whitney had paid $4,500 for the larger of the peachbloom vases. Regardless of the value of the vases, they remain a witness to their owner's taste as a collector.

Whitney, though a director of the Whitney Central Bank and Trust Company, founded by his brother George Q. Whitney, seldom attended meetings of the board. He took "little interest in business affairs."[6] He preferred the pursuits of collecting, painting, photography, music, and literature. A creative artist himself, he studied at the Ecole des Beaux Arts with Albert Herter. In his collecting he sought out one of the best instructors available, George F. Kuntz, of Tiffany's, in New York, who was also an adviser to J. P. Morgan on the collection of jades.

Whitney was less tradition-bound than one might assume, taking an avid delight in photography and motorcars. He was one of the first New Orleanians to own an automobile, a 1911 Locomobile. At the time of his death he had on order a second Locomobile. He could be seen spinning down many a Louisiana dirt road in a white duster, goggles, and hat, with a lady companion, a picnic hamper, and his camera and tripod. He took lovely photographs of bayous, live oaks, and plantation houses. The post–Civil War economy had left many plantations in a state of disrepair, and Whitney was able to catch with his camera much that has now been lost.

5. *Ibid.*
6. New Orleans *Times-Picayune*, July 20, 1913.

He was a sensitive interpreter not only of the countryside but also of the city of New Orleans. His planinum prints of the architectural beauty of the Vieux Carre predate Arnold Genthe's by some fifteen years. In contrast to the documentary feel of his scenic photographs, his still lifes are extremely romantic. Those compositions include many of the Chinese objects he bequeathed to the Museum, and show his reliance upon the painterly traditions he learned at the Ecole in Paris.[7] In his short life, Whitney brought into focus much beauty through his creativity and his philanthropy.

His gift to the Museum was heralded by fanfare in all the newspapers. Every detail seemed to be of interest. On the day the Whitney jades were transferred to the Museum, a reporter for the *Times-Democrat* wrote,

> Promptly at three o'clock a big moving van, with five men, backed up at the residence. The art pieces, heavily swathed in paper, were placed in large baskets, which were carefully loaded into the van. The doors of the wagon were locked and the driver proceeded slowly, taking no risks of breakage.
>
> The unusual number of men on the van was due to the fact that members of the family and Museum officials felt that a guard was necessary in transporting the collection, which is valued at many thousands of dollars, and could not be duplicated at any price. A list of the 145 pieces was carried by the men, and this was checked over by Charles W. Boyle, resident curator of the Museum when the collection arrived.[8]

In 1914, Mrs. George Q. Whitney, a local art patron who on occasion lent paintings to the Museum, donated five hundred dollars for cataloging and classifying the jade collection of her brother-in-law. Professor John Getz, of New York, was hired to do the preparation. This was the first scholarly catalog published under the auspices of the Isaac Delgado Museum of Art.

In the same year, the Museum received another collection, the gift of Mrs. Emory Clapp. Her donation comprised "twenty-two splendid examples of the medalist's art."[9] There were several bronze medals, but most were in silver. Among them were two medals by J. C. Chaplain, one of the czar and czarina of Russia and the other of Victor Hugo.

The year 1914 was a lean one. The only gift of note was from Mrs. Stanley O. Thomas, who donated a Battista Constantini watercolor,

7. Many of these photographs were given in 1976 to the New Orleans Museum of Art through the generosity of his grandnephew Morgan Whitney and Mrs. Whitney.
8. New Orleans *Times-Democrat*, November 1, 1913.
9. *Ibid.*

Arch of Tiberus; a Pieter G. Vertin oil, *Street Scene;* and a Pompeo Massani oil, *The Critics.* There followed, however, a landmark year, for the Museum in 1915 received the largest collection of paintings anyone was to give it until the Samuel H. Kress Collection was deeded to it in 1961. The gift was a collection of works from artists of the French salon, the Barbizon school, and the Munich group. The paintings were left to the Museum by Mrs. Chapman H. Hyams in her will, probated in January, 1915. There were thirty-six paintings in all, among them works by Sir Lawrence Alma-Tadema, Rosa Bonheur, Adolphe William Bouguereau, Jean Baptiste Camille Corot, Narcisse Virgile Diaz de La Peña, Jean Léon Gérôme, and Adolf Schreyer. There were also five pieces of marble statuary. The value of the bequest was the subject of some speculation; suggested figures ranged from $300,000 to $500,000.[10] Although representing conservative, academic taste, the Hyams Collection included fine examples by many of the most popular salon painters of the late nineteenth century. By 1915, however, such artists had fallen from critical favor, having been eclipsed by the far greater impressionist and postimpressionist painters. By the 1980s, critical reevaluation of nineteenth-century art had revived the reputations of the salon painters, and Hyams' collection had regained critical interest. Of course, such realistic, often sentimental, paintings had always been preferred by the general public to the avant-garde modernists of the twentieth century.

One newspaper reported the Hyams bequest as the most important thing to happen to the Delgado Museum since its opening. The reporter praised the connoisseurship of Mrs. Hyams, writing,

> But Mrs. Hyams not only had the means to procure the work of the world's most famous artists, she had the rare genius of selections. Her example of Corot is one of the very finest of Corot's paintings, and so with the other masters. Her subject by Corot, is worth perhaps $90,000 to $100,000, because it is Corot at his best. "The Charge of the Arabs" by Schreyer, is a marvel of action by an artist noted for his genius in depicting action in his paintings. And so through the list of treasures which she has presented to the Delgado Museum. Each is not only a celebrated artist, but is counted among the very best examples of that artist's style.[11]

Mrs. Hyams, who was born Sara Lavinia Todd in New Orleans in 1846, the daughter of Samuel Morse Todd and Sarah Potter Todd, was long interested in art and had traveled extensively through Europe.

10. New Orleans *Times-Picayune,* January 30, 1915.
11. *Ibid.*

She had visited the great European museums, and she frequented the ateliers of the famous artists of the day. Her painting by Bouguereau, *Whisperings of Love,* was purchased while it was on the artist's easel. The same reporter who praised Mrs. Hyams' connoisseurship wrote that "during Mrs. Hyams' visit to Paris in 1883 she visited the studio of the great Frenchman and saw him at work on the picture. She immediately made an offer for the painting only to be told by the artist that it had already been sold to Tooth and Company, the great London art dealers. Mrs. Hyams at once sent a commissioner to London empowered to buy the picture, and Tooth and Company sold it to her while it was yet on the easel."

Mrs. Hyams and her husband, who was the senior member of the banking and brokerage firm of Hyams, Moore and Wheeler, had lent the collection to the Museum's inaugural exhibition. Their deep concern for the success of the Museum was indicated by the codicil to Mrs. Hyams' will, in which she left the new facility her paintings and sculptures. The codicil was dated less than six months after the Museum opened, and it clarifies her motivation for endowing the Museum with her collection: "Owing to the fact that my dear son has no domicile in New Orleans and desiring that my paintings should not leave the City, I hereby give and bequeath to the City Park Improvement Association" According to the *Times-Picayune*, she requested that her donation "be placed and kept in the Isaac Delgado Museum of Art in a separate room to be known as the Art Collection of Mrs. Chapman H. Hyams." [12]

Chapman H. Hyams, Jr., then living in New York, was a well-known banker, clubman, and sportsman, whom his mother left a trust fund of undisclosed size. [13] His son, then a young child, Chapman H. Hyams III, was also the beneficiary of a trust fund under Mrs. Hyams' will. To her sister Bertha Alice Trufant, wife of Samuel Adams Trufant, who later became a board member and the treasurer of the Museum, she left an annual income for her life. To her niece and namesake, Sara Trufant Burguieres, she gave fifty thousand dollars, and to her nephew S. A. Trufant, Jr., twenty thousand dollars. From the sale

12. New Orleans *Item*, March 16, 1916.
13. He was active locally in the Boston, Louisiana, and Pickwick clubs as well as the Young Men's Gymnastic Club and the Southern Yacht Club, serving for many years on the house committee of the last of these. He owned a "crack yacht, the *Violet IV* which he kept at his summer home on the Thames River, New London, Connecticut" (*Club Life*, Spring, 1903, p. 22). Other New Orleans families such as the Whitneys and Moores also had summer homes there.

36

of her personal jewelry the proceeds were to be divided equally between City Park and Audubon Park for beautification improvements.

By her unprecedented bequest, Mrs. Hyams gave the Museum the support such a young and growing institution vitally needed. An editorial in the *Times-Picayune* of January 30, 1915, spoke of the consequences: "By the will of the late Mrs. Chapman H. Hyams, the Museum suddenly assumes a position of real importance in the art world." The editorial continued, "Few dared believe or hope that [Delgado's] munificence would be equalled, for many years at least, and one had come to look upon the Museum's donor as *facile princeps* in artistic philanthrophy. By the stroke of the pen Mrs. Hyams . . . has changed that, her paintings . . . will outvalue all the stone and steel of the building's initial construction."

Three weeks later an editorial in the *Times-Picayune* pointed out that as a result of gifts like the Hyams paintings and the Whitney jades, proper spacing and display in the Museum were becoming a problem. Indeed, it commented, "It is now quite apparent that the Museum building, in its present state, will not long be able to accommodate the treasures that have been pouring into it during the few years of its existence." In summation it said, "The addition, however, of one or of both wings to the building is a crying necessity and it is to be hoped that some patron of the arts in following the example set by Mrs. Hyams and Mr. Whitney may make his or her bequest in the form of a museum wing to bear his or her name." Such sensible advice went unheeded for more than fifty years.

Though no funds were offered for new additions to the Museum, money was given for the Museum's maintenance. Chapman Hyams wisely protected his wife's collection with an endowment of sixty thousand dollars in 4.5-percent interest-bearing bonds. Donated some four months before his death on April 20, 1923, the principal was to remain intact, with the income used for the upkeep of the Museum's collections. In the lean years of the Great Depression this donation, known as the Chapman H. Hyams Fund, was to prove a godsend in keeping a roof over the paintings and the heat on in the galleries. Hyams also set up a smaller fund, the income from which was to be expended in the maintenance of the room housing the art collection of Mrs. Hyams. The yield of that fund could be used for compiling catalogs, for varnishing the paintings, and for keeping the picture frames in good condition. The two funds represented the only maintenance endowment that the Museum had until 1961.

Hyams also added to the collection given by his wife. In December, 1915, he acquired two paintings from Ronald F. Knoedler, of New York: *The Masquerade Ball, French Opera House, Paris,* by Gaston La Touche, and *A Lesson in Lace Making,* by Joseph Bail. Knoedler had exhibited these and other paintings at the San Francisco Exposition. Hyams was guided in choosing them by Harry Walters, president of the Baltimore Museum of Art. Walters wrote, "I have always been a great admirer of the work of Joseph Bail, and consider the example you think of purchasing a fine picture." [14]

The year 1915 saw the Musuem benefit again from a will, although the trustees had to go to court to receive the entire gift. In March, 1915, Eugene Lacosst died and left an estate of $187,000. In a fascinating preference, he in his will requested to have twenty-five thousand dollars diverted from his estate to construct a tomb of white marble in Metairie Cemetery, in which only his own body and that of his mother would be interred. The will also spelled out bequests to several charitable organizations, to a few individuals (including Lacosst's mother, for whom he provided a lifelong pension of fifty dollars a month), and to the Isaac Delgado Museum of Art. He stipulated that the Museum receive his collection of bronzes and marbles. The residuary legatee of the estate, after his mother's demise, was to be Charity Hospital.

In 1916, Lacosst's mother, Jeanne Lacosst, sued Emile Pomes, the testamentary executor, and Charity Hospital, the residuary legatee, to have the will declared null and void, or in the alternative, to have herself declared the forced heir of Eugene Lacosst, who had no children, thereby entitling her to not less than one-third of the amount of his estate, or at least fifty thousand dollars. In the first instance, if the will proved to be ambiguous, she would inherit the entire estate. In the matter of the Lacosst succession, the supreme court of the state of Louisiana refused on June 30, 1916, to hear the case, because not all the legatees had been apprised of the fact that the will was being contested.

Before the remaining beneficiaries under the will could join the suit, Mrs. Lacosst died. Her daughter, Berthe Lacosst Heinisch, who was her mother's heir, continued the suit, however, in an attempt to gain her half brother's fortune. On January 3, 1918, a decision on rehearing the case was rendered. According to Mrs. Lacosst's testi-

14. Harry Walters to Chapman H. Hyams, November 6, 1915, in archives, NOMA.

mony, her son, Eugene, was born eight years before she was married. Eugene's father was Fabian Pradere, who himself was not a married man. Eugene was born in Mane, France, and he was registered at birth and baptized in his mother's name, that is, as Eugene Charles Lepine. In 1860, Mrs. Lacosst—then known as Jeanne Lepine—sailed to New Orleans, leaving the six-year-old boy in France with a relative. Two years later she married Jean Marie Lacosst, and after several years they sent for Eugene. He arrived from France and took up residence with his mother and her husband, immediately assuming the name Eugene Lacosst. In New Orleans, he was known only by that name. He established a successful hairdressing business on Royal Street and eventually took up his residence in the establishment, away from his mother and her husband. He was very close to his mother, nevertheless, and upon her husband's death he immediately provided another home for her, residing with her until his death. He was liked by his clients and admired by many as an amateur musician whose specialty was whistling.

The court found in favor of the defendants rather than Mrs. Heinisch. According to the definition contained in Article 202 of the Civil Code of Louisiana, Eugene Charles Lepine, or Eugene Lacosst, could not be called a natural child, nor was he in the classification of children acknowledged by their fathers. Hence he was considered illegitimate, or a bastard. As a consequence, he could devise by will the manner in which he wished to dispose of his estate, and his mother was not entitled to any portion thereof.[15]

Thus Lacosst's intent to aid some of the city's public institutions through his will was preserved. Besides the bronzes and porcelains, the Museum eventually received five thousand dollars from his estate. But Lacosst is remembered today mainly for his huge memorial sarcophagus, which looms over the flat land as one drives out Metairie Road. City wits often refer to it as the Roman bathtub. Erected from a design by the architects Burton and Bendernagel, it is considered one of the best examples of the massive tomb building that occurred in Metairie Cemetery from 1895 to 1925, and it is esteemed for the quality of its carving.[16] But imagine what a memorial that twenty-five thousand dollars could have built in the form of a named wing for the Museum or of an important acquisition.

15. *Louisiana Reports* 142, pp. 674–92.
16. M. L. Christovich (ed.), *New Orleans Architecture: The Cemeteries* (Gretna, La., 1975), 54.

The last important gift of the decade was presented to the Museum in 1916 by Alvin P. Howard, of New Orleans. Alvin, the son of Frank T. Howard ("the wealthiest man in Louisiana") and Emma Cora Pike Howard, was born on May 20, 1889. As a youth he traveled abroad extensively, visiting the major museums. But Howard's visits to archaeological digs are of greater note, for his gift to the Delgado Museum reflected the archaeological interest he possessed in his youth.

It was Alvin's grandfather Charles T. Howard who had laid the foundation for the family's fortune. Born in 1832 in Baltimore, the grandfather moved to New Orleans as a young man, and in 1854 he was appointed an agent in New Orleans of the Alabama State Lottery. After his military service during the Civil War, he returned to New Orleans and became an agent there for the Kentucky State Lottery. Familiar with the workings of state lotteries, he came to believe that Louisiana should have one too. With the support of a number of wealthy capitalists, he in 1868 secured from the state legislature a charter for the Louisiana Lottery, of which he was elected president. He was also one of the founders of the Metairie Cemetery Association, in 1872. He was an active half owner of the Maginnis Cotton Mills and a part owner of the Planters Crescent Cotton Seed Oil Factory. These endeavors placed him in the front ranks of the city's New South capitalists.

Alvin Howard's father inherited a large fortune, which he managed ably. He was a stockholder and director of several ventures, such as the New Orleans Gas Light Company, the New Orleans Traction Company, and the New Orleans National Bank. The historian Alcée Fortier wrote of him, "He has always been a firm believer in the great advantages for investment offered in the South, and pursuant to his conviction has reaped large profits from numerous enterprises, thus several times doubling the fortune left him by his father."[17]

Nonetheless, Frank T. Howard was not all business. He enjoyed many of the aesthetic benefits of life. Educated at Washington and Lee when Robert E. Lee was president of the college, he was a man deeply interested in intellectual enterprises in New Orleans. He was especially active in supporting the public libraries of the city. He served as secretary and treasurer of the Howard Memorial Library, which his sister, Annie Howard Parrot, had founded in 1889 at the cost of $115,000, as a memorial to their father. He was president of the

17. Alcée Fortier, *History of Louisiana* (4 vols.; New York, 1904), 239–40.

Fisk Free Public Library and the New Orleans Library. Fortier wrote that Howard was "a leader in artistic and literary circles, and a great traveler. His elegant home is embellished by a choice collection of paintings, statuary and articles of virtue gathered from all parts of the world."

It was those that Alvin Howard gave to the Museum in 1916—the objects de virtu that his father, his brother Edgar, and he had seen on their travels abroad in 1897, 1904, and 1910. On the first of the three trips, when Alvin was only eight years old, the travelers visited the tombs of Kertsch, in southern Russia. Upon his graduation from Yale in 1910, he returned to New Orleans, where he taught at Tulane and "showed an interest in archaeology." [18] He could not, however, continue his avocation, for his father's death in 1911 made his entry into the family business necessary.

The Howard Collection is, in any case, permanent evidence of his deep feeling for archaeology. It consists of ninety-one glass vessels taken from the excavation made at the Kertsch tombs of the Scythian kingdom, as well as several Grecian vases, figurines, and temple lamps, some of which were found at Siana, Rhodes, in the Bilroth excavations. According to the *Times-Picayune*'s art critic of the time, Robert B. Mayfield, "the collection is one of the finest of its kind in America and quite comparable in its beauty and antiquity to that of the Metropolitan Museum in New York." [19] Mayfield reported that "the collection was passed on by the curator of the British Museum and examined and approved by the noted Kuntz, the Tiffany expert." [20] The Howard Collection of ancient glass, significant for its number of large, unbroken vessels, was the beginning of the Museum's comprehensive collection of world glass which blossomed forty years later with the donation by Melvin P. Billups.

18. New Orleans *Tribune*, December 25, 1937.
19. New Orleans *Times-Picayune*, July 30, 1916.
20. L. C. Tiffany had been experimenting for years in trying to reproduce the glazes and textures of ancient glassmaking and had acquired many pieces from archaeological expeditions.

IV

Ellsworth Woodward

If the first decade of the Museum's growth depended on the efforts of many clubs, associations, and individuals, the second was shaped by the work of the Art Association of New Orleans. The story of the Museum in the 1920s is almost entirely an account of the Art Association's active support. From the inception of the Museum, the Art Association's participation was assured by Isaac Delgado's letter of intention dated April 26, 1910, in which he directed that the board of administrators of the Museum was to consist of representatives of the Art Association and of the City Park Improvement Association.

In the beginning the park association's representatives, once the association had donated the land and promised to maintain the grounds, played a secondary role. In determining artistic matters, they had almost no part. What exhibitions were to be held, how the shows were to be financed, how many exhibition galleries were to be constructed, what gallery space was to be devoted to the display of arts and crafts, and what goals were to determine the permanent collection—all these questions received the attention of, primarily, the representatives of the Art Association.

It was the Art Association that had money for exhibitions. Its members were experienced in obtaining shows, and they had contacts throughout the United States. Among its members were many local artists and art patrons. The Art Association was the artistic arbiter in the city, and its program during the 1920s became the Museum's. Its one-man shows, visiting artist's exhibits, and juried and nonjuried salons were all hung in the galleries of the Museum. Thus Ellsworth Woodward proudly wrote in 1930, in summing up the successes of the Art Association during the 1920s, that its achievements were "not the acts of individuals, rather they are the result of community spirit."[1] But

1. "Twenty-Seventh Annual Report of the Art Association of New Orleans" (1930), 9.

however proud Woodward may have been of the achievements of the "community spirit" of the Art Association during this period, in retrospect it is possible to see that it had a deleterious effect on the development of the Museum. The rapid growth of the first decade turned into the near-standstill of the second.

Although there were more exhibitions, with the result that attendance increased moderately, the Museum did not receive the donation of even one noteworthy collection, nor did the board of administrators purchase anything remarkable during these years. A series of art-appreciation lectures was initiated, yet not one major painting or sculpture was added to the Museum's permanent collection. When the first curator, Charles Wellington Boyle, died in 1925, his position was not filled by a professional until 1948. The Museum did not actively seek or raise funds for accessions. The Hyams' maintenance fund, given in 1923, was so poorly managed that the capital did not increase by one penny in the six years prior to the stock-market crash of 1929. So apathetic was the board of administrators that the bylaws were amended to count three members present as a quorum. In place of the enthusiasm, the excitement of the earlier period, there was now a waning vitality.

Explaining the decline of interest, Ethel Hutson wrote that "in 1921 came the first post-war depression—the market for pictures fell—and for some reason the habit of buying works of art has not yet returned here. The friends of art grew discouraged, and for some time local artists were invited to exhibit only in the annual exhibitions."[2] Miss Hutson's memory of the twenties was much colored by her proximity to the Great Depression. Had she forgotten the millions of automobiles manufactured and sold in the 1920s to as many millions of Americans? Had she forgotten the great new fortunes amassed in the constantly rising stock market and in the new gushers of the Texas, Louisiana, and Oklahoma oil fields? And what about the phenomenal development of the radio and airplane? Did the words and names that are so reminiscent of the independence and prosperity of the era, like *flapper*, the Charleston, Zelda and F. Scott Fitzgerald, *bathtub gin*, and Dixieland jazz, have no significance to her? Indeed, the growth and prosperity of New Orleans during the period confutes her explanation, even if there was the agricultural downturn that occurred in 1921–1922 as a result of the boll weevil's devastating invasion of the

2. Ethel Hutson, "The Art Association of New Orleans," Warrington *Messenger*, October, 1936, p. 9.

Deep South. The New South that writers like George Washington Cable and Joel Chandler Harris had envisioned decades earlier at long last was becoming a reality. No longer was the region wholly dependent on agriculture. There were new industries, new jobs, and larger salaries than ever before. The population grew quickly, and the construction of housing boomed. More tonnage passed through the port of New Orleans than previously; the port grew to be the second largest in the nation and created jobs for thousands.

It would be more plausible to trace the slump in the Museum during the 1920s to the dominance of the Art Association of New Orleans' influence on the Museum, and more particularly, of the influence of its guiding light, Woodward. Woodward was a founder of the Art Association, and its president in 1908. Later he was the chairman of its executive committee. A well-known painter and printmaker, as well as a professor and dean at the School of Art at Newcomb College, he was eminently qualified to serve as a representative of the Art Association on the charter board of the Isaac Delgado Museum of Art. It is completely understandable that he won appointment as one of a committee of two to select the winning architectural design for the Museum's construction and as the chairman of the Museum's art committee.

As dean, beginning in 1890, of the School of Art at Newcomb College, Woodward had raised it to the position of the preeminent art school in the South. The crafts—pottery, needlework, silversmithing, and bookbinding—designed and executed there became nationally and internationally known. Among the outstanding awards the school won in pottery, for example, were the bronze medal at the Paris Exposition in 1900, the silver medal at the Buffalo Pan-American Exposition in 1901, the silver medal at the Saint Louis Louisiana Purchase Exposition in 1904, the gold medal at the Jamestown Tercentenary Exposition in 1907, and the grand prize at the San Francisco Panama-Pacific Exposition in 1915. "The story of Professor Woodward is . . . the story of the birth, progress, and success, second to that of no other section of the country, of Southern Art," wrote one commentator.[3]

Woodward's educational philosophy was based on the conviction that a New South was being born and that art education was essential to its cultural and, in turn, its economic progress. For Woodward, art

3. Mrs. E. A. Flower, untitled article, *New Orleans Life*, November, 1926.

and industry were inseparable. Each depended upon the other for success. In a lecture at the Museum on ceramic pottery, he remarked, "In all manufactured articles in which there is an appeal to taste, those articles sell best and bring the highest returns which possess the imprint of art." [4]

His promotion of the design and production of the internationally acclaimed Newcomb pottery illustrates the truth of his statement. Indeed, its manufacture was extremely profitable. For over thirty years, the sale of Newcomb pottery yielded an average monthly income of over a thousand dollars for the school and its students. If Newcomb could do so well, why not establish an enormous pottery works in New Orleans? Woodward constantly urged the need for a large-scale pottery industry to take advantage of the fine and bountiful clays of southeast Louisiana. He dreamed of seeing the city "become noted for a fine pottery center as much as Grand Rapids, Michigan, for example is noted for the manufacture of furniture." [5]

When Woodward began teaching at Tulane, the Deep South was only starting to come to grips with the backwardness of its educational system and the need for improvement. "It is almost impossible for us to realize at the present time when opportunities are so many, what these first classes in art meant. . . . Engineers, architects, draftsmen, commercial artists, all clamored for the chance to have lessons in art," [6] a chronicler of the times wrote. Art was one of the disciplines considered vital to a young man's education if he was to compete in the technologically advanced world. Woodward explained, "Today we train our students in the basic principles of art and we show them how they can apply these principles to industry. If they have the flair for pure art, this training is only that which they should rightfully go through. If they find they do not have the flair, they can fall back on any one of the special applications and adopt it as a lucrative profession." [7] He showed his students how art could be made to pay off.

His beliefs about art and industry were assimilated by generations of his students throughout the South as well as by the board of administrators of the Museum. It seemed eminently sensible to builders of a new era of prosperity. Previously expressed in the mid–nineteenth

4. New Orleans *States*, September 14, 1925.
5. New Orleans *Item-Tribune*, September 14, 1925.
6. Flower, *New Orleans Life*.
7. New Orleans *Item*, February 28, 1939.

century by the arts-and-crafts movement and by the pre-Raphaelites, Woodward's ideas were allied with the theories of "useful art," art that appeals to people because it is practical and educational. Such concepts were very popular at the Rhode Island School of Design, where Woodward had studied as a young man, and they inspired art nouveau's reaction to the supplanting of craftsmanship by industry. The result was that artists like Emile Gallé, Victor Horta, Charles Rennie Mackintosh, and Louis Comfort Tiffany produced many new designs in furniture, textiles, posters, glass, and illustrations. Newcomb under Woodward's tutelage produced numerous pieces in the resulting style.

But art nouveau soon gave way to more experimental currents in art. In 1910 in France, cubism was first accepted for formal showing in the Salon des Independents; Wassily Kandinsky wrote "The Art of Spiritual Harmony" and created his first abstract work; in Germany, *Der Sturm*, a vehicle of the expressionists, was first published, and the second exhibition of the Neue Sezession was held. It included the works of Georges Braque, Pablo Picasso, and Georges Rouault as well as those of the German expressionists.

These movements were too radical for the conservative Woodward. The Young Turk of the 1880s, educated in the arts-and-crafts tradition and an advocate of art nouveau, became an intransigent academic by the 1920s. Under his guidance the art school at Newcomb continued to produce ceramics and other works in the arts-and-crafts style well into the 1930s. While he was chairman of the Museum's art committee, the Delgado acquired not one of the works of the French impressionists or of the European or American avant-garde—no Monet or Renoir, no Picasso or Matisse, no Marsden Hartley or John Marin.

In fairness to Woodward, it must be granted that his conservative attitude toward modern art was not unusual for his time. The great Armory Show of 1913 in New York and Chicago, which first introduced the European avant-garde to the American public, was greeted with nearly universal derision from the press and art establishment. The battle for modern art was won only slowly, led by the Museum of Modern Art, in New York, which was founded in 1929. Outside New York City, realism with a regionalist slant held sway during the 1920s and 1930s. Modern art triumphed only in the 1950s, with the international success of abstract expressionism.

In 1925, Woodward became the acting director of the Delgado Museum. He held that position for fourteen years, and for six of those years he was president of the Museum's board as well. In 1920, he had

founded the Southern States Art League, and he served as its president for sixteen years. In such positions he was able to promote his own concept of art to the exclusion of the conceptions he abhorred. Many of the men and women who had earlier cooperated in putting the Museum on a sound footing took offense at Woodward's attitudes or were excluded by his control. More and more frequently the Museum mounted shows of strictly local or southern artists, passing up the traveling exhibits of the eastern art associations. Woodward fostered a regionalism of sorts.

As the "foremost promoter of art in the South," Woodward loved to repeat that "art begins at home."[8] In 1923, at the third annual exhibition of the Southern States Art League, he explained his viewpoint:

In the past there has been no opportunity for the Southern artist to win recognition at home—to train himself on his own ground and keep his work characteristic of the soil from which it sprang. With New York and Philadelphia as the mecca for all young artists, the East has been skimming the cream off our bottle. They have taken our geniuses and made them their own. The Southern States Art League with its semi-annual exhibitions at one of the large Southern cities promotes the discovery of our young artists and supplies the chance for them to place their work before their own public for criticism and sale.[9]

Woodward's contemporaries knew that his life was dedicated to the advancement of art, and that his mission had been to show the people of the South the "beauty of the land they loved, to give them the ability to so interpret it that others would value it, to hold high the torch of self-appreciation, and to give them a capacity for the cultural use of leisure time, so that when prosperity came, they were able to enjoy it."[10] But however beneficial his promotion of southern art was, it had a detrimental effect on the development of the Museum, which ceased to serve one of the main purposes for which it had been established.

A primary obligation of a public museum is the acquisition of artistic treasures that can give the community the experience of a range of the art forms and movements of the past and the present. When a museum does not meet that responsibility, the justification for its existence abates. Today, it is virtually impossible for a new museum to represent the entire artistic production of human history. The scarcity and the high cost of artistic works are now prohibitive. But the avail-

8. *Ibid.*
9. *Ibid.* March 8, 1923.
10. Flower, *New Orleans Life.*

ability and the modest cost of important art works in the 1920s are incontestable, from the European old masters, to the French impressionists, to the modernists of the school of Paris. No such works were even considered for acquisition during the period, for according to Woodward there was too much good southern art to be obtained. Unsurprisingly, the Museum became a storehouse for mediocre works.

The Museum featured exhibitions of artists whose names are now forgotten. In 1920, the highly popular Harry B. Lachman returned to New Orleans to exhibit in the Museum thirty-two of his landscapes. As the same time, Hugh Tyler, of Knoxville, Tennessee, exhibited forty-five paintings of South Sea Islands scenes. And as usual there was the annual showing of the Art Association of New Orleans, about which the reporter S. N. Strauss commented,

> It is a good show, but not one distinguished by any work of superlative qualities. On the other hand, there is hardly a canvas in the collection that falls below a rather high plane of excellence. The exhibit differs strikingly from that of last year in that there is a startling absence of paintings by more radical groups among the city's artists, the few examples of this kind represented being of distinctly inferior quality to those seen last season. The conservative element reigns supreme, and evidently has done its best to make a good showing, many of the old guard having outdone themselves on this occasion.[11]

Among the "old guard" were Charles Wellington Boyle, with a portrait of his son, and Ellsworth Woodward, "whose *Moonlight* is evidently a new departure in the output of this well-known painter. It is a study of trees in blue light of the moon, throwing their deep shadows over a little house with candlelight streaming from one of its windows."[12] Most of the works in the Museum's shows were for sale, in keeping with one of the reasons for such exhibitions.

In March, 1920, there was an exhibition of paintings by Helen Turner, and in April a watercolor show by members of the American Water Color Society. In June, there was a hanging of the paintings of Nancy Barnhardt, of Saint Louis, whose works had previously been on display in the city at the Grunewald Hotel. The 1920 season came to a close with a show by the French painter Victor Charreton.

The outstanding Museum event of 1920 was a benefit exhibit in behalf of the Philharmonic Educational Fund. It was a loan show gathered from various collectors in the city. Writing about the paint-

11. New Orleans *Times-Picayune*, March 14, 1920
12. *Ibid.*

ings exhibited, the art critic Robert B. Mayfield said, "The names comprise some twenty-five of the most famous in the annals of modern art, and in each instance the men are represented by one or several of their most characteristic and complete performances." [13] The exhibit included three works of Claude Monet and six of Childe Hassam. Among Hassam's was *The Goldfish*, which had gained notoriety when it was seen in New York. In addition, there was a whole gallery devoted to James McNeill Whistler's etchings and lithographs, all of which belonged to the noted local collector Hunt Henderson. Also shown were works by Eugène Louis Boudin, Edgar Degas, Robert Henri, George Benjamin Luks, and John Henry Twachtman. It was an impressive show, and one that bespoke the quality and variety of New Orleanians' artistic taste during the period. Judging by the list of patronesses who attended the opening, it was also one of the major social events of the year. But it would be many years before such an exhibit would be drawn again from the private collections of New Orleans.

It is disappointing that paintings of the quality of those on view in the Philharmonic benefit did not come to belong to the Museum during the 1920s. The reasons given are usually financial. As a newspaper editor stated, the Museum had "to depend on a sort of pot-luck city budget for scanty funds." [14] Still, that explanation is not altogether credible. There were sufficient funds in the coffers of the Art Association of New Orleans to mount numerous exhibitions, to buy paintings, and to award cash prizes for juried and nonjuried salons. And the Museum's art committee did purchase several works during the decade, among them *My Mandarin Orange*, by Gertrude Roberts Smith, a professor of drawing at Newcomb, for $250 in 1920; *Priscilla Morton*, by Camellia Whitehurst, of Baltimore (the prize-winning painting of the Southern States Art League show of 1923), for $300 in 1923; and a statuette of Adriadne by Pietro Ghiloui, of New York, also exhibited in the Southern States Art League show. Purchased as well were *The Harvest Moon*, by William P. Silva, a southern artist then working in California, in 1924; *Dancing Shadows*, by William H. Singer, Jr., in 1925; *Paradise Wood*, by Woodward, in 1927; and *Alice by the Sea*, by Mary B. Sawtelle, of North Carolina. The Museum acquired other paintings through the Arts and Crafts Club. Twice during the 1920s, the club raised funds at the suggestion of Lyle Saxon—first, in 1924,

13. *Ibid.*, February 1, 1920.
14. *Ibid.*, February 14, 1920.

to purchase *A Peasant Woman,* by the Russian artist Abram Arkhipov, and second, in 1928, to buy *Race Horses,* a work by the local artist Weeks Hall.[15] These works were pleasant in appearance, to be sure, but none was of a quality to justify its purchase by a serious museum.

Almost 90 percent of the accessions during this period were by southern artists, the single exception being the collection of Chinese bronzes that the Museum bought from I. M. Cline in 1928 with funds from the Lacosst bequest. Those pieces, for which the Museum paid $3,135, Cline and a number of reputed authorities affirmed to be of great antiquity and quality. Recent scholarship, however, dates all to the Ming dynasty or later, a period now undergoing reevaluation by art historians.

In February, 1921, the season opened with an exhibition of paintings and etchings by Anne Goldthwaite, of Alabama and New York; that was followed by the Art Association of New Orleans' annual members' show in March. In April, watercolors, pencil drawings, and woodblocks by Alice R. Huger Smith, of Charleston, South Carolina, went on display. The fall season opened with a presentation of Dutch paintings from the Laren school.

The first event of the 1922 season was a show featuring three of Gaston La Touche's paintings and eighty of his sketches and studies. In March, in covering the annual exhibit of works by members of the Art Association of New Orleans, a reporter observed, "The most interesting thing about the exhibition is the progress shown by some of our local artists; in nearly every instance the work this year is far better than that of last season or the season before."[16] Among the newly recognized artists at this show was Caroline Durieux, whose still life was "in color . . . perhaps the most interesting in the exhibition."[17] The end of the year saw another show of Charreton's works. The potential acquisition of one of his paintings was discussed in the newspapers and "led

15. During this period, only three other gifts of paintings were made. In 1926, Henry W. Wack, of New York, donated Leon Dabo's *The Sea—Evening—Low Tide—Oak Point,* and in 1928, Felix P. Vaccaro gave Frank T. Hutchen's *Amar: The Spahi.* Vaccaro had purchased his painting from an exhibition of Hutchen's works at the Museum, a show that had been sponsored by the Art Association of New Orleans. The third gift, donated in memory of Pierre Antoine Lelong by John H. Pepper, was the painting *The Revolt of Pavia,* by Paul E. Boutigny. This painting had formerly been lent for twenty years to the Metropolitan Museum of Art, and later to the Louisiana State Museum, in New Orleans. Because of its deteriorated condition the large painting was deaccessioned in 1981.

16. New Orleans *Times-Picayune,* March 8, 1922.

17. *Ibid.*

to sharp criticism of the relative merits of the paintings on the part of those interested with the result that, if the hope of the management is realized the painting *Effect of Sun on Snow* will be bought."[18]

The opening show of 1923 restricted itself to the paintings of Nicholas Brewer, of Chicago. That was followed in February by a one-man exhibit of the works of Charles W. Hawthorne, the American impressionist who had founded the Provincetown Art Association. April brought the watercolors of Edmund S. Campbell to the Museum. The biggest event of the year was the Southern States Art League show, with more than two hundred works displayed throughout the Museum. That show was a catapult for the whole movement of southern art. New Orleans became the center of the movement because it had a fine museum for exhibition purposes and because Woodward, the founder and first president of the Southern States Art League, resided there. From the New Orleans headquarters of that organization came not only circuit shows that aimed at taking the best pictures to other southern cities but also the smaller one-man shows that had the purpose of introducing young artists to the South. Basic to Woodward's belief in the southern artist was the conviction that the artist deserved a forum not merely in which to exhibit his work but also in which to sell it. The shows provided just what Woodward thought was needed in that respect, much as a commercial art gallery does today. The Museum's first Southern States Art League show sold watercolors, etchings, pottery, and oil paintings valued at more than five hundred dollars—a great deal of money in those days.

The paintings of William P. Silva opened the 1924 season at the Museum. In March was the annual show by members of the Art Association of New Orleans. The winner of the hundred-dollar prize was Woodward's brother, William Woodward, for his oil *The Wading Pool.* In April, there was the show of small soap sculpture sponsored by the New York City Art Center. Exhibited in May was a collection of watercolors, oil paintings, miniatures, etchings, and crayon and pencil sketches from the circuit offering of the Southern States Art League. The final presentation of the year was one of watercolors and block prints assembled by the American Federation of Art.

The following year featured exhibits of William H. Singer's works and of the American artists of the 1924 Venice International Exposition, as well as the usual annual shows. Most of the efforts that year

18. *Ibid.,* October 7, 1922. It was not acquired.

were concentrated on the Museum's need to expand, which had elicited the "donation of $10,000 by one of its members toward that end."[19] There was to be a two-story addition, including an auditorium and new exhibition galleries.

Miss Hutson reported,

> The original plans, which provided such an extension in the rear of the original building, have been turned over to Julius Dreyfous, of the firm of Weiss and Dreyfous, by the building committee, of which two members, Felix Dreyfous and Ellsworth Woodward, are still on the board of administrators. . . . They have instructed the architects to make the plan in entire harmony with the style of the first unit, and to bear in mind particularly the demand for more adequate space for the display of industrial art—the crafts which minister to the architect and builder, the home and the office, factory and store, church and school and hospital, ship and train and automobile.[20]

The idea of providing more gallery space for the decorative arts was seriously discussed by the board of administrators of the Museum, and most board members agreed on its necessity. Ellsworth Woodward plainly concurred, lamenting, "If only we could have begun 25 years ago—when older houses of the city were full of fine furniture— to collect examples of different periods and styles, what a wonderful collection we should have now."[21] He spoke of the value of a decorative-arts wing primarily in terms of its importance to the artisan craftsman: "Think what it would mean to artisans today who wish to reproduce a Louis Seize set, for instance, to be able to see and examine in detail two or three authentic examples of that period, safely housed and adequately displayed in the Delgado Museum."[22]

A month after the initial news releases concerning the proposed addition, Miss Hutson wrote an article in the *Times-Picayune* of July 12, 1925, laying out the reasons for the new wing. "New Orleans is a gateway of Latin American commerce," she commented, and therefore there should be more interest shown in the art of that area. She mentioned that there were in the Museum only five examples of Latin American art. "It is the realization of this lack," she wrote, "that has prompted the board of administrators to start a movement for adding wings to the Museum, in order to give space for such a collection of

19. New Orleans *States*, June 28, 1925.
20. *Ibid.*
21. *Ibid.*
22. *Ibid.*

Latin American arts as will permit visitors to gain some idea of what the countries south of us have to offer in the way of art, architecture, and the various artistic crafts." As one of the members of the board of administrators was quoted as saying, "The growing importance of our trade relations with Latin America make it imperative that we should know something of the art of these lands, since art is vital to manufacture and to commerce." Apparently, though, the appeal for new galleries specifically to house the decorative arts had been dropped.

The emphasis on Latin America coincided with the local interest in the archaeological expeditions that Tulane University was then sending to the region. But that emphasis was no more successful than the one on the decorative arts in motivating prospective donors. Nor was there any further discussion recorded in the minutes of the board concerning how the money needed for construction costs could be raised. Almost no articles or editorials appeared in support of the proposed expansion. A wait-and-see attitude prevailed: the money would surely be donated by someone. In 1930, Woodward could still write optimistically, "Others will surely be found able and willing to round out the necessary amount to add a wing to this Museum." [23] It did not occur to him to seek the money in a citywide fund-raising drive. It would be forty years until the wings were added to the Museum.

In 1926, fewer than thirty-one thousand persons visited eleven exhibitions. In January, there were paintings by Knute Heldner, watercolors by Stan Wood, and etchings and lithographs by Arthur B. Davies. In February and March, the twenty-fifth annual Art Association exhibition was held, and judging from the newspaper headlines, it was a very disappointing show, for too few Louisianians exhibited. Also in February, the Museum offered more than one hundred canvases in a show of the American Allied Artists. In March, the watercolors of Sadie A. E. Irvine and Marcelle Peret were hung in the Museum galleries and Adelaide A. Robineau's porcelains went on display. In April, seventy-nine watercolors came to the Museum from the New York Water Color Club and the American Water Color Society.

At the 1926 circuit show of the Southern States Art League, the most popular paintings were Ella Sophnisba Hergesheimer's *Mother's Day* and Camellia Whitehurst's *Claire*. The outstanding exhibition of

23. "Twenty-Seventh Annual Report of the Art Association of New Orleans," 9.

the year was the Art Association's second juryless show. The first, which had been held in May, 1915, was the first nonjury show in America. The purpose of the juryless show was to stimulate young and daring artists to come forward with new and challenging works. In 1926, twenty-seven artists exhibited forty-seven paintings, but there was little that startled or shocked. Old names like Alexander J. Drysdale, Weeks Hall, Gertrude Roberts Smith, Gideon Stanton, and Ellsworth Woodward dominated all the newspaper accounts. The Texas artist J. B. Sloan gave a one-man show of etchings in November and December, ending the fullest exhibition schedule of the 1920s.

The year 1927 was quiet, offering a Knute Heldner show, a display of Japanese ivories, swords, and blockprints, the annual Art Association show, a third nonjury show of the Art Association, a Southern States Art League circuit show, and an exhibit of early Chinese and Persian pottery owned by Martha Gasquet Westfeldt. In 1928, three one-man shows featured the works of the Swiss painter Albert Gos, of Frank T. Hutchens, and of Wayman Adams. Also on the program were the annual showing by members of the Art Association of New Orleans, a fourth nonjury show, and the Southern States Art League circuit exhibition. In 1929, the Museum displayed the paintings of Rockwell Kent and Clarence Millet and the lacework of Marie Ada Molineux, and it played host to the usual annual shows.

Woodward's dominance of the New Orleans and southern art worlds inevitably caused jealousy and resentment among artists and collectors. As a trustee of the Delgado and an officer of both the Art Association of New Orleans and the Southern States Art League, he had great influence over who and what was included in the annual exhibitions at the Museum. Without his support, it was hard for an artist to establish a reputation or sell very much.

Woodward often served as a juror for the annual exhibitions and thus was directly involved in selecting works to be exhibited. The resentment he could cause is documented in a letter from Drysdale, a well-known New Orleans landscape painter. Drysdale wrote to Woodward in February, 1929, after hearing from him as chairman of the jury for the twenty-eighth annual exhibition of the Art Association:

> I am in receipt of your notice in regards to my *Portrait Study* being rejected by your Jury. . . . I have had the opinion of a number of Artists on the picture who stand as high, if not higher than you do in the World of Art & your opinion or the opinion of your Jury does not amount to a

damn with me. I have over 1000 pictures scattered over the world. I have created a style of my own & I don't give a damn for the opinion of so-called art critics.[24]

The minutes of the board meetings of the Delgado Museum, the lists of exhibitions shown at the Museum, and the accessions records all prove that the 1920s were bleak years for the Museum. The rapid communication made possible by newspapers and radio meant that new ideas were disseminated more quickly and broadly than ever before. Inevitably, new movements in the world of art quickly attracted critical scrutiny and generated debate. As a result, museums began to collect the works of the new twentieth-century schools; at the same time they began to upgrade their older collections of Greek and Roman antiquities, Egyptian and Chinese objects, and medieval, Renaissance, and old master paintings and sculptures.

Many museums hired the first of a new generation of professional curators educated at Harvard, Yale, and Princeton—Harvard having instituted the first graduate course to train curators in 1923. These professionals brought new ideas of conservation, research, presentation, and collection to the museums that employed them. They contributed greatly to the exciting period of development that occurred at many of the nation's greatest art museums in the 1920s. New museums were being founded, and older ones were expanding. In 1925, John D. Rockefeller, Jr., provided the funding that let the Metropolitan Museum of Art acquire George Grey Barnard's medieval collection, which later formed the nucleus for the Cloisters, also a Rockefeller gift. The establishment, in 1929, of the Museum of Modern Art, in New York City, had a profound influence on the acceptance of modern art in America.

During the 1920s, the Isaac Delgado Museum was both geographically and aesthetically sheltered from the new winds blowing through the art and museum worlds. The Museum had no professional staff and no endowment for purchases or operations. Its board was steered by the artistically conservative but eminent educator Ellsworth Woodward. The promotion of southern artists became Woodward's lifework, and he took full advantage of the organizations he controlled—the Delgado Museum, the School of Art at Newcomb College, the Art

24. Alexander J. Drysdale to Ellsworth Woodward, February 20, 1929, in archives, NOMA.

Association of New Orleans, and the Southern States Art League—to achieve his goals. Although his achievements in the field of education were admirable and his patronage of southern artists praiseworthy, his preoccupation with regionalism gave the Museum's art collection a narrow, provincial focus. As a consequence, the institution lost the opportunity to acquire important art works of national or international stature at a time when they were both plentiful and financially within reach.

Woodward's promotion of southern art also retarded the development in New Orleans of serious collectors of important art, either old master or modern. Art museums in other cities, through their exhibition programs and the example of their purchases, nurtured a taste for, and encouraged the acquisition of, quality art by private citizens. A museum short in purchase funds must build its holdings by courting private collectors, whom the museum must guide, if only through the intelligent exercise of its own options. Woodward's preoccupation with southern art fortified the interest of local collectors in such works. The great masters of twentieth-century art were working in Paris and New York, however, not in the southern United States. Although Woodward's integrity and devotion to art were unimpeachable, his unremittent championing of the southern did not allow the Delgado Museum to assemble a balanced collection of American and European art, either contemporary or old master, during his years of stewardship.

Isaac Delgado in a wicker wheelchair on one of his frequent visits to East Coast resorts, *circa* 1900. Delgado donated $150,000 to build the Isaac Delgado Museum of Art in City Park.

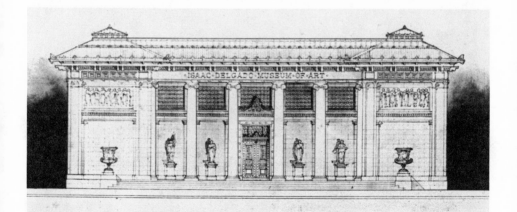

Front elevation of the winning entry in the competition for the Isaac Delgado Museum of Art, by Samuel A. Marx, of Lebenbaum and Marx, Chicago, 1910.

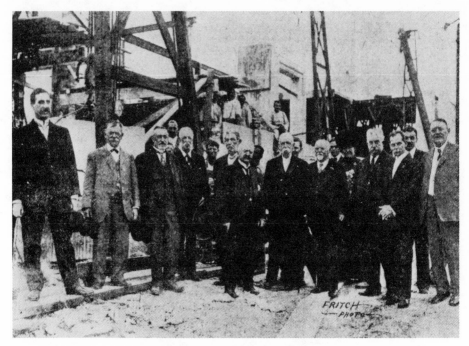

The cornerstone dedication of the Isaac Delgado Museum of Art, on March 22, 1911, with the founder, board members, and guests. Isaac Delgado, in a rare public appearance, is fourth from the right in the front row. Reproduced from the New Orleans *Daily Picayune*, March 23, 1911.
Courtesy NOMA

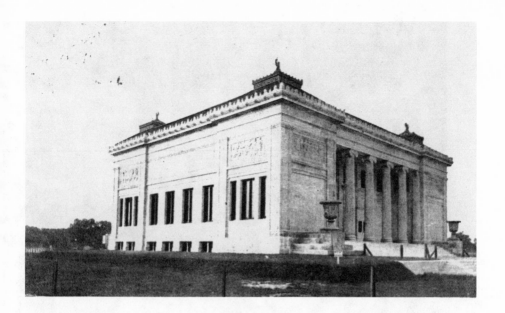

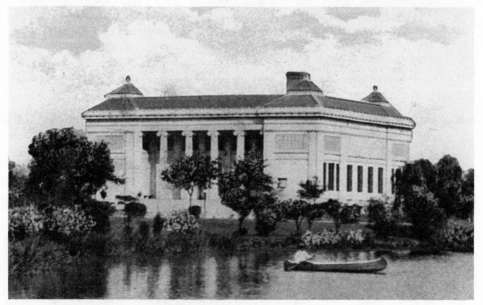

Three early postcards of the Delgado Museum, *circa* 1914–1920. The card at left shows the entrance to Lelong Avenue at Beauregard Circle, with a double row of royal palms down the center. The trees were killed by a winter freeze in the 1920s. The other two cards show the first-floor windows on the building's sides, which in 1970 were covered by the new wings.

1st card courtesy The Historic New Orleans Collection, Museum/Research Center, Acc. No. 1973.136.7; 2nd and 3rd cards courtesy NOMA.

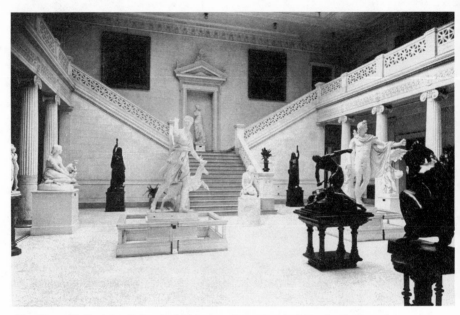

The Great Hall of the Delgado Museum, *circa* 1917, holding both the collection of plaster casts of antique Greek and Roman sculptures, including the Venus de Milo in the niche on the stair landing, and nineteenth-century French bronze sculptures.

Photograph by Charles L. Franck; courtesy The Historic New Orleans Collection, Museum/Research Center, Acc. No. 1979.325.5807.

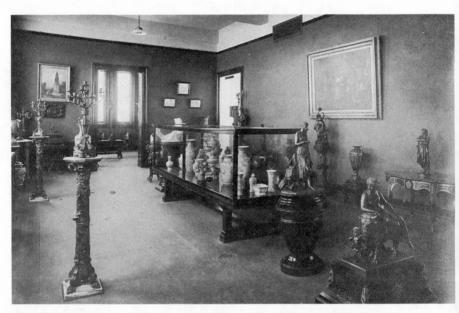

The Delgado Room at the Museum, *circa* 1917, with the collection of decorative arts and sculpture belonging to Mrs. Samuel (Virginia McRae) Delgado that Isaac Delgado bequeathed to the Museum in 1912.

Courtesy NOMA

Self-portrait by Morgan Whitney, *circa* 1900. Whitney was one of the Delgado Museum's first benefactors, making a bequest of his collection of Chinese jades and porcelains in 1913.
Courtesy Whitney Family Collection

Mrs. Chapman H. Hyams. Mrs. Hyams in 1915 bequeathed to the Delgado Museum her collection of thirty-six European paintings and sculptures, the most important donation made to the Museum in its first fifty years.
Courtesy NOMA

Tomb of Eugene Lacosst in Metairie Cemetery, New Orleans. Only after litigation over Lacosst's will did the Museum receive his collection of bronzes and porcelains.

Stewart Enterprises—Lake Lawn Metairie Cemeteries and Funeral Home

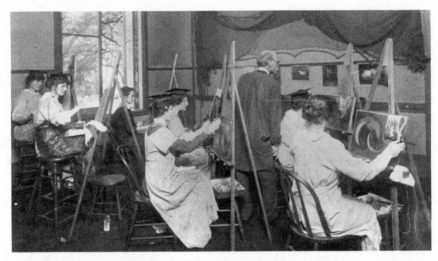

Ellsworth Woodward with a painting class in the School of Art at Newcomb College. Woodward served as founding director of the school from 1886 to 1931 and was a founding administrator of the Delgado Museum, where he was acting director from 1925 to 1939 as well as board president from 1934 to 1938.

Louisiana Collection, Howard-Tilton Memorial Library, Tulane University

Ethel Hutson, painter and newspaper reporter on art events in New Orleans. Miss Hutson was Woodward's right hand in many art organizations, and she served for many years as secretary to the director of the Museum and as secretary-treasurer of the Southern States Art League.
Courtesy NOMA

Board president Arthur Feitel congratulating winners in the 1950 annual of the Art Association of New Orleans. From left to right: Alonzo Lansford, Museum director; Feitel; Pat Trivigno, member of the art faculty of Newcomb College and a member of the year's jury; Juan José Calandria, honorable-mention winner; and Howard J. Whitlatch, of Tulsa, winner of the first prize for sculpture.
Courtesy NOMA

Arthur Feitel, center, president of the board of administrators of the Museum, in April, 1953, presenting illuminated scroll of gratitude to Mr. and Mrs. Rush H. Kress for the long-term loan and the promised gift of twenty-nine Italian old master paintings from the Samuel H. Kress Foundation.
Courtesy NOMA

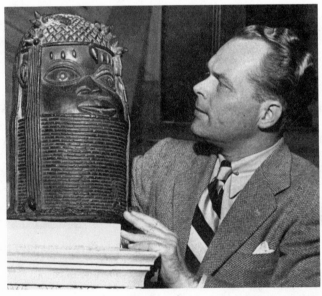

Museum director Alonzo Lansford announcing the anonymous gift in 1953 of the bronze *Head of an Oba*. From the Benin Kingdom of Nigeria, the head was the first African sculpture to enter the Museum's collection.
Courtesy NOMA

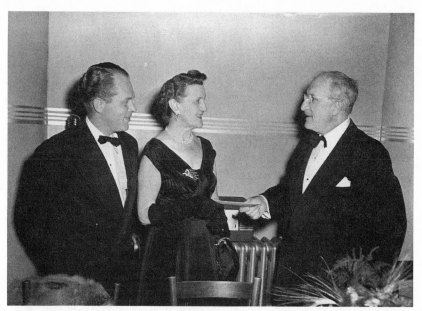

Mrs. William G. Helis, longtime Museum trustee and benefactor of the Museum's education program, presenting a check for the Junior Art Association's children's program to Arthur Feitel, with Alonzo Lansford.
Photograph by John L. Herrmann; courtesy NOMA

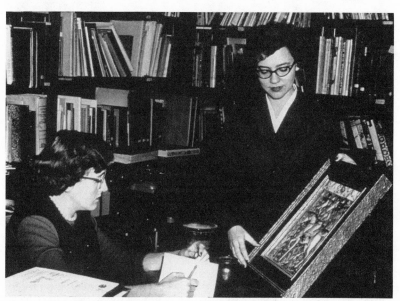

Sue Thurman, Museum director, at right, cataloging art works in 1959 with the assistance of Barbara Neiswender (later Pate), then a secretary. In nearly thirty years at the Museum, Mrs. Neiswender served in a number of positions, including that of the Museum's first assistant director for development.
Courtesy NOMA

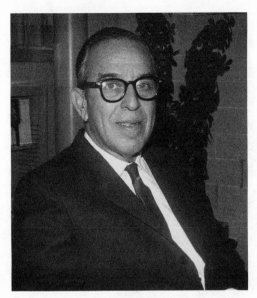

Charles Kohlmeyer, Jr., a prominent New Orleans attorney. Kohlmeyer led the fight to reorganize the Delgado Museum board, making it independent of the Art Association of New Orleans and the board of commissioners of the City Park Improvement Association.
Kohlmeyer Family Collection

James B. Byrnes, the newly appointed Museum director, in the overcrowded basement storage area in May, 1962. Byrnes here announced that "the Delgado is too small an art museum for a city the size of New Orleans."
Courtesy New Orleans Times-Picayune

Three Museum trustees—from left to right, Mrs. Richard W. Freeman, Mrs. Edgar B. Stern, and Mrs. Samuel Logan—conferring at the gala "Bring Estelle Home" dinner at the Roosevelt Hotel, on December 18, 1964, with jazz greats Billie and DeDe Williams playing behind them.
Photograph by Charles Moore; courtesy Life *magazine*

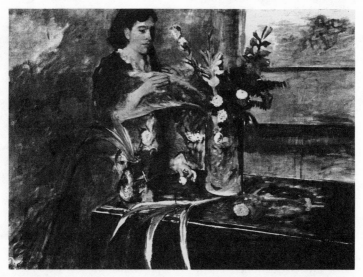

Portrait of Estelle Musson, painted by Edgar Degas in New Orleans in 1872 and purchased for the Museum by public subscription in 1965.
Courtesy NOMA

The auction room at Gallier Hall, October 25, 1965, during the auction of surplus works of art to benefit the Museum's acquisitions fund.
Courtesy NOMA

Mr. and Mrs. Frederick Stafford, left, with Mrs. J. Frederick Muller, at the first Odyssey Ball, November 13, 1966, organized by the Museum's new Women's Volunteer Committee. Mrs. Muller was chairman for the ball.
Courtesy NOMA

Melvin P. Billups, whose great collection of historic glass was received by the Museum in 1969. The collection made the Museum one of the nation's most important repositories of such material.
Courtesy NOMA

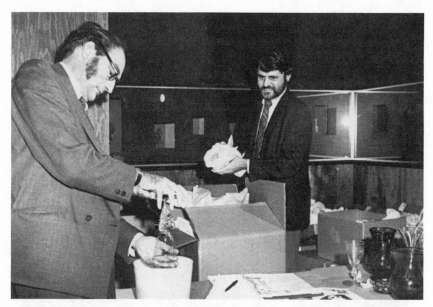

James B. Byrnes, Museum director, and William A. Fagaly, curator, un-
packing Melvin P. Billups' glass collection at the Museum in 1969.
Courtesy NOMA

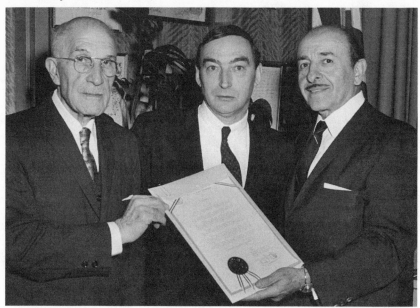

Arthur Feitel, longtime Museum trustee, James B. Byrnes, Museum di-
rector, and New Orleans Mayor Victor Shiro in 1966 announcing the gift
of the Ella West Freeman Matching Fund for the acquisition of important
art for the Museum.
Courtesy NOMA

Mrs. Edgar B. Stern, grande dame of New Orleans, community activist, and benefactor of the Museum, around 1975, standing in the drawing room of her home, Longue Vue.

Photograph by Mickey Demoruelle; courtesy Longue Vue House and Gardens

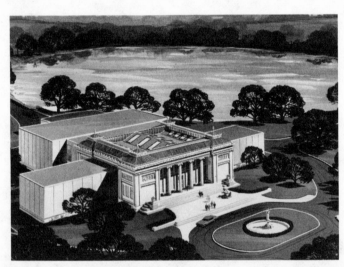

Artist's rendering of the proposed additions to the Delgado Museum in 1969. At the right is the Stern Auditorium, at the left the Wisner Education Wing, and at the back the City Wing for temporary exhibitions and the permanent collection.

Courtesy NOMA

At the cornerstone laying for the Wisner Education Wing in 1970, James B. Byrnes, Museum director, passing the trowel to Elizabeth Wisner, with her nephew Richard A. Peneguy, a longtime Museum trustee, and his daughter, Elizabeth.

Courtesy NOMA

Victor K. Kiam, New York financier. Kiam's bequest in 1974 greatly enriched the Museum's collection of African tribal art and twentieth-century painting and sculpture by masters like Pablo Picasso and Jackson Pollock.

Courtesy family of Victor K. Kiam

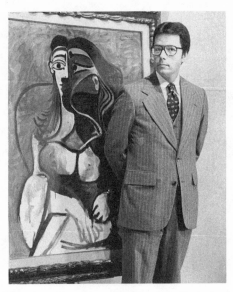

E. John Bullard, Museum director, with Picasso's *Portrait of Jacqueline* at time of the receipt of the Victor K. Kiam Collection in 1977.
Courtesy NOMA

Two of the Museum's greatest supporters and benefactors, Mrs. P. Roussel Norman, at left, and Muriel B. Francis, with E. John Bullard, Museum director, at a reception in 1984.
Courtesy NOMA

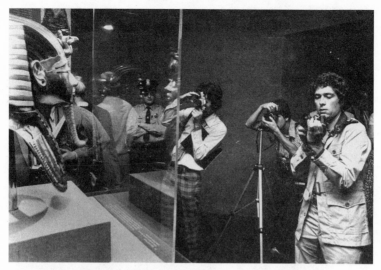

The boy king meeting the press at the New Orleans Museum of Art, prior to the opening of Treasures of Tutankhamun on September 15, 1977. The death mask of King Tut is solid gold.
Courtesy New Orleans Times-Picayune

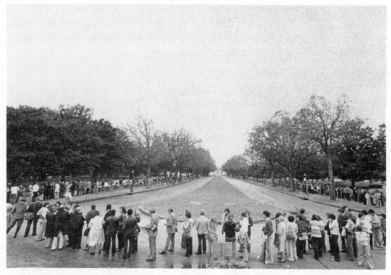

A not untypical day at the Museum during the Treasures of Tutankhamun exhibition, between September 15, 1977, and January 15, 1978, with visitors lining both sides of Lelong Avenue in the hours-long wait for admittance.
Courtesy of New Orleans Times-Picayune

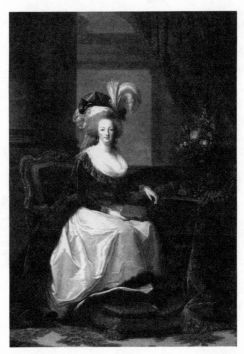

Monumental portrait of Marie Antoinette, queen of France, 1788, by Elisabeth Vigée-Lebrun, acquired by the Women's Volunteer Committee for the Museum in 1985 to celebrate the institution's seventy-fifth anniversary.
Courtesy NOMA

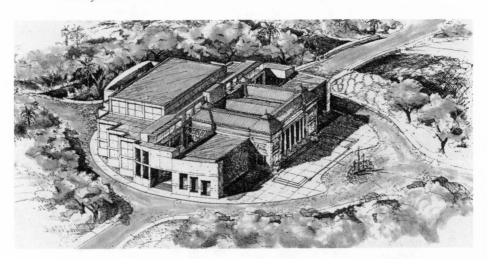

Artist's rendering of the proposed design for the expansion of the New Orleans Museum of Art, by Clark and Menefee, Charleston, S.C., and Eskew Filson Architects, New Orleans, 1987–1989. Projected for completion in late 1992, the new construction will add fifty-five thousand square feet of space to the existing seventy-five thousand square feet.
Courtesy NOMA

V

The Difficult Years

The 1930s brought a virtually complete suspension in the develop-
ment of the Museum's permanent collection, apart from the Kress do-
nation. The Museum's exhibition policy continued along the lines laid
down by Ellsworth Woodward for promoting southern artists and the
sale of their works. The Museum board remained under the domina-
tion of Woodward and the Art Association of New Orleans. Each year
in this decade there was an Art Association members' show with jury
and a second nonjuried show. There were several one-man shows as
well each year, featuring works by members of the Art Association,
including Eunice Baccich, Henrietta Bailey, Xavier Gonzalez, Angela
Gregory, Knute Heldner, Werner Hoehn, Charles W. Hutson, Sadie
Irvine, Robert B. Mayfield, Marie Ada Molineux, Nell Pomeroy
O'Brien, Betty Raymond, Albert Reiker, Will H. Stevens, and Rosalie
Roos Wiener.

The Delgado also offered the annual shows of the Southern States
Art League, which had been formed "for the purpose of drawing into
a federation all the art organizations and all interested individuals of
the South to the end that those no longer novices in the practice of art
might unite in post graduate shows to impress the public with art as a
means of revealing the South to itself, as interpreted by Southern men
and women." [1] Today such a viewpoint seems isolationist. But region-
alism was then a trend in many sections of the country, and the na-
tional depression hastened its growth. There was developing among
many artists a broad reaction against European ideas and influences.
Ethel Hutson described the attitude in the New Orleans *States* of Oc-
tober 12, 1930:

1. Estelle Barkmeyer, "Ellsworth Woodward: His Life and His Work" (M.A. thesis,
Tulane University, 1942), 47.

"Paint America First" is said to be the slogan in New York art circles nowadays, and not only are American artists turning more and more to subjects and scenes found in these United States, but even the dealers, who for so many years, time out of mind, have fostered French, Dutch, Italian, Spanish, British art, rather than American—have at last waked up to the fact that there is really, among buyers a keen interest in native art.

In the South, for the past ten years, there has been a concerted movement among Southern artists and art lovers to develop such an interest; and the Southern States Art League, by its annual and circuit exhibitions, and by prizes offered year after year for paintings of Southern subjects, has done much to focus attention on the beauty and paintableness of Southern scenes and Southern types.

The Art Association of New Orleans and the Southern States Art League were not alone in fostering and promoting southern art in the 1930s. Through the Regional Committee of the Public Works Art Project, the federal government hoped to provide employment for artists in the Gulf states. President Roosevelt appointed Woodward chairman of this four-state committee in December, 1933. Retired from Newcomb, Woodward was able to go on devoting his attention and influence to furthering the growth of southern regionalism.

Upon the resignation of Judge Charles F. Claiborne the following year because of illness, Woodward became the president of the Museum board. In actual fact, Woodward had been president in all but name for the two preceding years, for Judge Claiborne had been unable to attend any of the board's meetings. Given the financially depressed economy and Woodward's view of the Museum's mission, it is small wonder that very little of significance was added to the Museum's permanent collection during the 1930s. For Woodward, the development of the collection was not essential to the Museum's role of educating the people of New Orleans. He felt that the art of the past was too expensive to purchase in the original anyway; replicas would suffice. Contemporary art could be largely limited to the works of regional artists.

As president of the Museum board, Woodward evinced little confidence in his peers' knowledge of things artistic. Arthur Feitel, who became a member of the board in January, 1933, wrote that although prior to his election he had been a good friend of Woodward's, once a member, "I was not often consulted, but as time went on, more confidence was placed in me, yet I knew when I was supposed to say 'yes' and when I was supposed to say 'no.'"[2]

2. Feitel, "Confessions," 1.

Woodward was for many a difficult person to deal with, although he was loved and revered by thousands of his students, who considered him a man of humor and friendship. He "had a fiery temper. Persons and events could irritate him beyond endurance," a biographer has said.[3] He was a man who hated to be challenged in his control of the Museum, and the result was frequent bickering at board meetings. Woodward did not like to be outvoted on any issue, not that he often was. Feitel remembered a disagreement concerning the state of the entrance to the Museum. The steps had become so dilapidated that they were both dangerous to museum goers and threatening, because of leakage, to the storage areas beneath. When a proposal was on the table to obtain the necessary funds for the repair work from the Works Progress Administration, "Mr. Woodward, Mr. Trufant, and others were opposed to taking Government money" but Felix J. Dreyfous and Hippolyte Dabezies wanted to apply. Feitel wrote, "At each meeting there was a quarrel on the subject. Finally I incurred the displeasure of my good friend Mr. Woodward by taking the other side and the stairs were built."

Woodward, who "seemed to think that since the deaths of Whistler and Sargent nothing worthwhile had happened in the art world," often clashed over the merits of modern painting with a fellow board member, the art collector Hunt Henderson, who had served as the Museum's vice-president ever since May 7, 1920. According to Feitel, "in one such quarrel regarding Modern Art, Mr. Henderson resigned from the board and never visited the museum again until after Mr. Woodward's death."[4] Actually Henderson did attend a board meeting or two after the argument. It was upon the election of Woodward in 1925 as acting director that Henderson refused to attend any board meetings whatsoever, although he did not submit a letter of resignation until March 15, 1928. Even after tendering his resignation, he remained officially on the board for several years as a result of a motion introduced by Dreyfous to leave the resignation in abeyance. Certain board members vainly hoped that a reconciliation between Woodward and Henderson could be worked out. Henderson survived Woodward by a mere four months, and there was no chance to repair the damage done by Woodward's intransigent attitude toward modern art. As a result, the Museum board lost the greatest collection that could have been obtained from a New Orleanian of the period.

3. Barkmeyer, "Ellsworth Woodward," 10.
4. Feitel, "Confessions," 2.

Henderson's collection was the proverbial fish that got away. Undoubtedly Henderson was the most formidable collector of paintings and prints to live in New Orleans, in fact in the South, until the post–World War II period. Beginning with the inaugural show of the Museum, he had been a consistent lender of his art works. Among them were over 116 oil paintings, watercolors, drawings, and etchings by James McNeill Whistler. In 1917, Gideon J. Stanton arranged a special exhibition of these works through the Art Association. A beautiful catalog of the Whistler pieces was published, with an introduction by Henderson. In it he wrote that the assembling of "these pictures has given me a world of pleasure and I hope that this show will justify my enthusiasm to my friends."[5] Among the Whistler oils then owned by Henderson were: *Unfinished Portrait of Miss Maude Franklin; Ajaccio Corsica; A Harmony in Blue and Silver, Beaching the Boat; Belle a jour, bleu et violet; Brown and Gold, Lillie in Our Allie;* and *Nocturne un bleu et argent.*

The Henderson collection focused on the generation of the French impressionists and their friends. In the collection were two oils by Paul Cézanne; one oil and one sculpture by Honoré Daumier; one oil, several chalk drawings, and a lovely pastel by Edgar Degas; one oil and several wood blocks by Paul Gauguin; two oils, one brush and ink wash, and several etchings by Edouard Manet; six oils by Claude Monet; five oils and a color lithograph by Auguste Renoir; two sculptures by Aristide Maillol; two sculptures by Auguste Rodin; several color lithographs by Toulouse-Lautrec; a watercolor by Camille Pissarro; and two drypoint and color aquatints by Mary Cassatt. Henderson lent many of these works to the Delgado during the first twelve years of its existence. He also let them be exhibited at the Orangerie, in Paris, and at the Metropolitan Museum of Art and the Museum of Modern Art, in New York.

His collection was far more extensive than his contemporaries in New Orleans knew. It included works by artists as diverse as Aubrey Beardsley and Albrecht Dürer, Eugene Delacroix and Paul Manship, and Arthur B. Davies. He owned seventy-six Japanese prints, representing a collection in itself, including works by such masters as Harunbu, Hiroshiqe, Hokusai, Kuniyoshi, and Utamaro. Henderson

5. Isaac Delgado Museum of Art, *Catalogue of Etchings, Lithographs, Paintings, and Drawings by James McNeill Whistler* (1917), 1.

also held thirty-four of William Blake's engravings, twenty-one of which were proofs from 1825 for *The Book of Job*.

Exemplary of his deep commitment to modern art were two oils by Georgia O'Keeffe, a watercolor by Raoul Dufy, and a watercolor by John Marin. There were numerous etchings, watercolors, and drawings by Georges Braque, André Derain, Marie Laurencin, Henri Matisse, Georges Rouault, and Maurice de Vlaminck. Henderson owned a large Marsden Hartley oil, *Olive Trees*, and two oils by Pablo Picasso, *Still Life: Abstract 1922* and *Nature Morte*.

Nor did Henderson exclude local artists. He admired the works of Caroline Durieux and Weeks Hall, and he owned several pieces by each artist. Indeed, it is curious that in the inventory of the Henderson estate, a painting by Hall, *Bayou: Live Oaks*, was appraised at fifty dollars while Picasso's *Still Life: Abstract 1922* was given a value of forty dollars. Another oil by Hall, *Still Life: Bowl with Magnolias*, was listed at sixty dollars while Picasso's *Nature Morte* was valued at fifty dollars. Henderson himself, however, had paid a thousand dollars for *Nature Morte* in 1930.[6]

In an editorial at the time of Henderson's death in 1939, a friend wrote of him:

> Green trout within a hundred miles of New Orleans will get a break this year. Hunt Henderson won't be around to plague them. But trappers, farmers, anglers town-and-country-bred will miss him, and from the heart. The president of the Henderson Sugar Refinery was as well known at the cross-roads and along the bayous as in the business circles and Carnival clubs of New Orleans.
>
> Hunt Henderson was born to the sugar business. At 67 he had been for many years head of one of the two big strictly locally owned sugar refineries in Louisiana. He stood, then, both for the romantic past of agriculture and industry in this State, and for the adaptations and improvements that make the sugar business still important to its prosperity.
>
> But Hunt Henderson was not one to let being born to any role cramp his style. There was too much in life besides business for that, too much else to enjoy, too many kinds of people besides office associates to like and study. So he fished, played bridge, took his part in Carnival organizations and fun, read more than do some who make a career of it, and his intimates say found time to give a helping hand to many who stirred his sympathy.

6. Felix J. Puig, Inventory of the Estate of Hunt Henderson, November 23, 1934 (Notarial Records, New Orleans).

As an eager appreciator of art he served on the board of the Delgado
Art Institute, and as a son of Sewanee he gave time and effort to promot-
ing the interests of his alma mater and other schools.[7]

Henderson fit the normal pattern of the men involved in the cul-
tural and economic development of New Orleans at the beginning of
this century. Only his passion for art did not conform to the mold of
the typical businessman of the day. How did he come to form his re-
markable collection—and while he was still so young? In 1917, when
his Whistlers were first exhibited in the Delgado, he already held
most of the French impressionists.[8] At that time Henderson was forty-
four years old.

Henderson's interest in art is often attributed to the influence of his
sister-in-law, herself an artist. But Josephine Crawford did not begin
her art studies at the Arts and Crafts Club until 1924, and she did not
finish her studies abroad under André Lhote until 1929. It is likely
that Henderson influenced her more heavily than she did him. Nor is
it probable that Henderson's wife was the source of his artistic inclina-
tion. She denied that she played a formative role, despite her personal
acquaintance with artists like Renoir and Monet.

Henderson and his family did not restrict their philanthropy to art.
The School of Medicine at Tulane University was a notable benefi-
ciary. In 1931, Henderson and his wife joined his sister, Ellen Hender-
son, and his brother, William H. Henderson, in establishing an en-
dowment of over $135,000 for the Henderson Chair of Medicine at
Tulane. In a letter written in April, 1935, Henderson informed the
board of trustees of Tulane University of his intention to endow
Tulane University with his Whistler collection and advised them who
his agents would be for the sale of any items they desired to dispose
of. In September, Ellen Henderson died leaving him over $590,000.
Then in 1938, Sarah S. Henderson gave $210,000 to establish the
William Henderson Chair of Surgery, and upon her death, in 1946,
she left the university over $1 million to establish the William Hender-
son Chair of Tropical and Semi-Tropical Medicine.

Upon Henderson's death, in 1939, his entire estate and art collec-
tion went to his wife and son, with the exception of his library on
Whistler and his collection of Whistler's drawings, etchings, and

7. New Orleans *Item*, June 23, 1939.
8. He continued to acquire Whistler watercolors and oils even after 1917.

paintings, which he left "to Tulane University of Louisiana for the benefit of the Chair of Medicine."[9] Collectors and patrons of the arts in New Orleans have censured Tulane for the sale of the Whistler collection, which was valued at $20,324 at the time of Henderson's death. It seems clear, however, from his handwritten will of 1935 and his letter of April, 1935, to the university's board of trustees, with its mention of possible dealers, that it was his intention that the items be sold to benefit the Henderson Chair of Medicine. The Tulane University board of trustees, following Henderson's advice, sold the Whistler collection over a five-year period, from 1941 to 1946. The collection brought $31,000, an increase of about 30 percent over the estate valuation.

Records show, however, that Tulane received only twenty-odd paintings, prints, and drawings, rather than all 116 of Henderson's Whistlers. Charles Crawford Henderson owned four watercolors and one oil by Whistler, which his father must have given him sometime prior to his death. The fate of the seventy-odd lithographs is unknown. The library on Whistler, which contains a number of first editions, remains at Tulane University in the special collections of rare books.

Despite cordial relations over the years, the Museum never came close to obtaining any of Henderson's holdings from his widow. Muriel B. Francis, president of the Museum board from 1968 to 1969, said that on several occasions she had had conversations with Mrs. Henderson about the disposal of the collection. When the older woman asked Mrs. Francis about what she planned to do with her own paintings, Mrs. Francis had stated that because of high taxes she was going to bequeath her art to the Museum rather than her family. But Mrs. Henderson had felt strongly her husband's wish that his son have the paintings. The only painting she felt was really her own was Renoir's *Mother and Child with Cat,* which had been a present from her husband on the birth of their son. Mrs. Francis reported pointing out to Mrs. Henderson that "Charles is not interested in the paintings." Mrs. Henderson softly replied, "But his wife is."

Over the years following her husband's death, Mrs. Henderson sold items she was not fond of. In this way the magnificent Japanese master prints, a Renoir drawing, and several prints by Matisse,

9. Hunt Henderson to board of trustees, Tulane University, April, 1935, in archives, Tulane University.

Cézanne, and Vlaminck came to find homes in other collections. When Mrs. Henderson died, in 1970, leaving an estate valued at well over three million dollars, her son, Charles, inherited the collection. In 1974 he donated to the Museum a Degas pastel, *Dancer in Green*, in memory of his first wife, Nancy S. Henderson.[10] Nancy Henderson had served as a trustee of the Museum from 1960 to 1962 and again from 1966 to 1969. Mrs. Hunt Henderson had left the Degas to her in her 1964 will, but the daughter-in-law had preceded the mother-in-law in death. Charles Henderson felt that the pastel, always referred to as "Nancy's picture," should come to the Museum his wife had served. In 1980, Charles Henderson donated another painting, *Seamstress at the Window*, by Renoir, in memory of his second wife, Margaret. Thus two of the beautiful works of art that Hunt Henderson had collected before 1911 finally came to the Museum he had so devotedly aided in its beginnings.

During the depression years not many events in the Museum's annals could be called memorable. The Delgado received few important donations and made even fewer purchases. It was a time of hardship and deprivation. Indeed, the Museum was almost forced to close permanently in January, 1931, because the city council cut its appropriation from the 1931 budget. This story is intertwined with that of one of the largest single gifts made to the Museum during the period, the Samuel H. Kress gift. The unfolding of events generated a considerable amount of support in the city for the Museum and cemented public opinion behind the Museum against the politicians.

On November 29, 1930, the New Orleans *States* ran the headline "Delgado May Be Forced to Close," and the *Times-Picayune* titled its story "Delgado Museum Denied Support, May Close Doors." The *Morning Tribune* in its headline gave the amount of money involved: "Delgado Museum to Close Unless City Replaces $9,000 Budget Appropriation." During a hearing on the city budget for 1931, the city council had eliminated its $9,000 annual appropriation to the institution. Thus it looked as if the Museum would be forced to close its doors with the start of the new year. On November 28, when Woodward and Samuel Adams Trufant first heard of the cut, they went to see Miles Pratt, the finance commissioner. Made to "wait over half an

10. At the time of the gift the pastel was appraised at between $200,000 and $250,000. See New Orleans *Times-Picayune*, November 21, 1973. In Hunt Henderson's estate appraisal of 1939, it was valued at $500.

hour," Woodward and Trufant were informed by a secretary that the commissioner would see them on the following Monday.[11] According to Pratt, "I was in an important meeting when Mr. Trufant and Professor Woodward called. I sent out word asking them to wait, when it was apparent that the conference would be prolonged I sent out the request that they take the matter up with me Monday."[12]

The Museum board then addressed an open letter to the commissioner:

> The board of administrators of the Delgado Museum of Art has felt great concern for the failure on the part of the budget committee to provide in the budget of 1931, the usual appropriation of $9,000 for the maintenance of the museum located in City Park. Might we suggest that at the time Isaac Delgado tendered to the city the museum in City Park, it was made a condition of his gift that this museum should be maintained by the city in perpetuity? It is our belief that the city council by ordinance accepted the gift under the conditions as stated and that thereafter, the museum building was constructed. Since this, there was added to the museum, also as gifts to the people of New Orleans, two superb collections, one of modern paintings by Mrs. C. H. Hyams, valued at more than a quarter of a million dollars, and a collection of jades by Morgan Whitney, which is the second best in the country and which could not be duplicated for a less amount.
>
> A few days ago there was presented to the museum by S. H. Kress of New York, a painting by an Italian master, also of great value, and which, by the way, is the best example of the period to be found in the South. The board of administrators of the museum has no funds to operate the museum and . . . hence, if the city declines at this time to provide for such maintenance the board of administrators see no other recourse but to close the institution. It is the belief of the board that this would be nothing short of calamity. Not only is the museum a beneficial factor and a necessary and proper adjunct to our educational system, but is a source of great attraction to visitors coming from all parts of the world.[13]

In revealing the intended Kress gift, properly still a confidential matter, Woodward and Charles F. Claiborne hoped to put enough public pressure on the city council to regain the Museum's funds. Over the weekend, severe criticism was lodged against the politicians. In the Monday morning edition of the *Times-Picayune*, the editor wrote that since there had been no explanation for dropping the Museum's appropriation, it must be intimated "that someone had indeed enter-

11. New Orleans *States*, November 29, 1930.
12. New Orleans *Times-Picayune*, November 30, 1930.
13. New Orleans *States*, December 1, 1930.

tained the bright idea that New Orleans might save the $9,000 hitherto expended on the upkeep of the museum by the simple process of abandoning that public property worth several million dollars."[14]

The battle was quickly won. The Monday evening final edition of the New Orleans *States* ran the banner headline, "City to Restore $9,000 Fund to Delgado." Pratt "deplored the 'unnecessary clamor' which had been raised over the matter," saying "that the omission of the item was entirely unintentional, as the council had no thought of eliminating the Delgado appropriation."[15] He promised that on Tuesday, December 2, 1930, the city council would correct its oversight. On Thursday, December 4, the city council did indeed pass a new budget including the Museum's appropriation. The public hue and cry had saved the Museum.

Because the city council by reinstating the budget of the Museum, implicitly admitted its responsibility for operating it in perpetuity, Samuel H. Kress consummated his gift to the Delgado of *Madonna Nursing Her Child*, by the fourteenth-century Florentine Giovanni del Biondo. That painting was undoubtedly the single most important gift to the Museum during the whole decade. Woodward had selected the magnificent medieval masterpiece, which was valued at between fifty and sixty thousand dollars, when "he passed through New York on his way home from Europe."[16] The Museum board in November had a letter of intent from Kress offering to donate one of his paintings, but the benefactor asked that the gift be kept a secret until an official announcement could be made in January, 1931. Revealing the intended gift prematurely, in order to exert pressure on the politicians, could have backfired, for Kress was very fussy about the proper care and preservation of his paintings and he might have withdrawn the gift in view of the shaky finances of the recipient.

An elaborate presentation ceremony of the Kress gift was held on January 18, 1931. Dignitaries representing all the arts were present, and Woodward made the principal address. Paul S. Rossi, who served as the Italian consul in New Orleans, Professor John S. Kendall, of the School of Arts and Sciences of Tulane University, and the Reverend F. D. Sullivan, S.J., president of the Louisiana Historical Society, were among the important speakers. Woodward, after praising the painting and the generosity of Kress, outlined the Museum's history and con-

14. New Orleans *Times-Picayune*, December 1, 1930.
15. New Orleans *States*, December 1, 1930.
16. New Orleans *Morning Tribune*, January 14, 1931.

cluded with his usual sermon on southern art and its development. He noted, "Since the founding of the Delgado Museum, fourteen similar institutions in the Southern states have been opened to the public. The future holds promise that art will take its useful and honored place among the accepted forces in education." Rossi closed the day's orations, saying, "It is with a feeling of pride I see today a painting of my own Italy. As this artist was a son, announcing the day in which the Renaissance appeared, so may the seed of this painting fall on the fertile soil of New Orleans. . . . And may it be a promise of American art, which the South will ably represent."[17]

The Florentine madonna was only the beginning of a long and fruitful relationship between the Delgado Museum and the Samuel H. Kress Foundation. As a museum publication put it, "The foundation was originally conceived in 1929 by Samuel H. Kress as a broad philanthropic program 'to promote the moral, physical and mental well-being of the human race.'"[18] In line with its goals, it lent fifty-two paintings from Kress's private collection to the Museum in February and March, 1933. According to the art columnist Irene Cooper, the number of visitors attracted to the Museum by this exhibit was phenomenal: "In the two weeks that it has been on the local walls, more than 10,000 persons have viewed it—or rather they have gone out to see it, for sometime[s] the rooms get so crowded that it is impossible to see the pictures."[19]

In February, 1934, Kress presented the Museum with a portrait of Pope Clement XIII by Pompeo Girolamo Batoni, done about 1760.[20] A third painting, The Blessing Savior, executed by Vittore Carpaccio about 1510, was given by Kress in May, 1938. In the following year he presented over four hundred works of medieval and Renaissance artists to the newly formed National Gallery of Art in Washington, D.C. Fifteen years were to pass before another Kress painting came to the Delgado. But the initial gifts had been ones that the Museum's trustees could not have conceived of purchasing. They were invaluable as the first acquisitions in the formation of a historically representative collection of European art before 1850.

The initial donation by Kress inspired Dr. Walter F. Henderson,

17. New Orleans *States*, January 18, 1931.
18. James B. Byrnes, *The Samuel H. Kress Collection at the Isaac Delgado Museum of Art* (1966), 2.
19. Irene Cooper, "Pen, Chisel, and Brush," New Orleans *Times-Picayune*, February 26, 1933.
20. The portrait has since been reattributed to the Austrian Anton Raphael Mengs.

head of the x-ray department of Touro Infirmary and no relative of
Hunt Henderson's, to lend several works from his collection of old
masters. The New Orleans *States* of December 25, 1932, carried the
banner headline "Opens Art Collection as Death Beckons." The sub-
heads further explained, "Old Masters Among Rich Treasures of
Doctor" and "Dr. Henderson, Final Call Near, Sends Display to
Delgado." Dr. Henderson was to leave New Orleans on Tuesday,
December 27, 1932, for Rochester, Minnesota, to undergo a surgical
operation at the Mayo Brothers' Clinic. His health had been failing for
about two years. But he had experienced poor health before. After
completing his M.D. degree at Vanderbilt University, he had entered
the armed service during World War I and had contracted tuber-
culosis. To treat that illness, the doctors had used x-rays upon his
lungs. Intrigued by a procedure that could eradicate tuberculosis and
that saved his life, Henderson left general practice and trained in
roentgenology, becoming a leading authority in the field while still in
his thirties.

Collecting art was a "labor of love for Dr. Henderson." He haunted
auction sales, little shops in the French Quarter, and private Louisiana
homes in his search for paintings. His medical specialty aided him in
his hobby, for he "developed a notable system of using the X-ray to
prove the authenticity" of the painting. In this way he discovered that a
lovely sixteenth-century madonna had been "daubed over with a
crude still-life painting of a fish." This *Mater Dolorosa*, attributed to
Luis Morales, one of the teachers of Velázquez, was among the works
Dr. Henderson lent to the Delgado for display next to the Kress
Madonna Nursing Her Child.

Other works that Dr. Henderson lent were a carved panel, *Madonna
and Child*, attributed to Desidero de Settignano, who worked in Flor-
ence in the fifteenth century; a Flemish primitive, *The Visitation of the
Blessed Virgin Mary to St. Elizabeth, circa* 1425; and a German primitive,
a triptych *St. John and St. Matthew, circa* 1450. Woodward said, "These
four pieces from Dr. Henderson's collection are unquestionably an-
cient and rarely beautiful, and in my opinion of great value. Delgado
Museum is proud of the opportunity to exhibit them to the people of
New Orleans." [21]

At the time of Dr. Henderson's loan to the Museum, the Reverend

21. New Orleans *States*, December 25, 1932.

Lorenzo Capitani, a cleric and artist, was visiting in New Orleans. The New Orleans *States* reported that when Capitani, who was "one of the world's greatest specialists in the Primitives and the work of the Masters of the Italian Renaissance," was asked his opinion of Dr. Henderson's paintings, he said, "There is some very ancient work and some very beautiful work here." [22] He would not stake his reputation on naming the artists without doing more extensive research, but it was he who tentatively attributed the wood-carved panel to Settignano. [23] The intriguing tale of Dr. Henderson and his x-rayed old masters ends here. After his visit to the Mayo Clinic, nothing more was heard of Dr. Henderson or his family. No records can be found of his death or of the fate of his collection.

From time to time during these years money accumulated with which it was possible for the board to purchase a painting or a print. In December, 1935, Woodward announced his desire to acquire Wayman Adams' portrait of Grace King, the New Orleans author, for $1,300. Interest that had accrued to the Harrod Fund was to cover a portion of the cost, but it was necessary to raise the remainder through public subscription. The purchase was made official on June 14, 1936. In March, 1936, the Museum bought a portrait of the English actress Mrs. Elizabeth Hartley from the Fine Arts Galleries, of New York, for $1,000. At the time, the painting was judged to be by Sir Joshua Reynolds, but today it is considered the work of an imitator of Reynolds. In January, 1937, the board announced the purchase of an unusual oil painting, *Magdalen,* from B. Reed, of the Reed Gallery, of New Orleans, for $450. Once thought to be by Thomas Sully, it is no longer considered authentic. The board's final purchase of the decade came in 1938, as a result of a $500 bequest to the Museum by Lynn H. Dinkins, who left over sixty thousand dollars to several other institutions of the city. Because of the interest in medieval and Renaissance painting that the Kress gifts aroused, the board purchased *The Miracle of the Crucifix* by an unknown painter of the circle of Jaime Huguet. That painting is no longer deemed to be of a quality that would justify its display at the Museum. It is a third example of the misdirection of scarce funds by the board as a result of not having a professional art historian on the staff. The interest in medieval and Renaissance painting among board members was

22. *Ibid.*
23. New Orleans *Item-Tribune,* December 25, 1932

so strong after the Kress donation that they preferred to purchase this painting even though they had been negotiating for months with Clara A. Williams, of Kennebunkport, Maine, over a Degas pastel.

The board might well have made some effort to acquire the Degas, for the artist was the only French impressionist who ever painted in the United States. Indeed, the Museum could have afforded the purchase, for it had just received its only other monetary bequest of the period, a gift from Mrs. Edgar A. Fordtran, the former Anne Brook, who had died at her summer home in Asheville, North Carolina, on September 4, 1936. Generous in her bequests, she left fifty thousand dollars to the Protestant Orphan Boys' Home and ten thousand dollars to each of five organizations, including the Museum. The Museum also received the four paintings by Harry Lachman that she owned: *Notre Dame, Springtime; Les Martiques; Path to Corney;* and *South of France.*

With the Fordtran and Dinkins bequests in hand, the board on May 18, 1938, directed Woodward "to write [Clara A. Williams] and inform her: He was authorized to pay her $250 . . . not being in a position to pay more than $250 at this time."[24] In June, Mrs. Williams replied by letter that she would reduce the price of the Degas by 10 percent. The matter was then placed in the hands of a committee comprising Feitel, Woodward, and F. Julius Dreyfous. The minutes record nothing further concerning the matter until October 21, 1938, when Dreyfous reported that while in Maine he had been unable to see Mrs. Williams. Mrs. Williams had doubtless sold her pastel to someone who had a more realistic sense of its worth. Nearly thirty years passed before the Museum finally purchased its first painting by Degas, for nearly one hundred times the amount offered for Mrs. Williams' pastel.

The Museum was the recipient of a number of gifts during the 1930s, such as the donation by Newcomb College of over thirty pieces of Newcomb pottery, selected by Woodward. On display at the Delgado from its earliest years, the loan became a permanent gift in December, 1937. Other donations of the period were a bronze, *Crane and Young,* by Anna H. Huntington, from the artist and her husband in 1937; a painting, *Habitant House,* by Ivan Swift, from Mrs. Mabel Swallow-Mareau, of Detroit, in honor of Herman Seebold, in 1936; a paint-

24. Minutes of the Board of Administrators, Isaac Delgado Museum of Art, May 19, 1938.

ing, *Petit Vernon*, by Knute Heldner, from the New Orleans Assembly of Delphians in 1937; and a pastoral landscape by William Keith, from Nora Novra.

The Museum also accepted many items of memorabilia, and in this period it seemingly became a storehouse for the curios and miscellany of those who no longer had attic space for them. In July, 1931, the Delgado received from Lucille Carroll Jay, of Cleveland, Ohio, a number of artifacts that had belonged to her ancestor Captain John R. Carroll. Among them were a hand-carved ivory chess set, two silver perfume bottles of Persian design made from melted Chinese coins, several hand-carved ivory and sandalwood fans, and a sandalwood box. In all there were "19 or 20 huge crates filled with mementoes of her family," the majority of which fortunately went to Newcomb College and the Cabildo Museum.[25] One outstanding memento that the Museum did receive was President Zachary Taylor's ceremonial sword, which the state of Virginia had presented to him in recognition of his services in the Mexican War. J. G. Pepper gave the sword in February, 1934, in memory of Clarence F. Low. Among the hundreds of pieces of questionable merit was a collection of engravings and other illustrations, "both in color and black and white, drawn from magazines of 30 to 50 years ago," given by Gideon T. Stanton, a onetime board member and a former applicant for the position of director.[26] Mrs. Samuel Delgado's ivory-handled parasol and six Imperial-Sèvres Napoleon III plates were given by Ellenora E. Moss, along with her mother's enameled Swiss watch and her own mother-of-pearl card case. Besides these additions, a number of prizewinners from the Art Association shows and the Southern States Art League shows found their way into the Museum's permanent collection.

Not all the exhibitions in the Museum in the 1930s showcased works by southern artists—although almost one-half of each year's exhibition time was dedicated to the region. Light from the art world outside Dixie filtered through. Most of the credit for that belongs to Feitel, who "after a few years, finally convinced Mr. Woodward that we ought to get some modern shows."[27] It took no small amount of persuasion on Feitel's part, for after the first "modern" show (which took place while Feitel was secretary of the Art Association and prior

25. New Orleans *Item-Tribune*, July 5, 1931.
26. New Orleans *Morning Tribune*, January 17, 1936.
27. Feitel, "Confessions," 1.

to his election to the board of the Museum), Woodward was more than ever opposed to untraditional art.

This first "modern" show, which opened on May 11, 1930, was entitled Post Modern French Painting. It was, like so many, sponsored by the Art Association of New Orleans. H. W. E. Walther, president of the Art Association, said of it, "Frankly, the Art Association was experimenting when it brought the Modern French exhibition here from California." He admitted that the decision to bring it to New Orleans occasioned severe criticism because of the radical nature of the art, which "as a layman, I do not pretend to judge; but I do feel that we want to see what is going on in the world, even if we may not like all of it."[28]

The show consisted of thirty-two paintings by contemporary artists of, as one news reporter termed it, the "extreme 'modern' group." There were works by André Derain, Raoul Dufy, Sybil Emerson, André Lhote, Pablo Picasso, Radda, Marcel Rouche, Terechuvitch, and several others. It created a negative feeling in the local press, as can be seen in the headline "French Radicals Start Exhibition in Delgado Today." Nonetheless the show was popular. Eventually one of the major dailies carried the news "Exhibit Caustically Criticized to Remain Here Ten Days More."

The most surprising headline appeared in a paper several days later, upon the exhibition's closing: "Modern Painting Nets Stiff Price." Certainly the funniest appeared in the *Morning Tribune:* "Museum Reports Picasso Painting Disposed of Here." The Art Association of New Orleans was proud to announce, it was reported, that Picasso's *Nature morte* had been sold "for more than $1,000."[29] Its sale made the show a financial success and served one of the aims for which such exhibitions were sponsored by the Art Association: to stimulate persons to collect. Too many, however, felt the Picasso far from a collectible item. Miss Hutson wrote that "this painting, a small canvas in brown monochrome, which suggests many forms with diagonal, curved, horizontal and vertical lines, but does not really delineate anything definite, has been the storm-center of criticism during the entire exhibition. Many considered it an absurd 'flinging of a pot of paint in the face of the public.'"[30] The person who had pur-

28. New Orleans *States*, June 15, 1930.
29. *Ibid.*
30. New Orleans *Morning Tribune*, June 13, 1930.

chased it remained anonymous. One columnist, however, suggested that it was someone from out of state, for the negotiations for its purchase were made by an out-of-state agent. In fact, Hunt Henderson was the painting's purchaser.

Other "modern" shows were presented at the Museum during this decade, but six years elapsed between the first two. Woodward blocked all such shows even though there was a desire for them among, in particular, local artists and students and "those who had been abroad recently and seen enough of the 'modern art movement' to recognize and appreciate the symbolism used by Picasso and his followers."[31] The isolationism of the early years was beginning to wane and many young artists were reacting against regionalism. It took Feitel's influence with Woodward to obtain, finally, in March, 1936, a small "modern" show sponsored by the College Art Association. It consisted of twelve paintings by Matisse, Picasso, Braque, Laurencin, Fernand Léger, and André Masson, all from the collection of Paul Rosenberg. Miss Hutson wrote in her art column prior to the show's opening that the paintings "are guaranteed to make the public open its eyes, according to the chairman of the exhibitions committee, Arthur Feitel, who regards this as the most significant exhibition of the year."[32] The public had little opportunity to agree, however, because the show stayed in New Orleans for only two weeks, and it overlapped the more popular spring salon of the Art Association of New Orleans. It was something of a failure and as Feitel remembered, the paintings "were too modern for Mr. Woodward and I am sure that he despised them."[33]

Feitel made every intelligent effort toward expanding the exhibition policy of the Museum, but he was too often met with the more fervent strictures of conservatism. Not until Woodward became ill in 1937 could Feitel regularly schedule a "modern" show each year. In January, 1937, he brought the Museum of Modern Art's Six Modern Sculptors, featuring the works of Ernst Barlach, Charles Despiau, Jacob Epstein, Georg Kolbe, Gaston Lachaise, and Aristide Maillol.[34] Be-

31. New Orleans *States*, June 15, 1930.
32. New Orleans *Morning Tribune*, February 28, 1936.
33. Feitel, "Confessions," 1.
34. In November, 1931, there had been a small loan show of Jacob Epstein bronzes at the Delgado from David L. Cohn, who had just retired as president of Feibleman's Department Store, in New Orleans. He had collected the bronzes for several years. Cohn later moved to New York City.

cause of the popularity of the show, Museum attendance for 1937 increased by more than ten thousand over the previous year's record. Woodward, in an annual report to the board, reported that "the turnstile shows that 47,437 have entered the building as contrasted with 36,769 of last year." But he would not admit the reason for the increased interest. He wrote, "I do not think this indicates increase in public approval. It is accidental. Interest in art is a matter of slow growth and must be fostered with patience."[35] In 1938, the Katherine Kuh Gallery, of Chicago, sent a "modern show to the Delgado Museum consisting of works by Léger, Picasso, Aleksandr Archipenko, Hideyo Noguchi, and Raymond Johnson. In 1939, through the Museum of Modern Art, Feitel obtained the largest show of "modern" artists seen up to then in New Orleans. It filled three galleries on the second floor and was entitled The Bauhaus—How It Worked. On exhibit for the first time in the city were works by Josef Albers, Marcel Breuer, Lionel Feininger, Walter Gropius, Johannes Itten, Wassily Kandinsky, Paul Klee, László Moholy-Nagy, Oskar Schlemmer, and others.

An area of "modern" artistic endeavor that the Museum vigorously supported in the beginning of this period was photography. The Museum offered several exhibitions of works by members of local camera clubs. As early as 1932, the Museum held a loan show of Margaret Bourke-White's photographs. And the Delgado was the first museum to recognize the talent of the now internationally famous Clarence John Laughlin, giving him his first one-man museum show in 1936. The art critic of the *Times-Picayune* wrote about the great innovative photographer,

> For an amateur photographer who has followed his art for only two years, Laughlin . . . has done remarkable things with his small camera. For the past year and a half he has been developing and enlarging his own photographs in a home-made dark room. He has tried to do rather a difficult thing in this exhibition. He explains his purpose by saying that he attempted to trace the psychic state of a certain period. Self-taught in art, Laughlin has developed an amazing feeling for clear, good composition and the relation of opposed lines. In an effort to capture the effect on a scene on himself, he has resorted to focusing from interesting angles. The total show is extra ordinarily good for an amateur photographer.[36]

35. Ellsworth Woodward to the board of administrators, Isaac Delgado Museum of Art, January 20, 1938, in archives, NOMA.
36. Irene Cooper, "Pen, Chisel, and Brush," New Orleans *Times-Picayune*, October 4, 1936.

Laughlin credited Miss Hutson, the secretary of the Museum, with persuading Woodward to allow him to exhibit at the Delgado. Of all the southern artists Woodward supported through the Museum, Laughlin was the only one of this period to gain international acclaim.

The death of Woodward on February 28, 1939, marked the end of an era for the Museum. Perhaps even Woodward himself realized prior to his death that change was in the air. Feitel and a few Young Turks had gone to great lengths to bring in new and stimulating exhibitions. They also tried to establish order in the exhibition spaces, clearing up the clutter of objects and putting together items consonant in time, style, and the like. A few months after Woodward's death, the Sunday *Item-Tribune* noted in its headline of July 9, 1939, "Delgado Museum Changes Policy." The article continued,

> Visitors to the Isaac Delgado Museum of Art this summer find it the same as ever externally, but as soon as they step inside they see many changes.
>
> "There are two theories of museum administration," said the late President of the Delgado Museum, Dr. Ellsworth Woodward, not very long before his death last February. "The old theory, to which I must confess I cling—no doubt I am an 'old fogy,' as the young folk think—is that . . . you have a good thing . . . good examples of art from all periods and countries . . . and by exposing [viewers] to good examples they learn to know what is fine, and to set up standards for themselves.
>
> "The other theory is that the museum itself must be a thing of beauty, not only in its design and architecture, interior and exterior, but in the arrangement of all the objects to harmonize with its halls and galleries, and with each other. Under this theory one must avoid any 'cluttering-up' and must perforce store away a large proportion of the objects acquired, showing only those few which accord with each other and changing the exhibitions frequently. Most present-day museums are run on this theory."

The reporter continued that

> influenced by such considerations, the board of administrators of the Museum has given a free hand to the acting director, Arthur Feitel, and other members of the art committee, F. Julius Dreyfous, Richard Koch—both like Mr. Feitel architects—and Warren B. Reed, an artist and former art dealer, to rearrange many of the objects in the Museum, retiring some temporarily, and placing others where they appear to better advantage.

Indeed, a new era was at hand. In August, 1939, a new slate of officers of the board of administrators of the Museum was selected. Felix

J. Dreyfous, the last remaining founding member of the original board, became president, and H. W. E. Walther, the former president of the New Orleans Art Association, became vice-president. Feitel was named acting director.

VI

Arthur Feitel

In his capacity as acting director, Arthur Feitel implemented a number of long-overdue changes at the Museum, particularly in the display of objects. He retired some pieces from view, while he reframed and exhibited others for the first time in years. He corrected labels, repositioned cases, and cleared them of clutter. He had paintings cleaned and some reattributed, such as the large canvas of *Telemachus and Ulysses*, supposedly by Jacques Louis David. Given in 1915 by John G. Agar as a memorial to his father, William Agar, it had held a prominent position in the permanent collection. Researchers for the WPA arts project "had failed to find a signature, but undeniably had found it to be by a member of his school," and furthermore, to represent Odysseus and Diomed visiting Philoctetes to obtain the arrows of Hercules.[1] (More recent research has identified the painting as *Ulysses and Neoptolamus Seeking Philoctetes on the Island of Lemnos*, by Maximilien Felix Demesse, a student of Baron Gros; Demesse submitted it to the 1828 Prix de Rome competition.)

As part of his housecleaning, Feitel had whole galleries rehung with the intention of presenting a more chronological and historical approach to art. He also introduced innovations in the physical plant, installing racks in the basement for the storage of paintings. The ventilating system was revamped to make the Museum more bearable for visitors in the warmer months.

This brief period was crowned by two important acquisitions, through donation. A portrait, *Stephen Mallory*, thought then to be by Thomas Sully but now considered a copy, was given by Dr. and Mrs. H. deB. Seebold, and a portrait, *Pierre Landrieux, Recorder of Mort-*

1. New Orleans *Sunday Item-Tribune*, July 9, 1939.

77

gages, by Jacques Amans, came to the Museum from I. M. Cline. Both these oils had been exhibited the previous year in the WPA show, New Orleans Artists Prior to 1900.

The changes brought a freshness to the Museum and prefigured a new era. But Feitel was powerless to bring about miracles overnight. Although he was acting director of the Museum and president of the Art Association of New Orleans, he could not revamp the exhibition policy completely. As long as the Art Association contributed over 80 percent of the funding for shows, it would control what the Delgado exhibited. As long as local artists remained a powerful force in the Art Association, they would demand the twice-yearly salons of their works. Feitel's voice was but one among many.

The Southern States Art League, founded by Ellsworth Woodward and headquartered in New Orleans, stayed a dominant force in the local art scene. The artists who were its members demanded that their works continue to be seen at the Museum. The tradition of Museum support for local and regional artists had become the cornerstone upon which the Delgado's exhibits rested. It was the law according to Ellsworth Woodward. Consequently, over one-third of each year's exhibit time was devoted to the display of the latest productions of the "magnoliaists." And that did not reckon in the exhibit time allotted the winners of the regional shows.

The list of exhibitions in 1939 illustrates the Museum's provinciality. In January of that year the Museum displayed the batiks of Fred Dreher, of Missouri, and housed a loan show of New Orleans silhouettes, organized by the WPA. In February and March, the Museum visitor saw over 150 paintings, prints, and sculptures in the thirty-eighth annual Art Association of New Orleans juried show, and the works of Lamar Dodd, head of the University of Georgia art department, in a one-man show. A watercolor exhibition from Ferargil Galleries, of New York, an Orrefors glass show, and a display of fine bookbindings from the Bibliotheca Parsoniona, of New Orleans, were on view in April, and in May the Southern States Art League presented its circuit show. June brought the annual Camera Club exhibit; July and August, ivories from the collection of Charles H. Behre. The fifteenth annual exhibition of work by members of the Art Association came in September; and in October the Ellsworth Woodward Memorial Art Show was held. Hans Mangilsdorf presented a one-man show of his sculpture and drawings in November, and during the same month one could view The Bauhaus—How It Worked,

organized by the Museum of Modern Art. In December, The Evolution of the Skyscraper, also from the Museum of Modern Art, came to New Orleans.

With the exception of the last two shows, the exhibitions of 1939 were mediocre. The thorough housecleaning accomplished in the beginning of the year was not enough to draw people repeatedly to the Delgado. Thousands of the curious had come to the Museum in 1933 to see the fifty-odd Italian Renaissance paintings from the Samuel H. Kress Collection. But when shows are dull and commonplace, people just do not attend.

The acting director of the Museum knew that attracting people is a job fraught with difficulties. Feitel recalled, "For out-of-town shows it was not only a question of trying to get a schedule where one exhibition would not overlap another, but with a limited budget . . . we had to consider the fee and the freight."[2] Then if the show was too avant-garde, it might not be appreciated by the art-supporting public. Thirty years of indoctrination by Woodward on the value of local art were not without their effect. The works of Georges Braque, Paul Gauguin, Henri Matisse, Pablo Picasso, Pierre Auguste Renoir, or even Claude Monet, might be seen and even admired, but New Orleanians on the whole preferred Xavier Gonzalez, Angela Gregory, Weeks Hall, and Nell Pomeroy O'Brien. New Orleans loved its sons and daughters. Nonetheless Feitel persisted in bringing in major outside exhibitions from time to time during the next decade. Those shows contributed the few interesting events in an otherwise dull period in the history of the Museum.

The first of the significant exhibits of the period was the famous one, Hitler Banned Art, organized by the Committee of Twentieth Century German Art, in London. It came to the Museum in May, 1940, under the auspices of Blanche A. Byerly, of New York. The exhibit included major German artists whose works had been proscribed as degenerate by Adolf Hitler. Represented were Max Bechmann, Lovis Corinth, Lionel Feininger, George Grosz, Carl Hofer, Paul Klee, Oskar Kokoschka, Wilhelm Lembruck, Max Liebermann, Franz Marc, Paula Modersohn-Becker, Emile Nolde, Max Pechstein, Christian Rohlfs, Karl Schmidt-Rottluff, and Max Slevogt. Marc's well-known *Blue Horses* was the most popular painting shown, every art critic of the local newspapers praising its beauty.

2. Feitel, "Confessions," 4.

During the same month it was announced that "what many consider the most important art show of the decade" was coming to New Orleans in December.[3] The great Picasso show, Picasso: Forty Years of His Art, had been organized by the Museum of Modern Art. The show had visited Chicago, St. Louis, New York, and San Francisco, where it had met with tremendous success. The Art Association of New Orleans was delighted to obtain it for the Delgado, although the cost was of some concern. As Feitel recalled, "the fee and transportation were very expensive, but with my good friends Richard Koch, the architect, and Xavier Gonzalez, the painter, we jointly signed the contract. Miss Sarah Henderson guaranteed a part of the financing."[4]

Feitel, Koch, and Gonzalez enlisted the patronage of a number of art and educational institutions throughout the state to obtain the necessary funds. With Miss Henderson as a silent partner, the three formed a committee with Duncan Ferguson, of Louisiana State University; Charles Gresham, of Gresham Galleries; Frederick Hart, of Tulane University and Newcomb College; Morris Henry Hobbs, of the Association of Louisiana Etchers; Albert Lieutaud, of the Arts and Crafts Club; John McGrady, of the New Southern Group; and Charles Reinike, of the Reinike Academy of Art. It was the goal of this committee to raise enough to free the exhibit of admission fees. The cost of the show was fifteen hundred dollars. By November the committee was still five hundred dollars short of its goal, and it became necessary to impose an admission charge of twenty-five cents to defray costs.

Despite the importance of the Picasso show and the enthusiasm for it on the part of the committee, attendance was low. Feitel considered the show a success, because at the closing the Museum was ahead fourteen dollars, but the figure means that only 2,056 people attended the exhibit. The poor attendance may have been a result of scheduling the show during the holiday season, December 20, 1940, to January 17, 1941. But the low response definitely did not owe to a bad press, as had been the case in 1930 with Post Modern French Painting, a show that included several of Picasso's works. Indeed, in the ten years that had elapsed, the local art critics had become much more appreciative of the numerous modern works included in the exhibit. Among these were the world-famous *Guernica*, of 1937; *Les Demoiselles d'Avignon*, of 1907;

3. New Orleans *Item*, May 22, 1940.
4. Feitel, "Confessions," 4.

The Woman in White, of 1923; and *The Race*, of 1922. Almost the entire Museum was filled with these outstanding works of art.

The manner in which the Picasso paintings were hung was curious. Elizabeth Catlett, the African-American artist whose sculpture of Louis Armstrong is now in Louis Armstrong Park, has related a visitor's reaction to the show. The first time that she ever came to the Delgado was in 1941 to see the Picassos. She was teaching at Dillard University at the time and wished to bring a group of her students to see the exhibits. To do so she had to obtain special permission for her black students to enter City Park. The students were enthusiastic about being in the Museum for the first time, and their response to the exhibition was heartwarming to her as a teacher. She was surprised, however, to see the Museum's older paintings hanging side by side or intermixed with the Picassos. The *Guernica*, though, was installed on a special freestanding wall in the center court among the statuary in the Great Hall.[5] Such a presentation must have been as startling to the viewer as some of the paintings themselves.

Dr. Rudolph Matas, the noted doctor of tropical diseases who was later to become one of the Museum's benefactors, attended the exhibit. He remembered seeing in Barcelona an exhibit of works from Picasso's youth. Those works were more conventional, many depicting street life in Paris among the poor and laborers, and Matas preferred them. For him they were "as full of forlorn despair as 'The Song of the Shirt.'" The New Orleans show, however, included only a few paintings from the period that Matas favored.

It was Feitel's hope that he could obtain funds to buy for the Museum one of the bronze busts displayed in the show. It was priced at only $800, "but I could only raise $500," Feitel said, "and could not buy it much as I would have liked. Today it would be worth many times more."[6] Despite this disappointment and the poor attendance, Feitel felt that "this exhibition was a breath of fresh air for our musty Museum."[7]

Two shows in 1941 resulted from the support of the Bultman family. The first of these was a choice selection of drawings and paintings by a dozen European masters of modern art, from the collection of Fritz Bultman and his sister, Muriel B. Francis. Ethel Hutson wrote in

5. Elizabeth Catlett, interview with author, February 15, 1984.
6. New Orleans *Sunday Item-Tribune*, December 29, 1940.
7. Feitel, "Confessions," 4.

her art column that it might almost be called an "artistic League of Nations," for "the artists represented include German, French, Spanish, Italian, and Russian painters."[8] There were works by André Derain, Edgar Ende, George Grosz, Wassily Kandinsky, Helmuth Kolle, Fernand Léger, Joan Miró, Josef Moder, Claude Monet, Odilon Redon, Josef Scharl, Gino Severini, and Toulouse-Lautrec. One newspaper headlined the exhibit, "Moderns Jolt Conservative Exhibits in Delgado Museum."

That same month—March, 1941—the Museum offered a show of paintings by Hans Hofmann. It was the first exhibition of his works held in an American museum. The show was organized by Fritz Bultman, his father, A. Fred Bultman, Jr., and Mrs. Hans Hofmann, who was visiting the Bultman family at their Louisiana Avenue home. An artist in his own right, Fritz Bultman had begun his studies under Hofmann at the age of sixteen in Munich. With Hitler's rise in Germany, Hofmann emigrated to Chicago to teach. Fritz Bultman had followed his teacher to Chicago and from there to New York.

The two shows the Bultman family sponsored in 1941 were the beginning of a long tradition of support for the Delgado by that family. In 1943, A. Fred Bultman, Jr., was elected to the board of trustees, on which he served for several years before his death. His daughter, Muriel B. Francis, was a trustee for many years and was the first woman president of the board, in 1968–1969.

Each show was bound to bring with it some difficulty, and the outbreak of World War II created special problems for traveling exhibitions. According to Feitel, "there was always something to worry about—the printer delivered the catalogues late, or the caterer would fail to arrive, or we could not get the exhibition installed on time, or the guards were sick or the labels were late, or the works mislabeled, or the majority of members (most of whom were ignorant in matters of Art) did not like the show." Furthermore, he added, "Any one of these things or dozens of other annoying happenings always made a director appear to be a no good so and so."

A case in point was the 1941 one-man show of the murals of Condido Portinari. "As he was a Brazilian painter we prevailed upon the Mississippi Shipping Company to sponsor it. They sent out elaborate invitations and had refreshments for the guests, but the show failed

8. New Orleans *Sunday Item-Tribune*, January 5, 1941.

to arrive on time. We finally were able to locate it up North. As the paintings were very large the ordinary freight car could not take them. The paintings arrived about a week later, after they were able to get a gondola car to carry them. When they arrived at the Museum we could not get some of them through the doors." The murals were finally squeezed diagonally through a rear door, but, Feitel continued, "it was impossible to hang them in the rooms upstairs so we had to exhibit them on the upstairs walls of Statuary Hall."

Of the numerous shows at the Museum during the war one of the most significant was the collection of refugee French art treasures. "During the San Francisco Exposition, shortly before the advent of World War II, there was a large collection of French paintings, sculpture and other objects exhibited there. The French cargo boat, *Michigan*, was carrying a portion of these things back to France," remembered Feitel, "and was in the Panama Canal in June, 1940, at the time of France's surrender. The boat was ordered to proceed to the nearest American port and there discharge its cargo." In New Orleans, the art works were stored in a fireproof warehouse. "For three years," Feitel said, "I tried unsuccessfully to have these things for exhibition at the Delgado, but it could not be done as there was no one with the proper authority who could act for the owners. After the invasion of North Africa in 1943, I wrote to Senator Ellender who interceded with our State Department to get permission from the French Committee of National Liberation. We made the opening of this show a demonstration of Franco-American unity."[9]

Indeed, the November 20, 1943, opening was one of the biggest events of the war years at the Museum. Lloyd Cobb, president of the Art Association of New Orleans, spoke a few words of welcome before the assembled guests and distinguished French visitors, among whom were René Batigne, the commissioner of French art in the United States, and André LaFarge, president of L'Union Française. The artists whose works were exhibited were Matisse, Picasso, Pierre Bonnard, Emile Bourdelle, Edgar Degas, Raoul Dufy, Moise Kissling, Auguste Rodin, Georges Rouault, Maurice de Vlaminck, and Jean Edouard Vuillard. Because of the popularity of the show, the Museum held other international exhibits demonstrating Allied solidarity, in which the contemporary artists of China, Great Britain, and

9. Feitel, "Confessions," 4.

Holland were on display. This major exhibition of French art was warmly received by the community, whose French sympathies were strong.

Overall, however, the war years were an unexciting epoch in the development of the Museum. There were still no endowment to speak of, no professional staff, no museum shop, and no auditorium, and there were very few new pictures. Not enough influential people served on the board, and those who did "came to the monthly meetings as a matter of routine. They did little to advance the course of the Museum between meetings." [10] The acting director and his secretary oversaw every aspect of the Museum, from hanging shows to authenticating attributions. The amateurishness that prevailed is illustrated in one of Feitel's anecdotes:

> About a year before we entered the Second World War, I was called to the phone in my office to hear someone, greatly excited, complain bitterly as though he had been personally insulted. It was Japanese Consul-General Ito. He said that he had visited our museum and seen a Japanese Buddha enshrined in a Chinese Shrine. I explained to him that my knowledge of the arts of the Far East was very limited. Did he notice anything else? "Among your small bronzes there may be some errors in the labels." If I wanted he would ask several Japanese scholars to come down from the Washington Embassy to expertize [*sic*] our oriental objects. Three men about forty years old came and translated all the inscriptions.

Another story concerns the loan of an El Greco painting belonging to Mr. and Mrs. William G. Helis:

> I understood from Mr. Dabezies that Mr. and Mrs. Helis owned an El Greco and I was anxious to borrow it to exhibit at the museum. Lloyd Cobb arranged that I should meet Mr. Helis at his office and I made the request of him to borrow it. He said he had loaned it to the Greek Ambassador in Washington, but when it came back he would be glad to loan it. It was months later when Dabezies rang me to say that we could take it to the museum any time we wanted. He suggested that we go there in my car that afternoon. When the servants tried to put it in my car it was too big for the car doors so we went inside the residence to consider our next step. He said he had an old time seven-seat Packard and he would ring his wife to have the chauffeur bring it up. The servant said that Mrs. Dabezies was not there and had gone to a funeral in the Packard. Mr. Dabezies said "Arthur that gives me an idea. Laudumiey is indebted to me for sending him so many funerals of the French Society. I will ask

10. *Ibid.*, 2.

him to loan us his old coffin truck, which I know is plenty big." He gave
Laudumiey the name and address and cautioned him to be sure to send
it to the right house. We were sitting in the Helis living room looking out
toward the street and we were astounded when the vehicle in question
stopped across the street and the driver rang their bell. We ran out to
correct the error, but it was too late. Soon all the neighbors were out
thinking that someone had died in the Helis home. We had the painting
put inside the truck and had the driver follow us to the museum.[11]

Despite the lack of professionalism, the truth remains that Feitel
gave unselfishly of his time to do everything in his power "to make the
museum something for which the City could be proud."[12] Without his
efforts, the Museum might have suffered substantial neglect in this
period. Besides bringing outstanding exhibitions, he initiated a series
of guest lectures and art films. The development of the first art classes
for children was another landmark for the acting director. And a youth
cultural program began under his administration in conjunction with
the New Orleans Junior League in 1947. That unique program was
designed to foster the interest of children in museums. The first of
many program events, a show entitled John J. Audubon's Louisiana,
featured Indian crafts, stuffed birds, flower arrangements, Louisiana
furniture, and Audubon prints, and occupied four of the Delgado's
main galleries. It was the beginning of the efforts in children's educa-
tion that would become a regular part of the Museum's programs.

These successes were not easily achieved. "It was an uphill battle,"
said Feitel, who was conscious that his new ideas often foundered be-
fore the conservative and sometimes intransigent board. The age of
most members of the board was well past the half-century mark.
Many had simply been on the board too long. The president, Felix J.
Dreyfous, was then in his late eighties; he had served on the board
continuously since the Museum's founding in 1910. His son, F. Julius
Dreyfous, served as well. By 1944, Hippolyte Dabezies had been sec-
retary-treasurer of the board for ten years, and he would continue in
that capacity for another eleven years. Feitel himself had been a mem-
ber of the board for over eleven years. The few new names on the ros-
ter were those of men who rotated on and off in quick succession.
Most were younger men who came to feel that their time and advice
would be better directed to other endeavors.

Feitel recalled these years: "I tried to sweep some of the antiquated

11. *Ibid.*, 9, 16.
12. *Ibid.*, 7.

ideas and prejudices away, but it was a long, slow effort which was usually resisted at every turn. I felt that the Museum Board as stipulated by the Delgado letter of gift did not result in the best interest of the museum. Six members were appointed by the City Park Commission and three by the Art Association of New Orleans." He emphasized that he "felt that the Board should be larger and that it should be selected from wider and more influential elements of the city. A museum needs people of great wealth or influence, or both." Feitel met with little success: "When I often suggested changes in the size and selection of the Museum Board every lawyer who ever served on the Board would always claim that such a board would be illegal as it would violate the wishes of Mr. Delgado."

Because the board could not be enlarged, Feitel hoped to persuade certain influential people to join the Art Association and then to stand for election to the board. His luck was no better there. "After consulting my colleagues I personally called on such prominent people as Lloyd Cobb, Darwin Fenner, Edgar Stern, Jr., Harry Latter and a number of others. After a good deal of persuasion I succeeded in enlisting Lloyd Cobb. He told me that he did not have much time. . . . Others who were contacted flatly refused."

Stymied, Feitel sought to enlarge Museum support by tapping individuals of wealth and influence who might aid the Museum's growth through donations of paintings or money. It was in this initiative that he enlisted the A. Fred Bultman family, who "generously loaned their spacious home to us and to others for receptions, meetings, and lectures. At times when refreshments for a party would give out, Mr. Bultman would insist that we help ourselves to his large supply. He and his daughter Muriel were always in the forefront of helping us . . . , as well as using their influence with their friends to help support such things. I remember so many times when Mr. Bultman would make a timely donation so that the museum could do something that it could not have done otherwise."[13]

Another of the new faces Feitel brought into the Museum was that of Mrs. William G. Helis, who for many years was a kind and generous patron. Under her auspices the Museum held an annual Christmas party for children from the art classes, at which there were not only entertainment, refreshments, and presents but also cash prizes for meritorious work done by the students. She also gave funds to

13. *Ibid.*, 2, 5, 14.

purchase two important old masters: *King Louis XII of France Dispensing Alms*, now attributed to a follower of Barent van Orley (*circa* 1515–1520), and *Memento Mori*, now ascribed to the seventeenth-century Florentine Giovanni Martinelli. The latter painting, more popularly known as *Death Comes to the Banquet Table*, had been attributed to a number of the followers of Caravaggio.

Feitel also renewed his contact with some former friends of the Museum, such as Samuel Weis, a former board member who had resigned when business had required him to move to Chicago. The acting director claimed that his patient interest in Weis brought several worthwhile paintings to the Delgado. Among those that Weis gave the Museum in May, 1943, were a Flemish-school painting, *Christ on the Way to Calvary;* a sixteenth-century Dutch painting, *Portrait of a Woman,* by Michael Janszoon van Mierveldt; a seventeenth-century French painting, *Portrait of a Court Lady,* attributed to Robert Tourniers; a replica of one of Gilbert Stuart's portraits of George Washington; and *Casino at Monte Carlo,* by the nineteenth-century Italian artist Pompeo Mariani.

Feitel was not always so successful with prospective donors, however. Some eluded him. One of these was Weeks Hall, of New Iberia, Louisiana, the local artist of some renown who lived at Shadows-on-the-Teche. Feitel recalled that "during his later years he started to discuss with me the future disposition of his house. He had a horror of thinking that possibly an unappreciative public would some day tramp through it. Always having Delgado Museum in mind I thought it would be a good idea that he leave 'The Shadows' to our museum. I explained that we would sell it and build rooms or a wing at Delgado as a memorial to him, or buy several masterpieces and identify them as his gifts." Hall apparently weighed the proposition at length, and frequently he called Feitel at five o'clock in the morning to discuss his ideas. Then Hall called the next morning half an hour later to apologize for having called so early the previous day. "He finished by willing his house to the National Trust for Historic Preservation. I chalked up another disappointment. One can't bring home a duck every time he goes hunting." [14]

After the death of Felix J. Dreyfous, on November 15, 1946, Feitel was elected president of the board of administrators of the Museum. At the time of his election on January 11, 1947, he promised to "do

14. *Ibid.*, 16.

everything possible to improve the museum and its collections, and to stir up more public interest in the museum." He told the Art Association, "I hope we yet will raise sufficient money to employ a fulltime qualified director of the museum."[15]

In its thirty-seven-year history, the Delgado had never employed a professionally trained director. Indeed, there had been a full-time curator, Charles Wellington Boyle, but he was only a landscape artist who had accepted the position as a sinecure. Boyle knew nothing about administering a public museum. He was a nice fellow who supinely accepted all proffered gifts, unwilling to snub anyone by refusing a donation. He held exhibitions as matters of business, with paintings for sale by the artists, artist associations, or commercial art galleries. Boyle conducted art classes that were popular, but they did not increase Museum attendance. By the time of his death in 1925, much of the collection was a catchall of curios, casts, and castoffs.

Feitel's call in the late 1940s for a professional director was not surprising to the board of administrators of the Museum. He had initially pointed out the need on June 15, 1939, when he submitted his first full report as acting director. The twelfth point in his report was the request that the acting president of the board apply for an "additional appropriation to cover the salary of a Curator or Director from the City of New Orleans for the year 1940." The request was ignored. That year and for the next six years, the city council appropriated only seven thousand dollars annually toward the Museum's operating expenses. The Museum's investments from the Hyams and Harrod funds yielded a yearly income of only fourteen hundred dollars. The sale of catalogs and postcards brought in another fifty dollars. Without an additional appropriation from the city, no professional director could be hired.

During 1940, Feitel brought the matter up again at several meetings of the board of administrators. In one session on this topic the minutes reveal that the treasurer, Dabezies, told the board that it could spend between $2,000 and $2,400 for the services of a full-time director. In March, 1940, Gideon J. Stanton, a former board member, applied for the position, and the board referred the matter to Feitel. Stanton was denied the job because of his lack of museum training. Two years later Alfred Wellborn reported to his fellow board members an interview he had had with Morgan Marshall, administrator of the

15. New Orleans *Item*, January 10, 1947.

Walters Gallery, in Baltimore, concerning the qualifications for a director for the Museum. In August, 1942, Edward Whetzle applied for the post of director, but the board ruled that he did not have the qualifications needed in a capable administrator.

The war years brought no action on the matter. According to Feitel, steps could not be taken until the politicians agreed to appropriate the salary of a director. One may imagine Feitel's delight when this occurred, in 1948. That year, the city council appropriated $28,445 for the Museum's budget, four times the annual budget in the previous ten years. The sum of $9,000 was set aside for an "Art Director's Salary and Art Acquisitions."

On January 9, 1948, the board of administrators formed a committee "to select a suitable curator, and if necessary to pay for all expenses, travel and otherwise, found necessary in making a good selection." The members of the committee were Feitel, Cobb, and F. Julius Dreyfous. At the same meeting the board took up a problem concerning the Museum custodian, who lived in the basement with his wife and child: "Mr. Feitel called attention to the Board—that Mr. Dubret used the basement to dry his wash clothes and thought it best to buy a dryer for his use as the dampness might hurt some of the paintings stored in the basement." [16] After much discussion the board agreed to authorize the expenditure for a dryer.

The search for a director now began in earnest, but no one applied despite several inquiries by potential candidates. In March, 1948, Dabezies suggested that the matter be postponed until August 1, 1948, and the board approved. In June, Xavier Gonzalez wrote to Feitel suggesting "a Mr. Lanzo Langsford [sic] as Curator." [17] Nothing was done until the September board meeting, when Feitel, with an air of mystery, "told the Board that he had been informed that a certain man in New York would make a very good Curator for the museum. After some discussion, it was decided that Mr. Feitel would telephone this party and write him to come to New Orleans at the museum's expense, and interview the members of the committee. The salary was to be limited to $7,500 a year." [18]

After nine months, definite action had been taken. On September 29, a special meeting was held at which Feitel reported that Alonzo

16. Minutes of the Board of Administrators, Isaac Delgado Museum of Art, January 9, 1948.
17. *Ibid.*, June 10, 1948.
18. *Ibid.*, September 9, 1948.

Lansford (now spelled correctly), associate editor of the *Art Digest*, had come to New Orleans to meet him and his committee. Lansford had been shown the Museum and told what was expected of a curator or director. Feitel, after concluding his report on Lansford, "recommended his employment. Messrs. Dreyfous and Cobb both said that they thought it would be a good thing for the museum to employ Mr. Lansford [and] that they had been to lunch with him and their reaction was very good." [19] The board agreed unanimously to offer the position to him.

Lansford agreed to accept the job beginning in December, 1948. The announcement, released on October 23, 1948, made only the back pages of most of the New Orleans newspapers. The headlines were tiny caps. To the press, the appointment was evidently not momentous. But the board of administrators felt otherwise, saying in a statement, "We feel that a museum of the importance of the Delgado in a city as large as New Orleans should have a full-time director. Mr. Lansford's appointment is another step in making our city a great educational and cultural center." [20]

The administrators were correct. They had taken a great step forward in appointing a professional to the position of director. In Lansford, they had hired a man with good experience in the art world. A native southerner, he had received his B.A. from the University of North Carolina and had done graduate work at the Pennsylvania Academy of Fine Arts. For three years, before going to serve in the military in World War II, he had been director of the Telfair Academy of Arts and Sciences, the South's oldest museum of fine arts. He had studied at the Art Students' League, in New York, and at the time of his acceptance of the directorship was an associate editor of the *Art Digest*, in New York. Lansford was a person whose background in the art world was well rounded, and he was highly competent. As an artist, critic, and museum administrator, he combined many areas of expertise. He was the man Feitel had been looking for for almost ten years.

19. *Ibid.*, September 29, 1948.
20. New Orleans *Item*, October 23, 1948.

VII

Alonzo Lansford:
The First Professional
Director

The basis of the success of nearly all early American museums seems to have consisted of an alliance between two or three dominant men: an active president good at stirring up interest and money in the community, a sensitive collector of sound taste and large pocket book willing to make really significant donations, and finally a director, usually something of a showman, competent and devoted and with long tenure and close association with his president.

—Nathaniel Burt, *Palaces for the People*

A wiser man with the experience of Alonzo Lansford might not have accepted the position of director. The Museum was in a deplorable state. It had only two major collections, the Hyams and the Whitney; it had few paintings and almost no endowment; it labored under a leaky roof; and it was constricted by an octogenarian board of administrators accustomed to exercising total control. Two staff members—a secretary and a janitor-guard—constituted its staff, and the membership was of no significant size. The books showed only five hundred dollars a year allocated for art purchases, and nothing for programs. Beyond all that, the building was outmoded. But the short, redheaded man was youthful and full of expectations; with zest he faced the almost insurmountable task of turning the Delgado into a professional art museum.

Lansford felt that because of the progress the city had made in the previous decade, it could help him meet the challenge he confronted. He believed that there was an "opportunity for the museum to participate in New Orleans' new spirit of international co-operation already manifested by International House, the International Trade Mart and the Free Trade Zone."[1] He added, "We have a wonderful opportunity

1. New Orleans *Item*, December 2, 1948.

here for the interchange of North American and Latin American Culture."[2] Lansford planned exhibitions that would encourage this interchange, and he hoped that businesses participating in trade with Latin America would help pay the costs. In his first public utterances, Lansford spoke of bringing business and art together, for "businessmen and their wives have replaced the renaissance princes and bishops as collectors of art."[3]

But Lansford found more immediate responsibilities awaiting him in great number at the Museum. On the job less than one month, he had to hang two large French shows previously arranged by the Art Association of New Orleans. Most of the permanent collection had to be taken down and stored for the duration of the loan shows. The opening was planned for January 9, 1949, as a climax to Salute French Week. The shows were in keeping with the new international spirit then so prevalent in New Orleans. The first consisted of thirty-two paintings by Georges Braque, Paul Cézanne, Jean Baptiste Camille Corot, Gustave Courbet, Jean Auguste Ingres, Elisabeth Vigée-Lebrun, Henri Matisse, Claude Monet, Pablo Picasso, Camille Pissarro, Auguste Renoir, and Maurice Utrillo. These were on loan from the Durand-Ruel, Matisse, Rosenberg, Silberman, and Wildenstein galleries of New York. The second show comprised 160 graphic works by Monet, Renoir, Toulouse-Lautrec, Pierre Bonnard, Honoré Daumier, Raoul Dufy, Paul Gauguin, Odilon Redon, Auguste Rodin, and Georges Rouault, on loan from the George Binet Gallery.

At the same time, the Delgado displayed its recently acquired bronze sculpture *Hercules the Archer,* by Antoine Bourdelle. The acquisition of it was the culmination of a dream of Feitel's. Ever since the 1943 show of impounded French art, he had hoped to purchase a large bronze sculpture from that exhibit, but negotiations had been to no avail. Six years later, through Angela Gregory, a local sculptor who had studied under Bourdelle in Paris and who had remained a close friend of his wife's, Feitel learned, he said, that "the widow of Antoine was willing to sell us a fine casting of Bourdelle's famous statue of *Hercules the Archer.* I convinced our Board that they should 'find' the money. It was a little less than $7,000."[4] The announcement of the purchase, along with a photograph of it installed in the Great Hall of the Museum, made the front page of the *Times-Picayune*. The statue

2. New Orleans *Old French Quarter News*, December 10, 1948.
3. New Orleans *Times-Picayune*, December 1, 1948.
4. Feitel, "Confessions," 4.

was big news, for the Museum had never before purchased anything so expensive.[5]

It was not long before Lansford turned his energies toward improving the Art Association of New Orleans. He devised an entirely new type of jury system for its annual event. The change was long overdue and was necessary if nationwide interest among artists and gallery owners was to be aroused again. Lansford hoped that the annual exhibition of the Art Association would return to being national—even international—in scope, as had been the case at the turn of the century, when artists such as Monet, Thomas P. Anschutz, Mary Cassatt, William Merritt Chase, William Glackens, Childe Hassam, Charles Hawthorne, Robert Henri, Winslow Homer, Maurice Prendergast, Frederick J. Waugh, and J. Alden Weir were participants.

Juries for the exhibit were frequently drawn, Lansford found, from among local talent, and the composition of the juries could often be impugned. Feitel illustrated how the old system had degenerated:

Our Art Association Committee once named three of us to be the Jury to judge the Annual Exhibition. The other two members were Xavier Gonzalez, the artist who taught at Newcomb, and Robert B. Mayfield, a part-time artist who worked for the *Times-Picayune*. Mayfield was a conservative in his artistic thinking, he had a good sense of composition and even had a painting in the permanent collection of the Museum. Gonzalez was a very good artist, of national reputation, a progressive, whose work included nearly all phases of the evolution of modern art. I, who disliked being on a jury, served as Chairman. The other two jurors had each picked a painting for the prize. Gonzalez was very much in favor of a non-objective work and Mayfield was very much in favor of an extremely conservative work. They asked me to make the decision but I refused as I did not like either painting. A heated argument ensued between the two jurors. Gonzalez stated that Mayfield did not know what a good picture was. He refuted the statement of Mayfield, who had said that Gonzalez was opposed to anything realistic. Gonzalez stated that he was not opposed to any painting that is well composed, whether objective or non-objective. "There is a painting across the way down on the first floor that is fine. See how well the two children are composed in relation to the small picture on the wall back of the children. There is a good painting and it is realistic." Mayfield replied, "I am glad that you like it because I painted it." That year it was necessary to call in another jury to make a decision for the First Prize.[6]

5. The statue was pulled from its base by vandals on the night of Christmas Eve, 1978, with the result that the bow broke at its seam.
6. Feitel, "Confessions," 3.

An embarrassing level of conflict of interest also plagued the juries. In the 1906 and 1909 Art Association exhibition, a jury member, William Woodward, received the silver medal.[7] The brother of Ellsworth Woodward, he was awarded top prizes four times while his brother served as a juror. In all, Ellsworth Woodward served on the annual's jury thirteen times. He himself was a gold-medal winner in 1910, when he competed against Chase, Hassam, Henri, Weir, and Chauncey F. Ryder. In 1927, he was not only on the jury but was also the purchase prizewinner. In 1935, he was the cash prizewinner in two categories: painting and watercolor.

Lansford's new jury system was intended to dispel the look of connivance. Henceforth, there would be three jurymen, each a professional artist from outside New Orleans and Louisiana. They would evaluate the submissions separately, instead of working together. Each piece would be numbered, and a juryman's choice for acceptance in the show would be by number. The jury would meet and review the acceptances. They would then vote on prizes, discussing the reasons for their choices. After the exhibition had opened and had been on public view for a week, members of the Art Association could attend a symposium at which the jurors explained fully their reasons for awarding each prize. The symposium concept was entirely new, and Lansford said he had "not heard of it ever being tried before."[8]

The new system was both revolutionary and successful. There were more than 389 entries, of which 187 were accepted. The participating artists were from as far away as Indianapolis, New York City, and Columbia, California. Charles L. Okerbloom, Jr., of Tulsa, Oklahoma, won first prize for a watercolor, and Neppie Conner, of Fayetteville, Arkansas, won first prize for an oil. By encouraging out-of-state artists to submit works, the Museum met its obligation to recognize and serve artists who were pushing beyond the creative frontier. During Lansford's directorship, such now-recognized masters as Fritz Bultman, Morris Graves, Balcomb Green, Rico Lebrun, George Rickey, Theodore Stamos, James L. Steg, Rufino Tamayo, and Mark Tobey participated in the annuals.

At the same time, Lansford was making attempts to discover works privately owned by New Orleanians and not yet exhibited in the Museum. He hoped to stimulate the interest of the owners in the Museum and, in some instances, to inspire greater appreciation on the

7. New Orleans Museum of Art, *1977 Artists' Biennial* (1977), 1.
8. New Orleans *Item*, February 10, 1949.

part of owners for what they possessed. Lansford was frequently quoted in newspaper columns "to be searching for certain painters' works, those of Richard Clague and of his students, William Buck and Marshall Smith." He promised that if enough such pieces were found, there would be a Clague exhibition at the Delgado.[9] By such means, and with the aid of two noted collectors of American and Louisiana material, Lansford was able to bring to light a number of good paintings.

One find was an oil portrait of General Persifor Frazer Smith, a Mexican war hero, done by William Edward West when Smith was a young man visiting Paris. It was lent to the Museum in 1949 on indefinite loan by Smith's great-great-granddaughter, Mrs. H. Windsor Wade. She also lent a fine bayou landscape painted by William Buck. E. C. Runte lent George D. Coulon's *City Park at the Turn of the Century*, and Mr. and Mrs. Cornelius Rathborne lent several cotton-field scenes by William Aiken Walker. In consequence of such public interest, the Museum developed a Louisiana Room.

The growing Louisiana collection integrated American art and Louisiana art, bringing together popular artists of historical merit, both local and national. Works by American and Louisiana artists were affordable. Many significant painters, such as John J. Audubon, Dominique Canova, Richard Clague, Louis A. Collas, Edgar Degas, Matthew Jouett, Samuel F. B. Morse, Thomas Sully, John Vanderlyn, and Jean J. Vaudechamp, had worked in Louisiana. Since Louisiana families had in their possession portraits, landscapes, and religious paintings by talented artists from throughout the world, Lansford reasoned that these could provide a large pool from which to obtain works for the collection. He recalled that "in the early 19th century a plan was laid for a national art gallery in New Orleans. European experts collected great European paintings and sent them to this important city. But the financial backing suddenly folded up and the paintings were sold here. Many of them found their way into Eastern museums, but some of them must have been bought by residents and plantation owners."[10] By appealing to local pride, the director hoped to call forth good works of art for the Museum.

His efforts were quickly rewarded. In 1949, the Museum inherited

9. *Ibid.*, May 5, 1949. Twenty-five years elapsed before this promise came to fruition in the exhibition Richard Clague, 1821–1873, which traveled to museums in Shreveport and Baton Rouge, Louisiana; Corpus Christi, Texas; and Mobile, Alabama.

10. New Orleans *Times-Picayune*, October 2, 1949. *The Toilette of Psyche*, by Charles Joseph Natoire, is just such an example.

Canova's *The Holy Family* from the artist's granddaughter, Estelle Magendie. In 1950, a Degas bronze sculpture of a horse was presented to the Museum by the artist's grandnephew, Michel Musson. That bronze was one of ten that came to the Musson family as part of the settlement of the estate of René Degas, the artist's younger brother. The artist's mother, Celestine Musson, was born and reared in New Orleans. Eventually René married his first cousin, Estelle Musson, and lived in New Orleans from 1866 to 1878. It was while visiting his brother and sister-in-law in New Orleans for five months in the winter of 1872–1873 that Degas painted his famous *Cotton Office, New Orleans*. After René abandoned his wife and six children, Estelle changed her name back to Musson.

For years the Musson family had been visited by artists, art critics, historians of art, museum curators, and art collectors, such as Mr. and Mrs. Edward G. Robinson. All wanted to see the Musson collection of Degas bronzes. Finally, in 1950, the Musson family sold all but one of the sculptures in New York through the E. and A. Silberman Galleries. With deep gratitude, Lansford accepted the gift of the remaining bronze, *Walking Horse*, for the Museum's collection. He confided, "It would have broken my heart if all the bronzes had left the city. I've been wishing for quite a while that we had one of them in the museum." [11]

In February, 1951, a full-page newspaper article with the banner headline "Delgado Collection Shows How Museum Grows: Museum Adds to Treasures with Low Outlay of Funds" enumerated the gifts and loans to the Museum. During the brief two years that Lansford had been director, he had acquired not only the works already mentioned but also the oil *Free Woman of Color*, by Louis Antoine Collas, from Felix H. Kuntz; the oil *Indians Marching Through Louisiana*, by Alfred Boisseau, from W. E. Groves; and three watercolors *Amalfi*, *Veere*, and *This Field*, by Ellsworth Woodward, from Mrs. R. H. Coates. Lansford also obtained—on long-term loan—twenty-two oil paintings by William Aiken Walker, from Mr. and Mrs. J. Cornelius Rathborne.

Lansford's emphasis on material from Louisiana did not overshadow his concern for developing the collection in other areas. His forays into the private collections of the city led to the donation or loan of many other paintings. For example, a Peter Paul Rubens oil, *The Holy Family*, was lent by Joseph E. Jubin in 1949. And the estate of

11. New Orleans *Times-Picayune*, *Dixie Roto*, April 16, 1950.

George M. Derby lent a handsome oil portrait of a New England ancestor, by Joseph Badger.

"The great artist of tomorrow may be the artist at your elbow today and the museum that acquires fine contemporary art reaps its reward in years to come," stated Lansford in one of his first New Orleans interviews, in October, 1949. [12] True to his conviction, Lansford pioneered in acquiring works by artists associated with the emerging abstract-expressionist group and the surrealists. Apart from the Delgado, only museums specializing in modern and contemporary art were then attempting to own such works. James B. Byrnes, who later became director of the Museum, thought Lansford amazing for his achievements in this area. The Delgado, which had virtually no resources for making purchases, had bought Dorothea Tanning's *Guardian Angels* in 1949, through the Kate B. Jordan Fund, and had successfully pursued collectors who donated many important early examples of works from the abstract-expressionist and surrealist movements. For example, in 1951, Lansford obtained Adolph Gottlieb's *Dream* from William E. Campbell, who had written *The Bad Seed* under the pseudonym of William March. In the following year, Mr. and Mrs. Isaac Heller presented the Museum with Max Ernst's *Everyone Here Speaks Latin*, which according to Byrnes had been inspired during a visit of the artist and his wife, Peggy Guggenheim, to her sister, Hazel Guggenheim McKinley, in New Orleans during 1941. During the same period, Muriel B. Francis gave the early canvas *Sleep* by William Baziotes, and her brother, Fritz Bultman, gave a two-sided panel painting by Hans Hofmann. Both Bultmans were instrumental in persuading their friend William Alexander, of New York, to donate the painting *L'Art de la conversation*, by the surrealist René Magritte.

Throughout the 1950s, Campbell continued his beneficence to the Museum. He made anonymous donations in May, 1953, of an oil, *The Crucifixion*, by Georges Rouault, and in August, 1953, of an oil, *Landscape at Cassis*, by André Derain. In a *Times-Picayune* article announcing these donations, Lansford thanked the generous benefactor without mentioning his name, since his "modesty compels anonymity." In 1954, Campbell presented Raoul Dufy's watercolor *Deauville* to the Museum and, later, a portrait by Marie Laurencin entitled *La Belle Agnes in bleu*.

Campbell was considered by many a thoroughly difficult man, and

12. New Orleans *Times-Picayune*, October 2, 1949.

not generous by nature. Feitel remembered him as a "hard-drinking, horrible person." He related the circumstances surrounding the transfer of Campbell's paintings to the Museum's collections with distaste. Campbell, who had got mad at Lansford for some reason or other, had called Feitel at his office one afternoon. "I heard a great deal of sacrilegious cursing and Mr. Campbell told me he wanted 'the damn thing out of his house,'" Feitel recalled. He had not comprehended Campbell's drunken outburst, and "asked him to explain. It was about a 'Crucifixion' by Georges Rouault. He did not believe in blood sacrifice and I could have the damn thing if I wanted. Needless to say, I went to get it as soon as possible; and I gave it to the museum." A year later, Campbell again called Feitel and told him that "he was thinning out his collection and I could have a Derain and Dufy whenever I wanted to come and get them. I immediately left the office to get my car. When I arrived at Campbell's house in the French Quarter, the two paintings were on the sidewalk leaning against the front of the building. No one was around. I called to him and he replied, 'Why the hell don't you take them?' I brought them to the museum."

Campbell "was always complaining about his high income tax and how much some of his insane relatives cost him every year." Ever patient with the eccentric and irascible donor, Feitel "persuaded him to give the paintings to the museum instead of to me and, thereby deduct from his income tax." It was with good reason that Feitel cultivated Campbell's goodwill. "I thought I had discovered a gold mine," he said, "and with my friend Kearney Livaudais I would visit him and discuss his paintings. He wanted to give me a Bombois and a Viven, but I was trying to get two of his Soutines, one of his Modiglianis and a Matisse. He said, 'Damn you, Feitel, you only want the more costly things, but I'll see.' A few weeks later he died of a heart attack and the collection was sent to New York where it was sold for the benefit of his relatives." [13]

In the early 1950s, the Museum purchased three French paintings: *Eglise Notre Dame de Royan,* by Maurice Utrillo; *Baigneuses,* by Jean Souberbie; and *Still Life with Fish,* by Maurice de Vlaminck. The first two were purchased from accumulated money in the acquisition fund; the other one was purchased with a legacy left the Museum by

13. Feitel, "Confessions," 13.

Cora Tertrou. But the most outstanding development of the collection under Lansford's administration came through the donation by the Samuel H. Kress Foundation of a priceless collection of thirty masterpieces from the Italian Renaissance. Feitel made the announcement of the stunning gift at the annual dinner of the Art Association of New Orleans on Thursday, October 16, 1952.

The negotiations with the Kress Foundation had taken place over a two-year period, and although the newspapers and public announcements styled the acquisition of the Kress paintings a gift, it was far from that in 1952. In reality the thirty Italian Renaissance paintings came to the Museum as a loan. Only if stringent guidelines were followed were the paintings eventually to become the outright property of the Museum. The loan of the paintings and their prospective gift immediately forced the Museum board to initiate a partial modernization of the Museum's facility. A letter written by Rush Kress to the Museum trustees on July 24, 1952, outlined some of the expectations of the foundation:

> We will present to the Samuel H. Kress Foundation board of trustees at a future meeting the possibility of including your museum to receive the loan collection of my brother's paintings. We are emphasizing to you the following for your thoughtful consideration and analysis to meet the requirements of the display, care and protection of the objects of art while they might be consigned to your institution. The final indenture of gift in the event we reach an agreement will not be made until 1956, by which time we will have complete experience as to future care and safety of my brother's objects of art.
>
> Your director has been (or will be) given the opportunity of making the selections of the objects of art for your consideration; there will be no newspaper or other publicity up until the time of the shipment of the paintings as all arrangements are to be made quietly with only the associates of your institution.
>
> You will submit to us later blueprints showing the width and length of the rooms, the ceiling heights with doorways and other openings clearly specified. The four wall layout will show the actual size of the layout of space provided for the paintings for each wall. No paintings are to be covered with glass.
>
> You will also please advise us as to your lighting facilities in the individual rooms; also in regard to the possibility of access into the building in which loss might occur.
>
> We have found from recent experience that local employees of museums have not adhered to our specifications and consequently we are

advising you that if our instructions are not fully and completely followed by you and all your employees (particularly trustees) that the objects of art will be recalled by our Foundation.

Our paintings will be hung flat against the wall in accordance with our own method of hanging same, with the necessary hardware with the paintings shipment, and each painting is to be securely fastened to the wall so that there will be no opportunity of a painting being removed at any time except as per our written instructions.

It is understood that no changes in the collection, hanging, etc., are to be made at any time without our written authority.

As these objects of art are irreplaceable, we must insist that a continuous average temperature of 67° and relative humidity of 47% be maintained during the 24 hours of each day they are in your possession.

You will also specify to us in writing what provisions will be made for properly guarding each room, so that at no time will there be any possibility of the paintings or their frames being touched or otherwise interfered with by visitors and by employees except for careful cleaning of dust.

In the distribution of my brother's collection of art, our purpose is fundamentally for the purpose of giving our children and grandchildren the opportunity of not only the enjoyment and study of fine, irreplaceable objects of art, but is also principally for instilling and developing a high moral and spiritual quality as a bulwark against the possible inroads of socialism and socialistic thought throughout the nation. We are not concerned about communism, for like naziism and fascism, such followers of Marxism will eventually fall by their own weight.

Until the final indenture gift is made we protect the paintings by our fine arts insurance policy. If at any time they should show any evidence of being affected by heat, lack of moisture, or other conditions you must immediately communicate with us when we will have the paintings sent back to us for our care.

This is not written with any feeling on our part that you will not cooperate with us but there have been a few recent misunderstandings and we are advising you so that the objects of art will receive the same safety, care and protection that is and has been given by the National Gallery of Art in Washington, D.C.

Let us not overlook that canvases have been cut out of frames in several instances due to the neglect and improper supervision, and lack of personal responsibility of the trustees and employees of several institutions during the past few decades.

The minutes of the meetings of the board of trustees of May 14, 1952, recorded that the cost of altering three galleries to house the Kress Collection was expected to be twelve thousand dollars. Later,

the cost of air-conditioning the entire Museum was added. The board approved the costs, referring the matter to the city. Although at first Mayor deLesseps S. Morrison expressed some doubt that the hard-pressed Appropriations Committee could provide the needed fifteen thousand dollars, within several months the committee had authorized the funds. Construction was well under way at the time of the public announcement on October 16, 1952.

The newspapers credited Lansford with the selection of the Kress paintings that were coming to New Orleans, but Arthur Feitel had been involved as well. He wrote that "in the early 50s Lansford heard that the Samuel Kress Foundation might be willing to give art collections to a number of museums. I was recovering from an operation in a Philadelphia hospital; but as soon as I was able, I hurried to New York and interviewed Mr. Guy Emerson, the director of the Foundation. He gave me a cordial reception, asked me a lot of questions and encouraged me to pursue the matter further."

Feitel continued, "Our contacts with the members of the Kress Foundation were almost continuous. Mr. and Mrs. Rush Kress were very kind, hospitable and encouraging. I shall never forget my most pleasant relations with them, and most especially our stay at their estate, Huckleberry Hill, in the Poconos Mountains of Northeast Pennsylvania." The estate was equipped with facilities for art conservation,

> where a large number of Italian restorers worked under the leadership of Mario Modestini. . . . In the basement . . . were large vaults similar to those of a bank. There were also laboratories for examining paintings: chemical, x-ray, infrared, photography, and a reference library. . . . The paintings were stored on sliding racks and there was also a large vault containing Italian Renaissance frames. These frames alone were insured for $600,000.00 and would be worth a great many times more as time went on. It was a great experience pulling out the racks to view the paintings on each rack. At the time our selections had not yet included a Crucifixion and at our request we were given the small one by Battista da Vicenza.

Then Feitel and Lansford went to the National Gallery, in Washington, D.C., where they selected additional paintings. Feitel recalled that the National Gallery had been given first option on the paintings, and that representatives from other museums were to make choices from the many remaining pieces. In the process, he and Lansford struck up a quite cordial relationship with David E. Finley and John

Walker, respectively director and chief curator of the National Gallery. Still other selections were made at the Kress apartment in New York. Feitel added, "Once while visiting the Kress Foundation offices in New York, I saw a very attractive painting by Paolo Veronese in Guy Emerson's office. *Sacra Conversazione* was so lovely that I came back in his office to look at it again before leaving. When I returned the next day to look at it and admire it, Guy said, 'Now look here, Arthur, you are not trying to take this picture off the wall of my office.' A few days later it was assigned to us."

Feitel's recollections of relations with the Kress Foundation and family are invaluable in reconstructing the history of the Kress acquisitions. He has related, for example, that as a courtesy, he attempted to make hotel reservations for Mr. and Mrs. Rush Kress in New Orleans shortly before Mardi Gras. Kress was indignant when he heard the cost of accommodations in the city during that season, and he and his wife ended up not making the trip. Instead, he donated the cost of the hotel suite to the Red Cross. But Feitel added that "on Mardi Gras Day, Rush Kress was at the Foundation office in New York. He saw a painting on the wall that reminded him of Mardi Gras. He immediately had the painting, *The Minuet*, from the studio of Giovanni Battista Tiepolo, sent to us." [14]

The announcements of the Kress Foundation's "gift" and of the partial refurbishing of the Museum facility in order to receive it were met with surprisingly mild enthusiasm in the local press. Only the *Times-Picayune* wrote an editorial on the subject, praising the donation in one brief line as "grade A art news for New Orleans." The remainder of the editorial concerned itself with the Museum's need for expansion—"either a downtown (Vieux Carre) branch or a museum annex." [15]

In February, 1953, an exhibit of northern European masters was presented in New Orleans. The show was also seen in Birmingham, Atlanta, and Chattanooga, at the museums that had received, or hoped to receive, a collection of Italian paintings from the Kress Foundation. One of the purposes of the show was to stimulate local interest in the acquisition of works that would supplement those of the Italian school. The exhibit included works by Jan Brueghel, Lucas Cranach, Marcus Gheeraerts, Jan Gossaert, Jacob Ruisdael, and Anthon Van Dyke. No one in New Orleans purchased any of these old

14. *Ibid.*, 10–12.
15. New Orleans *Times-Picayune*, October 18, 1952.

masters, but the show influenced Arthur MacArthur to give the Museum his oil *St. John the Baptist Preaching in the Wilderness* in memory of his aunt, Agnes Leonard MacArthur Parsons. Lansford attributed the painting to the Flemish painter Martin de Vos, but it is now considered a joint work by Denis van Alsloot and Hendrick de Clerck.

Finally, the day of the dedication of the Kress Foundation largess arrived, and the newspapers devoted innumerable columns to it. On Friday, April 24, 1953, the Museum and the Chamber of Commerce cosponsored a luncheon in the Grand Ballroom of the Roosevelt Hotel in recognition of the generous gift of the Samuel H. Kress Foundation to the people of New Orleans. Honored guests were Rush Kress, the brother of Samuel H. Kress; Mrs. Kress; Guy Emerson, of the board of the foundation; and Finley, the director of the National Gallery. Mayor Morrison presented the guests with plaques of honorary citizenship and keys to the city. Then Feitel, speaking on behalf of Governor Robert F. Kennon, presented Kress with a colonel's commission on the governor's staff. Finley gave the keynote address, remarking that "in making great works of art available to a tired and confused world, Mr. Kress and his brother and the Kress Foundation are doing something of greater value than any of us can realize at this time." [16] The luncheon was a great success, but only because of the last-minute efforts of Feitel and others. He wrote that "on Monday, a few days before the luncheon, only 35 people had made reservations. I frantically organized a committee to telephone and contact people as we could not possibly greet the philanthropists in the Grand Ball Room of the Roosevelt with only 35 people. The City Park Commission and other organizations cooperated. I donated the cost of a table of eight for some of my artist friends and on Friday we had over 250 people." Feitel commented, "The evening ceremony was very pleasant, with few speeches, a colorful Negro band and refreshments. In my years at Delgado this was the first and only time that we had ever seen Mayor Morrison at the Museum. Mr. and Mrs. Kress were so delighted with the well planned ceremonies that they would often speak of it years later." [17] *Time* magazine wrote,

> In Manhattan, Collector Kress and the officers of his Kress Foundation could take pleasure in the fact that the first showing of their gift was New Orleans' biggest art event in 40 years. The museum has rebuilt three of its galleries, put in new lights, air-conditioned the entire build-

16. *Ibid.*, April 25, 1953.
17. Feitel, "Confessions," 12.

ing in anticipation. New Orleans citizens got reproductions of the new treasures on buses, in their gas and electric bills, and the museum expects to double its number of visitors next year. Said Alonzo Lansford, director, "It was a heady experience . . . to be able to point to masterpieces and say, 'I'll take that one and that one.'"[18]

Although outwardly everything went smoothly, there was still much to be accomplished before the Italian Renaissance paintings belonged to the people of New Orleans. The Museum was still on trial; so, too, was the city. Emerson put it bluntly, in an interview with the New Orleans *Item* of April 24, 1953, when he said, "The Kress officials hope the museum here will now undergo a sound period of growth." He explained the purposes of the foundation's gifts:

> For many years most of the great works of art in the United States have been concentrated in the museums of a few large cities. If you wanted to see paintings you had to go to the cities.
>
> But in Italy, where some of the greatest works were produced, fine paintings can be seen in almost every town. They are not all gathered in Florence, Venice, or Rome. There are fifty cities or more in Italy where the native or the traveler can see examples of the greatest and the best.
>
> That is the ideal we now have for the United States and New Orleans is part of our program.
>
> We are very hopeful that this gift to the Delgado Museum will inspire other people of wealth and taste to add to this nucleus.
>
> What a truly noble and novel concept to share with lesser museums around the country the masterpieces assembled by a great collector— objects far beyond the finances of the smaller institution, indeed in this manner of giving throughout the nation many millions would come to benefit and not just one institution in a city where many could not travel to see such works of art.

Others have perceived not only artistic motives behind the Kress gifts. They have conjectured that the Kress brothers wished to apply to art the same technique that made them their fortune in chain stores. Certain paintings that the National Gallery of Art returned to the foundation when it replaced them with more expensive or finer examples were to be donated

> to other less fortunate museums all across the country. Over a score of such lucky places (Seattle, Portland, Raleigh, Houston, Columbia, Atlanta, Birmingham, Memphis, Denver, Miami, Tulsa, Allentown and others) boast Kress rooms, glowing with European art from 1300 to 1800

18. *Time*, April 27, 1953, p. 90.

with a strong emphasis on Italian early Renaissance. Southern museums have been particularly favored, notably the state museum in Raleigh, North Carolina—a reminder of the Kress Brothers' early success with their stores throughout the South. In place of five-, ten-, and twenty-five-cent stores we now have five-, ten-, and twenty-five-thousand-dollar pictures, and the same happy principle has been applied to repay communities for their commercial support. [19]

Today, few would fail to appreciate the magnitude and quality of the Kress Foundation's donation to many of the nation's museums, both great and small. Finley has commented, "I think one is justified in saying that never before in the history of the world have such imagination and generosity been shown in bringing great art to the people of an entire country, continental in extent. In looking back over what has been accomplished in these few years by Samuel H. Kress and his brother, Rush H. Kress, and the trustees and staff of the Kress Foundation, their achievement seems almost incredible when one takes into consideration the difficulties of acquiring great works of art under present conditions." [20]

Having received the paintings, the Museum was on trial to determine whether what had been proffered would remain in New Orleans. A period of sound growth had to be achieved. Perhaps the real significance of the Samuel H. Kress Collection lay in the challenge it posed to the Delgado to improve and grow, to catch up with the greatness that had come so recently to its halls. The beloved local columnist Pie Dufour was one of the few to comment on this implicit challenge after the celebratory luncheon on April 24, 1953:

And at the luncheon, Mr. Finley, said his "mouthful," as follows:

"The American people, with their unerring instinct for what they need and want, have already come to the conclusion that they need the museum. Furthermore, they know what the museum means, in both tangible and intangible values, to their community. For in this country today we judge a city not only by the size of the population, the development of its transportation facilities, the extent of its banking resources, the volume of its commerce and its industry, but also by [the] excellence of its schools and universities, its museums, its symphony orchestras, and other evidences of a cultural life that differentiates it from its neighbors."

Mr. Finley's theme is one which I have sung on many occasions in this space. The greatness of New Orleans is not going to be measured exclu-

19. Burt, *Palaces for the People*, 263.
20. David E. Finley, *A Standard of Excellence* (Washington, D.C., 1973), 91.

sively in terms of our material progress. To be genuinely great we must keep pace culturally with our physical growth.

Are we doing it?

Mr. Finley very kindly suggested that we are: "And so, in this great city of New Orleans, with its long tradition of civilized living, we can be sure that cultural activities will be given a place commensurate with their importance and will become, as they should be, part of the everyday life of the people who comprise this community."

Can we—those of us who live and love New Orleans—be as sure as Mr. Finley that "cultural activities will be given a place commensurate with their importance"?

I for one won't until the city government at least doubles the present absurd Delgado Museum budget of $34,000 a year. . . .

The presentation of the Kress Collection to the people of New Orleans is a real challenge to the City Fathers. This "big league" gift has lifted the museum out of the "bush leagues" for which the Kress Foundation, Arthur Feitel and Alonzo Lansford are to be thanked.

Now that we have received this gift what are we going to do about it?

Giving a key to the city to Mr. Kress is very nice. Having Governor Kennon create him Colonel Kress is very nice too. Saying fine words of appreciation is also very nice.

But what is New Orleans really going to do about it? Is it going to sit back, allowing that institution to continue to operate on starvation income, and hope some other benefactor like the Kress Foundation will come along with another fabulous gift?

What we did not do—and I mean the Delgado board and the city officials—during the past forty years has robbed this generation of a great art museum. For the past forty years we prated a lot about our culture and our traditions but did not do much to show that we had or respected either. Otherwise the Delgado Museum would not have been the "bush league" institution it was until the Kress paintings were put up on its walls this week. . . .

And now we have the Kress Collection. In itself it is a wonderful thing—a wonderful asset. Its greatest value, however, could be that it awakens the City Fathers to the necessity of beginning right now to create a great museum for the people of 1975 and after. [21]

Although there was much to be done to live up to the standard set by the Kress Foundation, a great deal had already been accomplished by Lansford and Feitel. Indeed, their accomplishments seemed herculean, compared with those of the previous forty years since the opening exhibition. In less than six years they had added new depth to the collection through purchases, gifts, and loans of modern

21. New Orleans *States,* April 25, 1953.

French masters, of abstract expressionists, of surrealists, of nine-teenth-century American and Louisiana artists, and of early Italian masters of the Renaissance. By reconstructing the juried annuals, Lansford and Feitel had broadened the base of the competition, encouraging more contemporary artists to participate. They had overseen the renovation and air-conditioning of the Museum. They had cultivated new benefactors and had inspired persons to become involved in the Museum who had never done so before. They had obtained a one-sixth increase in the Museum's budget—not much, by others' standards, but for New Orleans a significant increase. The teamwork of Feitel and Lansford had proved highly successful, and as Pie Dufour saw, greater success could yet be won. In the next years, the resolute efforts to modernize, enlarge, and improve the Museum would continue.

VIII

Strides Forward

Alonzo Lansford had achieved the successes of the first year of his directorship through his engaging personality, boundless enthusiasm, and professional ability. These strengths he exercised on all he met, for the benefit of the Museum. The board of administrators gave him its full support—particularly its president, Arthur Feitel, who recalled that Lansford "was intelligent, likeable and experienced in the museum field."[1] Feitel introduced Lansford to his many contacts and, together, they influenced them in behalf of the Museum. Lansford also sought out many persons nearer his own age and brought them, for the first time, into Museum activities and projects. Much that was accomplished resulted from personal contacts.

The Museum had almost no organizational structure. There was no group of "Friends of the Delgado" to offer support through membership dues. The Art Association of New Orleans seldom had funds to support the purchase of works of art except those produced by its own membership. There was no advisory council of citizens who could aid the trustees in their activities. There was, however, a very enthusiastic press, represented in particular by the reporter and critic Alberta Collier. The Museum received more coverage than a full-time press agent could have brought it. Pie Dufour, Marie Louise Ferguson, Thomas Griffin, and Burdette Westfeldt wrote hundreds of thousands of lines of copy telling of Museum events and activities, criticizing shows, announcing gifts and loans, and editorializing on the growth and development of the Museum. Indeed, the press was the Museum's most organized ally in presenting its needs to the people, the politicians, and the philanthropists. But a willing press

1. Feitel, "Confessions," 10.

was not the only friend the Delgado would need for achieving new growth.

Rush Kress's letter of July 24, 1952, made it altogether clear to Lansford and the Museum trustees that certain improvements had to be made in the Museum's physical plant before the Samuel H. Kress Collection could become a permanent gift. Lansford enthusiastically interpreted this condition as a mandate to expand the Museum by adding a new wing. In the face of the mayor's refusal on September 29, 1952, to aid with even minimal renovations, Lansford announced a $1.5-million campaign to increase the Museum's exhibition space. "The building is bursting at the seams," he declared. "It has been necessary to put in temporary storage many of our fine exhibits because of the 28th annual autumn exhibition sponsored by the Art Association of New Orleans."[2] The very next day, however, the newspaper carried a retraction: "Delgado Museum 'most heartily welcomes' contributions for prizes, operating expenses, additions to the collection or for additions to the building but 'present plans for improvement do not include a campaign to raise money for a wing,' said Director Alonzo Lansford." Lansford concluded the interview with the statement that "remarks to that effect yesterday were erroneously construed to mean that the museum plans to campaign to raise $1,500,000, the estimated cost of building a wing, which the museum badly needs."[3]

The organization required to mount a fund-raising campaign of that magnitude simply did not exist. The Museum's board of administrators was too small and its membership too old. They had become too dependent on the city's largess. Rather than expand the facility, the board determined simply to refurbish it to meet the Kress guidelines. They could think about museum expansion later, if that was necessary.

At the time of the opening of the Kress Collection, it was painfully apparent that officials of the Kress Foundation expected more of the Museum than a renovation of one gallery into three. The program of distributing the foundation's paintings to museums throughout the country was compared by Rush Kress to spreading seed corn in fallow fields.[4] Feitel recalled that "the Kress Foundation made gifts with the idea of encouraging the people of the city to also do some-

2. New Orleans *Item*, September 29, 1952.
3. *Ibid.*, September 30, 1952.
4. *Ibid.*, April 24, 1953.

thing for their museum." Feitel also confided that when he and Lansford were visiting Kress at his country home, they were assured of "his love for New Orleans," and they "were led to believe that he would recommend that we would get more than other cities."[5] Challenged by such magnanimity, Lansford and Feitel endeavored to increase the Museum's size as well as the quality of its programs.

Two weeks after the opening, Lansford wrote a lengthy letter to the editor of the New Orleans *Item,* explaining the Museum's needs. Arguing that one new wing was not all that was needed, he wrote, "Before Delgado can further expand its programs or its collections, it first must extend its building facilities and the staff to maintain and operate it, and to properly integrate its functions." He outlined the need for three new wings, which could be built on land adjacent to the present building. "Of particularly critical need," he wrote, "is a Children's Wing, with classroom facilities for the overcrowded art classes, and facilities for a flexible Junior Museum." He invited those "interested in our community's cultural welfare, to join the Art Association, through which they can best promote the kind of art and the kind of programs in which they are most interested."[6]

Five days later, at the monthly meeting of the Museum's board of administrators, Feitel reiterated Lansford's proposals, suggesting that the three new wings be built as time permitted at a cost of $500,000 each. "The first proposed wing," he said, "would house visiting exhibitions, children's classrooms and a temporary auditorium." As to funding, Feitel remarked, "Measures for a concentrated drive are being studied."[7]

No drive was organized in 1953, and the press made no further mention of the Museum's planned expansion until July, 1954. During the year's interval, the board had agreed to a $1,425,000 expansion of the physical plant and then had simply added that amount to its budget request to the city. The board had made no attempt to organize a fund-raising campaign.

Meanwhile, Feitel was busy drafting architectural plans for the ex-

5. Feitel, "Confessions," 13. The Brooks Gallery in Memphis, Tennessee, almost lost the Kress paintings because its park commission delayed in making a decision on an addition to the museum. In the Memphis *Commercial Appeal* of July 4, 1953, the Delgado's accommodation of the Kress Foundation proposals was held up as an example of New Orleans' pride in cultural matters. The citizens of Memphis were warned to remember the Delgado's example. The newspaper in that way attempted to get the park commission to make a decision about housing the Kress gift proposed for Memphis.

6. New Orleans *Item,* May 8, 1953.

7. *Ibid.,* May 12, 1953.

pansion. Ms. Collier reported that by July 11, 1954, Feitel had "carefully designed his own blueprints to show where every brick and closet would go." There were to be two one-story wings joined to the right and left of the main building. A two-story wing would rise at the rear of the old building. The wing on the right, as one faced the building, would consist of a four-hundred-seat auditorium, a print gallery, staff offices, and a board meeting room. The wing on the left would hold three large galleries, and the outside wall would be of plate glass to allow the display of works of art to visitors walking or driving through the park. The wing at the rear of the Delgado building would house the children's museum, several small galleries, two studios, a library, and a sculpture court. The entire plan was designed so that the wings could be built either at the same time or separately, depending on the Museum's resources.

The reporter observed that the expansion could be accomplished either through a public bond issue or by gifts. She wrote, "Your $5 might buy a few bricks, a neighbor's $50 might add a window or the rich man's donation might build a whole wing."[8] Shortly thereafter the *Times-Picayune* ran an editorial praising Feitel's plans and supporting the attempt to enlarge the Museum. Feitel refused to take all the credit, however, writing a letter to the editor on July 16, 1954, in which he said, "The plan shown was not mine but was a collaborative effort of our director, Alonzo Lansford, our architect board member, Julius Dreyfous, and the writer."[9]

In spite of Feitel's inaction with regard to implementing a fund-raising campaign, this flurry of attention in the press generated wider backing for the expansion. The sculptor Lindsay Daen, in an open letter to the editor of the *Times-Picayune*, called for a drive to raise the necessary funds, and he called the project "vitally important to the growth of New Orleans nationally and internationally."[10] Daen underlined his commitment by making his own contribution, the first gift in the expansion-fund drive. That was soon followed by an anonymous donation, made on August 1, 1954. Ms. Collier wrote enthusiastically, "These donations are two stones of a foundation that could grow so quickly if the many who love art would turn a hand to the project."[11]

8. New Orleans *Times-Picayune States,* July 11, 1954.
9. New Orleans *Times-Picayune,* July 16, 1954.
10. *Ibid.,* July 27, 1954.
11. *Ibid.,* August 1, 1954.

The two modest gifts did not go far toward the required $1,425,000, but they made a hopeful beginning. The board of administrators, however, still did nothing to promote a voluntary campaign. The board, the director, and the members of the Art Association of New Orleans all waited as if for a miracle. And they were more than a little reinforced in their passivity by the city Planning Commission's recommendation in October, 1954, that $540,000 be placed in the 1958–1959 municipal budget for additions to the Museum.

In November, Feitel attempted to enlist the support of the Art Association by making a plea at the annual members' dinner. He clumsily spoiled the opportunity, however, by repeating a joke about the number of parties held by the Association and the amount of sherry consumed.[12] His tactlessness won him few adherents, nor were any donations forthcoming. Months would elapse before the newspapers again mentioned a fund drive for Museum expansion.

In July, 1955, Feitel, confident as a result of the funding that the Planning Commission had approved, requested an additional $812,000 for the new wings in the 1959–1960 city budget. He called the request urgent, "not only because the museum cannot adequately take care of its permanent collection, but because it is in line to receive several large and important collections when and if it can house them. Foremost among these is an additional grant from the Kress Foundation."[13] Feitel, using the same strategy that Ellsworth Woodward had employed in 1930, hoped to pressure the city councilmen into giving the Museum the additional money.[14]

But in September, the Planning Commission "did a double flip."[15] It shelved, indefinitely, its previous recommendation earmarking $540,000 in the 1958–1959 budget, and it recommended that only $252,000 be designated for Museum expansion in the 1959–1960 budget. It offered no explanation. The press called for a reconsideration of the Planning Commission's decision. At the time of Samuel H. Kress's death, the Times-Picayune editorialized that "culturally the Kress grants have deeply affected the communities to which they have been donated. Physically, they have stimulated construction of one entirely new museum and eight new wings. Unfortunately this city has

12. New Orleans States, November 11, 1954.
13. New Orleans Times-Picayune, July 17, 1955.
14. See Chapter V.
15. New Orleans Times-Picayune, September 18, 1955.

not yet met the challenge for increasing the facilities of the Delgado despite the likelihood that the Kress Foundation would consider a considerable increase in its grants if New Orleans would provide the space."[16]

Stunned by the seemingly arbitrary action of the Planning Commission, Feitel and the board issued a formal announcement of a fund drive for Museum expansion. The goal was set at $575,000, and Bernard Manheim made the first contribution. The newspapers photographed him depositing his check in a large Sèvres vase that had been placed in the Great Hall of the Museum to receive financial gifts from the public. Despite the publicity, the drive was nearly a total failure, and nothing further was heard from Lansford or Feitel during 1956.

The truth was that the trustees simply lacked the organization, energy, and dedication to mount a fund-raising campaign. They expected the city government to pay for everything. Too few of the board members were truly interested in art; most merely sat as appointees of the board of City Park. Moreover, Lansford's responsibilities as director were too numerous to let him organize and run the fund drive.

In 1953, at the time of the opening of the Kress Collection, Lansford was also busy with plans for the Museum's first major international exhibition, a show of French art in commemoration of the sesquicentennial of the Louisiana Purchase. E. V. Richards, Jr., general chairman of the Louisiana Sesquicentennial Commission, explained to the Young Men's Business Club, "We're after $5,000,000 worth of art of the 1803 period from the Louvre and this would be exclusively a French exhibit in the Delgado museum shown to the public free of charge."[17] The show was to open in October, 1953, when celebrations throughout the state were to be in progress. Governor Robert F. Kennon announced the names of the members of the Sesquicentennial Commission: R. T. Andress, of Shreveport; Harry W. Gilbert, of Wisner; Thomas Jordan, of New Orleans; Randolph A. LeBlanc, of Franklin; Thurston B. Martin, of New Orleans; Dr. John M. Mosley, of New Roads; James A. Noe, of Monroe; and S. W. Planche, Jr., of Lake Charles. Only one of these men had any connection with the Museum, and that was Jordan, a noted collector of Americana, who had resigned from the board of administrators several years earlier.

16. *Ibid.*, September 23, 1955.
17. *Ibid.*, January 29, 1953.

Soon after the announcement, in February, 1953, of the sesquicentennial show of French art, the Junior League of New Orleans opened a two-month exhibit at the Museum focusing on life at the time of the Louisiana Purchase. It was intended primarily as an educational exhibit for children. For years the Junior League had conducted not only the Museum's docent program but also the entire educational exhibition program. For this purpose it had its own gallery in the Museum, where it was expected to present five shows a year. For the previous six years, however, it had mounted only two shows each year. One of the most popular paintings in the Junior League's sesquicentennial exhibit was a portrait of Thomas Jefferson by Rembrandt Peale, son of the famous artist Charles Willson Peale. The portrait had been done in the newly built White House in January, 1805, when Jefferson was sixty-five years old.

By August, the conception of the sesquicentennial exhibit of French works had changed from what Richards had announced. The show was now conceived to encompass French masterpieces from five centuries, the fifteenth through the nineteenth. Georges Wildenstein, the multimillionaire art dealer, who owned galleries worldwide, had been persuaded to help organize the show. He assisted in negotiations with the French government, and he broadened the scope of the exhibition. It was to be the "first great retrospective exhibition of French Painting presented in this land."[18] Indeed, it was the United States' first major loan show of paintings from French museums. Lansford summed up the excitement accurately when he said, "Art circles the world over are buzzing about the Louisiana Purchase Sesquicentennial art exhibit."[19]

In preparation, Lansford had the Museum galleries redecorated. With the exception of the Kress, Hyams, and Whitney galleries, which had just been redone for the opening of the Kress Collection, all the exhibition rooms and the central hall were repainted. That summer, Lansford also cleaned and revarnished all the paintings in the Hyams Collection. At that time too, he ordered all the glass removed from the Hyams paintings, that had covered them since 1910.

Robert J. Newman, a businessman and financier with overseas connections, was sent to Paris in August to make the final arrangements and to complete the selection of the French works. A notable collector

18. Isaac Delgado Museum of Art, *Masterpieces of French Painting Through Five Centuries* (1953), 9.
19. New Orleans *Item*, August 30, 1953.

himself, Newman completed his task in a few weeks and cabled the list of borrowed works to Lansford. Among them were Nicolas Poussin's *Eleazer and Rebecca,* Claude Lorrain's *View of a Seaport,* François Boucher's *Aurora and Cephalus* and *Sylvia Fleeing from the Wolf,* Jean Baptiste Greuze's *The Milkmaid,* Jacques Louis David's *Portrait of Antoine Mongez and Madame Mongez,* Jean Auguste Ingres' *Portrait of the Duc d'Orleans,* Eugène Delacroix' *Greece Dying on the Ruins of Missolonghi,* and Jean Marc Nattier's *Portrait of Madame de Pompadour.* The French museums that lent the twenty-odd works were the Louvre and the museums of Bordeaux, Compiègne, Grenoble, Nancy, Tours, and Versailles. Valued at over a million dollars, the French works were accompanied in transit by Michel Florisoone, curator of paintings at the Louvre. Newman, emphasizing the paintings' significance, told reporters, "These are from the galleries of the museums. They were taken off the walls. This is no collection from the basement."[20]

The national media, including *Time* magazine, *Art Digest,* and the New York *Times* featured articles about the great French loan. But the borrowed paintings were too few for the intended show. Consequently, Wildenstein instructed Vladimir Visson, director of the Wildenstein Gallery of New York, to organize a loan to the Delgado of sixty-one major French works owned by American collectors, galleries, and museums. It was Visson's job to scour the country and cajole owners into cooperation. He was very successful and obtained many outstanding loans: Francois Clouet's *Portrait of Cosme de Pascarengis,* Georges de La Tour's *The Young Smoker,* Antoine Watteau's *Halt of an Army,* Jean Baptiste Oudry's *Dog and Swan,* Jean Honoré Fragonard's *Les Délices maternelles,* Elisabeth Vigée-Lebrun's *Portrait of Marie Antoinette,* Claude Monet's *The Jetty at Le Havre,* Edgar Degas' *Portrait of a Man, Mlle Fiocre dans le ballet de La Source, Study for The Cotton Merchants—New Orleans,* and *Dressing for the Dance,* Vincent van Gogh's *Entrance to the Public Garden in Arles,* Toulouse-Lautrec's *Portrait of M. Henri Nocq,* and Paul Gauguin's *The Sulking Women.* It was an admirable array of French art, and Lansford was overwhelmed by the generosity of the lenders. "This exhibition is bigger and better than we deserve," he confessed. "It has set an extremely high standard."[21]

Other art exhibits of importance were opened in the city during the

20. *Ibid.,* October 2, 1953.
21. *Time,* November 16, 1953.

period of October 13–18, 1953, the week finally established for the sesquicentennial celebration. Ambassadors and ministers from thirty countries were present at the festivities. President Dwight D. Eisenhower arrived on Saturday, October 17, to officiate at the events of the day. Newcomb College sponsored the show Goya and Spanish Engraving, which the Spanish ambassador, José Felix de Yequerica, opened on Friday, October 16. The Louisiana State Museum displayed a collection, on loan from the French Museum of National History, of documents, maps, and watercolors relating to the French colonial period. But the opening of the French art exhibition at the Museum was by far the most popular event. For days the press had stirred up interest, with articles describing the collection as everything from valuing "25 million" to being "priceless."[22] Requests to see the exhibit were so numerous that Lansford had to explain publicly that "the French government would not allow part of the show to open before the entire exhibit is opened officially by Ambassador Henri Bonnet." He added, "Attendance at the official opening will be by invitation only as some 40 ambassadors, staff members, and other dignitaries will be on hand for the ceremonies."[23]

Opening the exhibit, Feitel acknowledged the Museum's gratitude to Ambassador Bonnet and all of France for the loan of the magnificent paintings. He said,

> The dazzling splendor of the many works on display here today is part of an unfulfilled dream which will become a reality only when the Delgado Museum has an entire wing devoted to an exhibition of art of France, the mother country of Louisiana. . . . Nowhere has the genius of the French people shown itself to a greater degree than in the domain of artistic achievement. . . . This exhibition, the greatest exhibition of French painting ever held here, could not have taken place except for the active support and influence of you and your colleagues in America and France.[24]

Bonnet, after thanking Feitel for his opening remarks, proceeded to award Lansford the Palmes d'Officier d'Académie Française "in recognition of many services and many merits." Afterward, the ambassador snipped the ribbon that had been stretched across the marble staircase leading to the Museum's second-floor galleries, where the exhibition was on display. One newspaper reporter wrote that once

22. New Orleans *Time-Picayune*, October 4, 1953.
23. *Ibid*.
24. New Orleans *States*, October 18, 1953.

the ribbon had been cut, there was a "surging forward of the crowd which rolled up the stairs like a tide and engulfed the principals."[25]

On the first day that the exhibit was open to the public, three thousand visitors saw the French paintings. The show broke all attendance records at the Museum. In the two-month period between October 17 and December 17, a total of 33,587 people came to the exhibit. The persons who had visited the Museum during the same period in 1949, 1950, 1951, and 1952 totaled 8,896. To the disappointment of many, the exhibit had to close almost two weeks ahead of what was originally planned, for the Wildenstein Gallery wished to exhibit it as a benefit prior to the return of the paintings. By closing day on January 3, 1954, over fifty thousand viewers had seen the show. It is hardly surprising that 1953, the year of both the opening of the Kress Collection and the sesquicentennial exhibit, established an attendance record of 104,000.

The two most popular pictures in the exhibit were *The Cotton Exchange*, by Degas, and *Planter's Family in Louisiana*, by Marguerite Gerard. The latter was so admired that Lansford persuaded the gallery that had lent it, anonymously, to extend its visit. Museum officials let it be spread in the newspaper that they felt "the picture belongs in New Orleans" and that they hoped "to find some angel who will help them acquire it permanently."[26] No angel appeared.

Decidedly unpopular were the single van Gogh, *Entrance to the Public Garden at Arles,* and the other four works of Degas. Degas' *Cotton Exchange* drew favor because of the local interest, but the remaining paintings by this artist were panned. One columnist wrote, "It was heartening to hear the opinion confirmed by other voices as we shuddered by [the paintings]. And outside the museum, we stopped a stranger and asked her what she liked best in the whole show. 'I don't know,' was her musing answer, 'but I sure know what I hated most. It was the van Gogh, and after that, the Degases. How can they call that art?'"[27]

Other museums such as the National Gallery of Art, in Washington, D.C., and the City Art Museum, in St. Louis, tried to persuade the French government to let them have the show, but to no avail. When the paintings were dismantled and packed into their crates, they were sent to Wildenstein's in New York City for the benefit scheduled for

25. *Ibid.*
26. *Ibid.*
27. *Ibid.*, January 5, 1954.

January 10. But the French loans did not arrive there by the tenth. The sixty-one American paintings, which had been shipped by truck, were delivered to the gallery on time, but the priceless French collection had disappeared. On January 2, 1954, Hélène Adhémar, a representative of the Louvre, had flown to New Orleans to supervise the packing and crating of the paintings lent by France. Those operations had been accomplished on January 4 and 5. On January 6, Railway Express had dispatched the twenty-one paintings by way of the Illinois Central Railroad through St. Louis to New York, insuring them, on the orders of the French government, "as ordinary freight with a maximum valuation of $10,000."[28] Then Madame Adhémar flew to New York to await the arrival of the paintings on January 9, but they did not come. Cables flew back and forth between New York and New Orleans, but it was several days before the paintings were located. They were discovered inside a boxcar on a siding, where the railroad cars had been switched to weather a storm. To everyone's relief, the paintings had not been stolen or damaged while they were sidetracked. Because they did not carry a priority clearance, they had been treated like any other cargo. The whole episode jangled the nerves of Museum officials, although the full responsibility for shipping lay with Madame Adhémar.

The description of the sesquicentennial events gives merely a partial idea of how busy Lansford was in 1953. Not only did he have to oversee many of the details of the exhibits that year and undertake the redecoration of the galleries and the rejuvenation of the twenty-nine paintings in the Hyams Collection, he also had to court lenders and donors of art works, pursue prospective benefactors, and attend board meetings. He wrote guidelines for docent training, made speeches at meetings, and lectured at art seminars. At the same time, he was expected to be present at the Museum, as much as possible, in case an important visitor called. In addition, as the Museum's registrar, he was, in his spare hours, to catalog the Museum's collection. Besides answering his own correspondence, he was expected to write articles for art magazines and to authenticate works of art. Indeed, he acted as the equivalent of a full staff at any other major museum. To have expected Lansford to do all this was outrageous; to have expected him to do more would have been absurd. It is little wonder that he could not consider giving time to fund raising for expansion of the Museum.

28. New Orleans *Times-Picayune*, January 13, 1954.

The next years brought little respite for Lansford. In 1955, he introduced the Museum's first news bulletin, as well as a series of concerts at the Museum by the Symphony String Quartet of the New Orleans Philharmonic Symphony Society. A Museum first that year was a one-man show by an African-American. That show consisted of a large retrospective of paintings by Clementine Hunter, of the Cane River area near Natchitoches. In addition to her exhibit, and the many others during the normal course of the Museum year, there was another major international show, Vincent van Gogh, 1853–1890.

What Lansford called "undoubtedly the finest van Gogh show ever to come to the South" consisted of thirty-two paintings and five drawings.[29] Part of the legacy van Gogh had left to his brother, the works were lent by the artist's nephew and namesake, Vincent W. van Gogh. Originally they had been in a larger show mounted in observance of the hundredth anniversary of the painter's birth. Vincent W. van Gogh then exhibited the paintings in Curaçao, where he had business interests. To defray the costs of shipping and insurance, he offered them as well to Miami and Palm Beach. New Orleans was the last city on the tour of these fine paintings, which covered the artist's entire career, but with emphasis on the popular Arles period. Among the works shown at the Museum were the famous *Self-Portrait with Straw Hat, The Douane, Vincent's Bedroom,* and *The Potato Eaters.*

The show was unusually expensive for the Museum and the Art Association of New Orleans. Insurance evaluations on the paintings went over $1.5 million. Transportation arrangements were costly. The nephew insisted that the work be shipped by air, taking up four passenger spaces inside a sky-lounge compartment. The artist, who during his lifetime could ill afford the cost of a third-class railway ticket, would surely have wondered at the expensive arrangements. Because of the high costs, the admission fee for the show was fifty cents per person, or twenty-five cents per person in groups of twelve or more. In addition, the sale of catalogs and postcards helped defray the costs. The exhibit ran from March 27 through April 25, 1955.

The opening was almost endangered. On Tuesday, March 22, the paintings were secured on Eastern Air Lines at Miami, accompanied by Ann Atkinson, assistant director of the Lowe Gallery. The plane took off on time, but it was delayed by severe head winds. Scheduled to land at 10:29 P.M., it did not arrive in New Orleans that night. For several hours, Lansford feared that there had been a crackup. Finally,

29. *Ibid.*, March 20, 1955.

at 4:30 A.M., all the paintings arrived safely. Lansford, "who had risen at 6:00 A.M. the morning before didn't get to bed until 8:00 A.M., 26 hours later, physically and mentally exhausted."[30]

The monthlong exhibit was a success, despite the admission fee. Ms. Collier, the newspaper columnist, praised Lansford and Feitel for daring to sponsor the exhibit despite the costs. A total of 10,598 New Orleanians gazed upon the Dutch master's paintings, making this exhibit the "most popular show in museum history."[31] Over $1,307 worth of catalogs, at fifty cents each, and over $1,195 worth of postcards and prints were sold.

Writing about this exhibit, Feitel recalled that van Gogh's "famous first great painting, *The Potato Eaters,* was damaged. It seems that a few blisters had formed in the lower left-hand corner of the picture, probably due to heat. Bus loads of school children were allowed to visit the exhibition without being properly supervised. Undoubtedly some child's curiosity was awakened and he pressed against one of the blisters and the particles fell to the floor." Feitel related that, upon being notified by the building custodian of the particles on the floor, he rushed to the Museum and shut the room containing the painting from public view. "We carefully gathered up the particles and placed them in a sealed envelope. Our director was told about the damage, but he failed to promptly notify van Gogh's nephew in Holland."[32] One can only assume that Lansford, a restorer, simply took matters into his own hands, for the matter received no further mention.

In April, 1955, a hullabaloo occurred between the Delgado and the state museum, the Cabildo, over the possession of a large, seventeenth-century canvas by Pierre Mignard depicting Anne of Austria holding a portrait of her son, King Louis XIV. The painting had hung for years in the mayor's parlor at City Hall (today Gallier Hall). But now the city property management director, Victor L. Wogan, Jr., discovered it in a storage room of City Hall. Appalled by its state, Wogan removed the portrait for cleaning, reframing, and appraisal. It was then valued at seventy-five thousand dollars. Apparently the painting had been lent by the mayor to the Cabildo for its sesquicentennial exhibit in 1953; when it was returned, it was relegated to the basement storage. Because of the neglect, Wogan recommended to Mayor Morrison that it be placed on indefinite loan to the Delgado Museum.

30. New Orleans *Item,* March 28, 1955.
31. New Orleans *States,* August 28, 1955.
32. Feitel, "Confessions," 6.

"The place for a valuable work of art like that is in the art museum and not City Hall," Wogan said. "Besides, when we move to the new City Hall now under construction there will be no place to hang it where it will show to advantage, since the ceilings there will be much lower than those in the present City Hall." This story was front-page news in New Orleans. Lansford cautiously accepted the painting "as of now. I know the quality of the painting as a work of art. It has little historical value and the place for it is an art museum. That is what I would recommend."[33] He further pointed out that the painting had come to the city "as a windfall a number of years ago" through the will of a former New Orleanian.

The following day, the *Times-Picayune* headlined an article, "Museums Argue over Art Relic." J. Ray Samuel, secretary of the board of trustees of the Louisiana State Museum and an amateur local historian, wanted the painting turned over to the Cabildo. He commented, "It is the only fine picture of the man for whom Louisiana was named . . . and it most definitely belongs in the Cabildo which was associated with early French Colonial days." Samuel stated further that upon Mayor Morrison's return to the city, he would ask for the painting. "Samuel disagreed with Lansford's assertion that Delgado is better equipped physically, as far as preservation of such works is concerned. He said: 'We are well equipped to handle rare works because of a new air conditioning and humidity-control system in our display rooms, and the best proof of it is that some of the nation's leading museums are showing a willingness to trust us with loans of valuable art.'"[34]

On May 3, 1955, the conflict was finally settled. The solution to the problem was revealed in an administrative directive to Wogan from David R. McGuire, Jr., the chief administrative officer of the city. The memorandum, as released to the newspapers, read,

> Let me commend you, a true lover of art and culture, on the rediscovery of Anne of Austria and on your plans to refurbish and restore her to her original glory.
>
> This comely creature should not be permitted to languish sight unseen in an attic storage room surrounded only by old maps and discarded red tape. Her being brought to light by the Department of Property Management is an achievement worthy of some sort of certificate.

33. New Orleans *Times-Picayune*, April 28, 1955.
34. *Ibid.*, April 29, 1955. As every schoolchild learns in Louisiana, the Cabildo was built by the Spanish and has no relation whatever to French colonial government.

The lively interest displayed by both the Delgado Museum (Municipal) and the Louisiana State Museum (State) in seeking possession of Queen Anne is understandable. However, the mayor and I view with alarm the apparent controversy that appears to be developing among the High Muftis of the local art world over the issue who gets Anne.

Indeed, we have spent the better part of this week end cogitating over this latest crisis in government. And we have concluded that a schism among these prophets of art and their respective followers would rival in sheer ferocity the War of the Roses or a Hollywood divorce case.

Regardless of the outcome of the impending struggle for possession of Anne, the innocent office holders of City Hall would be certain to lose.

Moreover, it seems to the Mayor and myself that the community already is sufficiently divided on other issues—perhaps less important in the ultimate cosmos, but nevertheless burning at the moment.

For this and other reasons stated below, the Mayor and I have decided that Anne of Austria shall be returned to her former dwelling place—the Northwest wall of the Mayor's parlor [in City Hall].

Lansford, nevertheless, obtained for the Delgado a likeness of Louis XIV. In January, 1956, Hirschl and Adler, of New York, gave the Museum a painting of Louis XIV by Nicolas de Largillière.[35]

The single most significant achievement of Lansford during 1955 was the acquisition of the Billups glass collection for the Museum. Having learned of the collection, and of the fact that Melvin P. Billups had a connection with New Orleans, Lansford wrote to him in 1954. Their correspondence grew, and eventually Billups invited Lansford to see the collection. In October, 1954, Lansford traveled to New York and, upon seeing the glass, suggested to Billups that he give it to the Museum. Billups was hesitant to commit himself, because of his feeling that "no one in New Orleans knows anything about old glass."[36] Apparently Billups thought that there were other museums where the collection might be better appreciated. Lansford, who did not allow himself to feel rebuffed by this response, continued to court the reluctant donor.

A native southerner, Billups was born in 1879 and grew up in Mobile. After a long bout with typhoid fever interrupted his education at the University of Alabama, he held several jobs in Mobile and Seattle before moving to New Orleans to become general foreign freight agent for a group of seven railroads. In New Orleans, he met Clarice Marston, whom he married on March 28, 1910.

35. This painting has since been reattributed to Claude Lefebvre.
36. Melvin P. Billups to Alonzo Lansford, July 8, 1954, in archives, NOMA.

When the federal government formed the United States Shipping Board, which was to oversee the operation of American merchant ships, it designated New Orleans as the regional office for shipping in the Gulf of Mexico. At the suggestion of businessmen from the New Orleans Cotton Exchange, the Board of Trade, and the Chamber of Commerce, Billups received appointment as district director of the shipping board. He served in that capacity for a number of years, undertaking the awesome job of overseeing more than four hundred ships during wartime, establishing the district office, and appointing its large staff. Billups distinguished himself, and in 1920, E. L. Simpson, of Simpson, Spence and Young, asked him to go to New York City and take over management of the firm's subsidiary, the Texas Transport and Terminal Company. Billups accepted, and in 1958 he became president of that company.

Throughout the forty-nine years that he was a resident of New York City, Billups had remained a southerner. He fondly remembered his twelve-year sojourn in New Orleans, where his bride had been born, and her death in 1951 reinforced his affection for the city. Indeed, his primary reason for deeding the collection to the Museum was his love of his wife's native city. He visited New Orleans a number of times after reaching his decision. And he often showed his glass collection to New Orleanians who visited his apartment in New York.

In February, 1955, Lansford had made another trip to New York to see Billups and his collection, which was continuing to grow rapidly. By then, it comprised some 470 pieces. On February 9, Lansford informed the Museum's board of administrators that Billups had been considering the bequest of his collection, valued at about fifty thousand dollars, to the Museum.[37] By November 9 of that same year, Billups wrote to Lansford,

> Everything is now in order with respect to my Glass Collection, and the following is the plan that has been worked out by the Lawyers whom I have consulted.
>
> On or about the middle of December, I will send to you a Deed of Gift, as per copy attached hereto, for certain pieces having a market value of $13,000. or $14,000., as may be determined at that time.
>
> The Gift will provide for a reservation to myself of a life estate in the Gift. The present total value of the Collection is slightly in excess of $60,000, having had additions since you saw it, in both the American

37. Minutes of the Board of Administrators, Isaac Delgado Museum of Art, February, 1955, p. 261.

and Foreign sections, of several rare specimens. Every year after 1955, some time in December, I plan to make a new Deed of Gift to the Museum of certain specimens, with the same life estate reservation at a value to be determined in the month of December, until the entire collection has been deeded to the Delgado.

In December of this year, I will arrange with the Insurance Company that the Museum be protected as a Beneficiary of the Gift portion. Of course, I will continue to take care of premiums on the insurance on the Gift amounts, on account of my life interest.

I also am planning to revise my Will to provide that any portion of the Collection, which has not been given to the Museum prior to my death, should pass to the Museum at that time. . . .

Without wishing to restrict in any way, the manner in which you should exhibit this Glass, I myself think it should be kept together and shown in a special room with other Glass as you now have, or may acquire hereafter. The George Horace Lorimer Collection in the Philadelphia Museum, is in a special room, and the DuPont Collection, at Winterthur, is all together. I understand the Toledo Museum keeps all of its Glass in a special room. My Collection is growing (I now have five cabinets all full) and I have been told by a good many who know Glass that they consider it, even as it now is, an important Collection. I should think that it might stimulate interest in the collecting of old Glass, and might even induce public minded citizens to make gifts of other kinds to your Museum, if shown in this way, instead of being kept in storage, and a few pieces brought out from time to time. . . .

As I have explained to you, I am giving the Collection to the Museum, as a Memorial to my wife, Clarice Marston Billups.

Without any further fanfare this unassuming man gave the Museum one of its most important collections. It represents the entire historical span of glass manufacture, from ancient times to the turn of the current century. David Grose, curator of glass at the Toledo Museum of Art, has said, "Without doubt . . . the glass at New Orleans ranks among the top ten in this country."[38] One indication of its importance was an exhibition, and the publication of a catalog, of selections from the Billups collection by the Corning Museum of Glass in 1968. The gift was completed upon Mr. Billups' death in 1969, when the last of the items were physically received by the Museum. The collection then numbered over three thousand objects, with an appraised value of a million dollars.

Lansford continued to work hard to increase the size of the permanent collection. In 1956, he met with some success, for William Carr

38. David Grose to E. John Bullard, February 25, 1977, in archives, NOMA.

gave the Museum its third Tiepolo, *St. Joseph and the Christ Child*. The first Cuzco-school painting, *St. Jerome*, was added to the collection that year by John Jay Cunningham, of New York. He also gave *Serpents and Insects*, by the seventeenth-century Dutch artist Otto Marseus van Schrieck. The noted collectors Mr. and Mrs. Harris Masterson, of Houston, gave the Museum *View of the Grand Canal*, purportedly by Antonio Canaletto; *Sleeping Venus*, purportedly by François Boucher; and *Portrait of Henry III* and *Madonna and Child*, purportedly by Tintoretto. In 1957, they also gave the Museum *Two Muses*, purportedly by Jean Honoré Fragonard and *The Vanity of Earthly Love*, by Luca Cambiaso. Of the Masterson gifts, Feitel said, "It is a dream come true"; and Lansford was described as beaming "like a small boy with his first electric train." [39]

With so many claims on Lansford's time and personal attention, it is evident that an expansion-fund drive could not depend on him to any great degree—even with the support of the press, Arthur Feitel, and a handful of art lovers. In those years, Lansford was the dynamic hub about which all the Museum's activities revolved. He galvanized interest in the Delgado, which advanced by giant strides during his first eight years as director. Feitel was helpful, but he had become too staid, as Woodward before him had become. Not knowing how to organize a fund drive, Feitel had always relied on the city's support or the generosity of some last-minute donor. And the administrators gave very little except opinions.

The director of an art museum must have the support of a strong board of trustees, or a strong nucleus of board members, working with him toward common goals. The board must be responsible for raising funds for whatever of the director's schemes it approves, leaving him free to oversee the thousands of matters involved in the daily administration of the museum. But the trustees of the Delgado in this period did not view themselves as fund raisers. They had hired Lansford, so they expected him to do their bidding. If the Museum needed a new wing, Lansford himself was expected to find the necessary funds or do without. The board's old-fashioned viewpoint would finally result in a serious conflict.

39. New Orleans *Times-Picayune*, November 11, 1956. In recent years several of the Masterson paintings have been reattributed: the supposed Canaletto to the school of Canaletto; *Portrait of Henry III* to the school of Tintoretto; the *Madonna and Child* from Jacopo to Domenico Tintoretto; the supposed Fragonard to Jean François de Troy; and *Sleeping Venus* to an unknown artist.

IX

The Lansford Firing

Alonzo Lansford's distinguished career as director of the Delgado Museum came to a surprisingly abrupt end. The New Orleans *States* of March 28, 1957, trumpeted, "Secrecy Veils Delgado Art Head Ouster," and the New Orleans *Item* headlined, "Silence Shrouds Move on Lansford." The next morning the conservative *Times-Picayune* ran a small one-column head, "Lansford Asks Firing Reason." Such was the beginning of the bitterest controversy ever to involve the Museum.

The newspapers reported that the Delgado board of administrators had fired Lansford, citing "incompatibility" between him and it. Arthur Feitel, president of the board, refused to explain the specific reasons for the dismissal or to disclose how many of the eight board members had voted for the dismissal in "executive" session on March 13, 1957. He said, "I don't think the public has a right to know why we fired Mr. Lansford. The only right the public has is to judge on the competency of the board in firing Mr. Lansford in executive session."[1] Duralde Claiborne, assistant secretary-treasurer of the board, supported Feitel's view, saying he had a 'difference of opinion' with persons who believe the museum board is a public body. What business is it of the newspapers to demand to know the reasons for the Lansford dismissal? We can hire somebody then fire him without having to explain to anybody."[2] Hippolyte Dabezies, secretary-treasurer, was out of town and could not be reached for comment. Of the board members approached, A. Q. Peterson, Alfred Wellborn, Edward J. de Verges, F. Julius Dreyfous, and Judge Frank J. Stich, all refused to comment. Mrs. Edward B. Benjamin and Mrs. William G.

1. New Orleans *States*, March 28, 1957.
2. New Orleans *Times-Picayune*, March 28, 1957.

Helis likewise refused to speak with reporters. R. M. Salvant said only, "I am a recent member and was not at the last two board meetings."[3]

The press believed that the public was entitled to an explanation, for it viewed the Delgado Museum of Art as a public institution. The New Orleans *Item* reminded its readers that "the Isaac Delgado Museum is an independent city agency supported by city funds."[4] The New Orleans *States* observed that the city appropriation for that year was $42,700 and that the Museum's funds from all other sources amounted to $2,335. From the outset the clarification of the board's responsibility to the public was one of the main points of contention arising from the Lansford firing.

The ouster of Lansford became a cause célèbre overnight. The morning news carried the reactions of a stunned art community. The New Orleans sculptor Lin Emery said Lansford's "summary dismissal without explanation is shocking. Both he and the city are entitled to a full investigation." Felix H. Kuntz, a noted collector of Americana, who had recently donated rare maps, manuscripts, and first-edition books to Tulane University as well as several paintings to the Museum, protested Lansford's "dismissal without a hearing or public reasons."[5] He and a number of other prominent citizens wired the mayor to protest the board's action.

Lansford claimed he was "completely in the dark," saying, "I don't know what it is all about."[6] Asking for a hearing so that he could learn the charges against him, he protested the board's action as "precipitous . . . arbitrary . . . unfair."[7] A request for a hearing was certainly not unreasonable. In the nine years that Lansford had been at the Delgado, he had worked untiringly and without respite in behalf of the Museum's growth and reputation. He had been responsible for the acquisition of several major collections, and his successes were well known in the city. The board's intimation in printed statements that a revelation of the reasons for Lansford's firing would be detrimental to his career was unfair. Claiborne had remarked to the press, "Mr. Lansford is making a mistake if he insists on knowing the reasons."[8]

3. *Ibid.*
4. New Orleans *Item*, March 28, 1957.
5. New Orleans *Times-Picayune*, March 29, 1957.
6. New Orleans *Item*, March 28, 1957.
7. New Orleans *Times-Picayune*, March 29, 1957.
8. New Orleans *States*, March 28, 1957.

Questioning the legality of the board's action, the press sought to learn whether the board had been in executive session, as asserted by Claiborne and Feitel, at the time it made the decision to fire Lansford. According to state law, "no final or binding action shall be taken during such closed or executive session." But not all the administrators agreed with Claiborne and Feitel; Judge Stich claimed that the board had not been in executive session. Judge Stich knew that the Open Meetings Act of 1952 provided that discussion might take place in private but that actual meetings of "all state parishes, districts or municipal boards or authorities with policy-making or administrative functions which receive or expend tax funds shall be open to the public."[9] If the meeting in question had not been an open one, the action against Lansford would have had to be deemed illegal.

Any confusion concerning the nature of the session on March 13, 1957, is dispelled by the minutes of the meeting. They clearly state that the meeting was an open one. That Feitel and Claiborne reported it as an "executive" session merely reflected their authoritarian posture regarding Delgado board meetings.

Present at the meeting on March 13 were Feitel, Mrs. Benjamin, Dabezies, Dreyfous, Mrs. Helis, Peterson, Stich, Wellborn, and Lansford. The meeting opened with the reading of the minutes of the previous meeting, their acceptance, and a treasurer's report. Then Lansford presented the director's report, after which he was excused from the meeting, as was the custom. This unfortunate but long-standing tradition was indicative of the general lack of rapport between the board and the director. Too often, the board did not know enough about Lansford's actions and plans, nor Lansford about the board's.

After Feitel made his report as president, the minutes state,

> there was some discussion about the Delgado paying for the Chamber Music Concert by the N.O. Symphony Quintet. The Board decided that as they had not authorized the playing of the N.O. Symphony they would not be responsible for the paying of the bill.
>
> The special committee's report was made by Judge Stich, in regards to Mr. Lansford and the operating of the museum. His remarks were concurred in by Mr. de Verges and Mr. Dreyfous.
>
> After considerable discussion in regards to Mr. Lansford the following resolution passed.
>
> Judge Frank J. Stich reported on behalf of the committee composed of himself, Edward J. de Verges and F. Julius Dreyfous, which was ap-

9. New Orleans Times-Picayune, March 29, 1957.

pointed at the last meeting to contact the director, Alonzo Lansford. Judge Stich stated that the committee held a meeting at which the President, Mr. Arthur Feitel, was present. The matter was discussed very fully and at length, and the committee came to the conclusion that it would be to no avail to discuss the matter with the director, Mr. Lansford. Judge Stich asked that the report of the committee be received and the committee discharged.

After a discussion of the matter, on motion made and seconded and unanimously passed, the report was received and the committee discharged.

On motion made, seconded and passed it was resolved that the services of Mr. Alonzo Lansford as director of the museum be discontinued as of and effective March 28, 1957, and that he be paid in addition to his salary for the month of March, two months' salary as severance compensation; further that Mr. Lansford be given the opportunity to tender his resignation effective March 28, 1957, in lieu of his services being discontinued as Director and that Mr. Duralde Claiborne, Assistant-Secretary is authorized and directed to advise Mr. Lansford on March 28 of the foregoing.

Mr. Wellborn voted against the resolution.

There being no further business, the meeting was adjourned.[10]

The minutes reveal nothing about the reasons for Lansford's dismissal, nor do they shed light on why a special committee was appointed to meet with him. The only important information to be discerned from the minutes is that Feitel was persuasive enough to convince the special committeemen that it would be useless to meet with Lansford.

By the end of March, both the city-council president, Victor H. Schiro, and Mayor deLesseps S. Morrison had called for the public disclosure of the reasons for Lansford's dismissal. The mayor deplored the board's view that it owed no explanation to the public, and the councilmen Fred J. Cassibry, Glenn P. Clasen, Walter M. Duffoure, and James E. Fitzmorris, Jr. concurred.[11]

In response to the mayor and councilmen, Feitel hurriedly met with fellow board members Peterson and Stich at Peterson's office in the National Bank of Commerce building. The outcome of the private conference was the decision to call a special meeting of the board of the Museum on Monday, April 1. At that meeting the board would

10. Minutes of the Board of Administrators, Isaac Delgado Museum of Art, March 13, 1957, pp. 17–19.
11. New Orleans *Times-Picayune*, March 29, 1957.

formulate an answer to the letter in which city-council president Schiro had called for an explanation of the board action. Present at the meeting were the board members who had participated in the decision to fire Lansford. Salvant, who had not been present then, did not attend.

The press was barred from the meeting as an executive session. The press protested under the Open Meetings Act, and Judge Stich emerged to say that he and Attorney de Verges had reread the act and were "of the opinion it has no application to Delgado Museum." They held that "the Isaac Delgado Museum was an 'incorporated independent body' and not a state or city agency." [12] The board minutes do not entitle the meeting an executive session, however, but rather call it a "Special Meeting of the Board of Directors of the Isaac Delgado Museum of Art." Barring the press because it was in executive session, the board at the same time failed to show on the record that its meeting was closed. Technically, its actions in the meeting would thus be legal.

After some deliberation, the board approved a resolution listing the reasons for Lansford's dismissal:

> On recent occasions Mr. Lansford, without the consent, knowledge or authority of the Board of Administrators, committed the Delgado Museum of Art for obligations which it had not considered or approved, notwithstanding the limited budget under which the museum operates. [13]

The resolution also cited Lansford's failure to acknowledge gifts made to the Museum, to consult the Museum's accessions committee before selecting works of art, and to see that objects in the Museum's collection were properly labeled. It alleged that he was derelict in his duties in that he did not get receipts for works of art when they were removed from the Museum or when they were returned, he did not direct the guards how properly to guard objects, and he failed to attend many functions given at the Museum by the Art Association of New Orleans. The resolution cited further complaints:

> It is the policy of DELGADO MUSEUM to give publicity, within its ability, to people who do things in the interest of the museum; instead of adhering to this policy, MR. LANSFORD seeks publicity solely for himself. MR. LANSFORD failed to extend the courtesy to friends of DELGADO MUSEUM by rec-

12. New Orleans *Item*, April 2, 1957.
13. Minutes of the Board of Administrators, Isaac Delgado Museum of Art, April 1, 1957, p. 20. See the attached copy of a resolution referring to concerts played at the Museum by the New Orleans Symphony Quintet.

ognizing donors and according them the proper credit, acknowledging gifts, or answering letters. Striking examples are:

During the sesquicentennial French Show, where no publicity or credit was given to the Wildenstein Galleries, who organized the show in France and America at great expense and to the benefit of DELGADO MUSEUM, or to the Chairman and another member of the Committee who contributed in a major degree to the success of the Exhibit. The Manager of Wildenstein Galleries, the Chairman and member of the Committee expressed grave disappointment because their efforts were not recognized and it required great effort and time to appease them.

. . . While the Kress Collection was obtained during MR. LANSFORD's tenure as director, the major credit therefore is by no means attributable to his efforts, but on the contrary, to the joint efforts of Mr. Arthur Feitel, President of the Board, and Mr. Lansford.[14]

Upon the adoption of this resolution, which denied Lansford a hearing, Feitel announced to the press that copies of the document would be available at his office the next afternoon at three o'clock. The press seethed. First they were barred from the meeting; then they were denied information about the contents of the resolution; finally they were told they would have the information a full day later, after the deadlines for the last edition. When asked by a reporter about the reason for Lansford's ouster, Feitel replied offhandedly, "We are going to try to explain." Another reporter pressed forward to ask if Lansford would get a hearing. To this Feitel replied, "That's all we have to say. I don't want to be impolite, but that's all."[15]

Unmollified, the press took up Lansford's cause and urged a fair hearing. Herman Deutsch, in his column, expressed the consensus point of view under the headline "Moral Obligation":

Consider: If a functionary is summarily fired "for the good of the service," without charges or complaints, that can mean anything; all too

14. *Ibid.*, 2. Of spurious charges employed as a reason for dismissing a museum director, these must be among the most outrageous. There seems to have been a great deal of jealousy at Lansford's being honored with the Palmes d'Officier d'Académie Française for his many services relating to the sesquicentennial show. All others who participated in organizing the exhibition were properly credited for their efforts in the state and local press as well as the national news media (see Chapter VIII). It is normal for a museum director, rather that the board members, to receive the official recognition of a foreign country for such an exhibit. Thus E. John Bullard, while NOMA director, was recognized in 1979 by the Egyptian government with the Order of the Republic for his efforts in regard to the Treasures of Tutankhamun exhibition held at NOMA in 1977–1978.

15. New Orleans *Item*, April 2, 1957.

often it cloaks something scandalous, so that the dismissed employee would not want the facts revealed.

Naturally, then everyone asks himself or his neighbor: Was Whoozis fired because he's a secret alcoholic? . . . Is he a junkie? Did they find his fingerprints on the wrong doorbell? Is he a deviate like some of those State Department cookie pushers we used to read about? Is he maybe even the leader of a Communist cell for this area?

If any of these things were true, the employee could accept his unexplained dismissal "for the good of the service" in silence, and let it go at that. But, Mr. Lansford did not do so, he asked that the charges against him be made public.

[The Delgado board has] a moral obligation to the public, to Mr. Lansford, and finally to itself to clear the atmosphere of a rising fog of ugly rumors.[16]

The board remained adamant against according Lansford a hearing. Opposition to the board's action grew. Pat Trivigno, a well-known artist and then an associate professor of art at Newcomb College, led a group of twenty-six artists to withdraw their works from the spring exhibit of the Art Association of New Orleans in protest against the treatment of Lansford.[17] The newspapers printed many editorials and letters in favor of a hearing. General public opinion solidified behind Lansford. So popular was Lansford's cause that on March 30, 1957, an organization was formed called Friends of the Delgado Museum. For years Feitel had spoken of organizing such a group; now, ironically, it had come into being. The Friends' goals were the retention of Lansford as director, the construction of a new wing at the Museum, and the solution of the Museum's financial and managerial problems.

A few supported the board's decision, but not necessarily for reasons related to the controversy. A letter to the editor from Hans Groth, director of the Edgewood Art Group, illustrates this point:

16. *Ibid.*, April 3, 1957.
17. New Orleans *Times-Picayune*, March 31, 1957. On March 30, 1957, he and twenty-six artists had sent telegrams to the mayor, Arthur Feitel, each member of the Delgado board, the New Orleans Spring Fiesta Association, and the Louisiana State Museum, stating, "We the undersigned artists, regret that we cannot cooperate with the Art Association, the New Orleans Spring Fiesta, and The Louisiana State Museum by exhibiting in the Cabildo arcade exhibition. We take this action as a protest against the unexplained dismissal by Arthur Feitel of Alonzo Lansford, as director of the Delgado Museum." The telegram carried the names of Pat Trivigno, Charles Richards, Walter Bock, Alvin Guillot, Helen Trivigno, John Clemmer, Ida Kohlmeyer, Katherine Choy, James Steg, Pauly D'Orlando, Lin Emery, Olive Leonhardt, Jack Hastings, Shearly Grode, Robert Helmer, William Gordon, Janet Kohlmeyer, George Dunbar, Hal Carney, Loren Oliver, Viola Frey, Jules Struppeck, Leonard Flettrich, Rai Murray, Byron Levy, and Marie Demeaux.

Abstract! Abstract! Is that what we are paying taxes for—to see Delgado Museum go to the dogs? To see a certain group of "artists" dominate the art association spring shows year in and year out is hard to believe, but at the Delgado everything goes. Now they are trying to chop Mr. Feitel's head off, because their abstract chum was fired. Orchids to Feitel for improving conditions at Delgado. We need it after light years of abstract.[18]

The publication by the board of its resolution listing the reasons for Lansford's dismissal did not quell the voices demanding a fair hearing. Trivigno labeled the charges against Lansford "puerile, vindictive and absurd," and he correctly perceived that at the heart of the imbroglio lay the question of the proper role of a museum director.[19] Also outspoken was Hugh J. Smith, Jr., a collector and the former assistant curator of the Metropolitan Museum of Art, who protested Lansford's firing, saying, "This is a disgrace to our city and places us back at the bottom of the list culturally. The board must be investigated."[20] The directors of the Art Association of New Orleans held a special meeting on April 3, 1957, and signed a statement declaring that the association had "not been advised nor consulted in the Lansford affair, and as a result is as uninformed as the public." The statement continued, "The board has not the freedom of expression because of the ambiguity created by having the same man, Mr. Arthur Feitel, as president of both the Delgado Museum and the Art Association board. It might be inferred by the public that the Art Association concurs in the Delgado board decision, when this is not necessarily true."[21] The directors who signed the statement were Marc Anthony, A. Fred Bultman, John Clemmer, Joseph Daum, George Dunbar, Mrs. Crawford H. Ellis, William Gordon, Charles Kohlmeyer, Jr., Mrs. Cyril Laan, A. Richard Moulin, Dr. Sam Nadler, Robert J. Newman, Mrs. Ralph V. Platou, and Mrs. Leon M. Wolf, Jr.

Mayor Morrison was outspoken in urging the Delgado board to give Lansford a public hearing. On Thursday, April 4, 1957, at its regular meeting, the city council held a brief inquiry into the matter, to which the board members of the Museum were invited. All declined, with the exception of Wellborn, the board's vice-president. He defended Lansford's record, saying, "I believe that Mr. Lansford has made a very satisfactory record . . . and has done all that's necessary

18. New Orleans *Times-Picayune*, April 3, 1957.
19. New Orleans *Item*, April 3, 1957.
20. New Orleans *Times-Picayune*, March 31, 1957.
21. *Ibid.*, April 1, 1957.

to keep our board informed." Also present was Lansford himself, who requested a public hearing on the affair and articulated his offer to serve as Museum director without salary until the dispute was settled. W. E. Groves, a noted art collector, requested a clarification of the Delgado board's status. He pointed out that he had lent several paintings to the museum "with the intention of giving them to the city of New Orleans which I understood operated Delgado Museum."[22] If the trustees of the Museum regarded the board as a private corporation, not operated by the city and not under the city administration, he wanted his paintings returned, he said, so that he could carry out his original intention of donating them to the city.

On a motion offered by Councilman Cassibry, the council voted six to zero to demand that the board give Lansford, an "open and public" hearing no later than April 10, 1957, at their regular board meeting. The motion carried an amendment stating that should the board of the Museum refuse a hearing, the council would "take action," implying that the operating funds of the Museum would be cut. Another amendment to the motion asked the city attorney to report on whether the Delgado board came under the legal jurisdiction of the city council.

That same day, Lansford wired the secretary-treasurer of the Museum board, Dabezies, imploring him "for the sake of the museum to call a special meeting immediately or canvass board members by phone, or better still permit my temporary reinstatement immediately pending an early opportunity to calmly discuss our differences with the board. I sincerely regret that public outcry has placed board in unfavorable light and respectfully suggest that your prompt action now would avert further detriment, publicity and clear the atmosphere."[23] The acceptance of Lansford's reasonable offer could have greatly eased the rapidly heightening tensions. Feitel, however, was in Houston at a convention of the American Federation of Arts, and Dabezies and Wellborn were reluctant to act in his absence. The newspapers speculated that Feitel had gone to Houston with the purpose of finding new directors for the Delgado and for the Louisiana State Museum, in New Orleans, which had lost its director some weeks prior to Lansford's ouster. As board vice-president Wellborn could have accepted Lansford's offer in Feitel's absence, but evidently he lacked the

22. *Ibid.*, April 5, 1957.
23. Alonzo Lansford to Hippolyte Dabezies, April 5, 1957, 11:40 P.M., in archives, NOMA.

nerve. He told Councilman Burke at the meeting that although in the past he had presided over board meetings in Feitel's stead, those were occasions when "nothing of any importance comes up."[24]

Relations between Feitel and the press worsened daily. The reporter Bill Reed, of the New Orleans *Item*, wrote that he had attempted to get an interview with Feitel by calling him in Houston. On hearing his name and newspaper, Feitel had muttered, "Don't you bother me any more. I've had enough trouble from you people in New Orleans." The connection was then broken. The telephone operator rang Feitel's room in the Shamrock Hotel. After several minutes he answered.

"Hello, Mr. Feitel, we must have been cut off," the reporter said.

"We weren't cut off," Feitel corrected him. "I hung up. I'm tired of you reporters."[25]

Despite Feitel's complaints, much of the treatment he received from the press was fair. The newspapers simply reported his refusal to comment on the events surrounding Lansford's ouster. Feitel's uncompromising attitude fed the tension, as did his refusal to retreat one inch from his original stand in the face of the city council's request for a public hearing. Events went unchecked by any temperate hand, and emotions grew more heated. Mrs. Helis was frightened to give an interview to reporters. She said, "I've been threatened and I'm scared. People have been calling and not saying who they were, but they have been threatening me."

On the afternoon of April 5, Joseph E. Jubin, a retired businessman and art lover, went to the Delgado and removed from its walls an extraordinarily valuable painting he had lent it, *The Holy Family*, by Peter Paul Rubens. Jubin said he took possession of his painting because of the "'high-handed methods' of the board in the Lansford case," adding, "With all this confusion, I'd rather have it out than in." The same day, the newspaper reported that David R. McGuire, Jr., the city's chief administrative officer, ordered funds for the salary of the director of the Delgado withheld. He wrote Feitel a letter informing him that funds would not be forthcoming until the board had "clarified its position on the Lansford matter and several other items."[26] Soon thereafter the Kress Foundation, which had not yet fi-

24. New Orleans *Times-Picayune*, April 5, 1957.
25. New Orleans *Item*, April 5, 1957.
26. New Orleans *Times-Picayune*, April 3, 1957.

nalized its gift to the Museum, privately "threatened to withdraw its collection."[27]

Risking the loss of major paintings and of funds, Feitel and his board bent not at all. Indeed, on the morning of April 9, 1957, readers of the *Times-Picayune* learned of yet another startling development. The headline: "Feitel to Take Museum Post."

Feitel had announced to the press that because the director's salary was being withheld by the city, he himself would become the acting director on a part-time basis. He said, "I will make one or two trips a day to the museum and take care of the property. It's a pity I can't give all my time to the museum, but I have to make a living. I served as curator there before and I did a good job."[28] The board approved this arrangement at its long-awaited meeting the next day. At that session the press was admitted, but reporters were allowed neither to ask questions nor to take photographs.

At the start of the meeting, Dreyfous offered a motion, seconded by Peterson, to give Lansford a closed hearing "with designated members of the city government present in order that they may discuss the reasons of the dismissal and the charges against him."[29] When the vote was taken, the result was a tie. Peterson, Dreyfous, and Wellborn voted for a hearing. Dabezies, Stich, and de Verges voted against. Feitel was called upon to cast the deciding vote, and as expected, he voted against the hearing. The board then approved Feitel's appointment as acting director without compensation, and it authorized him to seek a new director. That vote was unanimous.

The city council responded on April 11, 1957, narrowly passing a motion to suspend Museum operating funds except for security. The seven-point motion also made it clear that the council stood ready at any time to negotiate with the Delgado board and that the suspension of Museum funds did not mean the council withdrew support for the arts in New Orleans. The motion requested the city attorney to advise the council as to ownership of the Museum, and it asked the budget analyst to confer with Lansford on what the city of New Orleans owned in the Museum. Cassibry summed up the council's majority view: "[The Delgado board] have not even seen fit to permit Mr. Lansford to be heard. They have told us in effect, that they are a private corporation. I don't think that we have anything to say to this

27. Feitel, "Confessions," 18.
28. New Orleans *Times-Picayune*, April 9, 1957.
29. *Ibid.*, April 11, 1957.

board other than we do not contribute public funds if you do not conduct yourself as a public body."

A meeting of the Art Association of New Orleans that same evening dissolved into name-calling and shouting as fifteen board members bolted from the session in protest. These were the same fifteen who had earlier signed a statement expressing regret over the Lansford ouster. At the Art Association meeting, they had tried to pass a resolution criticizing the handling of the dismissal, but they were outnumbered. A resolution giving Feitel a vote of confidence was passed instead. Anthony then introduced a request signed by more than five board members to call a special meeting of the Art Association within fifteen days, as provided in the association charter. It was that action that touched off the explosion of tempers.

Feitel, who was chairing the session, refused to consider a special meeting. Anthony pointed out to the chair that because more than five board members had signed the request, he was obliged to call the meeting or be held in contempt of the association's bylaws. Feitel reacted angrily: "Whether it is by the charter or not, I'm not calling any meeting. What are you going to do about it?"[30] Dr. Nadler jumped up and took the speaker's podium amid boos from Feitel's side of the room. He read a statement criticizing Feitel's presidency of the Art Association and the Delgado board. A tumult broke out, and though a committee consisting of Irwin Poche, Herbert C. Parker, and Charles Kohlmeyer, Jr., had been appointed to meet with three Delgado board members to coordinate the actions of the two groups, all was lost in the heated passions that erupted.

In the aftermath of that fiery meeting, Kohlmeyer, unsure whether he would accept appointment on the committee to tune the relationship between the Museum board and the Art Association, said that if he did, he would press for the enlargement of the membership of the Isaac Delgado Museum of Art Association. He called for an amendment to the charter of the Delgado Museum of Art Association that would enlarge the board of administrators. He also told reporters that he would suggest setting definite terms for board members, requiring that one or two board members be from the city government, and specifying that the Art Association of New Orleans be given the right to elect any additional board members.[31]

30. *Ibid.*, April 12, 1957.
31. *Ibid.*, April 13, 1957.

Kohlmeyer's public statements about the need for enlarging and changing the makeup of the board reflected an opinion many persons had held for years. Even Feitel claimed to be sympathetic to the possibility of change. He recalled that as early as "the Fall of 1956 I heard rumors that there was a group of people who would like to make changes at Delgado Museum. . . . I felt that the source of their ideas [was] very constructive and some new blood would be beneficial for the museum." Several members of the Art Association wanted to enlarge the board, he continued, and others wanted city representatives on it. "For years," he said, "I had continually urged this and each time that I proposed it, I was always told by the lawyers on our board that it would be illegal."[32]

Young professionals like Clemmer, Kohlmeyer, Trivigno, Alfred Moir, and James L. Steg were no longer to be put off by lawyers' arguments. They were impatient with the stumbling blocks to progress. Painfully aware of the inadequacies of the Museum and hoping to correct them, they joined together to force change. They were concerned not only with problems involving the board's composition but also with problems in the operation of the Museum itself. Through several directors of the Art Association of New Orleans, they suggested improvements for the Museum in early March, 1957.[33] Among what they proposed were a revision of exhibition schedules, the formation of a committee to investigate, evaluate, and study the permanent collection so that substandard works could be culled, and the exploration of the feasibility of rental art services, adult art classes, regular lecture programs, and improved library services.

There had been numerous proposals earlier for constructive change in the Art Association and the Museum. The first became known to the seventeen hundred members of the Art Association of New Orleans in a letter of November 30, 1956, signed by eighty of their number. The signatories maintained that "the Association [had] not kept pace with the dynamic development of the city."[34] It had remained unchanged, they argued, for twenty-five years, and the membership had no choice in the selection of its leadership. The reformers enumerated eight steps by which the association could rectify the situation. Among them were a revision of the association's charter and by-laws, the granting of aid toward Museum accessions, the expansion

32. Feitel, "Confessions," 16.
33. New Orleans *Times-Picayune*, April 19, 1957.
34. *1956 Art Association Letter*, November 30, 1956, p.1.

of Museum membership, a pursuit of financial support from groups in the city, and a rallying behind the Museum director's plans for better exhibitions and improved installations.

The letter expressed appreciation for the long and faithful service of the incumbent officers but went on to say that it was "now necessary to infuse new life into the leadership." It asked for the election of Kohlmeyer as president, Moulin as first vice-president, and Milton P. Adler, Robert A. Ainsworth, Jr., John Clemmer, Mrs. Crawford H. Ellis, Lin Emery, Mrs. W. Brooke Fox, Jr., Edwin Friedrichs, William Gordon, John Hall Jacobs, Alfred Moir, I. William Ricciuti, Mrs. Leon M. Wolf, Jr., and E. W. Rector Wooter as members of the board. The letter explained, "The president has been approached by a committee of the undersigned on the possibility of supporting the election of vigorous new officers. He has made clear his determination to oppose changes in the present group of officers, at this time or in the foreseeable future, but has signified his willingness to engage in a contested election." [35] The letter informed members of the Art Association that the election of officers would take place on December 10, 1956. Those who could not attend were asked to sign proxies and send them to George W. Rickey, chairman of the proxy committee.

This was nothing less than a bald attempt to retire Feitel. At a meeting with him on November 24, 1956, the reformers had asked for his cooperation and suggested that he would become honorary chairman of the board upon his retirement. But Feitel did not wish to retire. Immediately after his meeting with the members who proposed he step down, he had sent out his own mailing to Association members, asking their support. He, too, enclosed a proxy form—this one naming him sole agent for the December meeting. Feitel clearly meant to put up a fight.

Kohlmeyer was asked by several of the members of the Art Association to meet with Feitel prior to December 10 to work out an agreement. He arranged a meeting for December 6, four days before the Association election. Feitel insisted on remaining president. He agreed, however, to have Kohlmeyer as first vice-president, Herbert C. Parker as second vice-president, Louis J. Torre as treasurer, and Mrs. Ralph V. Platou as secretary. Feitel's slate of candidates for the board listed Mrs. Clyde Barthelemy, Mrs. Theodore Dendinger, Mrs. W. Brooke Fox, Jr., Mrs. Harry Latter, Mrs. John G. Panzeca, Mrs. J. Marshall

35. *Ibid.*, 2.

Quintero, Mrs. Albert J. Ruhlman, and Mrs. Leon M. Wolf, Jr. Feitel agreed to support a charter revision to prevent any officer from holding office for more than two years. He also agreed not to stand for reelection in 1957.[36] But he would not yield the presidency at once.

The vote on December 10 was a victory for Feitel. It took more than five hours to verify the over nine hundred proxies, because some of the persons who had voted were not actually dues-paying members of the Art Association. Under Feitel's administration, some members had been allowed to let their dues lapse as much as two years; this was just the sort of poor administration that Kohlmeyer and his associates were trying to correct. It was after midnight before a compromise could be effected on the count. But the election results were definitely favorable to Feitel, who was retained as president. All the officers were of his party as well: Mrs. Quintero, first vice-president; Parker, second vice-president; Louis J. Torre, treasurer; and Mrs. Ruhlman, secretary. Of the thirteen candidates for the board that Kohlmeyer's group supported in the November 30 letter, only six were elected: Ainsworth, Clemmer, Ellis, Gordon, Jacobs, and Wolf. The Kohlmeyer group did succeed, however, in seating four more of their group on the board, including Kohlmeyer himself, who commented that "even though [believing] that he had a majority of the votes . . . Mr. Feitel indicated that he would be willing to compromise on board candidates." Kohlmeyer continued, "Both sides, realizing that a compromise was to the best interests of the association, and Mr. Feitel also realizing that the numerical strength of our group gave considerable moral force to our claim, at least for substantial representation on the board, felt that the settlement was a good one, which should be acceptable to the entire membership."[37]

Feitel made several other concessions of import. One was the appointment of a new executive committee, of which at least three members were to be from Kohlmeyer's group. Another was the promise to appoint a committee to work on the charter and bylaws of the association.

The results of the annual Art Association meeting frightened the Delgado board of administrators, who considered them too sweeping. Nevertheless, despite what the Delgado board members thought, the Kohlmeyer group, which had formed behind Lansford's desire to

36. Charles Kohlmeyer, Jr., Memorandum to His Files, December 6, 1956 (Archives, NOMA), 1.
37. New Orleans *Times-Picayune*, December 16, 1956.

modernize the Museum, was not radical. It was imbued with the spirit of optimism and a belief in progress. One could be very optimistic about the future of New Orleans in 1956–1957, for progress was everywhere. Many of the modernization projects Mayor Morrison had fought for so valiantly were coming to fruition. The Industrial Canal was spanned by a new bridge; a second bridge across the Mississippi was under construction. The new Civic Center, comprising the City Hall, the State Supreme Court Building, and the main branch of the New Orleans Public Library, was completed. Rampart Street was enlarged and beautified with sculptures depicting heroes of Latin America, given by many of the city's southern neighbors. The port thrived as Latin American trade grew. New plans surfaced every day. One of the most frequently mentioned was for a downtown cultural center with a hall for opera and symphony, a theater for drama, and a museum. It was an exciting time—a period in which there was a solid commitment to progress.

The Delgado board was archaic. Six of its members were appointed by the board of commissioners of City Park. The other two were elected by the board of the Art Association of New Orleans. Most museum associations have thousands of members, but the Isaac Delgado Museum of Art Association was one and the same with the Museum board: a total of eight persons. In twenty years, no new member had joined the Delgado Museum of Art Association. Indeed, it was a tiny clique that controlled the major art resource of a city of close to a million souls.

Because of the hue and cry caused by Lansford's ouster and the city council's actions, Feitel was forced to appoint the six-man committee to coordinate Museum and Art Association affairs. As president of the Art Association, he appointed that group's representatives on the committee. As president of the Delgado board, he appointed the remaining representatives. Hence the deck was heavily stacked in his favor. Dreyfous, Peterson, and de Verges were appointed to the committee from the Delgado board. Those representing the Art Association were Kohlmeyer, Parker, and Jules J. Paglin. The committee met on Thursday, April 18, but accomplished nothing capable of resolving the Museum's situation. Years later, Kohlmeyer recalled that it never met again.

Factions began to form in the weeks preceding the special meeting of the Art Association on May 2, 1957. Speeches were readied, information sheets composed, supporters corralled, and votes counted in

advance of the meeting. There was a sense of tension throughout the art community. The day before the session, reporters, afraid they would be barred from the excitement, interviewed Kohlmeyer about how things might go. He assured the reporters that they would be granted admission to the Museum at 4:00 P.M. on May 2, 1957. He promised that if he was wrong, there would be a "lot of hell raised."[38]

A lot of hell was indeed raised at the meeting, although it did not stem from the barring of newsmen. It was the result instead of "rebellious members of the Art Association of New Orleans [asking] for the resignation of A. H. Feitel as president." The meeting, opened by Feitel, began with parliamentary wrangling. Soon Feitel gave Judge Stich the floor. While Stich was speaking, Feitel turned over the chair to Parker and quietly departed. What Stich told the assembled members was that no action could be taken, because the notice of the special meeting did not state a specific purpose for calling it. Stich's remarks were met with much "booing" and "hissing."

Kohlmeyer took the podium, citing state law and the Association's bylaws to confirm the legality of the proceedings. He introduced a resolution pertaining to voting rules and their establishment. But Parker declared the resolution out of order, saying the chair would not consider it. The outrage of the members compelled Parker, after a few minutes, to call for a vote on his ruling. By voice vote the Art Association killed Parker's decision and passed Kohlmeyer's resolution.

Then Moir introduced a motion that Lansford be granted a hearing as expeditiously as possible. This passed immediately, as did Trivigno's subsequent resolution to rescind the April 11 vote of confidence in Feitel and the other Delgado board members. Dr. Nadler took the microphone and lambasted Feitel's "sole rule," which he claimed had "played a dominant role in bringing us to our present disastrous state." Moir followed with a resolution asking for Feitel's resignation.

Bedlam broke out. Pushing and shoving, members grabbed at the microphone. Shouting and angry, everyone tried to be heard. When Parker announced that the meeting was adjourned, half a dozen members jumped to the podium. For a minute or two, Daum, a director of the Art Association, and his fellow board members Mrs. Quintero and Mrs. John A. O'Brien impassionedly discussed who should assume the chair.

38. *Ibid.*, May 2, 1957.

Daum won out and acted as temporary chairman. He straightaway recognized Groves, who called upon the members to "eliminate the bottleneck and we can make some progress." Everyone knew he was referring to Feitel when he spoke of the bottleneck. Kohlmeyer acknowledged that the meeting was officially adjourned but asked everyone to remain to hear the discussion. Near-violence flared several times. At one point, Mrs. O'Brien "heatedly pushed Kohlmeyer back several paces and took possession of the microphone."[39]

Little of lasting value came out of the tumultuous meeting. Instead, the clamor of the exchange seemed only to cause party lines to harden. At the same time, the free-for-all lowered most people's opinions of the Art Association of New Orleans. One editorial writer put it plainly: "Wouldn't it seem only reasonable that the defenders and champions of the finer things should be able to conduct a meeting amicably and in accordance with well-established rules of procedure?"[40]

When, years later, Feitel commented on the situation, the memory still elicited a tirade:

There were . . . two know-it-all college professors, both of whom have since left New Orleans, one of whom was soliciting votes from his defenseless girl students. People were being invited to meetings and cocktail parties and were being asked to sign petitions against the Delgado Museum Board and especially against me. These petitions would usually be published in the newspapers. Meetings had even been held secretly with the museum director at the museum, supposedly without the board's knowledge. These were the usual frustrated men and women who saw a chance to become important by having their names in the newspaper. There were those who wanted to use the Museum's grand stairway for their social ascendancy. I felt sure that one of the protesters had his marbles stolen when he was a boy.[41]

The position of the board of the Isaac Delgado Museum of Art was strengthened on May 4, when the attorney general's office of the state of Louisiana rendered the opinion that the board was a private corporation. That meant that it was not subject to the state law requiring public and open meetings. Earlier the city attorney's office had concluded that although the city owned the building, it did not have authority to operate the Museum. Only the board had administrative jurisdiction.

39. *Ibid.*, May 3, 1957.
40. *Ibid.*, May 4, 1957.
41. Feitel, "Confessions," 18.

Armed with these opinions, the Delgado board met on May 8, 1957. As previously, the place of the meeting was secret. But after an hour or so, reporters discovered its location. At the meeting, the board decided to ask the city council to restore the Museum's operating funds. It agreed that later it would consider admitting new members to the Isaac Delgado Museum of Art Association. It also committed itself to inquiring into donors' requests for the return of lent objects. One of the most recent requests to withdraw objects had come from Felix H. Kuntz, who requested the return of Collas' portrait *Free Woman of Color*, a Venetian scene attributed to Francesco Guardi, a miniature of the king of Rome by Jean Baptiste Isabey, and an eighteenth-century French miniature of an unknown subject. Kuntz said it was his intention to donate the works "to the people of the city of New Orleans when a satisfactorily organized and operated museum for the city is established."[42]

A reporter who asked a board member leaving the meeting whether Lansford's hearing had been discussed, got the reply "It wasn't even mentioned."[43] De Verges volunteered to reporters that in his considered legal opinion, the Delgado charter, insofar as it related to the composition of the board, could not be changed, in view of provisions set forth in Isaac Delgado's letters of February 26, 1910, and April 6, 1910. In essence, the board had done nothing to alter its stand. It was as intransigent as ever. Enraged, the Young Men's Business Association asked for a city ordinance making private organizations answerable to the city.

Despite the obstinate show of defiance to the city council, Councilman Jimmy Fitzmorris announced on Wednesday, May 15, that he would intervene in behalf of the Museum board and ask the city council to reinstate the institution's funds. He said, "I'm going to bring the matter up and dispose of it one way or another." Fitzmorris told newsmen that the board, in its letter requesting the restoration of financial support by the city, had "expressed a willingness to accord its dismissed director a 'private hearing' with Mayor and City Council president or both present and to make the stenographic transcript of the proceedings public if so desired by Lansford."

Asked about Fitzmorris' announcement, Lansford told reporters to be wary of the board's letter, for its sole purpose was to recover its

42. New Orleans *Times-Picayune*, April 14, 1957.
43. *Ibid.*, May 9, 1957.

funding. He pointed out that "the letter suggests only the least pos-
sible concession on the part of the board—a private hearing on its
own terms. This concession in no way satisfied the council's objection
to the board's method." Lansford correctly identified the real issue at
stake, saying, "The matter of discharging the museum's director is to-
tally eclipsed by a much larger matter, the fundamental organization
and administration of the museum as a public institution." He went
on to outline his blueprint for establishing the Museum on a firm foot-
ing. First, he argued, the Museum had to be recognized as belonging
to the people of New Orleans; its membership body had to be opened
to all interested persons. He reiterated what he had recommended
previously, that the board be enlarged with fixed terms of office and
that a majority of the trustees be elected from the general member-
ship. Furthermore, he urged that the taxpaying public be represented
by one or more appointees of the city council or mayor. Lansford sug-
gested that the new board, not involved in the controversy, review
the causes and circumstances of his dismissal. That group could ei-
ther reinstate him or confirm the old board's position. Only then, he
maintained, should the city reinstate the Museum's appropriation.
He concluded, "Once this long-needed reorganization is accom-
plished, and the public confidence restored, I am convinced that the
widespread and intense interest recently manifested in this contro-
versy can be converted into constructive action for a greater Delgado
Museum, of which New Orleans will be proud." [44]

The city council, bedeviled by numerous new problems, spent little
time dealing with the Museum controversy at its regular meeting on
Thursday, May 16. Fitzmorris was soundly defeated in his attempt to
have the Museum funds restored. By a vote of four to two, the council
voted to withhold the city's appropriation from the board until it
agreed to grant a public hearing to Lansford. The record shows that
Burke, Cassibry, Clasen, and Fitzmorris voted to withhold. Pretend-
ing imperturbability over the council's action, the Museum board
member de Verges told newsmen that the Museum had trust funds
with which it could keep the facility open and operating for a limited
time. In fact, the only trust funds then existing were the Hyams
trusts, and they were dedicated to the maintenance of the Hyams Col-
lection and to the care of the room in which it was installed.

On May 22, 1957, the Delgado board met and decided to close the

44. *Ibid.*, May 16, 1957.

Museum on June 30 if the city council refused to restore its appropriation. It admitted that the Hyams trusts did not generate enough income to sustain the Museum but reiterated its resolve not to give Lansford a public hearing. It put on record that Lansford "under no circumstances will be reemployed." It also acknowledged that it had "received and filed" a petition signed by 138 persons calling for a complete reorganization of the board, a review of the Lansford dismissal, and a new effort to get the city to restore its funds. The petition was introduced by de Verges on behalf of Kohlmeyer. To the press, de Verges termed it "indicative of an attempt to assume control of the museum."[45] Among those who signed were some of the city's most influential citizens.

Obdurate in the face of appeals for compromise, the board subtly employed its ace in the hole—the fear of losing the Samuel H. Kress Collection. Feitel recalled that the risk of the Kress Foundation's removing the collection was so significant that he "went to New York to reassure Mr. Emerson, Director of that Foundation."[46] His trip occurred in mid-May, when Kohlmeyer was in New York. Kohlmeyer's wife wired him at the Waldorf Astoria that day: "Lansford believes Feitel enroute to see Guy Emerson of Kress Foundation in New York before special Delgado Board meeting next week. Imperative you see Emerson and apprise him of situation. . . ."[47] Kohlmeyer did meet with Emerson, and he was able to reassure the foundation's director of his party's good intentions toward the future development of the Museum.

Alberta Collier reported in her newspaper column, "The World of Art," on Sunday, June 2, that Emerson had said that the threat of losing the Kress Collection was "not imminent" but that the Kress Foundation would be "most concerned" if the Delgado board closed the Museum. Nevertheless, Acting Mayor Victor Schiro, who according to Feitel "was very loyal to me," believed the threat to be an immediate one. Consequently, he introduced a proposal at the city-council meeting on June 6, 1957, to restore the Museum's support provided the Museum board accepted two persons from the council as ex officio members, that it looked into the possibility of enlarging its membership, that it held all general meetings at the Museum, with the

45. *Ibid.*, May 23, 1957.
46. Feitel, "Confessions," 18.
47. Mrs. Kohlmeyer to Charles Kohlmeyer, Jr., May 17, 1957, in archives, NOMA.

press invited, and that it staggered its members' terms. Schiro sought support for his proposal by portraying its adoption as necessary to keep from losing the Kress Collection. His argument was effective, and the council agreed to accept his compromise if the Museum board also assented to it.

That same day, Lansford announced that in order to safeguard his professional reputation, he had appealed to the American Association of Museums for an investigation of his dismissal. This prestigious association, bringing together the directors and the professional staffs of American museums, sets guidelines with respect to the functions of museum staffs and trustees. Lansford asked the city council to accept and consider the national association's report in lieu of the public hearing that had been denied him by the board. The city council, however, reached no decision concerning his request.

Lansford told reporters that "the report of the investigation itself 'would have no teeth' and would take no action one way or the other." He explained that the report would be on file at the association's headquarters in Washington, D.C., where it would be available to the public. In addition, a résumé of the report would be published in the association's publication, *Museum News*. "The report would describe the professional prestige of both sides of the question and reflect on the integrity of the employee and the governing body of the institution," Lansford said. "Its wide publication would let prospective employees of the museum in question know what to expect if [they] accepted a position there." [48]

The Museum board unanimously assented to Acting Mayor Schiro's compromise on June 12, 1957. [49] But by accepting Schiro's proposals, the board of the Delgado conceded nothing. Apprehensive of the possible loss of the Kress Collection if the situation festered much longer, Schiro did not insist on a fair hearing for Lansford. The Delgado board had won the battle; it had exercised with impunity its "right" to fire the director.

The city council met the following day and voted to restore city money to the Museum on a trial basis for the months of July and August. That way, the council felt, it might determine whether the board would operate the Museum in a manner "satisfactory to the people of New Orleans and to the administration and the council." Burke, Cur-

48. New Orleans *Times-Picayune*, June 7, 1957.
49. *Ibid.*, June 13, 1957.

tis, Schiro, and Walter M. Duffoure voted in favor; Cassibry, Clasen, and Fitzmorris opposed the motion. Fitzmorris argued against accepting the resolution, because "either the council is going to have to live up to its original position or it's going to have to reverse itself. We asked for only one thing [that is, a hearing for Lansford]." Cassibry opposed restoring the money even if the board met Schiro's conditions, for he realized that it was making no concessions. "We're not closing the museum," he continued. "The board ought to realize that they are [closing it] by their adamant position. Mr. Feitel said in my presence that 'we're not going to give Mr. Lansford a hearing and I'm not going to resign.'"[50]

A week later the board of administrators of the Delgado met and considered the measures it had agreed to in accepting the compromise with the city council. The board approved the addition of two ex officio members to represent the city on the board, and it reconfirmed its willingness to hold all general board meetings in public at the Museum. As to the city council's remaining stipulations, the Delgado board took no positive action, although its response may be learned from the board minutes:

> The President next requested the Board consider the possibility of amending the Charter so as to provide for a greater number of Administrators.
>
> It is the opinion of this Board, as confirmed by the Attorney for the City of New Orleans, that the charter of Isaac Delgado Museum of Art Association is not susceptible of amendment in so far as it relates to the composition of the Board of Administrators who are charged with the management of Delgado Museum.
>
> As it is the expressed opinion of the Mayor and Councilman Schiro that the possibility of expanding the Board should be inquired into, this Board respectfully suggests that the solution may be for some interested persons to consider legal proceedings against this Board for a Declaratory Judgment and thereby resolve the question of enlarging the Board.
>
> This Board agrees with the suggestion that the term of all its members should be staggered so as to insure wider public interest in the operations of the Museum and active participation by a greater number of the citizens of New Orleans; however, this is not a circumstance which this Board can resolve as the right to fix the term of office of members named to this Board rests with the organization, by whom they are appointed or elected.
>
> Members of this Board request these minutes to record that they will

50. *Ibid.*, June 14, 1957.

promptly suggest and urge the Organizations by whom they were appointed to take such corporate action necessary to comply with the above.[51]

Powerless to effect any substantial changes in the Museum board, Kohlmeyer brought pressure to bear on Mayor Morrison. On June 12, 1957, he wrote Morrison a letter in which he enclosed a petition asking for the reorganization of the Delgado. The petition had been organized by Martha Gasquet Westfeldt, and was signed by "a great many 'solid citizens' rather than 'long hairs.'" Kohlmeyer wrote,

> None of the citizens seem to want the Museum funds restored to the existing Board to be used under the conditions which prevailed in the past.
> I call your attention to the fact that we have tried to stay away from taking a position on the Lansford matter. My group has never fostered Lansford, but on the contrary has indicated that it would take no position as to the merits of the controversy because of a lack of knowledge of the background. I think most of us individually feel that the method of firing Lansford was outrageous, but we likewise feel that if we were in charge of the Museum we would hire him only on a trial basis so as to permit him to prove his worth.
> The group of which I am a member feels that the Delgado Board has forfeited its right to public support by virtue of its public be damned attitude, and that the Board has lost the confidence of the public. We believe that if the museum is reorganized we could get a substantial amount of funds donated to it for its support, but we doubt our ability to raise anything at all with the incumbent board remaining in office.[52]

Two days later, Kohlmeyer wrote Mayor Morrison again, reproaching him for his support of Schiro's plan: "I feel hurt that you did not see fit to tell me that you had changed your position. After all these years of friendly relations, I evidenced to you a personal interest in a public issue for the first time. I think that I was entitled to know where you stood and am writing you this note to tell you that I feel I have been badly treated."[53]

Shortly thereafter Mayor Morrison wrote to the city council and to Feitel, with a copy to Kohlmeyer. He said, "Before I can concur in the

51. Minutes of the Board of Administrators, Isaac Delgado Museum of Art, May 22, 1957.

52. Charles Kohlmeyer, Jr., to Mayor deLesseps S. Morrison, June 12, 1957, in archives, NOMA.

53. Charles Kohlmeyer, Jr., to Mayor deLesseps S. Morrison, June 14, 1957, in archives, NOMA.

4–3 council vote on reinstatement of Delgado Museum funds, I would like to be informed specifically what the Museum Board will do to bring itself into compliance with established City policy for all independent Boards and Commissions that receive city funds." He further pointed out that in the face of the city's recent loss of a million dollars in revenues from the state, it needed "every tax dollar very badly for essential services." He affirmed, "I do not propose to concur in the expenditure of tax money on activities or facilities which are going to be conducted in a private manner." [54]

But the day after he wrote that letter, Morrison agreed to support the decision to restore city funds to the Delgado on a trial basis for July and August. He also announced that Feitel, Peterson, and Stich would not accept reappointment to the Delgado Museum board when their terms expired in December, 1957. The situation was left to cool over the summer while plans were formulated to meet the public's desire of seeing the Museum compelled to reconstruct its system of governance.

On June 25, 1957, Kohlmeyer commented on the impasse in a letter to Mayor Morrison:

> We believe that it is essential that the Board of Delgado as presently constituted, be changed completely in personnel and in method of appointment before we can hope to acquire any public support for the museum. We see no reason why private and corporate contributors cannot donate sufficient funds to support the museum, at least to a substantial extent. This would, of course, have the effect of eliminating a large part of the tax money presently allocated to the museum. Ultimately, all support may be eliminated, or a more valuable public asset could be built. We feel, however, that it is impossible for any fund raising drive on an annual basis to be effective unless there is a radical change in the existing set-up. Public confidence must be restored before the necessary public support can be obtained. Moreover, it is a high probability that no professional man of any standing in the museum world would accept the Directorship of the Delgado Museum under the present Board set-up, and a competent professional, full-time Director is of course, a "must" in a museum the size of Delgado.

Kohlmeyer continued that his group suggested a seventeen-man board, with five from the City Park Improvement Association, five from the Art Association, five from the chief executives' offices of

54. Mayor deLesseps S. Morrison to Glenn P. Clasen, president of city council, June 19, 1957, in archives, NOMA.

local institutions—the presidents of Tulane University, Loyola University, the Chamber of Commerce, and International House, and the dean of Newcomb College—and two from the general public, elected by the city council. Kohlmeyer believed it possible to change the size of the board simply by amending the Delgado charter. He suggested terms of office for five years, with staggered expirations. In conclusion he wrote,

> I have been accused of seeking the presidency of the Art Association and now I have heard that I want to be President of Delgado. I was solicited to get in this fight by some people who thought that a reorganization was necessary, and who, in my opinion, had no idea of personal aggrandizement. Someone has to be the spokesman for any group and it fell to my lot to be the titular head of ours. I would be delighted to serve either the museum or the Art Association in any way that I could, but under the circumstances, I think I would be doing a disservice to the organizations to be President of either. Accordingly, I have determined, like General Sherman, that "if solicited, I will not accept the nomination; if nominated, I will not run; and if elected, I will not serve." [55]

Mayor Morrison responded to Kohlmeyer on July 1, saying that he appreciated the "very comprehensive letter, and both Dave McGuire and I would like very much to see some real private and corporate contributions come into the picture." [56] Morrison indicated that he would use Kohlmeyer's letter to stimulate action, asking councilmen to read it and give him their opinions.

Meanwhile, the investigation of Lansford's dismissal by the American Association of Museums was getting under way. On August 6, 1957, Philip R. Adams, director of the Cincinnati Art Museum, met with members of the board of administrators of the Delgado. Adams had been appointed chairman of the committee of inquiry by Edward P. Alexander, president of the AAM. Also on the committee were Arnold B. Grobman, director of the Florida State Museum, and Louis C. Jones, director of the New York State Historical Association. Grobman and Jones did not meet with any of the principals, for they were to make a judgment from the testimony Adams gathered and from any newspaper articles, letters, or other documents the chairman presented in his report. Adams had met with Lansford the previous day, taking a transcript of his testimony.

55. Charles Kohlmeyer, Jr., to Mayor deLesseps S. Morrison, June 25, 1957, in archives, NOMA.
56. Mayor deLesseps S. Morrison to Charles Kohlmeyer, Jr., July 1, 1957, in archives, NOMA.

Prior to Adams' talking with the board, reporters asked him a number of questions relating to its makeup. Adams said he had "never heard of a board of administrators organized as is the Delgado board."[57] The meeting was closed, and reporters were barred. Feitel's statement after the meeting was condescending; he said he had agreed to the session "out of politeness."[58] In truth, Feitel highly resented being investigated by a national association as prestigious as the AAM. Board members played down the significance of the official inquiry, suggesting that the association was largely made up of directors who would protect their own. Others in the art community patiently waited through the hot months for the official report.

On Tuesday, September 18, the city-council president Clasen announced that at the Thursday meeting of the council, he would introduce a motion to dissolve the Delgado Museum of Art Association. He said that in the motion he would propose that administrative control of the Museum be placed under the city department of property management, with the curator to be a civil-service appointment. Although his motion failed, the councilmen once again voted to cut off funds to the Museum, since the board had failed to set up staggered terms for its membership. Earlier in the summer, the council had appointed Fitzmorris and Duffoure as its ex officio representatives on the board. By the following week, Duffoure was able to offer a motion before council that operating funds be restored until December 31, 1957, by which time it was expected that changes would be made. The motion was approved four to three.

No longer was the issue of a hearing for Lansford a central one. It gave way to the larger objective of restructuring the board. Lansford and his wife, Gretchen, worked the entire summer on plans for establishing a gallery at 627 St. Peter Street, in the French Quarter. It opened Sunday, September 29, 1957, and featured works by American artists such as Gilbert Stuart, Jane Stuart, Thomas Sully, Christian Gullagher, several artists of the Hudson River school, and a few nineteenth-century Louisiana artists. There were also a number of works by French painters of the nineteenth century and hundreds of prints of the same period.

Displayed at the opening was Gilbert Stuart's fine portrait of Major Peter Fort, who had fought in the Battle of New Orleans. The painting

57. New Orleans *Item*, August 6, 1957.
58. *Ibid.*, August 5, 1957.

had been exhibited a number of years before at the Delgado, in a show sponsored by Hirschl and Adler Galleries, of New York. Almost twenty years after Lansford's gallery opened, the Stuart was purchased by the Museum board from Hirschl and Adler. Norman Hirschl, director of the firm, said at the time of the opening of Lansford's gallery that there was no direct relationship between the two dealers. He had known Lansford for years and held him in high esteem, Hirschl later said, but he "did not back Lansford at the time." Fixed now with a handsome gallery, Lansford stayed clear of the maelstrom that centered on the board.

The tumult was interrupted temporarily when it was announced in October that the internationally recognized surgeon Dr. Rudolph Matas had left the Museum a bequest of twenty-five thousand dollars that was to be used by the Museum administrators in the way they considered most useful for the encouragement and promotion of art education and culture. It came at the psychologically right moment for the board, but it had been prompted by nothing the board had done. Dr. Matas gave out of his long friendship with Isaac Delgado, who had become one of his first wealthy patients, in 1894, setting him on the road to financial comfort.[59]

Matas, too, remembered with gratitude Delgado's bequest of $200,000 to Charity Hospital in 1906. The sole stipulation of the gift had been that it be used to construct a surgical and gynecological theater for the treatment of indigent patients of both sexes. The facility, Delgado specified, was for medical instruction by the "professors of Surgery and Gynecology of the Medical Department of the Tulane University of Louisiana, my friends Dr. Ernest Lewis and Dr. Rudolph Matas, and their successors in their respective chairs."[60] Feitel recollected that "Dr. Rudolph Matas would visit the museum once in a while accompanied by his wife and after her death, his nurse. I was very fond of the old gentleman and we became good friends." Feitel said Matas "never could understand or appreciate any abstract paintings much as he would try to figure them out. After examining such paintings he would often turn to me and give his diagnosis—'A psychiatric case?'"[61] Whether or not he understood art, Matas certainly

59. Isidore Cohn, *Rudolph Matas: A Biography of One of the Great Pioneers in Surgery* (Garden City, N.Y., 1960), 235.
60. *Ibid.*
61. Feitel, "Confessions," 14.

understood friendship, and it was because of it that he gave to the institution that Delgado had established the largest unrestricted contribution it had received up to that time.

Although October thus began favorably for the Museum, the month turned sour for it. On October 9, the Southern Art Museum Directors' Association convened their annual meeting in Miami to discuss the "continuous execution of museum directors in the South."[62] There the assembled members resolved to deplore the action the Delgado board had taken and to "withdraw the museum from all professional recognition and reciprocal services until the museum re-establishes itself as an institution with good trustee-staff relations with a professionally trained museum director as administrator."

When news of this censure arrived in New Orleans, "Arthur Feitel was asked by phone if he would listen to the Associated Press dispatch from Gainesville and then make comment. He answered, 'Well, you needn't bother, I'm not interested.' He then hung up." Lansford was much more cooperative, saying, "I am not sure of the exact extent of the implications, but I am sure that it bodes no good for New Orleans' prestige in the immediate future."[63] He explained that it might possibly mean that the Chrysler exhibition, a major show planned for the fall, would be canceled, and certainly it meant that the previously planned Latin American exhibition would fall through.

The Southeastern Museums Conference met a few days later and unanimously endorsed the action taken by the Southern Art Museum Directors' Association. About the same time, Feitel received the report by the American Association of Museums. Published in the association's organ, *Museum News*, on November 15, 1957, it placed the board in an extremely awkward position:

> The Council of the Association felt that since the circumstances seemed in its own words to be "of sufficient moment to concern the future welfare of the museum or the employee, or the museum profession as a whole" a committee of inquiry should be appointed. The chairman of the committee spent the fifth and sixth days of August interviewing the principals. He received full cooperation from all concerned and submitted his findings to the other members of the committee.
>
> The committee has tried to maintain a proper detachment, and, looking at the discernible facts as they appear to be, has come to these conclusions:

62. New Orleans *Times-Picayune*, October 8, 1957.
63. *Ibid.*, October 12, 1957.

1. That the present organization of the Isaac Delgado Museum of Art and its relation to the New Orleans Art Association is a formula for administrative tensions and confusions.

2. That the Board's specific charges against Lansford, some of which may be legitimate, do not add up to a serious impugnment of his professional performance or personal conduct, especially in contrast to his eight years of productive service.

3. That Lansford's contention that the basic reason for his dismissal was a clash of personalities between President and Director seems to be valid.

4. That, while the Board feels that its dissatisfaction was "adequately called to Lansford's attention" on many occasions, his contention that he was not informed of the reasons for his dismissal is largely true. The Director was not ordinarily allowed to attend the Board's meetings beyond giving his monthly reports and the only channel of communication between Board and Director seems to have been the President who, in the Board's language, frequently "admonished the Director," "ordered," and "directed" specific administrative actions. It is easy to see how such communications might appear more personal than official.

5. That while the Board has undoubtedly power to fire, as it has to hire, and feels that two-months' severance pay was a generous arrangement, the abruptness and other circumstances of the dimissal were harmful to the individual and to the institution. They could also be expected to produce a strong press reaction in almost any community. A museum year is not unlike an academic year and it would seem reasonable to have continued the Director's appointment to November 15, 1957 (since he was appointed on November 15, 1948) as an eight months' terminal appointment. Abrupt dismissal in midseason not only makes it difficult for the employee to find a new appointment, but the Museum may also have difficulty in finding an adequate successor without a wasteful and confusing interim.

6. That the Board's action and motives were essentially negative, without any concrete plan for improved administration, whereas Lansford, under extreme handicaps, has shown a great concern for the institutional welfare of the Museum.

On December 9, 1957, a special meeting of the Isaac Delgado Museum of Art Association was held with the new members of the Kohlmeyer group present. At that meeting, a resolution was enacted extending the charter of the Museum to include two city councilmen as board members with voting powers. Thus the Museum complied with the council's demands of the previous summer.

Two days later, in a "harmonious meeting at the Delgado Museum of Art," Kohlmeyer was elected president of the Art Association of

New Orleans.[64] The other officers elected at the same time were Charles Reinike, first vice-president; W. E. Groves, treasurer; and John Clemmer, secretary. The reforming party had won out. Kohlmeyer appointed George W. Rickey and Robert J. Newman as the association's representatives on the Museum board. Feitel remained the Museum's acting director.

Kohlmeyer and his supporters turned their attention to finding a professional to take Feitel's place. To attempt to reinstate Lansford would have been injurious to the Museum. Because the bickering and fighting had to stop, Lansford was sacrificed. A new person from the outside would have to be found—one who could heal the wounds of the bitter controversy that had started with the impetuous firing of Lansford.

Lansford was the silent hero in the end. He did not force his cause to the detriment of the Museum. Although he had many friends in the Kohlmeyer group who would have continued to fight for his reinstatement, he did not press for his own advantage, knowing that that would doubtless do the Museum more harm than good. He had been exonerated by the American Association of Museums, and his professional reputation was intact. He had done much to enlarge and enrich the Museum and the art community of New Orleans. He could retire to his art gallery and his restoration work, knowing full well he had done his best.

64. *Ibid.*, December 11, 1957.

X

Charles Kohlmeyer, Jr., and Compromise

The harmonious meeting of the Art Association of New Orleans at the Isaac Delgado Museum of Art on December 11, 1957, did not end the battle for the Museum. It simply laid to final rest one of the martyrs, Alonzo Lansford. At the meeting, after the nomination committee's presentation of its slate of nominees, Miriam Barranger, a local artist and a loyal friend to Lansford, nominated him to the Art Association board. According to the newspaper accounts, it was the "only tense moment at the meeting."[1] But the chair pointed out that Lansford could be nominated from the floor only if the nominating committee's report was not approved. Its report was accepted by a vote of sixty-three to three, though the newspapers reported that there were a hundred abstentions. The voting majority, led by Charles Kohlmeyer, Jr., felt that pursuing the Lansford matter any farther would be detrimental to the Museum.

Kohlmeyer and his party turned their efforts to countering the sway Arthur Feitel held over the Museum as acting director. They felt their goals could be achieved through a reorganization of the Museum board. They wanted the size of the board increased as well, to make it more representative of the community. But all that work had to be preceded by a search for a museum professional to become director.

In his capacity as president of the Art Association, Kohlmeyer was the most powerful member of the Museum board, given that the Art Association provided all the funding for exhibitions, lectures, and social functions, a sum that constituted nearly half the Museum's budget. When Feitel held such power, he had been accused of wielding coercive influence over the Museum board. Would the situation

1. New Orleans *Times-Picayune*, December 12, 1957.

be different in the hands of a reformer, and most important, could changes be achieved peacefully and without further harm to the Museum?

Immediately after his election as president of the Art Association and his appointment to the Museum board, Kohlmeyer expressed his goals in a letter to Laurence Coleman, president of the American Association of Museums: "I am not at all interested in the merits of the controversy between Lansford and the Board, but I am interested in attempting to force a reorganization of the Museum along proper lines. The section of the A.A.M. committee's report dealing with the relationship of the Art Association with the Museum gives me a good deal of ammunition." He concluded, "I hope that the next ninety days will mark a complete change in the basic set up, because unless it is changed, I think that we can do nothing at all in the art world locally."[2]

Acting under the extension to the charter adopted by the membership a month earlier, the board of administrators of the Delgado Museum of Art elected new officers at its meeting of January 8, 1958: Charles E. Whitmore, president; Kohlmeyer, vice-president; Dr. Edwin L. Zander, secretary-treasurer; and Duralde Claiborne, assistant secretary-treasurer. The election of officers was unanimous, although an exception was voiced "that should Mr. Whitmore for any reason be unable to act as President, the action of Mr. Kohlmeyer in then assuming the presidency of the Delgado Board while also serving as President of the Art Association might revive the criticism previously experienced on these two offices being held by the same person." Kohlmeyer answered that he was certain that if a contingency occurred that required him to assume the presidency of the Museum board, he would resign as president of the Art Association.

The meeting also addressed several other important matters, including the investment of the $25,000 bequest from the estate of Dr. Rudolph Matas—the largest cash bequest the Museum had ever received. The discussion concerning whether the bequest should be invested or spent for sorely needed renovations brought forth vehement opposition to any expenditures for updating the building until a master plan for the entire Museum had been drawn up. George W. Rickey, a new board member, expressed the sense of the majority

2. Charles Kohlmeyer, Jr., to Laurence Coleman, December 16, 1957, in archives, NOMA.

when he said that "it would be well to defer work of this type until a permanent director had been employed so that the benefit of his ideas could be obtained and also that the work that would be done would be in keeping with the exhibits and uses of the rooms contemplated by the director."[3]

The board began thinking, too, about Kohlmeyer's proposal for its own reorganization. His suggestion was that a panel of three attorneys—Charles L. Rivet, Edward J. de Verges, and Judge Frank J. Stich—determine the legality of expansion and give an outside opinion as to whether or not the size of the board could be increased by the charter amendment. Kohlmeyer also proposed that a committee be jointly appointed by the board of commissioners of City Park and by the Art Association to study the organizational setup of the Delgado board in relation to those two entities and to report its findings as soon as possible.

The problems the Delgado administrators faced in the new year were multifaceted and interrelated. They were to find a new director, to refurbish the Museum's worn-out physical plant, and to reorganize the governing board. Even persons with vast museum experience face such challenges with apprehension. Nonetheless, under the moderating guidance of Whitmore, the board quickly took its first steps. In the end, however, success in solving any one problem too often hinged upon a resolution of another, and Kohlmeyer's desire to restructure the board had to defer to other more pressing needs.

The Lansford crisis had left the New Orleans art community uneasy about the future. People wondered what competent professional would apply for the directorship of a museum whose board behaved as a high-handed clique, refusing to answer to anyone for its actions. How could a sound and aesthetic renovation of the Delgado be accomplished unless there was a professional director in charge of it? How could the board best be organized to represent the artistic needs of a community? And certainly not least, what were to be the artistic goals of the Museum?

In February, at its monthly meeting, the board announced that George W. Rickey, a sculptor and a professor of art at Tulane, would serve as chairman of a special committee to screen applications for the directorship. Also serving on the committee were F. Julius Dreyfous

3. Minutes of the Board of Administrators, Isaac Delgado Museum of Art, January 8, 1958, pp. 2, 4.

and Feitel. Whitmore reported that he had a "list of about twenty applicants" which he would turn over to Rickey.[4] But instead of discussing the applicants, setting up criteria for their evaluation, or establishing procedures for interviewing them, the meeting turned to "more pressing matters." The minutes show that if the issues discussed were more immediate, they were hardly more pressing.

Behind the scenes, however, other ideas were under discussion that would bear upon the Museum's finances, directorship, and renovation. On February 4, 1958, Kohlmeyer held a meeting on the possibility of enlarging the membership of the Art Association, thereby increasing revenues through the additional fees. He was also interested in having Whitmore look into a closing of the Museum on Mondays, in order to cut costs and bring the Delgado into conformity with other museums in the city. Kohlmeyer wanted, as well, to appoint a committee to study the Hyams trusts and to review the management of those funds by the Whitney National Bank.[5] He suggested discontinuing the Hyams Room, saying, "I have always thought that our Museum was far too small to permit a substantial portion of the space to be devoted to a permanent exhibit."[6] On Kohlmeyer's agenda too was a more significant role for the Art Association in the Museum's accessions process. It was his belief that the Art Association of New Orleans accessions committee—consisting of Henry Stern, the well-known antique dealer; James Lamantia, professor of architecture at Tulane; Alfred Moir, professor of art history at Tulane; and Rickey— was more able and knowledgeable than its counterpart at the Delgado.

Meanwhile, Rickey conducted the search for a director, inviting possible candidates to apply. By the March meeting of the board of the Museum, Rickey was able to announce that there were twenty-seven prospective candidates, although applications had actually been received from only "seven men and one lady."[7] The board's records reveal that, of those eight applicants, only three received se-

4. Charles Kohlmeyer, Jr., to Charles E. Whitmore, February 4, 1958, in archives, NOMA.

5. The Whitney National Bank invested Hyams' money in low-yield, tax-exempt securities when the Museum was a tax-exempt institution; it could have obtained higher yields from other securities of unquestioned safety that are acceptable for the investment of pension funds and the like. The corpus of the Hyams trusts had not grown in the thirty-odd years that the bank had managed it. See Minutes of the Board of Administrators, Isaac Delgado Museum of Art, March 12, 1958, p. 2.

6. Kohlmeyer to Whitmore, February 4, 1958, in archives, NOMA.

7. Minutes of the Board of Administrators, Isaac Delgado Museum of Art, March 12, 1958, p. 2.

rious consideration: John Everett Brown, curator of education at the John Herron Art Museum, in Indianapolis; Jerome Allan Donson, director of the Long Beach Museum of Art, in California; and Sue Thurman, former director of the Junior Art Gallery of Louisville.

Brown, a native of Gloucester, Massachusetts, was thirty-one years old. He had received an A.B. in 1950 from Western Reserve University, with a major in English and a minor in art history, and he had attended the Graduate School of Western Reserve in the same fields. He had served as a lecturer at the Cleveland Museum of Art and as curator of education at the John Herron Art Museum. In addition, he had won the first Research Fellowship granted by the Corning Museum of Glass. Brown's credentials included experience in the educational side of museum work, an area in which the Delgado needed to cultivate strength. His work with glass at Corning also recommended him, because the Delgado acquired more of the Billups Collection each year.[8]

Donson was one of those who applied for the directorship at Rickey's invitation. At thirty-four he was among the oldest of the candidates. He had earned his A.B. in social studies and fine arts from the University of Southern California in 1949 and an M.S. in education in 1950. Donson had attended graduate school in art history at the American University in Denmark and at the University of California at Berkeley. He had experience as a preparator at the Museum of Anthropology, and he had served as director of the Florence Museum, in South Carolina, and as director of the Long Beach Museum. Particularly attractive was Donson's experience in the administrative end of museum work.

The third candidate, Thurman, had been born in Hopkinsville, Kentucky, in 1927. A Phi Beta Kappa, summa cum laude graduate of the University of Kentucky, with a major in fine arts, she had joined the faculty of Wilmington College, in Ohio, in 1949. The next year she was selected one of sixteen fellows of the American Council of Learned Societies, and she began graduate studies at Columbia University, concentrating on the functions of art among primitive societies. While pursuing her M.A., she worked intensively with the

8. The fact that the Museum was receiving a portion of the Billups Glass Collection was known to only a few people. "The only people connected with the Museum" who had seen it, according to Melvin P. Billups, "were the two who are out—Lansford and Feitel." See Melvin P. Billups to Charles Kohlmeyer, Jr., April 21, 1958, in archives, NOMA.

storage collections of the American Museum of Natural History, the Museum of the American Indian, and the Brooklyn Museum. In 1952, she accepted the position of director of the Junior Art Gallery of Louisville, an experimental project sponsored by the Junior League and the Louisville Fund. Thurman had also served as a visiting professor of art at the University of Kentucky. She was highly regarded by the Delgado search committee for her academic prowess, as well as for her work in Louisville as director of the Junior Art Gallery.

While in Louisville, Thurman had introduced an educational arts program for the uninitiated of all ages. Not only had she supervised financial and program matters but she had also doubled the museum's budget and attendance. She had been able to organize a membership program that helped pay for the gradual purchase of a permanent gallery collection. And she had written and published numerous catalogs of exhibitions. Such accomplishments indeed commanded favorable attention by the committee, aware as it was of the needs at the Delgado. That Thurman was a woman seemed the only impediment to her selection.

But Thurman made a strong enough impression from the start that even gender bias did not long work against her. Rickey and Moir, who both felt the desperate need for a professionally experienced director, were more frank with Thurman than they were in their correspondence with other candidates. They laid all the Museum's problems before her candidly. Moir wrote to Thurman on January 27, 1958,

> I do not know how much Mr. Rickey has written you about the Delgado Museum, but it has up to this point in time been a very inefficiently run institution, hampered not only by insufficient public interest, and therefore, an insufficient budget, but also by incompetent management. No parts of the museum collection are fascinating, even potentially, although there are a few pieces of Louisiana art, particularly landscapes, which suggest to my mind one future area of development. There is also a small, not very distinguished, collection of contemporary American painting and there are three rooms of Kress paintings. In the past, I do not think the Board has cared much about preservation or interpretation one way or another, although I am inclined to believe that the newly elected Board would favor an interpretative approach, particularly considering the fact that no very substantial amounts of money can be expected for the museum in the immediate future.
>
> There is no professionally trained staff at the museum at the present. The staff consists of an office secretary, who is willing, but addlepated, an aging retired Navy Chief Petty Officer who is the Museum Superin-

tendent, extremely conscientious, helpful and able, who really runs the museum, the museum guards, I think no more than four in number, and some nice, casual volunteer lady helpers. There is a Saturday morning class for children. I think I can assure you that you will find a few Justus's on the Museum Board, although it is hard to identify any of them with the Ulfert either.

This all sounds extremely pessimistic I am afraid. The brighter side of the picture is that we now have very actively interested in the museum, a fairly large group of people, probably as many as a hundred, representing all aspects of the population of the City of New Orleans. Some financially able, others social, others at least partly experienced in museum activity, who are at present working very hard at the museum and who can be expected in the future to devote a great deal of effort to its improvement. I think any new director coming in could look forward to a great deal of enthusiastic cooperation from this group with the minimum of interference and back-biting. My impression of the new Museum Board is that its members would be anxious to do as much as possible for the development of the museum within the limited scope of their experience and would be inclined to cooperate fully with any museum director whom they trusted. Fortunately, for the museum, George Rickey is on the Museum Board and as I am sure you know, he speaks always with good sense and always convincingly, so I believe any new museum director could look forward to his helpful guidance of the Museum Board.

. .

P.S. I see in your letter another question which I haven't answered, that is, what are the main drawbacks to successful operation of the museum. I think the main drawback is that people in New Orleans are unaccustomed to having a good museum, don't know what a good museum is, and have to be educated as to what it is and how much it costs to have a good museum. As you may judge from what I have written above, we already have a nucleus group for this educating process and in the past year we have made very heartening progress. I can not speak for George, nor can I speak as an artist as I am an art historian, but I find New Orleans an extremely agreeable place to live and have found many of my most intimate friends among the group of vigorous artists, mostly in their early thirties, twelve of whom, incidentally, are opening on the 2nd of February, a group show at the Riverside Gallery in New York. New Orleans is, of course, not New York, but some of us, George and I included, consider this to be an advantage.[9]

It is a bit surprising that after receiving this letter, Thurman continued to pursue the job opening. Indeed, at one point in the search it

9. Alfred Moir to Sue Thurman, January 27, 1958, pp. 1–2, in archives, NOMA.

was unclear whether Thurman was being considered for the position of director or of curator, for Rickey told her that some board members felt that both appointments should be made. He asked her whether she would accept the curatorship "under a good man." [10] In a letter dated February 17, 1958, she answered,

> As strange as it may seem, I myself would undertake either the directorship or the curatorship with equal enthusiasm: provided a really alert colleague would be at work on the other. It has been proven time and time again that no museum is any better than its exhibitions and programs (the curatorship); conversely, that exhibitions and programs are meaningless without strong community education, sound financial procedures, etc. (the directorship).
>
> Trying to decide which position you would rather hold—minus a strong partner on the other—is like trying to decide whether you would prefer to be blind or deaf. You would wish to avoid either! In general I will say (without knowing which direction my own application has been sent by now) that the two positions will be almost equally demanding (both on qualifications and on performance) and that they probably should be almost equally remunerative. The distinction between the two probably best lies in authority rather than in salary.
>
> Personally, I am agreeable to either candidacy. During the past year, I have been invited to apply for several directorships and for several curatorships: and the two really seem equally interesting to me. If you sense, in this instance that the still-overweight conservative side of the board membership would be strained to accept and work with a woman as director, I would say to avoid this unnecessary overtaxing. We know they have already had problems with a man as director. [11]

On February 24, 1958, Rickey wrote to Thurman that he had officially placed her name before the board in candidacy for the directorship. He noted that the board was "just beginning to realize what sort of job it has ahead of it in trying to make the place respectable enough to be attractive for a sound candidate." [12] He also reiterated that the Museum needed two staff members, a curator and a director. A week later he wrote to Thurman about her candidacy saying, "I think frankly there will be some prejudice in the end against a woman. Most of the Board are rather conservative older men. Some of us think there is a great deal to be said for getting two people and not one." He added, in conclusion, "I don't know how this will go. It's a tough situation in many ways and it may not really develop its true

10. George W. Rickey to Sue Thurman, undated, in archives, NOMA.
11. Sue Thurman to George W. Rickey, February 17, 1958, in archives, NOMA.
12. George W. Rickey to Sue Thurman, February 24, 1958, in archives, NOMA.

character until they start being turned down by some people that they think they would like to have. This would be very healthy."[13]

The board's irresolution dragged on through March, and by April the number of candidates had dropped. Kohlmeyer, who had given the Donson candidacy much review, finally decided against it, and Melvin P. Billups, who had spoken with Kohlmeyer about the directorship, came to the conclusion that neither Donson nor Brown was experienced enough for the position.[14] Of the top three candidates, Thurman remained. In March, 1958, S.G. Creighton, a professor at Indiana University, had written Rickey that "Sue is admirable in many ways professionally: thinking up fresh and stimulating themes for exhibitions, getting stunning loans from unexpected resources for them, installation, and getting into the consciousness of the public are her outstanding virtues." One problem he mentioned was that a position would have to be found for her husband, who was a painter and professor of painting. Another difficulty, Creighton wrote, concerned Thurman's "executive relations with her staff, which she tends to slavedrive (along with herself) and her board. She resigned in Louisville over a policy principle, and the board was simply startled, having no inkling."[15]

Thurman's virtues outweighed her liabilities in the eyes of the selection committee. Its members also believed that finding a position for her husband would not be hard, for there were opportunities at Tulane and at the newly forming branch of Louisiana State University at New Orleans. Thurman's willingness to come cheaply in comparison with the men also counted in her favor. On May 20, 1958, the board, upon the recommendation of the selection committee, passed a motion to hire Thurman as director for a three-year period provided she had a male curatorial assistant. Kohlmeyer was designated the board's representative in drawing up a contract with her.

A more volatile matter occupied most of the board meeting in May. For a large nude bronze sculpture, *Hercules the Archer*, by Antoine Bourdelle, had been positioned at the plaza entrance to the Museum, where everyone entering or leaving the Museum could see it. Glenn P. Clasen, a city councilman, took exception to the statue's presence outside the Museum and wanted it moved back inside Statuary Hall,

13. George W. Rickey to Sue Thurman, March 4, 1958, in archives, NOMA.
14. Charles Kohlmeyer, Jr., to George W. Rickey, April 28, 1958, Melvin P. Billups to Charles Kohlmeyer, Jr., May 13, 1958, both in archives, NOMA.
15. S. G. Creighton to George W. Rickey, March 21, 1958, in archives, NOMA.

where he felt it would be less "offensive." Rickey disagreed with Clasen's standards, arguing that "many nudes are on exhibition in parks, both here and abroad." The sharp discussion ended only when Robert J. Newman said that "he could see nothing improper in the statue being outside, but rather than antagonize the Council at this time, when funds were needed for a Director's salary, he would go along with the request of the Council."[16] A motion was passed to bring the statue back within the Museum.

The press had a field day with this. On May 21, 1958, under a picture of *Hercules the Archer* on the plaza of the Museum, the *Times-Picayune* ran the front-page headline "Museum Board Votes 4–3 to Take Hercules Inside: Displaying Nude Statue on Outer Steps Rapped." The picture's legend explained that "Clasen branded the statue as 'indecent' and 'bad for school children.'" Most of the letters to the editor that followed favored leaving the statue outside. Public controversy was again astir, and the Museum was again in the middle of it.

Alberta Collier, the art critic of the *Times-Picayune*, took the occasion to criticize the condition of the Museum. She wrote that under the acting directorship of Feitel, "the presentation of the museum's collection has deteriorated," and she decried the "hodge-podge" and "clutter" that she saw in the Delgado's halls. Applauding the decision to put the Bourdelle nude outside, where "for the first time the magnificent sculpture could be seen in a proper setting," she accused the board of "capitulating" in its vote to remove it from the plaza entrance. At issue, she suggested, was "whether such incidents are possible because of the basic weakness of the museum board setup." Continuing, she wrote of the board,

> Five of its members by law are drawn from the City Park board and may or may not have any interest or background in art—only three come from the Art Association of New Orleans.
> Last year's addition of two ex-officio members from the city council has not added to the art-conscious section of the board.
> Enlargement and modernization of the board has been discussed and recommended. No announcement has yet been made on any progess toward finding legal means for such a change.[17]

The hubbub that arose incommoded the Museum Board as it tried to hire a capable professional as director. Dependent upon the city

16. Minutes of the Board of Administrators, Isaac Delgado Museum of Art, May 20, 1958, p. 3.
17. New Orleans *Times-Picayune States*, May 25, 1958.

council for operating expenses, the board felt pressured by the council's criticism. Financial realities were an effective check on artistic freedom.

Kohlmeyer, who had been completely open in his correspondence with Thurman and who, incidentally, had voted against moving *Hercules the Archer*, mentioned nothing of the controversy in his letter to her of May 26, 1958. He addressed only the matter of outlining a contract that might be agreeable to her, and he proposed one wording:

We hereby offer you the position of Director of the Museum on the following terms and conditions:

1) You are to assume your duties in New Orleans as Director on or about September 1, 1958.

2) Your salary will be fixed at the rate of $7,000 per year for the calendar year 1958; $7500 per year for the calendar year 1959; $8,000 per year for the calendar year 1960; and $8500 per year for the calendar year 1961. Your salary will be paid to you monthly.

3) This contract shall terminate unless renewed by mutual consent on December 31, 1961.

4) You will be granted no vacation in the year 1958 but in each of the subsequent three years you will be allowed a three-week vacation without deduction in pay.

5) Your duties as Director of the Museum will be to care for the existing permanent collection and seek additions thereto; to supervise the internal maintenance of the museum building; to provide for the installation of the permanent and temporary exhibits which may be shown at the Museum; and generally to operate the Museum as its Chief Executive Officer subject to the general supervision of the Board of Administrators and within the terms and conditions of the budget which will be afforded to you. In this connection your attention is invited to the fact that the Art Association of New Orleans has been known as the "Exhibiting Agency" within the Museum and that activities therein in the past have been supervised by that organization which has had a very close working arrangement with the Museum. Your duties will also encompass liaison with that Organization and the direction of its activities insofar as the Museum is concerned.

6) In addition to the staff of the Museum already in existence, which includes Mr. Dubret as Custodian, Miss Ducros as Clerical Assistant and the Guards, who also do janitorial and minor maintenance work, the Museum will arrange to procure the services of a curatorial assistant for you. Your assistant's salary will be fixed at a sum not to exceed $5500 per annum.

7) It is understood that at the termination of this agreement, it may be that the Museum will desire to procure the services of a Director at a sal-

ary substantially higher than the maximum amount which your salary may reach hereunder. If so, it may be that the curatorial position or the assistant directorship will be offered to you, and you indicated your willingness to accept this possibility without binding yourself to an acceptance of a secondary position in the museum.

If the foregoing meets with your approval, I shall appreciate it if you will sign and return a copy of this letter, whereupon it shall serve as a contract between us.

Thurman wrote her reply on June 1, 1958. After expressing pleasure at being invited to accept the directorship, she commented on the specific points of the proposed contract:

I will hereafter follow the itemization of your formal letter, sometimes combining items which seem to me to interrelate (namely, 2 *with* 6 then 3 *with* 7). I shall purposely leave item 5 until last. It constitutes the real heart of the agreement and merits some direct comments from the candidate taking on the duties.

(1) AGREEABLE. We are currently showing our rural home and expecting to make whatever reductions prove necessary to complete its sale by September 1. May I interpret "on or about" to mean that I might even begin early (sometime in August) in the rare event that selling and moving goes *faster* than scheduled? I know it would be distinct advantage to arrive quietly and go over the files, etc., prior to my introduction and the fall season.

(2/6) Item two is AGREEABLE in consideration of item six, which I realize is a completely new item on your staff budget. Item six must, of course, be honored immediately. As we are all aware, the two salaries *combined* would be a sum suitable for the Director's responsibilities alone—were the Museum a "going concern" today. But to get it on its feet, the Director must place professional help as the highest of all considerations.

Concerning item six in particular, it must be understood that the second professional is needed to work full-time on a block of duties peculiar to the assistant namely, fulfilling on a day-to-day basis in the presentations set up in advance by the director. The unaccustomed presence of a second professional must not be interpreted as a freeing of the director to become centrally involved in tangent matters, for example money-raising, matters which belong in the capable hands of local financiers, attorneys, and the like. To focus this comment, I add that most plants this size consider the minimum number of professionals to be four: director, assistant director, curator of collections, and curator of education. The Delgado staff will start out overloaded, and will have to work out volunteer solutions—additional work!

Further to item six, I would reserve the right to enumerate qualifications of the curatorial assistant and select same, subject to Board approval. Also, I understood in my conversations with George that $5,500 will be made available for the curatorial assistant's salary. Since a good curatorial assistant will cost no less than this, and a poor assistant would indeed be worthless at any price, should we reword "sum not to exceed $5,500" to read instead "sum of $5,500 available"? This is not to say that the full sum would necessarily be spent (should we run into difficulty in finding the perfect assistant), but merely that it *can* be spent on a worthy candidate, in full.

While speaking of other staff members, I will insert my answer regarding the existing staff, hiring, etc. I think that the Director must have the freedom, after consulting with the Board or with a standing committee within the Board, to hire and fire the nonsupervisory personnel. Otherwise, the Director cannot expect maximum cooperation from the kind of person likely to do this kind of work. Of course, I understand that Mr. Claiborne's position is somewhat unique—and perhaps inefficient—but that it will eventually expire of its own accord. So far as I am concerned, if the reasons for retaining Mr. Claiborne's services are sound *and* if Mr. Claiborne has proven himself altogether capable, he could continue to handle the books, subject to reference by the Director.

(3/7) AGREEABLE, both items. May I add that I find item seven extremely forthright and considerate, as the Board's actions beyond the dates of this three-year period are entirely out of my realm. I only hope that in three brief years the museum can begin to show sufficient progress that it *can* move into higher gear, status-wise and salary-wise. In any event, the Board can express itself at that time as to any possible renewal or revision of my position with the Museum.

(4) You mentioned your uncertainty about the vacation period, so I won't be shy about noting that it is customary for professional museum personnel to receive one month's vacation. Usually vacations come during summer months, on an alternate system. My month would probably be either July or August, due to slackness of operations locally and elsewhere in the museum world. It is important that the assistant also receive the full vacation, for we could hardly get a good person without it, speaking competitively.

As to my punching of the time clock, George has told me that one of the nice things about working with New Orleans people is that they are more appreciative of concrete accomplishments than of rigid schedules. Although it is my very nature to work hard, I like to reserve the right to adopt whatever timing seems sensible. It is this extent of freedom which allows an intellectual individual to compromise the grind of administrative realities with the gentle pace of artistic planning.

The same approach would hold for travel, to arrange loans or attend

conferences. All conscientious museum directors invest as much time as they can spare on these contacts. This is a field in which colleagues are extremely generous with aiding each other's programs, provided the ties are kept strong.

(5) AGREEABLE. I want to add that the Director is usually just as interested as the Board in having a Museum all can be proud of. But the Director is somehow in a position to realize a bit more immediately how slowly these things come to pass. It might appear that since the Museum has been running without Director or Assistant it should take shape immediately once these people are present. Actually, the most improvements the first year would be behind the scenes: "housecleaning" of all types, especially in the storage collection. Exhibition-wise, there can be only rented shows during the months required to plan and develop unique ones—which are the only answer to quality operations, especially when the permanent collection is of uneven quality. It will also take a while to establish a program for training graduate art students for docentry. The same holds for Junior League and other civic volunteer channels. So it is my belief that we must all expect to work steadily and hard, with a concept of great patience.

Though I really enjoy the intrigues of promoting and publicizing, I would expect to have any real campaign *follow* getting the museum in good order. Finally, attendance: this comes in naturally, as the direct response to a good museum, well promoted. To summarize my ideas on priorities: (a) good galleries with good interpretation at the Museum, (b) lively promotion to increase use of same, (c) further public services appropriate to an art museum, added gradually enough to be done well.

To continue with regard to the Director's philosophy, my above statements presuppose authority in proportion to responsibility. I feel sure that the Board will be only too glad to be relieved of the countless operational decisions, of a program nature, which it has had to deal with lately. Therefore, I review the fact that I would wish the Board to initiate all those actions involving primarily its own talents—at all times participating to the fullest in the museum's entire program. Reciprocally, I would expect to originate exhibition ideas, the arrangement of the galleries, and other such matters as have set up the requirement that the Director's special training and experience lie in the field of art. In so doing, the Director should at all times be considerate of the Board's great efforts (all contributed) which make the whole operation possible.

I feel that the most can be accomplished by having the Museum's sponsors and the Museum's personnel fully informed of each other's plans and efforts. To this end, I suggest some arrangement whereby the Director be free to attend Board meetings fairly regularly: making reports of progress, problems, etc. This seems a fairly efficient way of keeping each other posted. Such matters as the Board might prefer to discuss in private might be worked on in committee and reported at pe-

riodic sessions scheduled especially for these matters. It has never been my idea to be a voting Board member, but rather a well-informed Director. I trust that some arrangement for regular "visiting" by the Director would be acceptable to every Board member and would necessitate no amendments to existing documents.

This ends the itemized matters, with apologies for the lengthiness of my comments.[18]

On June 12, the city council voted the funds necessary to hire Thurman. Kohlmeyer wrote to her,

I am glad to be able to say that it looks as if everything is in order. And if you are still of the same mind, you will be our new Director. . . .

. . . I must tell you that the delay was due to the fact that we had difficulty in getting the City Council to give us back the appropriation which they took away when Mr. Lansford left. . . . Mr. Whitmore appeared before the Council this morning however and we squeezed through by a four to three vote on a reinstatement of enough to cover the additional payment which we will have to make to you when you come down.[19]

He ended the letter with a discussion about timing the news release of her appointment, remarking, "The papers are full of the Museum again." But he failed to explain why. He passed over the Hercules incident entirely, despite the board's unanimous vote on June 10, 1958, to reconsider the earlier action removing the statue. Nor did he mention the antagonism still voiced by city councilmen like Theodore M. Hickey at the Museum board's unwillingness to hold itself accountable to the city council. Hickey felt the appropriation vote should have been postponed until council could "find out once and for all just what is the status of the Delgado Board. What right do we have to contribute to an institution or a board which is a quasi-public institution?"[20] Whitmore, addressing the council, skirted that issue and stated simply that the time had come when "we cannot continue to operate the Museum on a part-time basis. It must have professional direction." He underlined his assertion by suggesting that the Samuel H. Kress Collection would be withdrawn "in the near future unless the Museum can obtain a director." His warning proved effective, and by a vote of four to three, Thurman's salary was approved through the year.

18. Sue Thurman to Charles Kohlmeyer, Jr., June 2, 1958, in archives, NOMA.
19. Charles Kohlmeyer, Jr., to Sue Thurman, June 12, 1958, in archives, NOMA.
20. New Orleans *Times-Picayune*, June 13, 1958.

Eager to begin her new job and anxious to observe the situation at the Museum firsthand, Thurman arrived with her husband in mid-July. Her three-year contract had been signed and reported to the board on July 9, 1958. The problem of selecting the director resolved, the board anticipated a more professional relationship with the new appointee than it had had with Lansford. Everyone was optimistic that the era of bitter controversy was in the past, and no one was more ready to begin than Thurman.

XI

Sue Thurman:
Renovation, Reorganization,
and Controversy

From the beginning, Sue Thurman stressed that favorable press relations were tantamount to success. She knew that the goodwill of the press was essential if the Museum was to hold a leading position in the art community of New Orleans. The press reports on Lansford's dismissal had, perhaps inadvertently, contributed almost daily to that controversy during 1956–1957. Tempers had risen to a fever pitch; certain grandes dames had lifted clenched fists and jostled gentlemen off the podium at the Art Association of New Orleans, requiring the police to step in to quell a near-riot. The press duly reported the bedlam and continued inflaming resentments with the coverage it lent.

Even after the controversy over Lansford had cooled, the newspapers dwelled unremittingly on the Museum's problems. They blew out of all proportion and placed heaviest emphasis on the negative. They missed no chance to ridicule the museum's board, as in the stories about *Hercules the Archer*.

Thurman hoped to change the attitude of the press by fostering good relations with it. She believed that the announcement of her own appointment would set the tone for future coverage, and she invested considerable thought and planning in an effort to coordinate appropriate, well-timed announcements in both New Orleans and Louisville. She was naturally concerned about her husband's search for a job in New Orleans, and she did not wish to make the announcement of her acceptance of the post at the Delgado until his position had been solidified. In correspondence with Charles Kohlmeyer, Jr., she conveyed how important she deemed these matters.[1]

Kohlmeyer himself expected the publicity about Thurman's appointment to reverberate, but the announcement, arranged to appear

1. See Chapter X.

simultaneously in the Louisville *Times*, evoked a disappointingly muted response.[2] Although the article made page 1 of the *Times-Picayune* of June 29, 1958, it captured only a one-column headline: "New Museum Leader Named." A small photograph of Thurman appeared, but most of the copy ran in the back pages. The article was insignificant, not the herald of a new beginning for the Museum, which Thurman wanted it to be. Most of the space was devoted to rehashing Lansford's dismissal and the conflict between the arts groups of the city.

Barbara Neiswender, later assistant director for development for the Museum, who was hired by Thurman to be secretary to the board and administrative assistant, has recalled that Thurman always felt she started on a bad footing with the press. It seemed to her that the newspapers had handled her appointment very cavalierly, and this remained a thorn in her side throughout her tenure as director. Often she sensed a wall of silence in the press. When the Art Association of New Orleans sponsored a press party at the Museum on September 15, 1958, to introduce her, the coverage was practically nonexistent. It appeared on a back page with only two inches of copy.[3]

Despite the inauspicious beginnings, Thurman turned with zeal to administrative, programming, and housecleaning problems that had been too long neglected. Before mid-July she had begun a thorough study of the Museum. Officially her job was to start in September, but she set to work at once, talking with trustees and discovering numerous areas that cried for attention. She had to contend with the Samuel H. Kress Foundation's concern that a fire hazard in the Museum basement was imperiling its paintings, with the disposition of the Noh robes that the Metropolitan Museum of Art wished to purchase in spite of its insufficient funds, with the possibility of cleaning out the storerooms and selling unwanted objects, with the need to make repairs to the building, with the hiring of a professional staff, with the preparation of a budget, with the need to establish an organized program of fund-raising, with the reorganization of the Museum board, and with the compilation of an accurate registry of the Museum's holdings. The existing stewardship of possessions and loans was appalling. Often items lent to the Museum were parked unclaimed or unidentified in a remote corner of the Museum basement. On the

2. Charles Kohlmeyer, Jr., to Sue M. Thurman, June 12, 1958, in archives, NOMA.
3. New Orleans *States-Item*, September 15, 1958.

very day Thurman was first presented to the full board, Olga Ross Brooks petitioned it for the return of a painting of her great-great-great-great-grandfather Colonel Von Schaumburg that her aunt, Aziemia McLean Green, had lent "many, many years ago." The board minutes show that "no one present at the meeting had any recollection of the painting, and the letter was referred to Mr. Dubret as custodian for information."[4] Deplorably, there was no written list of the Museum's gifts and loans.

Thurman worked earnestly in those first few months, trying to map a plan to bring order out of chaos. Kohlmeyer at this time wrote to George W. Rickey, saying, "I think Sue is keenly aware of the challenge which the museum job offers. I am confident that we have made no mistake."[5] Kohlmeyer and his wife, Janet, tried their best to ease Thurman's task. Mrs. Kohlmeyer spent hours at the Museum answering the phone, writing letters, and manning the volunteer's desk in cramped, crowded quarters. Kohlmeyer spent hours soliciting additional funds from the business leaders of the community so that the Museum could expand its activities. The modest level of support he asked is evident from several paragraphs of one of his letters of solicitation:

> The city furnishes the funds to pay the salaries of the operating personnel at the Delgado Museum (Director, Guards, etc.) and pays the bills for maintenance. The Art Association, a non-profit organization which is the "membership" body of the Museum, is its "exhibiting agency" and pays for all of the shows, exhibitions, acquisitions, etc. We rely entirely on our dues and contributions from members and the public to procure our funds. Only this year, since the new group is in office, has there been any concerted effort to increase membership and procure the civic support which we think is necessary to make the Museum a vital part of the cultural life of the community. We have a budget which contemplates the expenditure of about $30,000 and we hope in the future to build this up to double that amount. We think we can do it, but naturally we need the support of the same businesses and individuals called upon so many times to support charitable and civic ventures.
>
> We see no reason why New Orleans cannot be made the center of the art movement in the South and why it cannot also become one of the leading cities in the world in the field of contemporary art. We plan to extend our activities to Central and South America, and hope to have

4. Minutes of the Board of Administrators, Isaac Delgado Museum of Art, July 9, 1958, p. 2.
5. Charles Kohlmeyer, Jr., to George Rickey, July 14, 1958, in archives, NOMA.

New Orleans serve as the "port of entry" for Central and South American art into the markets and Museums of the world. Plans in this regard should be publicly announced within the next sixty days.

As I told you, Mr. Berry turned us down flat on the theory that activities such as ours should be sponsored only by persons interested therein. He seems to deplore the fact that the Whitney gives anything to the Symphony. On the other hand, Mr. Davis at the Hibernia agreed to give us $350 (or $365 which is $1 a day) and Mr. Legier at the American gave us $200 which I have in hand. Skinny Andrus took over for George Dinwiddie at the Public Service and I think, if you would give us $350 from the NBC, I could probably get $900 or $1,000 from Skinny. D. H. Holmes has given us $250 and Adler's and Maison Blanche have given $100 each. We are just getting underway and this appeal is made to you several months late.

I hope you will respond this year and that you will put us in your budget for a similar amount in succeeding years. I think we can do a real fine job for the community, particularly in view of the fact that we have a new Board at Delgado, and a good new Director, and all of the fuming and fighting of the last year has been patched up to the apparent satisfaction of all concerned.[6]

Historically, New Orleanians had not been overly generous benefactors. Nonetheless, for the first time, the administrators were making concerted efforts to raise funds. Ultimately, the results would be rewarding.

By the time Thurman attended her first board meeting as director on September 11, 1958, she was ready to take a number of actions with a view to improving the Museum. Of prime importance to her and to a number of the board members as well was her need for a proper staff. For example, she needed a secretary with an art background and polished professional skills beyond what the long-standing employee, Hilda Ducros, offered. Consequently, the board terminated the employment of Miss Ducros and hired Mrs. Neiswender, who for many years had been secretary to Henry R. Hope, chairman of the Department of Art of Indiana University and editor of the *College Art Journal*. Once Mrs. Neiswender was on the staff, Thurman could turn her efforts to filling the new position of museum curator.

At the board meeting of October 8, 1958, Thurman outlined her agenda for renovating and modernizing the museum plant. She presented a slide show that illustrated the sort of installations and exhibi-

6. Charles Kohlmeyer, Jr., to John Oulliber, president of National Bank of Commerce, August 28, 1958, in archives, NOMA.

tions that a trained museum staff could plan for a relatively small cost. For about fifty thousand dollars, she calculated, the Great Hall could be cleared of all statuary and miscellany, a public rest room for men could be provided on the same floor as the one for women, a staff room could be constructed from the basement men's room, a sales desk could be built to the left of the entrance in the Great Hall to sell catalogs, postcards, art books, and the like, a checkroom could be built to the right of the entrance, the Assembly Room could be remodeled for all group activities such as lectures, films, and children's creative classes, the storage area in the basement could be reorganized in order to clear space for a workroom, and the statuary collection could be remounted on the Museum grounds. Thurman also suggested installing lighted panels outside the Museum to announce Museum shows and hours.

The board agreed that much of what the new director suggested was necessary and even long overdue. Upon a motion of James E. Fitzmorris, Jr., it voted that the money available from the bequest of Dr. Rudolph Matas be set aside for a renovation and modernization program. The board, however, noted in the motion, "This action does not imply acceptance of the above mentioned plan in its entirety, nor in detail, but rather that it is intended as the expression of the Board of its support for a renovation program, the details of which will be more fully discussed at next month's meeting."[7]

Kohlmeyer opposed Thurman's plan. Writing to Alfred Moir, he complained, "Next Sue suggested major changes in the Museum set-up, which seem to me to indicate that she is going to attempt to build us an educational institution rather than a Museum. I have expressed myself at length in opposition to the plan—so much so that I think Sue feels that I have personally taken up the cudgels against her."[8] What agitated Kohlmeyer most was that in order for the work Thurman had in mind to be done, the Museum would have to be closed to the public from January 1 until September 1, 1959: "This, of course, means the cancellation of all Art Association functions including the Spring Show. Likewise it means no Fall Show because Sue will have a big opening of her own on some special event that she will install herself. I fear that this means that we will lose a great deal of our support and if the show is not held under the Delgado roof, it means the

7. Minutes of the Board of Administrators, Isaac Delgado Museum of Art, October 8, 1958, p. 3.
8. Charles Kohlmeyer, Jr., to Alfred Moir, November 3, 1958, in archives, NOMA.

opening of a breach that I do not think is proper."[9] As president of the Art Association, Kohlmeyer felt an abiding responsibility to it. He realized that if the director of the Delgado gained control of the exhibitions at the Museum, the Art Association's role would be attenuated. It would no longer control the shows at the Museum, as it had done for over forty years. Without the twice-yearly exhibitions of its members' works, people might drop their memberships in it. As these worries transpired, Thurman took on the appearance of a revolutionary, and unfortunately, Kohlmeyer was cast in the role of a reactionary.

Mrs. Neiswender has aptly recalled that "Sue Thurman was an oak and not a willow."[10] Sue was ready with her plans for renovation, and on Friday, November 14, 1958, she presented them to the board. After approving the plans, the board appointed a renovations committee, whose members were Rickey, Thurman, F. Julius Dreyfous, and Arthur Feitel. Dreyfous was made chairman. Financing for the renovation, estimated at forty-five thousand dollars, was to come from the Matas gift ($25,000), from the Fortrain Fund ($5,000), from the Lacosst Fund ($2,000), and from the Hyams trusts (the funds of which were to be used for redoing the Hyams Room). In addition, the Junior League of New Orleans had assumed responsibility for one of the large galleries on the first floor.

Charles E. Whitmore, the board's president, pointed out that the renovations would affect the exhibitions program already scheduled by the Art Association and that there would have to be cancellations. The board voted that, with the exception of the regional artists' show in March, 1959, the conflicting exhibits be canceled, and it instructed Thurman to replace them with shows she devised from the Museum's own collections. Kohlmeyer and Robert J. Newman cast the only dissenting votes. Thus was the precedent set. The museum's director would henceforth determine the shows and thereby control the educational thrust and development of the Museum. At long last, authority would rest with the director of the Museum rather than with an outside organization.

At the same meeting, Thurman announced to the board that she had completed the search for a curator of collections. She had hired Jacob Jerome Brody, a graduate of the University of New Mexico in art history and anthropology who had also studied at Cooper Union and

9. *Ibid.*
10. Sir William Paulet.

the Brooklyn Museum Art School and was working on a M.A. in archaeology. As curator of art at the Everhart Museum, in Scranton, Pennsylvania, Brody had gained experience in the care, installation, registration, and cataloging of museum collections. The board approved the choice and granted Brody an annual salary of five thousand dollars beginning December 1, 1958.

It was also reported that Charles E. Dunbar, Jr., Monte M. Lemann, and Harry McCall had reviewed the possibility of amending the museum charter with respect to the composition of the board of administrators and that they were submitting their study to the legal committee. Their opinion was that nothing indicated "that under the conditions now existing Mr. Delgado's wishes would be violated by an amendment to the Charter of the Isaac Delgado Museum of Art Association making new provisions for the choice of its Board of Administrators. That he would not have sought to impose a dead hand upon the free rights of amendment of the Charter, we think is indicated by his act in signing the charter without any restriction upon the right of amendment."[11] On December 10, 1958, the board of administrators agreed that a committee be appointed to reorganize the board.

In January, the reorganization committee began its work in earnest. The group consisted of Fitzmorris, Kohlmeyer, Rickey, Whitmore, Fred J. Cassibry, and Charles L. Rivet. Concurrently, plans were being worked out for a merger of the Isaac Delgado Museum of Art Association and the Art Association of New Orleans. On February 19, 1959, the board of directors of the Art Association of New Orleans had resolved "that a merger of the New Orleans Art Association with the Delgado Museum be approved in principle."[12] Kohlmeyer wrote, "The Art Association/Delgado merger is moving very slowly, although I do not know that the slowness is caused by any disinclination on the part of Whitmore and his group to proceed. Judge Stich died last week and I really believe that his death takes away the principal opposition."[13]

The two organizations that had supported the Museum for years would now come together as one. At the same time, the board of ad-

11. Charles E. Dunbar, Jr., Monte M. Lemann, and Harry McCall to Charles Kohlmeyer, Jr., November 11, 1958, in archives, NOMA.
12. Minutes of Board of Directors, Art Association of New Orleans, February 19, 1959.
13. Charles Kohlmeyer, Jr., to Alfred Moir, March 3, 1959, in archives, NOMA.

ministrators of the Museum would be reorganized, incorporating a broader segment of the New Orleans community and enlarging the Delgado's base of support. Rivet succinctly described the passing of the old era when he commented that the "expansion of the Board and its continuation must be set up so as never to become the 'tool' of any faction."[14] Not everyone agreed, however. Kohlmeyer, in a letter to Moir, wrote, "I feel that there should be a strong sedate board which turns over, if at all, on a very slow and difficult basis. As a matter of fact, if I were not constitutionally opposed to a self-perpetuating board, I would not object to the new board being self-perpetuating. In view of my feeling about such board, I am willing to have an election but want it to be very difficult to unseat the nominees of the directors who should come up for reelection on a staggered three or five year term."[15]

In the same letter, Kohlmeyer criticized Thurman for getting control of the Museum's exhibitions: "Just between us, Sue Thurman does not seem to me to be going along too well. She is playing coy with the Art Association and apparently wants a blank check to do as she sees fit with all of the funds. . . . The situation is, of course, very complex and certainly no one can be expected to work for two bodies. Nevertheless the Art Association historically has always handled exhibitions and programs and I rather doubt that the group is going to be willing to simply give up its function." He concluded, "I personally do not feel that it should, although I have attempted to withhold any comment on leadership for fear that I would be criticized for doing the same thing that Feitel did."[16]

The merger of the two groups and the enlargement of the board were interrelated. The general concept for enlargement of the Museum board was, according to Rivet, that "with any expansion, the Board, and not the membership of the Association, must wind up in sole control of the affairs of the Museum, including its staff, its finances, its building and the program housed there-in."[17] The board of commissioners of City Park was not to have the largest representation on the Museum board. In the past, the board of City Park had named

14. Charles L. Rivet to James E. Fitzmorris, Jr., Fred J. Cassibry, Charles E. Whitmore, George W. Rickey, and Charles Kohlmeyer, Jr., March 16, 1959, in archives, NOMA.

15. Kohlmeyer, to Moir, March 3, 1959, in archives, NOMA.

16. *Ibid.*

17. Rivet to Fitzmorris, Cassibry, Whitmore, Rickey, and Kohlmeyer, March 16, 1959, in archives, NOMA.

five representatives to the Museum board, and the Art Association had chosen three. The Museum board had no power to select its own membership. Under the new plan developed by the committee on reorganization, only two members were not to be elected by the Museum board members, the two chosen by the city council from its members. The Museum board was to select the remaining twenty-one from the two nominees sent to it for each seat. There were to be six members from the board of City Park, six from the general membership of the Isaac Delgado Museum of Art Association, six nominated, one seat apiece, by the presidents of the Chamber of Commerce, International House, the New Orleans Clearing House, the New Orleans chapter of the American Institute of Architects, the United Fund, and Tulane University, and three elected at large. The three-year terms of board members were to overlap, and no member was to serve more than six consecutive years.

On May 7, 1959, Cassibry, vice-president of the city council and a member of the Delgado board, announced the plan at the city council meeting. Three days later, Kohlmeyer, president of the Art Association, announced his board's approval of the plan and of the merger. It was assumed that the plan would be approved without difficulty by the Delgado board at its May 15 meeting. But before that, Edward J. de Verges, a member of the board of City Park, sought the opinion of an attorney, Louis B. Porterie, as to the legality of the proposed enlargement, and Porterie affirmed that "the Delgado Charter could not be changed insofar as its Board composition is concerned." [18]

As a consequence, the board of the commissioners of the City Park Improvement Association met and passed by a seventeen-to-three margin a resolution instructing its representatives to the Delgado board to vote against the plan of board enlargement. Its action caused a furor. Both Whitmore, the president of the Delgado board, and Rivet, the chairman of the reorganization committee, tendered their resignations from the Museum board immediately. "We both stated as the reason for resigning," said Rivet, "our avowed abhorrence at the thought of being given a mandate relative to how we should cast our respective votes on matters before the Delgado Board, on which we sat as members, and not rubber stamps." [19] By a five-to-zero vote, the Delgado board, feeling "it would be disastrous to the future wel-

18. Minutes of the Board of Administrators, Isaac Delgado Museum of Art, May 15, 1959.
19. New Orleans *Times-Picayune*, May 16, 1959.

fare of the Museum and of cultural activity in New Orleans to accept the resignations," tabled them until the next regular meeting. The board members also approved the reorganization plan by a five-to-zero count and instructed its legal committee to prepare a schedule of the further actions it needed to take in order to complete the reorganization. The Delgado board voted unanimously that the board of City Park's legal advice was "incorrect."[20]

On May 18, Kohlmeyer wrote to Herbert Jahncke, president of the board of City Park, to comment on the Museum board's reaction to the board of City Park's resolution and on the tabled resignations:

> I cannot overestimate the value of Messrs. Whitmore and Rivet to the Delgado Board. Their wise counsel, administrative ability, patience and willingness to give their time and efforts unstintingly towards the furtherance of the Art movement in our community have already borne fruit. I need not, I know, call your attention to the renovation program within the museum building; a new professional staff has been retained; and the Museum has started to emerge from the morass in which it was foundering for the past twenty years.
>
> The Art Association of New Orleans, a membership organization composed of many of the leading citizens of the City, has gone on record through its Board of Directors, as favoring the reorganization and as recommending a merger of the Art Association into the Museum Association if the plan is adopted. In my opinion, the Museum cannot stand another crisis such as rocked its foundations following the precipitate firing of its prior Director: if these resignations are accepted, the Museum will probably never recover—at least not for ten years. Public confidence, only now being restored, will be lost again.
>
> I feel it would come with ill grace for me to condemn the action of your Board, which I am sure was taken in the utmost good faith. I nevertheless want to take this opportunity to advise you of certain matters bearing on the controversy which I believe have not been brought into proper focus. They are as follows:
>
> Mr. Delgado's letter of February 26, 1910, imposed two conditions on his gift: the first that the Art Association and the City Park Boards have equal voices in the management and control of the building and its maintenance, and the second that a room be reserved for the permanent exhibition of his personal collection of objets d'art. Both of these conditions have been violated, and if the opinion of your special counsel is correct, it would seem that your board is already in default and is liable for the return of the $150,000 donation.
>
> But the letter of April 26, 1910, clearly qualifies the original letter, and

20. Minutes of the Board of Administrators, Isaac Delgado Museum of Art, May 16, 1959.

specifically authorizes the formation of an association to sponsor the new Museum. Thereafter, the present corporate form of association was obviously agreed upon, for Mr. Delgado personally signed the Museum charter. Moreover, the Museum was given to the City by the Park Board and was accepted by the Commission Council in Mr. Delgado's lifetime. The City Park Board, I submit, thereupon permanently and effectively abdicated its authority and control of the Museum, except insofar as it might vicariously exercise control through its appointments to the Museum Board. Moreover, when Mr. Delgado signed the Museum charter and thereby approved the clause therein authorizing its amendment in any regard, he expressly empowered three-fourths of the members of the organization to change the method of selecting its Board. I consider these facts self-evident.

Even if I am wrong in my conclusion, I cannot see how it is possible for the City Park Board, which is an entirely separate organization, to be or become legally liable for any action now taken by the Delgado association. Such a concept of law is new to me.

If Mr. Delgado meant to charge the City Park Board with the responsibility for the Museum's operation and maintenance, he could have insisted that the charter be so written as to preclude amendment; the personnel of the latter Board could have been permanently fixed; or the control could have been vested in City Park. However, he did none of these things.

As a lawyer and a citizen, I am delighted to see your Board zealously protecting the wishes of a benefactor now dead these past forty-six years. But, as a practical matter, the Museum needs broader support than has been accorded it in the past. The base of the Board must change, so that the entire citizenry may be eligible for membership. If this can be accomplished legally, certainly no moral dereliction is involved.

One final word about the resolution which your Board adopted on May 14, 1959; it is arrant nonsense to state that the management and control of the Museum is vested in a Committee; it is unmistakably and beyond peradventure vested in its own corporate Board. An apology for increasing the Board, thereby destroying the City Park majority thereon, will not serve: the increase was sponsored by City Park representatives and is, according to the very terms of the resolution, a violation of the terms of the "bequest." It is a fait accompli, and the action cannot be rescinded.

Dictating the manner in which the City Park appointed directors on the Delgado Board must vote is contrary to every tenet of good government. You thereby decide a question without benefit of debate and reasoning and counsel. And the philosophy of the whole organization is destroyed, for with such action the City Park Board, not the Delgado Board, controls the Museum. Such a state is directly contrary to the

donor's wishes, for otherwise, he would never have bothered to have set up a membership organization and to have provided for its governing body. He would have made the gift directly to City Park and during his lifetime would have challenged any change in the conditions imposed.

I will be glad to discuss this matter with you at any time, but I sincerely hope you will prevail upon your Board to change its directive. The Museum, as I said above, will probably be unable to stand another scandal, and (though I do not want you to take this as a threat) I doubt that the Art Association will continue to support it under these conditions. I also doubt that any City funds will be available for maintenance and operation in the future.[21]

The City Park commissioners were determined, however, to stop the Museum's reorganization of its board. On May 25, 1959, they met and agreed to institute court action to test the legality of the proposed reorganization. Shortly thereafter the City Park commissioners filed in civil district court for a definitive judgment on the status of the proposed reorganization, asking specifically for a declaration whether it would be in violation of any condition imposed upon the board of City Park as recipients of the $150,000 donation by Delgado.

The next meeting of the Museum board intensified the brouhaha, and the controversy predictably resulted in more headlines, editorials, and letters to the newspapers. Thurman wrote a letter to the editor praising everyone: the Museum board for its planned expansion, the Art Association for backing it, and the board of City Park for asking the court to ascertain if it was legal or not. Nerves were on edge as everyone waited for the court's decision.

On June 4, 1959, the city council voted six to zero to approve the plan for reorganization and enlargement of the board of administrators of the Museum. Because of the council's action, Porterie advised the legal committee of the board of City Park to ask the city council to relieve the board of City Park by ordinance of any responsibility to adhere to the conditions at the time of the Delgado gift. It was understood that if the city council, as representative of the city of New Orleans, the universal legatee of Isaac Delgado, did so, the board of City Park would no longer object to the reorganization and would withdraw its suit from civil district court. Accordingly, on July 16, 1959, the city council absolved the City Park commissioners of any conditions that were imposed by Delgado in his gift of $150,000. On July 29, 1959, the proceedings of the civil district court entitled *New*

21. Charles Kohlmeyer, Jr., to Herbert Jahncke, May 18, 1959, in archives, NOMA.

Orleans City Park Improvement Association and Herbert Jahncke vs Isaac Delgado Museum of Art Association and the City of New Orleans was dismissed.

Evidently the city council's support and that of the community, as evidenced in letters to the editor, editorials, and news articles, as well as Kohlmeyer's letter of May 18, 1959, had strong collective influence on the board of commissioners of City Park. Without further public commotion the Museum was able to establish its plan for a new board. The first board to act under the reorganization was seated in January, 1960, fifty years after the Museum's founding. The officers of the board were Whitmore, president; Kohlmeyer, vice-president; Rivet, secretary; and Newman, treasurer. The other members were Cassibry, Fitzmorris, Jahncke, Rickey, Mrs. Edward B. Benjamin, John Clemmer, Wallace M. Davis, Mrs. Joseph A. Diaz, F. Julius Dreyfous, Arthur Feitel, Mrs. Richard W. Freeman, Lewis Gottlieb, Mrs. William G. Helis, Mrs. Charles C. Henderson, Joseph M. Jones, Richard Koch, Mrs. Samuel Logan, Mrs. George B. Montgomery, A. Q. Peterson, George J. Riehl, Mrs. C. S. Williams, and Leon M. Wolf, Jr.

During the controversy, Thurman kept the Museum from stagnating and went on with the renovation of the building. Funds continued to come to the Museum through her influence and tact. On May 21, 1959, she announced an anonymous $5,000 gift for "any special renovation project." [22] Ten days later there was news of a gift of ten thousand dollars from Mrs. E. James Koch and Mrs. Olivier Billion for remodeling one of the large galleries on the first floor of the Museum. That gallery was to be designated the Downman Room in honor of the donors' late father, Robert H. Downman, and was to be adapted for use as an auditorium as well. The new money assured that the renovations would be completed as planned, although the costs had risen to ninety thousand dollars.

Confidence in Thurman's administration of the Museum manifested itself in numerous other ways during this difficult period. The most important was in the development of an education department with funding from the Junior League of New Orleans. Having participated in volunteer programs since 1947, the Junior League, under the presidency of Mrs. Samuel Logan, agreed to provide the Museum with the salary of a curator of education for two years. This curator

22. New Orleans *Times-Picayune*, May 21, 1959.

was to assist the Junior League in the development of a docent program at the Museum. The Junior League's beneficence enabled Thurman to develop a dynamic program of art education for the community that would reach thousands of school children over the years.

The new education program was announced in June, 1959. Thurman quickly set about interviewing candidates for the position of curator of education, and by August she had narrowed her choice to Albert Aaron, of the Albright Art Gallery, in Buffalo. A graduate of Bard College, Aaron attended the Graduate School at Indiana University as a Woodrow Wilson fellow, and Yeshiva University as a Ford Foundation teaching fellow. He had taught at the prestigious Cranbrook Academy, and while there he helped organize the first contemporary gallery in Detroit. At the Albright Gallery, he had reorganized the education department. Aaron began his job at the Museum in October, 1959.

During the same month, the finishing touches on the Museum's extensive renovations were completed. Two exhibitions opened early in November: a show of contemporary works by Fritz Bultman, a New Orleanian living in New York who was a former student of Hans Hofmann and an associate of the abstract expressionists in New York; and an important collection of French impressionist and post-impressionist works comprising fifty-six paintings, drawings, and sculptures lent by an anonymous collector. The loan of the impressionist and postimpressionist collection was a major event, for the works in it had not been publicly exhibited in New Orleans since before World War II. Mrs. Henderson, of the board of administrators, greatly admired Thurman and arranged the loan. Because of its importance, Thurman had the opportunity to prepare her first major exhibition catalog.

With so many claims on her time, the director naturally looked forward to Aaron's presence on the staff. Within his first month he was not only to organize a docent training program but also to train the docents to guide the thousands of city schoolchildren already signed up for the November tour program. And indeed, Aaron's program was a huge success, as was the revitalized Museum as a whole. The newspapers mustered some long-overdue praise. A *Times-Picayune* editorial on November 4, 1959, commented enthusiastically on "the new exhibitions, the newly decorated galleries and a new auditorium. And, as fine as all that may be, it is surpassed by a new atmosphere of friendliness and service to the art-loving public." The editorial ended

on an upbeat: "A new spirit of dedication seems determined to make Delgado measure up to expectations."[23]

Thurman's modernization of the Delgado building earned manifold dividends. On November 21, 1959, the Samuel H. Kress Foundation announced that the Delgado Museum would in 1961 become the permanent recipient of the Samuel H. Kress Collection then on loan. The Kress Foundation art director, Guy Emerson, noted that "he originally found a 'difficult' situation here" but that he had concluded that "since the advent of the present museum 'regime' the Delgado has evolved into one of the best in the United States. So, we feel that our original decision was justified."[24] Thurman and the board must have enjoyed a measure of vindication after months of headaches and hardship.

In December, the Art Association of New Orleans and the Isaac Delgado Museum of Art Association voted at last for the merger that had been four years in the making. The united group could represent the general membership of the Museum and not merely the special interests connected with exhibitions and the promotion of member artists. Thurman praised the union, saying, "It will be a pleasure working under such a well organized group which has the real interest of the museum at heart."[25]

In keeping with the successes of 1959, the artists' annual of 1960 brought 568 entries, 208 of which were selected for the exhibition. The show included works of artists from Alabama, Arkansas, Florida, Georgia, Louisiana, Mississippi, North Carolina, South Carolina, Tennessee, and Texas. Clearly, the divisive years of the late 1950s had not compromised the artists' annual, the oldest such show in the South. The winner in 1960 was the New Orleanian Ida Kohlmeyer, who was awarded a prize of five hundred dollars for her abstract expressionist oil *Passage*. The show would continue to grow in succeeding years so that in 1977, by then a biennial, afterwards a triennial, it would attract entries from more than 1,250 artists.

The string of successes contributed greatly to the general air of expectancy that pervaded the Museum and New Orleans' other cultural institutions during this period. Better times seemed to be ahead. A cultural arts fund was being established, promoted by Edward B.

23. *Ibid.*, November 4, 1959.
24. *Ibid.*, November 21, 1959.
25. New Orleans *States-Item*, December 29, 1959.

Benjamin. There was some word that the new fund might offer the Museum an endowment of as much as $100,000.[26] Another hope for increased money for the Museum, according to the board and Thurman, lay with the state of Louisiana. Since the Delgado was the only art museum in the state, in civic spirit it belonged not only to New Orleans but to the entire state as well. State representative Kenneth C. Barranger, of New Orleans, actively supported that view. He introduced into the state legislature House Bill 1035, to provide twenty-five thousand dollars for the Museum out of the general fund for 1960–1961. Supporters hoped that once the expenditure was approved, it would become an annual appropriation.

In addition, for 1961, the Museum staff and board increased their budget request to the city by fifteen thousand dollars. The substantial increases they had received in the past led them to expect continued support from the city. The proposed allocation for 1961 of $74,900 was almost three times what the city funding had been when Thurman became director.

Cultural aspirations were the more buoyed when the city Planning Commission made public its proposed Cultural Center. Charles F. O'Doniel, director of the Planning Commission, called it the "most important project now contemplated for revitalizing New Orleans' central business district." The multibuilding complex centered on the Municipal Auditorium, which was to become a sports arena, and it was expected to encompass a music hall, a community building, a theater, and a museum. The museum, which was to display contemporary art, was "seen as a downtown addition to Delgado Art Museum's art facilities rather than a replacement."[27]

It was a perfect frame of mind for celebrating the Museum's fiftieth birthday. Thurman and her staff worked for months on the preparation of the Delgado birthday show The World of Art in 1910. This major exhibition filled ten galleries with works by George Wesley Bellows, Paul Cézanne, Marc Chagall, William Merritt Chase, Raoul Dufy, William James Glackens, Childe Hassam, Winslow Homer, Wassily Kandinsky, Paul Klee, Oskar Kokoschka, Wilhelm Lehmbruck, John Marin, Henri Matisse, Max Pechstein, Pablo Picasso, Georges Rouault, Maurice Utrillo, Jean Edouard Vuillard, and James McNeill Whistler, to name but a few. Thurman wrote, "The year of

26. Edward B. Benjamin to Charles E. Whitmore, February 25, [1960,] in archives, NOMA.
27. New Orleans *States-Item*, October 24, 1960.

founding could hardly have been more auspicious. 1910, given the perspective of time, classifies as one of the most decisive art years of the Twentieth Century in terms of newsworthy art events and note-worthy art personalities. Throughout the Western World, the Museum's founding year was indeed one of uncommon determination on the part of artists to discover new aesthetic paths." [28]

Amid the preparations for the exhibit, Brody, the curator of collections, was asked to hand in his resignation effective September 1, 1960, since he had not completed compiling the Museum's records of gifts, loans, and purchases. Thurman therefore had to focus energy on finding a replacement for him. At this juncture she had little time to spare, for she was preparing the birthday exhibition, as well as a show for the Knoedler Gallery, in New York, of the anonymous French impressionist collection that had been at the Museum in 1959. A benefit was planned around the Knoedler show to raise funds for the Museum's art accessions. Under the circumstances, everyone was on edge, and a serious altercation occurred when Thurman learned from Brody that Kohlmeyer had "expressed being 'completely fed-up' with her management of the Museum." Kohlmeyer, according to Brody, was unable to tolerate the situation any longer and was about to go to the newspapers with the whole story.

On August 9, Thurman fired off a letter to Kohlmeyer, confronting him with what Brody had told her. She wrote, "While I am very much aware that one must not jump to conclusions on the basis of rumor, as Museum Director, I feel compelled to bring this matter to some conclusion. Due to the gravity of the situation, I definitely feel that a written reply is in order, and I hereby request same." She concluded, "If you are *not* dissatisfied with my efforts and accomplishments to date, you will doubtless be glad to correct a misquotation without delay. On the other hand, if you *are* displeased, you will doubtless be equally willing to enumerate your dissatisfactions to the source at this time." [29]

Charles Kohlmeyer replied two days later,

> I sincerely regret that you have chosen to write to me as you did. These sorts of things are best handled in a face-to-face discussion such as you and I had once before, but since you have written formally, I shall reply in the same vein, although I feel under no obligation to do so.
>
> As is true in most cases of rumor, the remarks which you attribute to

28. Sue M. Thurman, *The World of Art in 1910* (1960).
29. Sue Thurman to Charles Kohlmeyer, Jr., August 9, 1960, in archives, NOMA.

189

me have been taken out of context. I do not recall using the first phrase you quote, but I have certainly never said anything about going to the newspapers with any "story." To my knowledge, there is no "story." If there were one, it could be only be detrimental to the Museum to "leak" it or tell it to the papers, and I would do nothing that could harm the institution.

In my opinion, you are an extremely capable person in your field. Within the past week, I have had occasion to sing your praises to Mr. Latter and to Mr. Guillory (of the Public Service Company) in connection with solicitations of funds which I was making on behalf of the Museum. I feel, however, that your relation to your Board leaves a great deal to be desired. Our differences stem, I believe, from our respective concepts of the philosophy of running a Museum or any other organization. I think you want to work without supervision (and, possibly, assume the responsibility for the operation); on the contrary, I feel that the Board should govern the institution and you should implement the policies it sets (other than the technical portion about which, admittedly, the Board knows nothing).

You have an exceptionally fine Board of thinking people who want to help in formulating plans and procedures; they are not "yes" men and women, and I think they want the responsibility of decision put upon them. I think you have failed to make use of the Board in the fields where they could be of great service to the Museum.

Jerry and Jean Brody have been friends of Janet's and mine since they moved here. We visit in each other's homes. At no time during the period that the Board was considering Brody's job status was that subject mentioned in any conversation with him. After he had resigned, however, we did talk, at my invitation, about the Museum. In our discussion, Brody was completely loyal to you and the Museum, and said not one word which could be construed as derogatory or critical. I did state to him that you and I disagreed on basic principles on the Board-Director level. Although I have no definite present recollection, I may have said to him at that time that I would not accept the Presidency of the Board if it were offered to me because I did not feel I could get along with you. I had come to this conclusion following the lunch we had at Galatoire's.

Your writing me as you did points up the lack of rapport between us and is indicative of your attitude toward me—although this may be personal as to me and not to the entire Board. I believe and hope that my conduct in all Museum affairs and in all relations with you has been completely detached, regardless of my feeling that you resented any "interference" in your running of the Museum. I cite as an instance your first refusal even to consider making a study of the possibility of the International Show which we spoke about one day.

I feel that you have developed some new friends for the Museum, but I also feel that you have not made full use of the potential support avail-

able. This I attribute to the lack of liaison with the members of your Board, who could, if properly approached, have aided materially in an organized campaign to add members and contributions to a revitalized and growing cultural institution in our community.

I am rather outspoken and I have tried to answer you directly and without equivocation. I reiterate my regret at your method of approach: you have now made close cooperation between the Director and the acting President of your Board difficult, if not impossible. In view of Mr. Whitmore's illness, I hope this will not be detrimental to the Museum.[30]

On August 13, Thurman precipitately replied, "In view of your statements in the final paragraph of your letter, I can no longer consider this matter confidential. Accordingly, I will release my letter and the views expressed in your reply at Board Meeting on Thursday evening."[31] When the correspondence was read at the meeting on August 18, it was apparent to those present, remembered Mrs. Logan, that Thurman and Kohlmeyer had reached an impasse. It was fortunate, then, that after this meeting, Kohlmeyer did not have to continue to serve as acting president in place of Whitmore, since Whitmore resigned because of poor health.

To succeed him, the board elected Jahncke, who was not in any way connected with the rivalries of the past. A young, dynamic business leader, Jahncke was a vice-president and treasurer of Jahncke Services, one of the largest sand, gravel, and cement producers in the state of Louisiana. He had served as campaign chairman of the United Fund and as chairman of the Christmas-seal drive of the Tuberculosis Association of Greater New Orleans. He had been president of the New Orleans Parkway and Park Commission and president of the board of commissioners of the City Park Improvement Association. He had the necessary experience and connections to get substantial support for the Museum from the business community.

The meeting had another outcome of considerable moment: it was decided that the Delgado would not participate in the Cultural Attractions Fund. Mrs. Logan, who with Lawrence A. Merrigan was one of the first cochairmen of the fund drive that raised over $520,000, has said that "because of the unsure nature of the city's response to the Museum being funded by an outside entity the majority of board members were hesitant to join the fund. Likewise the trustees felt they could not bank on the amount they might receive from the

30. Charles Kohlmeyer, Jr., to Sue Thurman, August 11, 1960, in archives, NOMA.
31. Sue Thurman to Charles Kohlmeyer, Jr., August 13, 1960, in archives, NOMA.

fund."[32] To the board's disappointment, money was not forthcoming from the state legislature either. Nor did the Museum addition in the Cultural Center in the downtown area get off the drawing board.

Thurman found a replacement for Brody in Edmund Bradley Nielson, who assumed the position of curator of collections in September, 1960. He was a trained museum professional who had graduated from William and Mary College and who held an M.A. from the University of Iowa. A Fulbright scholar, he had also studied at the University of Florence, and he was a graduate of the Harvard Museum School. Nielson had previously served as research associate and curator at the Houston Museum of Art. Thurman immediately assigned him the task of setting straight the Museum's records of gifts, loans, and purchases and authenticating the permanent collection.

Calm settled once again over the Museum, and in November the fiftieth birthday of the Delgado was celebrated with The World of Art in 1910. It was an unqualified success. Numerous articles in the newspapers praised it and all associated with it. Headlines lauded the Museum in glowing terms like "A Museum Rises Out of Debacle."[33] Columnists and editors waxed poetic; a new era seemed at hand. All hoped that the squabbles of the past would be laid to rest once and for all. The fifty-year-old Museum moved toward its future with a revamped facility, an enlarged board, a more professional staff, and a supportive community.

32. Mrs. Samuel Logan, interview with author, May 12, 1985.
33. Houston *Chronicle*, November 17, 1960.

XII

Completing the
Reorganization

Outwardly, the rift between Sue Thurman and Charles Kohlmeyer, Jr., was settled with the election of Herbert Jahncke as president of the Museum board and with Kohlmeyer's resignation a month later as vice-president and as a member of the board's executive committee. But the hopes that the time of dissension was past were to be short-lived.

From the outset, Kohlmeyer and Thurman had not seen eye to eye concerning the role of museum director. Kohlmeyer viewed the director as the servant of the board, an employee who was under contract to do its bidding. Thurman disagreed. She conceived of the board and the director as peers working together. Both Kohlmeyer and Thurman were of an unyielding nature; neither could often be swayed from a course once taken. Both were, besides, adroit politicians. Thurman was as hard a fighter as Kohlmeyer, though often less subtle. The correspondence between Thurman and John M. Clemmer, a constant ally of Kohlmeyer's, shows that during this period the contentiousness between the director and Kohlmeyer was both pervasive and bitter.[1] They disagreed on matters ranging from vacation time for the new curator to whether or not their own acrimonious exchange of letters in the wake of the Brody firing should be entered into the minutes of the board meeting at which they were discussed. When Kohlmeyer resigned his vice-presidency of the board, Thurman thought she had won the war. A few months later she achieved an unqualified critical success with the fiftieth-anniversary show, and she rode the crest of that wave. Nothing had been spared to make The World of Art in 1910 a superb exhibit, and Thurman was well aware of its excellence.

1. Sue Thurman to John M. Clemmer, August 4, 1960, August 13, 1960, both in archives, NOMA.

But there were grumblings, especially from Kohlmeyer's faction, that ostensibly concerned the expenses of mounting the exhibition. The skirmishes over costs, of course, veiled a contest for control of the Museum. On January 26, 1961, Clemmer chaired an exhibitions committee meeting that focused on the high level of expenditures in connection with The World of Art in 1910. Thurman, in the final days of a difficult pregnancy and very ill, could not attend the meeting. Among those present were Kohlmeyer, Arthur Feitel, Mrs. Samuel Logan, and Leon M. Wolf, Jr. They discovered that although the board had authorized the disbursement of five thousand dollars for the exhibit in question, more than twelve thousand dollars had been spent. They also found that the exact amount was not readily calculable, for the books were a mess.

Kohlmeyer, who had opposed according the director autonomous responsibility for exhibitions, saw an opportunity to attack. In February, the exhibitions committee reported the large cost overruns on The World of Art in 1910 to the board in executive session. The result was a decision to make a proper audit of the Museum's books, the first in the Delgado's history. At the meeting of the board on March 15, there was much discussion about the audit, the Museum's finances, its holdings, and the like. As a matter of practicality, the allocation of funds within the Museum's annual budget had always been largely the responsibility of the director. But Wolf argued, "We should have some control over the monies." There were innuendos that during the Museum's renovation restricted funds had been used for purposes contrary to what was permissible.

In 1961, Thurman's employment contract came up for renewal. It was becoming apparent that numerous allegations might be leveled against the way the director had administered the Museum. If wrongdoing could be proved, it would be possible to deny her a new contract. At the March board meeting, Kohlmeyer and Wolf spearheaded a campaign to get resolutions adopted that would embarrass the director:

1. The permanent collection is the heart of this and all other museums, such an organization being the repository of public trust and the Trustees the administrators for the public;

2. The Board goes on record as being greatly concerned with the lack of a complete and accurate inventory and accession record;

3. The Director is instructed to commence and carry on to a prompt conclusion the necessary steps to remedy this situation and to report

to this Board at its next regular meeting on the procedures instituted and the progress made in remedying the situation.

RESOLVED THAT the keeping of proper records of the Museum Collections are of great importance and that such curtailment of activities as may be necessary to carry out the above resolutions is directed. Such curtailment is to be reported to the proper committees for recommended action of the Board.

RESOLVED THAT the Museum's permanent collection be exhibited on a revolving basis at all times where practicable, and that every effort be made to incorporate the collection or a part of it into exhibitions held in the Museum.

RESOLVED THAT the Director is instructed to prepare and submit to a Committee for its review and consideration a long-range plan for the development of the Museum including plant, financial support, collection, program and activities, staff, etc., and that the Committee study the plan and make recommendations on it to the Board.

RESOLVED THAT the President, with the approval of the Board, appoint a committee of ——— members of the Board to act on the foregoing resolutions.[2]

At the same meeting the board authorized the professional audit of the Museum's finances. This, as well as compliance with the other resolutions, required the immediate attention of the director. Thurman, who had recuperated from the birth of her son only so far as to make plans to return to work on a part-time basis toward the end of March, faced a herculean task. The imposition on her was compounded by Jahncke's failure to inform her immediately of the resolutions. She learned of them only on March 24, nine days after their adoption, and just two weeks prior to the meeting in April at which she would have to go before the board.

Thurman, knowing she was fighting for her professional reputation, rose to the occasion. In a letter to Jahncke on March 25, she requested the "opportunity to present relevant information to our Executive Committee at the earliest time possible, having no opportunity to review the matter at any level prior to the Board's adoption of the directive."[3] Despite the fact that on her return to the Museum, she needed to be heavily involved in plans for a major conference and for the Knoedler benefit in New York, she did not suggest a postponement. She prepared a lengthy and accurate report, assessing the Mu-

2. Minutes of the Board of Trustees, Isaac Delgado Museum of Art, March 15, 1961, pp. 4, 7.
3. Sue Thurman to Herbert Jahncke, March 25, 1961, in archives, NOMA.

seum's collections, as the board had requested. The executive committee met on April 4 to review what she presented.

Early in the report, Thurman noted that she did not intend to lay blame on anybody but that if there were shortcomings in the Museum's accessioning and cataloging, they were the "result of a lack of sufficient workers and money." She observed that between 1911 and 1958 no permanent records were kept, but that in 1958 a registration and cataloging cardex system was begun. During her tenure as director, every item in the collection had been registered, but because of the lack of funds, no duplicate cardex file had been made. For the same reason, a complete set of photographs of the collection had not been made either.

Concerning the physical state of the collection, Thurman concluded that all objects of glass, sculpture, porcelain, and pottery were in good condition. With the exception of the Samuel H. Kress Collection, however, she judged that the paintings had to be considered in poor shape, for the Delgado had never had a system of conservation or restoration. Consequently, she asked for funds for the conservation and restoration of some of the finer pictures. Those of less consequence, she suggested, might be deaccessioned.

Thurman emphasized the need to hire a registrar to work under the supervision of the curator of collections. In that way the cataloging could continue, but in addition the desirable process of eliminating low-quality items could begin. Certain pieces not of museum quality could be selected for sale, and others that had been held on extended loan could be returned to the owners or heirs. Space in the storage area would consequently become free for constructing proper storage units for the Museum's permanent collection. Thurman pointed out that to accomplish this, one person would have to devote an "absolute minimum of one quarter of a year."[4]

Thurman also suggested publishing a catalog of the collections and intensifying contacts that might lead to significant gifts of art. Moreover she recommended devising a plan to raise funds annually for the purchase of art works. She commented that the permanent collection was rotated and represented in exhibitions as much as possible and that the finest works were always on display. But because the collection consisted of only 2,378 objects, she asserted, there was not the possibility of mounting individual exhibits from the Museum's per-

4. Sue Thurman, "Report Regarding the Museum's Art Collection" (Archives, NOMA), 1,5.

manent collection every year. Until the permanent collection grew, much of the exhibition program would have to come from the outside.

Thurman's report showed that her short stewardship of the Museum's collection had without question been more than adequate. She had been charged in 1958 with cataloging and recording the permanent collection, and this she had done. The report also laid out reasonable plans for the future. It thus responded adequately to the board's resolutions and exonerated her of any wrongdoing with respect to the permanent collection. The executive committee was satisfied. Since it was convinced, as well, that the audit would disclose no improper use of funds, it proceeded to discuss rehiring the director.

To obtain the renewal of Thurman's contract, a special meeting of the Delgado board was called for April 20, 1961. Prior to the meeting, Mrs. Logan, chairman of the personnel committee, sent each member of the board a copy of Thurman's original contract, a copy of an unofficial position description of the directorship, and copies of materials relevant to Thurman's request for attention to certain points in any new contract. Writing on behalf of the personnel committee, Mrs. Logan urged members to familiarize themselves with the documents before the April 20 meeting.[5]

It was Mrs. Logan's wish to discuss the renewal of Thurman's contract before the full board in open session. Kohlmeyer, however, insisted that discussion take place in executive session.[6] The board concurred, and Thurman had to leave. No record exists of the discussion, and it was early June before the board came to a decision.

About this time, Kohlmeyer drafted and redrafted an undated letter to Jahncke, spelling out his thoughts on the Museum situation. Though he said that he doubted he would serve much longer on the Delgado board, he offered reflections on a broad range of issues: the political entanglement with the city council, media relations, the possibility of holding annual fund-raising events, and strategies for increasing membership. He also offered advice concerning the director. First he wrote, "Do not permit your Director to meddle in affairs which are reserved to the board." But he penciled through that line and became more specific: "The Director of the museum should not participate in its affairs at board level. The suggestion of names of people believed to be good board material is an outside limit and does not imply the right to politic for or against a prospective board mem-

5. Mrs. Samuel Logan to board members, April 17, 1961, in archives, NOMA.
6. Minutes of the Board of Trustees, Isaac Delgado Museum of Art, April 20, 1961.

ber; and under no circumstances can the Director be permitted to campaign for or against the election of officers."

Not satisfied with Thurman's report, he counseled,

> Despite all of the talk that has taken place, and at the risk of treading on the toes of the Director, the inventory of the collection should be proceeded with and tied in to records, to determine what is on loan and/or gift, and the terms and conditions of each. In this connection, you should have your right to sell or exchange works of art defined, and if the City insists upon this being done within the framework of the City Charter, ways and means of working with the proper City Department should be found so that the described end result is accomplished. This I believe to be essential. New storage room for unworthy objects which will be eliminated from the Collection should not be discussed until after the present financial crisis has been passed and the basement has been cleaned up, loan items returned, etc.[7]

At a special meeting of the board on June 7, 1961, the treasurer, Mrs. Richard Freeman, presented the auditor's report, which cleared Thurman of any suspicion of impropriety in the use of Museum funds. The board found nothing amiss but suggested that, to avoid confusion, all restricted funds in the future be placed in separate savings accounts. The board then, after going into executive session, agreed to hire Thurman as director for another year, with an increase in salary. In reaction, Kohlmeyer informed Jahncke of his resignation from the board.

On the following day, Kohlmeyer wrote to the board confirming his resignation: "In view of my irreconcilable disagreement with the Board on a matter of such major policy as the decision to offer to renew the contract of the present Director, I can come to no conclusion other than that my effectiveness as a member of the Board and its Committees is at an end. Please accept my resignation as of June 7, 1961."[8] Within a week, it was learned that Wolf had joined Kohlmeyer in resigning.[9]

The Delgado board would lose yet another member. On June 19, Clemmer wrote to Jahncke,

> Please accept my resignation from the Board of Trustees of the Museum.
> In submitting my resignation, I feel I should state my reasons for so doing.

7. Charles Kohlmeyer, Jr., to Herbert Jahncke, undated draft, in archives, NOMA.
8. Charles Kohlmeyer, Jr., to board of trustees, June 8, 1961, in archives, NOMA.
9. New Orleans *Times-Picayune*, June 16, 1961.

My principal reason is dissatisfaction with the Director. I believe Mrs. Thurman evidences a complete lack of trust in this Board. Mrs. Thurman tends to handle the Museum as if it were her own property and she obviously resents any suggestions being made to her by the Board or any of its members of Committees. . . .

At our last committee meeting we were presented with a program which we were told had to be approved and fixed by the following day, and were given no alternatives. We were also told that the proposed Degas show had been cancelled because of lack of committee approval, when it was obvious, I believe, that the Director had not commenced preliminary work on it. Possibly this was due to the Director's illness, but I cannot accept personal or Committee blame for the cancellation of the exhibition.

In his lengthy letter, Clemmer also complained of Thurman's budget overruns, and he charged that she had interfered with board matters. In addition, he cited personal clashes with Thurman—incidents of less substance but no less rancor. Clearly sympathetic with Kohlmeyer, Clemmer praised the former vice-president's efforts in behalf of the Museum, and said that in light of the board's intransigence, he could not "blame him for resigning."

Clemmer closed his letter by expressing dissatisfaction with the report by Thurman that had replied to the charges implicit in the board's resolutions earlier that spring: "I do not think the Board has received a clear answer to the resolution unanimously adopted at the meeting of the 15th of March, setting major Museum policy. Mrs. Thurman's attitude at the Executive Committee meeting following the adoption of the resolutions and her written report on them lead me inevitably to the conclusion that she is unwilling to accept the authority of the Board." [10]

Despite the resignations of Kohlmeyer, Wolf, and Clemmer, fourteen members of the board of administrators felt that Thurman deserved an extension of contract. The board made its offer to her on June 7, 1961, but according to the *Times-Picayune* of June 22, 1961, Thurman had not indicated whether she would accept the offer. Finally, on June 28, she declined it, having accepted the directorship of the Institute of Contemporary Art, in Boston. She would replace Thomas M. Messer, who was to become the director of the Guggenheim Museum, in New York. In her letter to the board she said, "My acceptance of the Boston offer is based upon many factors—the

10. John M. Clemmer to Herbert Jahncke, June 19, 1961, in archives, NOMA.

primary ones are the professional challenges involved and the enthu-
siasm of the Institute's board in feeling that my directorship will make
further contribution to the Institute's progress." She added,

> After considerable deliberation, I have concluded that the end of this pe-
> riod can actually bring the [Delgado] to the completion of the first major
> phase of its reorganizational efforts. Although the museum will still
> need many, many things—this is one measure of its vitality—it will have
> reached a stable condition and a creditable level of operations. . . . The
> present very high level of interest among the members of the Delgado
> board reassures me that this transition will be handled with the greatest
> of care. It is my feeling that we should now work towards the attainment
> of the various standard improvements which are underway; complete
> our several current special projects; and continue basic planning for the
> future.[11]

Within a few weeks, the personnel committee of the board was at
work, searching for a replacement for Thurman. At a special meeting
on September 6, Jahncke informed the board of three candidates for
the position and asked the board's approval "to offer James Byrnes a
three-year contract with a beginning salary of $10,500."[12] The board
agreed to Jahncke's request, and in October, James B. Byrnes visited
New Orleans. He had not yet accepted the offer.

While in the Crescent City, he discussed the directorship with the
Museum's personnel committee and reviewed both the collection and
the physical plant of the Delgado. On this visit he learned that the
final deeding-over of the Samuel H. Kress Collection would take place
on December 9, 1961, and that the Museum was the recent recipient
of fifty thousand dollars from the will of Jeanette Waugh Lapèyre, for
whom a room was to be named in the Museum. Impressed with the
clear progress the Museum was making, Byrnes decided to accept the
position. On November 22, 1961, the local newspapers could disclose
his acceptance.

Byrnes was a man of fascinating and varied museum experience.
Born in New York City in 1917, he acquired no college degree, proba-
bly because of the hardships of the depression. At age eighteen he
entered the in-service training program in museum education meth-
ods at the American Museum of Natural History and the Museum of
Modern Art, in New York City. During the years 1936–1942, he stud-

11. New Orleans *Times-Picayune*, July 2, 1961.
12. Minutes of the Board of Trustees, Isaac Delgado Museum of Art, September 6,
1961. This was $1,500 more than Sue Thurman had been offered.

ied to be an artist, first at the National Academy of Design, then at the American Artists' School and the Art Students' League. After World War II, he began his museum career at the Los Angeles County Museum of Art, then under the direction of Wilhelm R. Valentiner, the great German-born art historian and specialist in seventeenth-century Dutch and Flemish painting. Working first in the education division, Byrnes later became curator of modern and contemporary art. In 1949, he served as curator in charge of *Berlin Masterpieces*, one of the first great international loan exhibitions, shown in Los Angeles, San Francisco, and St. Louis.

In 1951–1952, Brynes studied art history and archaeology at the University of Perugia and at the Istituto Meschini, in Rome. In 1954, he became the director of the Colorado Springs Fine Arts Center. Two years later, Valentiner, his mentor, asked him to join him in Raleigh, where he was establishing the North Carolina Museum of Art. Byrnes served as associate director for two years and then as director from 1958 to 1960, after Valentiner's death. Edwin Gill, state treasurer of North Carolina, wrote at this period; "James Byrnes first came to us as an Assistant to the great William R. Valentiner. While Valentiner, of course, gave superb leadership to our young institution, it was Jim Byrnes whom he actually relied upon to organize and get our new museum under way. . . . The actual administration of our museum over a period of years was the responsibility of Jim Byrnes who gave us real dynamic leadership." [13]

The State Art Society of North Carolina commended Byrnes in a resolution on November 30, 1960, a partial copy of which was sent to Jahncke as testimony of the high regard in which Byrnes was held:

> Under the leadership of Valentiner, and on his own initiative, Byrnes has helped to make of our Museum a dynamic servant of all the people. Byrnes' concept of public service has been evidenced by loyalty to our State and its institutions, by a firm belief that the Museum should carry its message to the people through all media of communication—through newspapers, television, radio and through lectures and special publications—and by a strong sense of integrity, characterized by independent, discerning judgment dedicated to high standards.
>
> Under a program geared to public school needs, which was largely created by Byrnes and formalized by him into a Department of Education, each year thousands of school children pass through the Museum under the guidance of volunteer docents who implement in a magnifi-

13. Edwin Gill to Herbert Jahncke, November 2, 1961, in archives, NOMA.

cent way the staff of the Museum. . . . Through his good offices, Byrnes
has brought many and valuable gifts to the Museum ranging over the
history of art from Ancient Egyptian, Greek and Roman times, down to
the art of our own day.

Byrnes has at all times evidenced a great interest in contemporary art
and has lent his prestige as Director to the encouragement and recogni-
tion of individual North Carolina artists, as well as to our annual North
Carolina Artist Competition. From the beginning, Byrnes has had a sig-
nificant part in developing and implementing our program of changing
special exhibitions and in our distinguished program of publications. In
short, Mr. Byrnes, at first under the leadership of Valentiner and later on
his own, has done his best to make of our Museum a living thing, an
exciting activity, challenging the initiative of our people.[14]

These were the very qualities the trustees of the Delgado Museum
sought in a new director. Byrnes's interests fit well with the programs
that Thurman had emphasized, particularly in the area of education.
And his strong support of contemporary art recommended him to
those who felt that the Museum should continue its encouragement
of contemporary Southern artists.

On November 16, 1961, the board offered Byrnes a three-year con-
tract as director, with a starting salary of $10,500. He agreed to begin
on February 1, 1962. Thurman left the Museum in mid-November,
and in the interim Barbara Neiswender, the secretary to the board of
administrators, served as "coordinator" of the Museum.

The year ended quietly at the Delgado. In December the board
elected Robert J. Newman president. Jahncke refused to succeed him-
self, though he said "he would be happy to serve in any other capac-
ity."[15] Consequently he was elected first vice-president, and A. Q.
Peterson was elected second vice-president. Mrs. George B. Mont-
gomery was selected secretary, and Ernest A. Carrere, Jr., became
treasurer. Eight three-year terms on the board came open at this time,
and four of the places were filled by those who had served previously.
Reelected were Mrs. Logan, F. Julius Dreyfous, Mrs. William G. Helis,
and Joseph M. Jones. Elected for the first time were Dr. Isidore Cohn,
Mrs. Nolan Kammer, Mrs. Lee Schlesinger, and Percy H. Sitges.
Three months earlier Muriel B. Francis and Mrs. Edgar B. Stern had
been elected to fill the vacancies left by Kohlmeyer and Clemmer
respectively.

14. Resolution of State Art Society of North Carolina, November 30, 1960.
15. Minutes of the Board of Trustees, Isaac Delgado Museum of Art, December 13, 1961.

The reconstituted board benefited significantly from the infusion of energy and enthusiasm. It was to prove responsive to the needs of the community, and its efforts were supported by a professional staff of high quality and sound experience. The Museum could boast a new educational department that offered a broad range of programs—an innovation that would endure longer than the redoing of the physical plant or the systematizing of procedures. And the Kress gift was at last in its final stages. The thirty Italian Renaissance paintings would become the property of the Delgado on December 9, 1961. Under Thurman's direction, the years 1958–1961 had indeed been a significant time for the development of the Delgado, and even a man of Byrnes's vision and talent would have to strive mightily to achieve so much in so short a time.

XIII

James B. Byrnes:
The Struggles of the
First Years

James B. Byrnes came to the Delgado directorship fully cognizant of the many problems to be solved if the Museum was to become a first-class entity among the museums of the South. Its sisters included the Houston Museum of Fine Arts, founded in 1924; the High Museum of Art, in Atlanta, founded in 1926; the Virginia Museum of Fine Arts, in Richmond, founded in 1934; and the North Carolina Museum of Art, founded in 1939. All these originated from earlier art societies and were dynamic, progressive institutions. Some were developing estimable national reputations.

The North Carolina Museum of Art, from which Byrnes had come, derived from a state art society "founded in 1926, with the dream of an eventual museum."[1] It obtained its first collection in 1929 as a result of a substantial legacy, consisting of art works and funds, left by the industrialist Robert F. Phifer. In 1939, the Art Society moved into its first gallery, which had been built with WPA funds. Then, during the late 1940s and early 1950s, complex and fascinating negotiations with the staff of the Samuel H. Kress Foundation yielded one million dollars' worth of paintings by Italian and French old masters. Matching funds from the North Carolina state legislature made possible the purchase of two hundred more works of the old masters, like Thomas Gainsborough, John Hoppner, Claude Lorrain, Peter Paul Rubens, Anthony Van Dyke, and Francisco de Zurbarán.

It was during the period of these extraordinary acquisitions that Byrnes came to the North Carolina Museum as assistant to its first director, Wilhelm R. Valentiner. Working with Valentiner toward the metamorphosis of the North Carolina Museum, Byrnes learned first-

1. Betty Chamberlain, "How to Get and Spend a Million Dollars for Art," *Art News*, LV (April, 1956), 37.

hand what degree of success could be achieved with sufficient funds. Valentiner guided the young museum from being a painting collection to being a real institution. He developed the building provided by the legislature to house the collection, and he oversaw the creation of services for the citizens of North Carolina.

Byrnes, in consequence of his invaluable experience in institution nurturing, felt that the problems of the Delgado were not intractable. As part of one of the great museum success stories, he was confident that significant growth could be achieved at the Museum in New Orleans. To those who complained that there was no money for the Delgado, he suggested that the board needed to work harder to raise it. He recommended that greater support be asked from the city council, and he argued that the state of Louisiana should be approached again. Museum membership had to be increased, he maintained, and new ideas had to be generated that would bring additional resources to the Museum.

Byrnes was aware of the successes of the Thurman years and felt that efforts had to be redoubled to surpass them. Like Sue Thurman, Byrnes expected the Delgado board members to rescue the Museum from its gloomy financial situation; the board members were certain he was the man to show them how. Anticipation ran high among the majority of board members that Byrnes would work miracles.

But the Byrnes appointment had not come about without incident. A few reservations about him had been voiced by female trustees who had talked with contacts in North Carolina. Robert J. Newman and the men on the search committee overrode the misgivings in their eagerness to hire the promising candidate. Feeling the need for immediate action, they went so far as to fail to inform the women on the committee of the final interview with Byrnes at the Roosevelt Hotel. One female member of the committee recalled vividly that she was sitting in the lobby of the hotel, awaiting a friend, when she saw Newman and several other men on the search committee march into the hotel in a phalanx and ascend in the elevator to Byrnes's room. She realized what they had come to do. The next day it was announced that Byrnes would become the Museum's director.[2]

Herbert Jahncke, as president of the board at the time Byrnes was hired, made it clear to the trustees that in 1962 the Museum would receive an appropriation of fifty-two thousand dollars from the city

2. Mrs. Richard W. Freeman, interview with author, April, 1984.

council. That amount was three thousand dollars less than the institution had got in 1961, when it ended the year in debt. He concluded that more money had to be raised. He repeatedly reminded the trustees that the Junior League would no longer cover the salary of the curator of education as of December 31, 1961, and that the Museum needed to find other money if it was to continue the position.

In September, 1961, Jahncke had reminded the board members that the Delgado required fifteen thousand dollars before the year's end if the budget was to balance. He had suggested that a fund-raising dinner be held to celebrate the fiftieth year of the founding of the Museum. A committee was appointed, but it soon dropped Jahncke's suggestion since the committee agreed "that such an event would be too time-consuming to plan on relatively short notice."[3]

In all fairness, that may have been true. The workers on the Museum board had been greatly taxed by the successful drive that enlarged the membership to over 750, bringing in revenues of more than ten thousand dollars, and by the Knoedler's benefit exhibition in New York City. The proceeds from that exhibit's opening-night gala (at twenty-five dollars per couple) and from the general admission throughout May (at fifty cents per person) had gone to the Museum's accessions fund. The board members who worked hard on these projects were Muriel B. Francis, Mrs. Richard W. Freeman, Mrs. William G. Helis, Mrs. Charles C. Henderson, Mrs. Samuel Logan, and Mrs. George B. Montgomery. These women also served on various committees of the board. Since they would have had to recruit workers and organize them for a fund-raising dinner, it is little wonder that they turned the project down despite the desperate need for funds. It was clear that the Museum badly needed a pool of volunteers apart from the board.

It was another stumbling block to active fund raising that, as of 1961, the Isaac Delgado Museum of Art had no official tax-exempt status in the eyes of the United States Treasury Department. Of course, the situation was a considerable deterrent to potential donors. Ernest A. Carrere, as treasurer of the board, was assigned the task of filing for tax exemption and obtaining an official tax number. But that problem was not resolved during 1961, and it became an issue that Byrnes had to push to rectify as soon as possible. In 1962, the problem was turned over to Charles L. Rivet, chairman of the legal committee.

3. Minutes of the Board of Trustees, Isaac Delgado Museum of Art, October 8, 1961.

At the last regular board meeting of that year, Rivet told his colleagues that the federal government "had made a large number of requirements to be met before they would grant the Museum a tax deductible status." He said it would be necessary to amend the charter to show that the Museum building and its contents were the property of the city of New Orleans, and he added that the government also required a "provision in the Charter stating that upon the dissolution of the Corporation, its assets would be turned over to the City of New Orleans." The Museum had to obtain a letter from the last treasurer of the old Art Association indicating that its assets had been turned over to the Isaac Delgado Museum of Art Association. Rivet noted in addition that he was in the process of obtaining a letter from a representative of the city government stating that the board of trustees as it then existed "had been designated by the City of New Orleans to run the museum as property of the City."

Naturally, delays occurred. Thomas Heier, chief administrative officer of the city of New Orleans, was willing to sign the necessary letter upon the approval of the city attorney. But the city attorney had advised Rivet that "the City was unable to find in any document or correspondence anything to indicate that the City had recognized the Board of Trustees as the body designated by the City to run the museum."[4] Rivet went to City Hall to attempt a resolution of the problem and later said that he felt a letter would be forthcoming. When a board member asked how long it might take to sort out the tax-status difficulties so that fund raising could proceed, Rivet conceded that he had no way of knowing.

In the meantime, another fund-raising opportunity was lost. Mrs. Edgar B. Stern, a recent member of the board, had been appointed a member of an advisory committee on the performing arts by President John F. Kennedy. This committee was to raise thirty million dollars toward the construction of the National Cultural Center, in Washington, D.C., now known as the Kennedy Center. Mrs. Stern explained that various communities throughout the country were being given an opportunity to co-sponsor a two-hour closed-circuit telecast, which would "be one of those super-colossal spectaculars with just about every top performing artist in the United States appearing."[5] The cosponsor in each of the participating cities was to re-

4. *Ibid.*, December 14, 1962.
5. Pie Dufour, "A la Mode," New Orleans *States-Item*, April 4, 1962.

ceive 50 percent of the receipts. Mrs. Stern believed that $100,000 could be raised in New Orleans, so $50,000 would benefit the Museum. The board expressed approval of the benefit, and work began in March. The news media announced in April that the event would take place on November 15, 1962.

Newman appointed Mrs. Stern chairman of the benefit, and the board directed her to sign a contract with the Civic Auditorium and to make a deposit of one-half the charge. At the board meeting on April 18, 1962, a contract was signed with the National Cultural Center for cosponsorship, and certain decisions regarding expenses, such as the purchase of a $2,000 television screen, were ratified. The board also decided that the money from the benefit would be dedicated to Museum accessions and exhibitions. Then on August 15, 1962, Newman informed the board through Mrs. Stern that the telecast "would not take place. Reasons given were because of segregation in New Orleans." Newman explained that "Mrs. Stern had made it known to President and Mrs. Kennedy that there was no way an audience in New Orleans could be integrated and she was advised that it would not be possible to have the telecast in New Orleans."[6] Newman asked that there be no publicity on the turn of events, and the matter was dropped. Mrs. Stern promised that upon her return from her summer home in the Berkshires she would try to come up with a new idea for a fund raiser. Nationally, the closed-circuit telecast was unsuccessful, raising only about $350,000.

At the September board meeting, Mrs. Stern suggested an auction by the Museum to raise money. All items stored in the Museum basement that were undeserving of inclusion in the permanent collection might be sold. This was not a new idea. Thurman and Charles Kohlmeyer, Jr., had urged it many times in the past. They had sought approval from the city council for such a sale. At the meeting of April 18, 1962, the board learned that the city council had authorized the auction. Byrnes informed the board that 150 paintings had already been moved to warehouse storage space and had been divided into three groups: one for restoration and retention, one for loan to public offices of the city, and one for auction. Preparation for the auction was well under way.

The stymied efforts at fund raising in 1962 did not deter Byrnes from attempting to improve the Museum's finances. In 1961, the city

6. Minutes of the Board of Trustees, Isaac Delgado Museum of Art, August 15, 1962.

council had cut the budget for 1962 proposed by Thurman by three thousand dollars. Already by Byrnes's first board meeting in February, 1962, the Museum was running a deficit of $5,436.15. Byrnes knew he had to launch a campaign for change.

The first salvo was fired on February 25, 1962, in the Sunday *Times-Picayune*. Under the headline "Director Lists Delgado Needs, Asks More Funds, Space for Museum of Art," Byrnes stated that on a per capita basis, the museum was "among the underprivileged institutions of the country."[7] He explained that on a $100,000 annual budget, the Delgado could serve about sixty-five thousand to seventy-five thousand visitors. But he added that the Museum's real attendance was closer to eighty or ninety thousand each year. He proposed an effort to get the city to recognize the Museum's need and to appropriate enough to run the Museum effectively. The New Orleans *States-Item* reported that Byrnes said the city fathers should be persuaded to provide the necessary income "either through funds appropriated annually or through some form of mill-tax" and to "tie the museum to the growth of the city's revenues."[8] He even went so far as to propose a three- to five-year expansion of the Museum building.

In May, 1962, an excellent feature story in the *Dixie Roto* of the Sunday *Times-Picayune* focused on the Museum's central problems of space and money. Byrnes was quoted as saying, "Delgado is too small an art museum for a city the size of New Orleans. It also has to operate on an insufficient budget." He remarked that most of the Museum gallery space was devoted to the permanent collection and that when large exhibits were planned, they had to be accommodated in only three galleries. He suggested that "the best solution would be a museum addition that would double the size of the Delgado." Increasing the size of the Museum would have a beneficial effect on the growth of the permanent collection, he maintained, for "when collectors know a museum has enough space to house works of art properly, they are more apt to donate." He conceded that an expansion would demand a great deal of fund raising, but he pointed out that "even now money is needed to meet the museum's routine expenses. The present $100,000 annual budget is inadequate for a progressive art museum striving for national recognition." Byrnes notes that of the $100,000 annual budget, the city council contributed only $52,000,

7. New Orleans *Times-Picayune*, February 25, 1962.
8. New Orleans *States-Item*, February 24, 1962.

which covered only salaries. The balance had to come from other sources.[9]

Byrnes's next move was to send to the city council, in August, 1962, a budget request for $122,963. That budget had been approved by the Delgado board, with the councilmen John J. Petre and Walter F. Marcus, Jr., concurring. The amount of $86,088 was allocated to salaries for the thirteen staff members, to building maintenance, and to art conservation. The remaining $36,875 was to be spent for exhibitions, educational programs, art classes, and such. Alberta Collier wrote in favor of Byrnes's budget in her column in the *Times-Picayune,* and radio and television stations joined her in offering editorial support. Ms. Collier firmly believed that investment in the Museum would return great dividends. In fact, she emphasized that that had been the case in 1961, when "$50,000 in tax money was given to the museum" and that same year "donations of paintings, sculpture, other art objects and of monies amounted to more than $80,000, well over 100 percent [of] the sum expended by the City." Continuing, she noted that in 1962 the Museum had received "donations valued at over $100,000, almost 200 percent of the amount that will be spent all year by the City."[10] Among the works donated were Maurice deVlaminck's *Still Life With Bottles,* from Dr. and Mrs. Cranston W. Holmon, of New York City; Sir Thomas Lawrence's *Portrait of a Lady,* from Mr. and Mrs. B. Bernard Kreisler, of Greenwich, Connecticut; and Francesco Guardi's *Esther at the Throne of Ahasuerus,* from Mr. and Mrs. Harold L. Bache, of New York City, in commemoration of the eighty-fifth birthday of her mother, Mrs. Sigmund Odenheimer, of New Orleans.

When the board of trustees met on September 19, 1962, indecision and dismay seemed to rule. Though the board had submitted a budget request to the city council for 1963, it seemed unable to make any progress in addressing the still problematic finances of 1962. There were at least two rays of hope, however: first that the city council would approve the 1963 budget request, and second, that the planned auction of unwanted art works would bring in money to help.

The brightest moment of Byrnes's first year was the exhibition entitled Fêtes de la Palette, which was among the largest shows a director of the Delgado had ever organized. The subject was food and

9. Gil Webre, "Delgado's Troubles," New Orleans *Times-Picayune, Dixie Roto,* May 20, 1962.

10. Alberta Collier, "The World of Art," New Orleans *Times-Picayune,* September 2, 1962.

feasting, as presented by artists since the Renaissance. No better theme could have been selected for New Orleans, which prides itself on its unique contribution to the art of cuisine in this country. Byrnes himself wrote and edited the catalog for Fêtes, the first scholarly catalog to be written by a Delgado director and staff. It contained more than eighty-eight photographs in black and white of paintings and objects and one photograph in color. An edition of two thousand copies was printed.

The exhibit was a part of Byrnes's master plan for exhibitions, which he had discussed with the board very early in his tenure. Byrnes believed that a museum should create and assemble its own exhibitions whenever possible, and also that it should create special exhibitions that relate to the local community, using material from local collectors. The new director understood that such exhibitions stimulate in the public an interest in collecting, with the frequent result of gifts or other forms of support for the museum.

Fêtes was just such an exhibit, planned to appeal to a specific interest of the local public, and to use a number of local art works. Of the 166 objects in the show, some 65 decorative objects and 11 paintings came from New Orleans collectors. Among the local lenders were the Manheim Galleries, Henry Stern Antiques, Melvin P. Billups, Mr. and Mrs. Cyril Laan, Mrs. Harry Latter, Mr. and Mrs. J. Wilson Raker, and Mr. and Mrs. Henry Stern. Loans from outside New Orleans came from the Rijksmuseum in Amsterdam; the Musées de Bordeaux; the Boston Museum of Fine Arts; the Musée d'Ixelles, of Brussels; the Detroit Art Institute; the Mauritshuis, of The Hague; the Los Angeles County Museum; the Montreal Museum of Fine Arts; the Metropolitan Museum of Art; the Toledo Museum of Art; and the Centraal Museum, of Utrecht.

A gala fund-raising dinner was held on the opening night of Fêtes. Byrnes, as part of his overall plan for the Museum, had suggested that such events be held in connection with major exhibits in order not only to raise new funds but also to generate interest among potential Museum members. Mrs. Richard W. Freeman, Mrs. Robert J. Newman, and Mrs. Edgar B. Stern chaired the event. Mayor Victor Schiro agreed to serve as the honorary chairman of the honored patrons, who included the consuls general of Belgium, France, Germany, Italy, and Spain, as well as the honorary consul general of the Netherlands.

Admission to the event was by voluntary contribution in order to

attract prospective members. The newspapers were full of articles about the exhibition. The *Times-Picayune* devoted a whole page of the Thursday food section to the show. On opening night, November 19, 1962, more than three hundred people attended the buffet gala, which netted a profit of $1,182.88. Critically acclaimed, the show was well received throughout the community.

Of course, a few negative comments were inevitable at the December board meeting, when Byrnes was out of town. Roberta Alford remarked that since it was her last Board meeting, "as a former museum director, she wished to say that the present 'Fêtes' exhibition was one third too large. She added that she hoped that the museum would not again have an exhibition as large as the 'Fêtes' exhibition." There was also much discussion about the costs of the show. Fêtes had been planned to run over ten thousand dollars. The entire exhibitions budget for 1962 was only sixteen thousand dollars. Mrs. Logan and Richard Koch felt an exhibitions committee should be formed, given the great expense of such events. Newman disagreed, however, and as president refused to appoint such a committee. When Koch inquired of the chair whom Byrnes had consulted before laying out money for Fêtes, the president replied "that no one was consulted by Mr. Byrnes [but] that he felt that the Board maintained control over the funds expended by Mr. Byrnes by fixing and allowing him a $16,000 budget for exhibitions in 1962 and that he further felt that Mr. Byrnes as a professional man should be allowed to plan his exhibitions himself." [11] Ernest A. Carrere, Jr., closed the discussion by suggesting that Byrnes's contract be reviewed before the January board meeting to confirm the director's authority in scheduling exhibitions. Hence, by the end of Byrnes's first year at the Delgado, he was already being criticized by certain board members even though the community extolled Fêtes and the Museum's reputation was greatly enhanced by it.

A curious incident in Byrnes's first year occurred on January 5, when two bronzes were stolen from the Museum. One of the sculptures was a small Italian Renaissance bronze, *Jupiter*, by an unknown artist, and the other was *Walking Horse*, sculpted by Edgar Degas and donated by his grandnephew, Michael Musson, of New Orleans. Eleanor Martin, curator of education at the Museum, reported that

11. Minutes of the Board of Trustees, Isaac Delgado Museum of Art, December 14, 1962.

the two pieces were removed between 10 A.M. and 2 P.M., and that both had been unscrewed from their pedestals.[12] Jahncke, the first vice-president of the board, noted in an interview "that the usual complement of three guards was present during the entire period and that all exits, except the front entrance door, were sealed off at all times." He commented on the light attendance at the Museum that day and guessed "that one or more persons may have loosened the sculptures and walked out with them concealed in either coat pockets or handbags."[13]

Alonzo Lansford, the former director and now a New Orleans art dealer, valued the sculptures around eleven thousand dollars. A week later, Byrnes told Ms. Collier, the art columnist, that Lansford's figure was "very conservative."[14] The Delgado printed a circular with photos of the two figures and circulated them to museums, art galleries, and art dealers throughout the country. Skin divers searched the lagoons of City Park in an extensive hunt. The press composed many lines of copy, bemoaning the theft of two such beautiful sculptures.

The pieces may have been too hot to sell locally—or anywhere else, for that matter. On April 13, however, Frank Weed, head of the architectural drafting department at the Delgado Trades and Technical Institute, discovered them at the institute, where they had been for about six weeks. They had arrived in a package from Hollywood, California. Edwin I. Soule, director of the trades school at the institute, said that "after the package arrived at Delgado, it was opened by a warehouseman. Not recognizing the sculptures, he showed the pieces to various department heads, but they all said they had not ordered the material."[15] But when Weed observed the two objects in the school's boiler room, he instantly identified them.

If the first year of Byrnes's directorship was a slow struggle to improve the museum, so was his second. The Museum lacked direction, and apathy reigned. Often the board could not arrive at decisions. Too often there was not a quorum at monthly meetings. For example, on July 17, 1963, the eight board members in attendance discussed a plan by Byrnes to raise money for an acquisitions fund. But in the ab-

12. New Orleans *Times-Picayune*, January 5, 1962.
13. *Ibid.*, January 6, 1962.
14. *Ibid.*, January 14, 1962.
15. *Ibid.*, April 14, 1962.

sence of a quorum, the board could not form a committee to proceed with the plan.[16] Another all too typical delay was the result.

Although the Museum ended fiscal 1962 with a deficit and was running a deficit for 1963, no fund-raising campaign got off the ground. Whenever the subject came up, two objections dogged the idea: the Museum still lacked its nonprofit tax status, and the board member Mrs. Stern "felt it would be better for the museum to hold the drive for funds after the Cultural Attractions Fund drive was over."[17] Eventually in March, 1963, the Museum received its nonprofit tax number from the Internal Revenue Service, but the special fund drive committee was still constrained by Mrs. Stern's request for postponement until after the Cultural Attractions Fund drive. The situation remained the same month after month, while the Museum's deficit continued to grow. Finally at the board meeting of October 16, 1963, Carrere, vice-chairman of the special fund drive committee, "reminded the Board that approximately one year ago a Special Committee had been appointed to raise funds from large donors with the understanding that the gifts would be given over a period of three years." He said he felt that the Museum should undertake the drive immediately. The long discussion that ensued focused especially on whether a $100,000 goal would be attainable without assistance from outside the board.[18] The consensus of the meeting, however, was that a drive should be organized and a definite date set. Although Carrere marked the first week of December for beginning the campaign, the year ended without a launch. For 1963, the Museum was in the red, but the city made good the deficit.

But the Delgado was not without its successes. In 1963, Mrs. Logan headed a membership development program that made great strides. She visited the Houston Museum of Fine Arts and interviewed Charles Farrington, the staff member in charge of that insitution's membership program. With the assistance she received there, she devised plans for expanding the Delgado's rolls. Most major museums at that time employed staff who devoted their full efforts to membership, but the Delgado had no one for such a job. The Houston Museum of Fine Arts' revenues from memberships in 1962 came to $50,000; in New Orleans, the revenues from membership were only $10,044. The High Museum of Art, in Atlanta, had $30,388 from mem-

16. Minutes of the Board of Trustees, Isaac Delgado Museum of Art, July 17, 1963.
17. *Ibid.*, February 20, 1963.
18. *Ibid.*, October 16, 1963.

bership, and the Dallas Museum of Art had a membership income of $12,000.[19]

On Friday, September 13, the membership committee kicked off its official nine-day drive. Many would have thought the date inauspicious, but the women of the committee turned the unlucky date to advantage. The press played up the drive opening, and in the *Times-Picayune* of Saturday, September 14, photographs appeared of various of the women posed under open ladders and holding umbrellas open inside the Great Hall of the Museum. A legend under the half-page spread reads, "Jinxed? No indeed! These women triumph over superstitions to launch a membership drive on Friday 13 for Delgado Museum of Art."[20] At the board meeting of October 16, 1963, Mrs. Logan reported that the drive had recruited 174 new members, and brought in revenues of over three thousand dollars.

In 1963, Byrnes achieved success in the area in which every museum director strives long and hard—the enlarging of his Museum's collections. The new accessions in 1963 were valued in excess of eighty-six thousand dollars.[21] Several were gifts to the Museum from two of America's grandes dames.

The first gifts, four paintings donated in January, 1963, came from the world-famous art collector Peggy Guggenheim. She wrote to Byrnes that she wished four contemporary oils already on loan to the Delgado to become a permanent gift: *Osage*, by Paul Jenkins; *Femme*, by Geer Van Velde; *Abstraction and Scroll*, by Jacques Brown; and *Abstraction*, by Timothy Hennessey. In 1941, Peggy Guggenheim, then the wife of the painter Max Ernst, visited her sister, Hazel Guggenheim McKinley, who had settled in New Orleans in the late 1930s. She recalled the affability of New Orleanians, writing, "Hazel's friends, the Gonzaleses, were charming to us and showed us everything, including plantation houses and swamps. They introduced us to all their friends. Dr. Marion Souchon showed us his paintings in his office, where he painted between patients' visits. We had wonderful meals in the French Quarter and felt more at home there than anywhere in America."[22]

Another series of gifts came from Mrs. Stern, still a member of the

19. Pie Dufour, "A la Mode," New Orleans *Times-Picayune*, September 21, 1963.
20. New Orleans *Times-Picayune*, September 14, 1963.
21. Minutes of the Board of Trustees, Isaac Delgado Museum of Art, December 18, 1963.
22. Peggy Guggenheim, *Out of This Century* (New York, 1979), 257–58.

board of the Museum. The story shows how a director can involve a trustee in collecting and appreciating art. Mrs. Stern, an heiress to the Sears, Roebuck empire founded by her father, Julius Rosenwald, never pretended to know anything about art or to have much love for it. She told a story on herself: "My son-in-law, Tom Hess [longtime editor of *Art News*], said to me one day, 'I've gone through this house, and you will go to any means to avoid putting up an oil painting. You have glass. You have wood. You have paper.' So, after Mr. Stern died, a few years after that, I thought that I really had to go and look at some art."[23]

Byrnes was on hand to guide her. In May, 1963, he informed the board of directors of the Museum that he felt that "the Director should work with collectors in the effort to gain gifts for the museum. He added that he had worked out a plan with Mrs. Edgar Stern on a personal basis whereby he had suggested artists in Europe for Mrs. Stern to see after which Mrs. Stern was to send photographs of selected works for Mr. Byrnes' choice."

Byrnes received a letter from Mrs. Stern from the Ritz Hotel in Paris dated May 11, 1963, and had it entered in the board minutes:

> Well, my friend, I have never worked harder—getting nowhere fast—but I am mailing you two photographs—one—my all-out gift—if you approve of a marble Arp—and it's expensive—$20,000—without shipping costs and a base which one would get locally—it has been shown at the Tate Gallery as well as those Denise René mentions.
>
> The other is by a young Argentine woman [Alicia Penalba], who is on the come-uppance list—one deals with her direct—and her museum price is $2,700—the photo is in plaster, whereas I'm speaking, naturally, of a bronze and on a large, rough block of granite (unpolished) which in turn needs its own pedest[al].
>
> If you like and want the Arp I think you should confirm by air mail to Denise René. The other, if you are doubtful, we can discuss when I get back. If you would like it I'm willing—
>
> Have something really exciting for next year—one has to wait that long—Also Arp. The one real thrill I've had.
>
> Pictures are still beyond me either in price or art-wise, but I'm plugging.
>
> Great Question is—with $20,000 to spend would you want an Arp for the Delgado? Mrs. Bond will know where to reach me. Must get to work![24]

23. Mrs. Edgar B. Stern, interview with Pamela P. Bardo, July 3, 1977 (Typescript in archives, NOMA), 2, 12.
24. Minutes of the Board of Trustees, Isaac Delgado Museum of Art, May 15, 1963.

Mrs. Stern recalled this art-finding expedition years later. She asked a good friend in Chicago, Louisiana-born Lillian Florsheim, an established abstract sculptor, to advise her on the modern art world of Paris. She remembered that Florsheim said, "'I'll go with you.' She has an excellent wonderful collection of contemporary art. I said, 'No, because then it will be your tastes.' She said, 'No, I won't say anything.' She never did. So, I asked Byrnes, then curator, to give me a list of artists he might be interested in." Mrs. Stern mentioned that one of the sculptures she found was exorbitantly priced, adding, "I used that a little bit as a guideline . . . and sent back pictures . . . and when the museum liked them . . . that was my introduction. So, then it rubbed off on me a little bit." [25]

Mrs. Stern's European "work," as she described it in her letter to Byrnes, was retold by her biographer Gerda Weissmann Klein:

> In the meanwhile, Lillian [Florsheim] and Edith [Stern] were making the rounds of Paris galleries, meeting artists, making forays into the French countryside taking time out to dine at restaurants like the Grand Vefour, one of Edith's favorites. Rushing from the Riviera to a hair appointment in Paris, they might stop to enjoy a leisurely picnic lunch in places where Renoir and Manet had sought inspiration. Pressed for time, they would fly in a private plane to attend art exhibits, the copilot serving Bloody Marys, the food tasting invariably mediocre. Edith finally insisted that on-board meals should be ordered in advance from Maxim's.

Mrs. Stern found two shadow-box sculptures by Victor Vasarely with which she was very taken, and she purchased them for the Museum. It was Florsheim who "introduced Edith to Victor Vasarely, and Edith was instantly smitten by both the artist and his work." [26] The final piece acquired for the Museum on this trip was a large light sculpture by the Argentinian Julio LeParc.

On June 14, 1963, Byrnes wrote enthusiastically to Mrs. Stern concerning her gifts and some other works she was interested in. His letter shows the subtle influence he exerted over her:

> Before leaving for the conventions, I mentioned your proposed magnificent gift of the Hans Arp to the Board members. Great appreciation was expressed and I was asked to follow up on the project. I wrote a letter to the René Denise Gallery asking for additional photographs of the piece which, according to the letter of reply, are being prepared and I received

25. Mrs. Edgar B. Stern, interview with Pamela P. Bardo, July 3, 1977, p.13.
26. Gerda Weissmann Klein, *A Passion for Sharing: The Life of Edith Rosenwald Stern* (Chappaqua, N. Y., 1984), 247, 248.

more information on the piece itself such as the date of execution, former exhibitions and so forth. I have been asked by Mlle. Denise to send further instructions with regard to the shipping of the work but I thought I would await your return so that we can work out the details.

On my desk when I returned to New Orleans was a letter from Mr. Edouard Loeb, the Paris art dealer, in which he enclosed a color transparency of a beautiful painting by Max Ernst. I enclose a copy of Mr. Loeb's letter. I have finally figured out that the size of the work is 16 ³⁄₁₀ inches by 13 ²⁄₁₀ inches. Max Ernst is a personal friend of long standing and I am very pleased to see that after many years his work is now enjoying the success that it so richly deserves.

When I took over here in New Orleans, I was pleased to learn that one of the strongest groups of paintings that we had were the works by the group of surrealist painters of whom Max Ernst was a leader. Ernst was in New Orleans some time between 1941 and 1943 and had an exhibition at the Arts and Crafts Gallery from which the painting "Everyone Here Speaks Latin" was purchased and presented to the Museum by Isaac S. Heller. The Heller painting is a major example of Ernst's early work which must have been painted here in New Orleans. It shows a very lush swampy landscape with figures. It is done with the use of sponges and other transfer materials for which Ernst is so famous.

The transparency of the panel of 1958 which Mr. Loeb offers is every bit equal in quality to the canvas we now own and it would make a handsome addition to our collection. Without any hesitation, I would like very much to see the work in the Museum but I am mindful of the many fine artists of similar persuasion by whom we have no examples and I thought we might have a chance to go over some books to program the building of that section of the Museum's holdings. For example, we have nothing by Yves Tanguy, Miro, early Dali, early DeChirico, Paul Klee, Kurt Schwitters, to mention a few. Feeling that I know a little something about the kind of artists whose work might interest you, I have put forth just a few of the names of the many gaps in our collection. If you are particularly interested in the Ernst, I would be most happy to try to work it out because I think that an acquisition of this importance together with the masterful work by Hans Arp would do much to bring this Museum up to the standard that it should have enjoyed for a long time past.

I must say that for someone who expressed "restraint" about acquiring works of outstanding modern artists, you certainly have soared past the boundaries, for aside from Ernst and Arp, I think your discovery of the work of the sculptress Alicia Penalba is breathtaking for all three artists are of the first importance and I am indebted to you for bringing Penalba's work to my attention.

On my trip to Dallas, we were privileged to visit the collection of Mr. Ted Weiner where I saw a beautiful sculpture by Penalba which Ted Weiner has situated in the center of an artificial lake on his estate. I fell in

love with the sculpture and was delighted to learn that it was by our friend. I hope that one day we can get a chance to pay a visit to Houston or Fort Worth and to tour some of the collections there because I feel that while some of the collectors have gone overboard in display, they certainly can be congratulated for their enthusiasm and dedication.

Please let's get together as soon as it is convenient after your return and I will have some slides of the Weiner estate and other collections that I took on my trip which I would like to show you.

I hesitate to close the letter because I feel that I have not been able to express my intense enthusiasm for bringing our project to realization but the moment I am able to sit down with you and have a drink, I hope I can communicate with more ease.

Welcome back. There's much to talk about. I hope we can be together shortly.[27]

Art collecting did rub off on Mrs. Stern, as she had said. William A. Fagaly described her further contributions to the Delgado:

The flood gates were open and the following year gifts continued to pour into the Museum: a Naum Gabo sculpture, nine bronze reliefs executed by Jean Arp after designs by Sophie Tauber-Arp, a Vasarely painting and twelve serigraphs, and a construction by Lillian Florsheim. This same year a group of works of art were donated to the Delgado with Edith retaining life rights. Among the objects were an important oil study of clouds by the 19th-century English artist John Constable, a 19th-century portrait by New Orleans artist Jacques Amans, an Agam shadow box, and a major oil, dated 1926, by Wassily Kandinsky. This latter painting had a special affection for Edith from the moment in 1964 she first saw it at a luncheon in the home of her friend, New York art dealer Madeleine Lejwa. It was the first painting she claimed she ever bought for herself and it remained her favorite. She always seemed surprised with herself for being attracted to this colorful abstraction, painted by an artist she admitted she had never heard of before its purchase.[28]

In the same year, Mrs. Stern assisted in another Museum project. Earlier she had purchased for the Museum, through the Stern Family Fund, a collection of 44 oil crayon paintings and 110 drypoint etchings depicting historic French Quarter architecture, by William Woodward. It was Byrnes's inspiration to publish a catalog of these that could be sold in the Museum shop. The nature of the material in it guaranteed that it would be a very popular guidebook. Mrs. Stern lent the Museum five thousand dollars for the first printing and assigned

27. James B. Byrnes to Mrs. Edgar B. Stern, June 14, 1963, in archives, NOMA.
28. William A. Fagaly, "A Woman for All Causes, Including Art," *Arts Quarterly*, VI (October-December, 1984), 31–32.

the project to her niece by marriage, Simonne Stern. Mrs. Stern reasoned that the project would give the younger woman a stimulating task and that the loan would oblige the Museum to push the sale of the book. Indeed, the guidebook quickly sold out, and the Museum repaid the loan. Since 1964, the guide has been through five editions and sold over thirty thousand copies. Simonne Stern opened her own gallery in the French Quarter a few years later, specializing in contemporary New Orleans artists.

XIV

Bringing Estelle Home:
New Wings, New Name,
New Acquisitions

The year 1964 was the turning point in the Byrnes administration of
the Museum. After so many difficulties, everything seemed to fall
into place. James B. Byrnes's hard work was paying off. And a bit of
luck had its play too.

Museums need not only talented directors and staffs but also ca-
pable and willing trustees. Now the time had come for the Delgado,
for the board of trustees was made up of some of the wealthiest,
most powerful and influential, and most art-oriented citizens who
had ever served on it. And they were among the most willing and
hardworking.

The president of the board was F. Julius Dreyfous, who had served
on the board since 1930. His father, Felix J. Dreyfous, had been one of
the founding board members. The son was the architect of record for
Charity Hospital, the Louisiana State Capitol, and the old Governor's
Mansion. He was also a member of the board of managers of Touro
Infirmary and of the board of commissioners of City Park.

The first vice-president was Robert J. Newman, a member of the
Newman family of department-store and banking fame. A wealthy in-
vestment banker and financier with European connections, he had
served the Museum in the past as a board member and as the special
emissary in 1953 to Paris, where he made the selections for the Mu-
seum's international loan show of French paintings. He had just
served a two-year term as board president.

The second vice-president was Mrs. Samuel Logan, the former
Margot Bennett, of Atlanta. A graduate of Newcomb College, she was
president of the Junior League of New Orleans in 1959–1960. She also
served on numerous boards such as those of the Cultural Attractions
Fund, the Longue Vue Foundation, and the Louise S. McGehee
School.

Mrs. Richard W. Freeman, the former Montine McDaniel, of Forrest City, Arkansas, was secretary of the board. She graduated from Newcomb College in 1936 with a Bachelor of Design degree and married Richard W. Freeman, a Coca-Cola magnate. She was vice-president of the Junior League of New Orleans in 1953–1954, and like her friend Mrs. Logan, was a hardworking volunteer. She had served on the boards of the Louisiana State Museum, the New Orleans Symphony, the Greater New Orleans United Fund, the New Orleans Young Christian Association, the Community Volunteer Service, and the Pre-School for the Blind, and had been a member of the New Orleans Neighborhood Center Board.

The Museum board's treasurer was Percy H. Sitges, a native of New Orleans who graduated from Loyola University and became executive vice-president of the National Bank of Commerce. He had been president of the Louisiana Bank and president of the board of City Park, as well as a member of the board of DePaul Hospital.

Ernest A. Carrere, Jr., a board member, was also a New Orleans native. He received his B.A. and LL.B. from Tulane University and was a partner of the prestigious law firm of Jones, Walker, Waechter, Poitevent, Carrere and Denegre. He had served as vice-president of the New Orleans Bar Association, as a member of the advisory board of Tulane University Law School, and as a member of the board of City Park.

Arthur Q. Davis, a native New Orleanian, received degrees from Tulane and Harvard. His architectural firm, Curtis and Davis, founded in 1946, was one of the most distinguished in the South, designing buildings throughout the United States and abroad. Davis served on numerous civic boards and was the founder of the New Orleans Jazz and Heritage Foundation. He and his wife, Mary, were building a collection of Pre-Columbian artifacts.

An architect with the firm of Andry and Feitel, Arthur Feitel had served the Museum as president of the board and acting director for many years. After his earlier work in behalf of the Delgado, he now continued as an experienced trustee for the new administration. Feitel had also served as chairman of the Vieux Carre Commission and on the board of the Spring Fiesta.

Muriel B. Francis, a native New Orleanian, had recently returned from New York after selling her arts-management business. In New Orleans, she had taken over the management of the House of Bult-

man funeral home and had become an active supporter of the Museum, as her late father, A. Fred Bultman, had been. Well known in art circles in both New Orleans and New York, Mrs. Francis had cochaired the New York Knoedler benefit in behalf of the Delgado. Of all the board members at the time, she possessed by far the most important art collection.

Like Feitel, Mrs. William G. Helis, the former Betty Felich, had been associated with the Museum since the 1930s. In addition to donating several important paintings to the Museum, she for many years underwrote the Museum's art classes for children, as well as the annual Christmas party for the children. She served on the boards of the New Orleans Opera Guild, the New Orleans Symphony, Dominican College, St. Elizabeth's Children's Home, and DePaul Hospital. She was also chairman of the board of the Helis Foundation, which was established by her husband, the oil millionaire William G. Helis.

Paul R. Kalman, Jr., another native New Orleanian, was president of Kalman and Rogers, a public-relations counseling firm. He was a prolific writer and had published articles in the *Reader's Digest* and other major magazines. A well-known sportsman, Kalman served on the board of City Park and the board of the Southern Yacht Club, and he was president of the New Orleans Sportsmen's League.

Another board member with long service to the Museum was Charles Kohlmeyer, Jr., who was reelected in 1964 to a new three-year term. Kohlmeyer was born in New Orleans and educated at Tulane, where he received both B.A. and LL.B. degrees. He had served as president of the Art Association of New Orleans and was vice-president of the board in 1958 when he helped to steer the Museum on an even course after the dismissal of Alonzo Lansford as director. Kohlmeyer, whose wife, Janet, was founder of the Circle Gallery, was among the few board members who were serious art collectors at this time.

Walter F. Marcus, Jr., was born in New Orleans on July 26, 1927. He received his B.A. degree from Yale in 1951 after serving in both World War II and the Korean War. He received his law degree from Tulane in 1955. Marcus was elected to the New Orleans city council in 1962 and reelected in 1966. He was the city council's representative to the Museum board.

Also a native of New Orleans, Mrs. George B. Montgomery, the former Anne Cameron Kock, was a graduate of Barnard College. A very

active volunteer, Mrs. Montgomery had been president of the Junior League of New Orleans and had served on the boards of the United Way, the Holman Center, and the Family Service Society.

Mrs. P. Roussel Norman, the former Sunny Gould, of Houston, had moved only recently to New Orleans from Morgan City, her husband's home. Some years earlier she had organized an art exhibit in Morgan City of objects borrowed from the Delgado. She and her husband both became actively involved with the Museum when they moved to New Orleans, and at about the same time they began to assemble their extensive collection of contemporary art.

A graduate of Tulane University, Richard A. Peneguy was a native New Orleanian who served on the boards of City Park, Children's Hospital, and the Floral Trail. From 1950 he had served as secretary of the Wisner Fund, a bequest to the city of New Orleans by his grandfather Charles Edward Wisner, and had overseen and administered all the fund's assets, consisting of 900,000 acres of land in three south Louisiana parishes. Over the years, the fund provided millions of dollars to local community improvements.

A. Q. Peterson, known to all as Mr. Pete, was a native of Denmark who first settled in New Orleans in 1917. He was one of the founders of the Southport Mill, which in 1925 bought Southern Cotton Oil Company, the largest cottonseed-oil mill operator in the United States. The new company was named Wesson Oil and Snowdrift. Mr. Pete served as president of the firm from 1940 to 1960. When he retired, the company merged with Hunt Foods and Industries, later Norton Simon, Inc. Peterson served on the boards of the Texas and Pacific Railroad, the Lykes Corporation, and the National Bank of Commerce, and he was chairman of the board of governors of the Ochsner Foundation Hospital.

John J. Petre, a New Orleanian, graduated from Northern Missouri State College and founded John J. Petre, Inc., an insurance agency. He was editor and publisher of the New Orleans *Outpost,* a biweekly publication dedicated to civic concerns and activities in the Gentilly area, which was undergoing enormous growth and development. In 1956–1960, Petre served as a state senator. In 1961–1966 he was a city councilman and the second city-council representative on the Museum board.

Mrs. Lee Schlesinger, the former Shirley Latter, of the Latter real estate family, was a native of New Orleans who attended Newcomb

College. She started volunteer work in the Touro Infirmary Volunteer Nurse's Aid Program in 1933, after graduating from the Newman School. Later she became one of the founders of the Touro Gift Shop. Mrs. Schlesinger was on the founding board of the Cultural Attractions Fund and also on the boards of the Anti-Defamation League and of Crippled Children's Hospital. She and her father were avid collectors of English and European portrait miniatures. At the time of her service on the Delgado board, she was developing her own collection of French and American drawings, watercolors, and prints.

Mrs. Edgar B. Stern, formerly Edith Rosenwald, of Chicago, the Sears, Roebuck heiress, had since the time of her marriage in New Orleans been a civic activist. She served on the boards of Dillard University, the city's Park and Parkway Commission, and the New Orleans Symphony, and she was founder of the Metairie Park Country Day School. In 1951, she was executive secretary of the New Orleans Housing Projects. And she too—despite her initial disclaimers—was to become interested in collecting contemporary art.

Other prominent community leaders who served as Museum trustees in 1964 were Mrs. Clayton Charbonnet, Dr. Isidore Cohn, Mrs. Crawford H. Ellis, Nat B. Knight, Mrs. G. Frank Purvis, and Mrs. C. S. Williams.

With a board of such active citizens, Byrnes hoped to harness effective manpower on behalf of the Museum. From the outset, he had presented the trustees with a program for the development of the Delgado. It included expansion of the building, collection, and staff, and it proposed a number of strong concepts for future exhibitions. He wrote, "Among special exhibitions of modern art that occur to me is a major show on the theme of 'Jazz' in painting; a large showing of the works of Redon (whose mother was born in New Orleans); and a comprehensive showing of the work of Degas, featuring his stay in the city. In every case the exhibition would be accompanied by an illustrated catalogue. Funds for these shows would have to be raised by some form of special activity."

Byrnes believed that an exhibit organized by the Museum relating to an artist connected to New Orleans could stimulate local as well as national interest. It would initiate through the catalog original scholarship, increasing the Museum's standing among fellow institutions. And because it would need funds for such an expensive undertaking, its board would have to organize an activity to pay the costs. If such

an exhibit became an annual event, it would necessitate an institutional activity centered on fundraising.

For some time, Byrnes had been considering the Museum's sponsorship of a show of Edgar Degas' works, and he mentioned the possibility to the board on February 20, 1963.[1] The suggested cost of fifty thousand dollars damped the immediate enthusiasm of the trustees. Nevertheless, Byrnes kept firm to his conviction that such a show would be good for the Museum.

Initially, the suggestion of the Degas show had cropped up in a discussion of the major international exhibition that Newman, as president of the board, had been hoping for for years. He had privately obtained the promise of Governor Jimmie Davis to sponsor an act allocating fifty thousand dollars for an international biannual exhibition at the Museum, to foster Louisiana tourism. The Lovely Louisiana Tourist Association had agreed to participate in such an undertaking at its 1963 convention in New Orleans. At the board meeting on February 26, 1964, Newman announced that the Museum had received twenty thousand of the promised fifty thousand dollars for the envisioned exhibition. He added that although he had recently been unsuccessful in persuading the prince of Liechtenstein to lend the Delgado his private collection, he hoped that his personal contact with the Baron de Rothschild would yield an impressive loan. Peterson suggested that if this did not work out, it might be possible to obtain the Robert Lehman Collection from New York.[2]

All of these ideas failed, however, and the following month Newman proposed another—an exhibition that would coincide with the opening of the new Trade Mart building. Jointly sponsored by the Trade Mart and the Delgado, the exhibit would present art from countries served by the port of New Orleans. The trustees approved the concept in principle, but it turned out to be another that never came to fruition.

Meanwhile, Byrnes was still working on his Degas show. In June, a bit of luck came his way. An important oil painting done by Degas in New Orleans, a portrait of his cousin Estelle Musson, became available for sale from a private English collection. Byrnes mentioned this in his director's report to the board at its meeting on June 17, 1964,

1. Minutes of the Board of Trustees, Isaac Delgado Museum of Art, February 20, 1963.
2. *Ibid.*, February 26, 1964.

saying that "he felt that the Board might wish to give consideration to making a drive for purchase funds for the portrait among industry and the public."[3]

Mrs. Logan, second vice-president and chair of that session, later recalled that "she was surprised that no one responded to the director's suggestion to buy the Degas portrait."[4] Therefore, she herself spoke in favor of the purchase. Byrnes commented that if there was an expression of interest from the trustees, it would be possible to have the portrait sent down to the Museum for consideration. But the meeting did not have a quorum, so those present could not take official action. Mrs. Logan, not to miss an opportunity, said that she would work with Byrnes to acquire the painting "without committing the Board."[5] Mrs. Schlesinger volunteered to approach persons who in the past had been interested in helping toward the acquisition of a major work. The board agreed that the director, under the authority granted in his contract, could arrange with the dealer offering the Degas to have it brought to New Orleans for further consideration.

In that manner the wheels were set in motion for one of the most exciting events in the Museum's history. Mrs. Stern volunteered to aid Mrs. Logan and Mrs. Schlesinger. Taking the initiative, she invited about thirty civic leaders to the Museum for a po-boy luncheon. "The lunch was served in Mexican baskets with splits of champagne and plastic glasses. On the invitation she warned each of her guests that for their lunch they should each be prepared to write a check. As a consequence, fifty-five thousand dollars was either pledged or given at that first meeting, and the campaign to 'Bring Estelle Home' was successfully launched."[6]

On July 15, 1964, Mrs. Logan reported to the board that fifty-five thousand dollars had been raised toward the purchase of the Degas, and that another thirty thousand dollars could be anticipated. The price of the painting, somewhere in the vicinity of $200,000, was far from in hand. She asked the board for advice in the matter of raising additional funds, but little was forthcoming. Finally, she inquired whether the special committee should launch a campaign to raise the first $100,000 of the purchase price. But for the most part, the board

3. *Ibid.*, June 17, 1964.
4. Mrs. Samuel Logan, interview with author, April, 1985.
5. Minutes of the Board of Trustees, Isaac Delgado Museum of Art, June 17, 1964.
6. Fagaly, "A Woman for All Causes," 33.

was loath to undertake the task; consequently, the project fell to the "ladies of the 1964–1965 Museum Board of Trustees, who organized the drive that raised the basic purchase fund."[7]

On August 9, 1964, Mrs. Freeman reported to the board on behalf of the special committee that Mayor Victor H. Schiro was very enthusiastic about the purchase of the painting and had promised to help in every way possible. In October, a group of Junior League docents called on the mayor and persuaded him to appoint a citizens committee to raise the additional money needed. The minutes report, "Thus, the contemplated purchase can be considered a project of the City rather than of the Museum and its Board."[8] One can almost hear the sighs of relief from some male board members when that was announced, for despite the success of the women of the special committee, certain male members of the board feared that they could not raise the balance. Mrs. Logan recalled "being laughed out of the offices of Billy Burkenroad, Sam Israel, and Louis Roussel," all of whom felt that the community could not afford the Degas.

The campaign became a full-blown public one with the announcement on November 5, 1964, by Mayor Schiro of the appointment of a special citizens' committee "to negotiate for the acquisition of a major work of art by famed artist Edgar Degas for the Delgado Museum of Art." The newspaper article on the subject included a picture of the painting and mentioned its title, *Young Woman Arranging a Bouquet*. It explained that the painting was one of ten done in 1872–1873 during the artist's five-month visit to his brothers René and Achille in New Orleans. The subject was thought to be Estelle Musson, first cousin and sister-in-law of the artist. She was the daughter of Degas' maternal uncle, Michel Musson, and she was married to the artist's brother René. The initial asking price for the oil was reported to be $220,000, but the E. V. Thaw Gallery, in New York, which represented the owner, had lowered the price to $190,000. Byrnes had remarked that "the committee has raised half of the price and will attempt to raise the rest from private philanthropists."[9]

The following day the *Times-Picayune* ran an article about the drive, with a photo of Mayor Schiro, Seymour Weiss, chairman of the citizens' committee, and Mrs. John O. Prados, a granddaughter of the

7. James B. Byrnes, *Edgar Degas: His Family and Friends in New Orleans* (1965), 7.
8. Minutes of the Board of Trustees, Isaac Delgado Museum of Art, October 21, 1964.
9. New Orleans *States-Item*, November 5, 1964.

painting's subject. The headline read, "$85,000 Needed to Obtain
Prize: Mayor, Art Lovers Seek Painting." Weiss, the prominent owner
of the Roosevelt Hotel, said, "The museum's possession of this work
would 'put the Delgado on the map.'" Mayor Schiro concluded that
"the acquisition of the painting would be a fitting Christmas present
for New Orleans." [10]

By late November, projects were in full swing among the citizenry
of New Orleans as well as the rest of Louisiana in behalf of the cam-
paign to purchase Degas' portrait of Estelle. The girls of the Louise S.
McGehee School planned to raise funds by holding a huge white-
elephant sale. T. Hunter Pierson, an attorney in Alexandria, was ap-
pointed chairman for the campaign in central and north Louisiana.
He said that "Central and North Louisianians wanted to do their parts
in obtaining the painting for New Orleans." He quoted from a letter
written by Degas in 1872: "Louisiana must be respected by all her
children, of whom I am almost one." Pierson concluded that "since
Degas felt so close to Louisianians, . . . all sections of the state should
have a part in acquiring the work done here." [11]

On Wednesday, November 25, 1964, the Museum held a reception
to show the portrait and to sell tickets to a hundred-dollar-a-plate
fund raiser at the Roosevelt Hotel on December 18. Weiss paid all
costs of the dinner as his contribution. Bruce Baird, executive vice-
president of Armored Cars, donated his firm's services for transport-
ing the painting to the dinner, and the city provided free police pro-
tection. The door prizes included "a rare vintage champagne from
the House of Moet, a French-designed moleskin bolero jacket from
Quality Furs of New York, an antique French pin from Rothschild's of
New Orleans, an extremely large bottle of French perfume from the
House of Chanel, a prized French lithograph from the 331 Gallery of
New Orleans, and a valuable compendium of Degas art from the Pel-
ton Book Store of New Orleans." [12] Later it was announced that two
round-trip jet airline tickets to Paris had been added to the door
prizes by Richard W. Freeman, chairman of the board of Delta Air
Lines.

Throughout December the newspapers aided the campaign with
stories about the painting and the drive. In an article in the *Times-
Picayune*, Byrnes recounted the history of the hauntingly melancholy

10. New Orleans *Times-Picayune*, November 6, 1964.
11. New Orleans *States-Item*, November 24, 1964.
12. *Ibid.*, December 1, 1964.

painting, explaining that Estelle was blind at the time of the portrait. In fact, Estelle was going blind when she made a visit to France, "presumably to visit the shrine in Lourdes." On that trip, however, she met her cousin, René Degas, Edgar's youngest brother, and they fell in love. René followed her to New Orleans; when he arrived, she was completely blind. But he was determined to marry her despite family opposition that arose because of their being first cousins. Byrnes speculated that Edgar Degas also had great affection for Estelle, whose blindness may have inspired his fondness for her: "At the time Degas too was suffering from a vision deficiency. This may have given him a greater empathy for her." [13]

Estelle married René, and bore him five children. But after ten years, René abandoned his wife and children and returned to Paris, where he remarried. Estelle's father was so enraged that he had her drop her married name. Her children took their grandfather's name; hence, today there are no descendants of this couple named Degas, only Mussons. When Mrs. Stern coined the phrase "Bring Estelle Home," its poignancy captured the public imagination, giving the campaign a three-word slogan that seemed to echo the whole sad story.

As the date of the gala dinner neared, the newspapers gave full coverage almost every day to the acquisition of the painting. In fact, papers throughout the state featured the story. On December 8, 1964, the *Times-Picayune* ran a picture of Vanessa Helis and Lisa Schlesinger presenting $5,000 checks to Byrnes from the William G. Helis family and the Milton Latter Foundation respectively. The Junior League of New Orleans donated five thousand dollars to the campaign. And on the day before the gala dinner, another newspaper photo showed Byrnes accepting a check from Harriet McFaul, a member of the Louise S. McGehee School art-appreciation class, who made the presentation on behalf of the school.

The day of the gala arrived, and the event was a tremendous success. A total of sixty-eight thousand dollars was added to the purchase fund from the dinner, the menu for which included filet of truite sauté amandine Musson, parfait au sorbet Impressioniste, and petits fours Estelle. The function attracted many persons from across the state. The couple that traveled the farthest to attend the dinner

13. New Orleans *Times-Picayune*, December 14, 1964.

were Mr. and Mrs. Frederick M. Stafford, who flew in from Paris. The gossip column "C'est la Vie" noted, "It's particularly appropriate that the Staffords be on hand: Through Mrs. Arthur Davis, this summer Mrs. Stafford and Byrnes talked art here, and in consequence, two Degas drawings from the Staffords' extensive New York art collection are swelling that almost three-quarters of a million dollars of new art enhancing the museum." [14]

Nonetheless, the drive was still some $20,000 short of the $190,000 needed to redeem Estelle. The E. V. Thaw Gallery extended the purchase deadline from December 31 to January 14, but that added only two weeks' grace. Peterson as incoming president of the Museum board had authorized Byrnes to negotiate with the gallery, "offering the $170,000, plus a definite extra $5,000 plus the other $15,000 by June 1, "according to the *Times-Picayune* of January 13, 1965. This offer was turned down, and so an appeal was made to all in the community and throughout the state. New Orleans schoolchildren contributed nickels. Board members and volunteers manned a twenty-four-hour telethon at the Museum on January 13, 1965, the day before the deadline. Byrnes, armed with a photographic blowup of the painting, spent thirty-six consecutive hours in radio and television stations. His appeals were often sandwiched in for only a few seconds between commercials and announcements by disc jockeys.

On January 14, 1965, the *Times-Picayune* ran a quiet front-page headline that announced, "Goal Reached by Degas Fund." No newspaper headline could have conveyed the jubilation of those who had worked so long and hard to "bring Estelle Home." The paper went on to say, "Victory came in minutes before midnight without need to take advantage of an offer made a couple of hours earlier by local builder Sam Recile. Recile had promised to underwrite any sum that couldn't be raised by the final hour."

The art reporter Alberta Collier wrote, "Main credit for the success went to everyday men, women and children who wanted the Delgado Museum of Art to keep the Edgar Degas painting as its most prized possession." In this she was absolutely correct. In the final hours, hundreds of people called the Museum and pledged one dollar, five dollars, ten dollars, and up to one hundred dollars. "The money came from people like a woman who contributed her beauty parlor money

14. Laurraine Goreau, "C'est la Vie," New Orleans *States-Item*, December 15, 1964.

and a man who settled an estate and immediately pledged $100." Ms. Collier continued,

> Largest announced contribution of the day was a $5,000 pledge from the Fashion Group of New Orleans. One of the most touching was the pledge of a day's pay from each of the museum's 14 employees.
>
> Most harrowing moments for volunteer workers came about 2 P.M. when the museum's three phone lines went on a 45-minute blink. One call, a $1000 one, did get through during that period. It came from a woman who explained that she wanted to do it for the children of New Orleans.
>
> Because of the temporary telephone breakdown, Southern Bell Telephone and Telegraph donated $200 to help buy the painting.
>
> A gift of $100 came from a Negro life insurance company. A donation of $3 was delivered by "Jim, Jace and Jac . . . for picture."
>
> Mayor Victor H. Schiro said the effort proves the people want art and culture. "I want to particularly commend the people who have actually deprived themselves of essentials to put up a dollar or five dollars for the drive." [15]

The New York *Times* reported, "It was a near thing and the ransom was high but New Orleans last month repatriated a native daughter after nearly 100 years. . . . New Orleans came through, sometimes in dimes." [16] Byrnes concluded, "It was truly the people in all walks of life, who came forth in the most dramatic photo finish in art history." [17] He announced that on May 2, 1965, the Museum would open an exhibition, Edgar Degas: His Family and Friends in New Orleans, and that the centerpiece of the show would be the portrait of Estelle Musson. Also exhibited would be other works that Degas did while in New Orleans. The catalog for the show was to include articles by Byrnes and by noted Degas scholars. Thus the director finally got the show that he had suggested to the trustees three years before. The exhibition was to feature the official unveiling of Estelle's portrait, but of course, by the time the celebration was held in May, the picture would be virtually an icon, recognized by thousands of New Orleanians who had seen it through the news media or in person. Indeed, it needed no unveiling.

Still, Byrnes considered his most notable achievement of 1964—indeed, of his entire career—to be the acquisition of more than a million

15. New Orleans *Times-Picayune*, January 4, 1965.
16. New York *Times*, February 7, 1965.
17. New Orleans *Times-Picayune*, January 17, 1965.

dollars' worth of art for the Museum.[18] That was no mean task. It required untold hours and endless patience to cultivate potential donors and to teach future collectors. It required discovering the city's collectors and determining whether the collections in whole or in part merited inclusion in the Museum. The director had to practice diplomacy at every turn. Board members had to be nurtured to give and to give big. For Byrnes, it meant begging gifts of art from old friends and acquaintances. It meant cajoling politicians for funds for acquisitions. Most certainly, the director enjoyed such pursuit of art, for he did an excellent job.

Among the million dollars' worth of art amassed in 1964 were a handsome seventeenth-century Italian baptistry given by Bernard Manheim; a pair of glass doors painted by Paul Gauguin, entitled *Hurrah Tahiti*, from the Knoedler Benefit Fund and Mrs. Lee Schlesinger; a bronze sculpture by Auguste Rodin entitled *The Age of Bronze*, from Mr. and Mrs. A. Q. Peterson; a monumental oil by Maurice Utrillo entitled *Montmartre*, from George Frierson and the George Engine Company; and two works from Muriel B. Francis, one a sculpture by David Hare entitled *Moon and Sun*, the other a painting by Odilon Redon entitled *Portrait of a Woman with a Bird of Paradise and Butterflies*. In addition, that year Mrs. Stern's enthusiasm for collecting peaked, and she acquired a number of art works for the Museum. She really immersed herself in the hunt so totally that in a postcard to Byrnes informing him of her purchase of the Naum Gabo sculpture *Construction in Space—"Suspended,"* she asked, "Who is Julius Dreyfous? Claims he is Director of Delgado."[19] At the time, Dreyfous was president of the board of trustees of the Delgado and Mrs. Stern had served with him for several years on the board. That summer she purchased and gave to the Museum an oil, *Bellatrix C*, by Victor Vasarely, twelve serigraphs by the same artist, and an oil, *Sketch for "Several Circles,"* by Wassily Kandinsky.

In January, 1964, Byrnes went to Florida to visit his old friends Mr. and Mrs. S. J. Levin, of St. Louis, who had an extensive art collection. Catholic in their tastes, this couple owned works by Sam Francis, Willem de Kooning, E. L. Kirchner, Laszlo Moholy-Nagy, and Kees van Dongen, to name but a few. In 1963, they had given the Museum a painting by van Dongen entitled *Woman in a Green Hat*. They also

18. William A. Fagaly, interview with author, May 7, 1985.
19. Mrs. Edgar B. Stern to James B. Byrnes, May 7, 1964, in archives, NOMA.

had an extensive collection of Pre-Columbian artifacts. Byrnes persuaded the Levins to give a number of these to the Delgado, in keeping with his concept of an Arts of the Americas collection, which Alonzo Lansford had originally articulated. Among the twenty-three objects presented was a fine Tarascan-culture male warrior figure, a Tarascan-culture female figure, and a Chiriqui-culture metate in the form of a jaguar.

Byrnes also called on his old friend Morton May, of the May Department Stores family, for a donation. He received from May's company·eight Oceanic pieces from the Sepik River culture, among which was a good example of a New Guinea polychromed ancestral head with a headdress representing a bird and with a black and white zigzag "harlequin" collar.

Among the new donors recruited by Byrnes that year were Dr. and Mrs. Richard W. Levy, of New Orleans, who donated seventy-three objects of stone and pottery from the Pre-Columbian period. Dr. Levy was appointed to serve on the accessions committee that year, and the relationship between the Levys and the Delgado has become a long and lasting one. Another couple whom Byrnes drew to the Museum in 1964 were Mr. and Mrs. Frederick M. Stafford, of New York and Paris. Mrs. Stafford, the former Hazel Muller, of New Orleans, and a graduate of the School of Art at Newcomb College, had ties to the city but had never been impressed by Sue Thurman. "Byrnes, on the other hand, was an entirely different matter," said Mrs. Stafford. "He understood the sophisticated art lover. With Sue no chemistry from the first contact and no follow-up. That was not the case with Jim. There was chemistry and follow-up."[20] Consequently, she and her husband gave the Museum two drawings by Degas, one of which was of Sabine Neyt, the artist's housekeeper. From the association between the Museum and the Staffords would come many gifts over the years and the founding of the Odyssey Ball, the Museum's major annual event for raising funds for art acquisitions.

Important plans were under way in 1964 to contribute significantly to the progress of the Museum. Still on the drawing board was an auction of unwanted objects stored in the Museum's basement. Another project under continuing discussion was the expansion of the physical plant—not a new topic but certainly a nagging one. Space

20. Mrs. Frederick M. Stafford, interview with author, November, 1983.

was direly needed not only for exhibition of the permanent collections but also for traveling shows. Moreover, there was not enough space for the ever-growing staff's offices, for a museum shop, or for storage of the collections.

In January, 1963, city planners had suggested that an addition to the Museum be included in the new Cultural Center on Rampart Street, now known as Armstrong Park. That plan met with little favor from either the director or the board, however, for the proposed building was felt to be too small and would have been the last of three constructed in the project. Later the trustees discussed an alternative: that a branch of the Museum be built in the renovated United States Mint Building in the Vieux Carre. Feitel and Richard Koch opposed the idea, pointing out that the project would cost about a half million dollars and that space for parking would be scarce.

The problems of both the site and the cost of any expansion were to fester for months in the various committees, but on April 15, 1964, the trustees made it clear that they did not want expansion at the Mint Building or in the Cultural Center. Indeed, they proposed that money be raised for expansion on the City Park site. In compliance, the director two months later reported that he had submitted a capital budget to the city in the amount of $830,305, of which $750,000 was for the construction of a new wing. By September, the city Planning Commission had requested cost estimates for rehabilitation and expansion, and at long last the project was in progress.

At the board meeting of January 20, 1965, Mrs. Logan expressed interest in the formation of a women's committee to serve as a volunteer auxiliary for Museum activities. The proposal met with approval, but it was observed that before such a committee could come into existence, the bylaws of the Museum would have to change. Sounding a theme that had become a favorite of his, Feitel suggested that in any modification of the bylaws "provision might also be made for naming any future additions to the museum after their donor, retaining the name Isaac Delgado Museum for the presently existing structure, and calling the entire complex the New Orleans Art Museum."[21] Feitel had made the same suggestion the preceding month, saying that its implementation would facilitate fund raising for the expansion. His recommendation had sparked outrage and heated words,

21. Minutes of the Board of Trustees, Isaac Delgado Museum of Art, January 20, 1965.

but the memory did not deter Feitel from resurrecting his idea at every opportunity.

The establishment of a women's committee was essential at this juncture in order to assist the Museum in its many projects, such as its auction. On February 17, 1965, Byrnes notified the board that the city council had authorized the auction of objects the Museum no longer wanted and had specified that any money realized from the sale was to be used to purchase new works. He also informed the trustees that the movers behind the formation of a women's committee had volunteered to assist in the auction. Indeed, the volunteers had even selected a name: DAMES, for Delgado Art Museum Extension Society.

Mrs. Logan recalled that she, "Tina Freeman, Shirley Schlesinger, and Edith Stern brainstormed a list of possible ladies who might be interested in forming a volunteer group for the Museum and then sent them invitations to attend a meeting at the little playhouse at Edith Stern's." She added, "We knew more would show up if it were at Edith's rather than the museum."[22] About one hundred attended the meeting. Initially 150 women joined as charter members, and Mrs. J. Frederick Muller was chosen president. Having worked for years as Lansford's secretary, she knew the Museum exhaustively. Mrs. Muller attended the board meeting of June 16, 1965, to report the committee's formation.

At that session, Peterson, the president, had the secretary read a letter from Kohlmeyer expressing doubt about the advisability of organizing a second group within the membership of the Museum. One can speculate that Kohlmeyer did not want a women's committee formed because he feared it would eventually grow strong enough to control the board. Certainly the success of the "Bring Estelle Home" project pointed to the formidable powers of the women. But Carrere brushed aside Kohlmeyer's letter, suggesting instead that Mrs. Muller read the women's committee's plan of operation. After hearing it, those present agreed in principle to the establishment of the Women's Volunteer Committee, as it would henceforth be known. DAMES was considered not dignified enough, according to Mrs. Logan.

The women set to work immediately on the auction. They had to assemble items from the Museum's basement, select a site for the event, choose an auctioneer, set a date, and print a catalog. All the

22. Mrs. Samuel Logan, interview with author, May 12, 1985.

items selected for sale had to be checked and double-checked to ensure that they were owned by the Museum and not simply left on loan or in storage. It was an arduous task, and one the board or Museum staff could never have tackled alone. With this project, the Women's Volunteer Committee initiated a long and successful tradition of service, contributing millions of volunteer hours and raising millions of dollars for the Museum's projects and programs.

The auction was at first scheduled for September 20, 21, and 22, 1965, at Gallier Hall. But unexpectedly, Hurricane Betsy hit New Orleans, causing some of the worst storm damage in New Orleans this century. Consequently, the auction was postponed until October 25, 26, 27, with a Museum members' preview on October 21 and a three-day preview for the public on the intervening days.

There were over five hundred items for sale, but nothing was considered of museum quality. Most were thought to be cast-off junk that had simply been given to the Museum in its first decades when it was clear that no one else wanted it. There were many decorative items from the ornate period of the 1870s, 1880s, and 1890s. There were huge oriental vases large enough to hold Ali Baba, bronze statues supporting electric lights, plaster casts of antique sculptures, carved Victorian furniture, and even a late-nineteenth-century Chinese opium bed. There were 263 paintings, drawings, and prints as well.

It is a legitimate practice for an art museum continually to upgrade its permanent collection, and the deaccessioning and sale of surplus art is an important part of that sort of effort. Tastes in art change, however, and museums must be careful not to dispose of art works just because they are no longer fashionable. Looking back on the 1965 Delgado auction, it is now apparent that some of the works sold should have been retained. In particular a few nineteenth-century sculptures and some of the items in the decorative arts would have found a welcome in the Museum's permanent collection in the 1980s, when the elaborate, historicizing styles of the Victorian era had regained critical favor and were commanding high prices.

Mrs. Muller served as general chairman of the auction. She was assisted by Mrs. William Klein, production chairman; Mrs. George W. Reese, arrangements chairman; Mrs. Benjamin C. Toledano, catalog chairman; Mrs. Alfred Glenn, preparations chairman; and Mrs. C. Allen Favrot, publicity chairman. Morton Goldberg, Fernand Sanchez, and Henry Stern volunteered their services as auctioneers.

The first session of the auction netted $11,000 for the Museum's ac-

quisition fund. Some 130 lots, in addition to 25 lagniappes not listed in the catalog were sold. Among the items that went under the hammer were a late-nineteenth-century Chinese urn, the night's top sale at $800; a large French bronze and marble torchère, which brought $700; and a late-nineteenth-century Japanese preservation vase, which went for $425. An 1870 bronze, *Cupid, Love Defiant*, by the French sculptor Auguste Moreau, sold for $310. The paintings sold that night did not bring the anticipated prices. *Afternoon Light*, painted by the museum's first curator, Charles Wellington Boyle, did, however, command $235. W. Joseph Fulton, the Museum's curator of collections, called the night's session a dress rehearsal for Tuesday and Wednesday nights' auctions.[23]

The second session raised over $16,500. The top item that night was a 1910 French bacchante torchère from the Samuel Zemurray estate, which went for $1,100. The next most expensive item was the Chinese opium bed, which brought $700. The final session netted about $10,500, for a grand total of $38,000. A great effort had been made by the Women's Volunteer Committee, with great success. The organization had proved itself with a single event, adding to the euphoria felt by the Museum family as a result of the successful campaign that brought Estelle home.

The next year, 1966, was another that was exciting and challenging, and much that occurred continued to be the result of the active participation of the board members, especially the women. Mrs. Ellis, Mrs. Francis, Mrs. Freeman, Mrs. Logan, Mrs. Norman, Mrs. Schlesinger, and Mrs. Stern were established as a dynamic force who together would continue to serve the Museum for the next twenty years.

On February 16, 1966, Carrere as president informed the trustees that he had been in contact with representatives of a large foundation who wished for the time being to remain anonymous but who were disposed to give a substantial sum to the Delgado for the acquisition of works of art provided that the city of New Orleans and the Museum met certain conditions. Carrere and Feitel had sat down with Mayor Schiro to determine the city's interest in accepting the foundation's proposal. The mayor had indicated his favorable attitude, and he said he would discuss the matter with the city council.

Carrere then outlined the proposal. It was that the foundation

23. New Orleans *States-Item*, October 26, 1965.

would give $100,000 in 1966 and the same amount in 1967, to be used for the acquisition of works of art, provided "that the museum will raise an equal amount for acquisitions in those two years, and that the City of New Orleans will update to 1967 the capital budget allotment on the budget for 1969 to be used for the construction of an additional wing for the museum." It took only a brief discussion for the board to agree to the proposal, and they directed Carrere and Feitel to continue the negotiations. On March 16, 1966, Carrere read to the board a letter from Mayor Schiro agreeing to the foundation's request:

Mayor Victor H. Schiro has briefed the Council Members on the prospectus with reference to Delgado Museum of Art.

We understand that a Foundation, of financial responsibility, has offered to donate to Delgado Museum of Art $200,000.00, consisting of two annual payments of $100,000.00 each, for the acquisition of art, provided:

1) That the Board of Trustees of Isaac Delgado Museum of Art shall raise, by public subscription, matching funds in the amount of $100,000.00 in each of the two years of said donations;

2) That the City of New Orleans, acting through its Councilmen, shall up-date Item XVI of the Capital Improvement Budget relating to Isaac Delgado Museum of Art, Item 3., scheduled as a constituent part of a Bond issue in 1969 in the amount of $1,145,225.00, for the complete renovation of the Museum, to the year 1968 and

3) That the Council will lend its best efforts to assist the Board of Delgado and the Mayor of New Orleans in this project, and, more particularly, with reference to the realization of funds required by reason of the said Bond issue.

We represent to the Isaac Delgado Museum of Art and to the prospective donors, including the said Foundation, that the bonding capacity of the City of New Orleans is adequate to absorb this item in the Capital Budget of 1968, and that we know of no legal or other impediment to submitting it to the electorate.

Further, we will support the proposition that said Item XVI, 3. shall be amended to read "Complete renovation of Museum and construction of new wing to existing building," and that it be included in the Capital Budget of 1968.

We make this statement of intent to your Board to encourage it to do the work to obtain the said matching funds as a step in the direction of assisting Delgado to accelerate its Museum program, particularly, acquisitions, so as to bring it to a level of such programs engaged in by competing Cities of comparable size in the South.[24]

24. Mayor Victor H. Schiro to board of trustees, Isaac Delgado Museum of Art, March 16, 1966, in archives, NOMA.

With this letter in hand, the board agreed to plan a drive to obtain the matching funds. At the board meeting of April 20, 1966, the foundation was revealed to be the Ella West Freeman Foundation. The gift had come to the Museum from trustees of the foundation, Mr. and Mrs. Richard W. Freeman. The board also learned that the term of the challenge grant had been extended to three years.

Carrere remarked that the generosity of the Ella West Freeman Foundation "could be compared to the gift of Isaac Delgado of the Museum Building and the acquisition of the Kress Collection as the third great milestone in the museum's development." The *Times-Picayune* editorialized that the challenge "represents a fine opportunity—the first, in fact, that the museum has ever had . . . —to put its acquisitions program on a solid financial basis."[25] These assessments of the importance of the Freeman Foundation proposal were accurate, for the gift forced the city to take seriously the need for expansion and to place it before the public in a referendum on a bond issue. The board itself faced the formidable task of raising $200,000 within two and a half years. But by the board meeting of May 18, 1966, Carrere was able to report that nine trustees had pledged twenty thousand dollars toward the Ella West Freeman matching grant. At the same meeting Mrs. Muller suggested that the Women's Volunteer Committee plan a fall fund-raising event to help in reaching the goal.

At the meeting of the board on July 20, it was reported that another five thousand dollars had been raised from the board toward the matching grant. It was also announced that a board member, Kalman, had prepared without fee a brochure to present information concerning the fund drive. Plans were under way to hire a professional to assist in organizing the drive once the board solicitation was complete.

In August 1966, Byrnes hired William A. Fagaly to fill the position of registrar. That proved to be the director's most important and lasting addition to the Museum's staff. With a B.A. and M.A. from Indiana University, Fagaly had served as the assistant registrar at the University Art Museum at Indiana while a graduate student, specializing in African art. After a year at the Delgado, he was promoted to curator of collections, and he later became chief curator before assuming his current post of assistant director for art. During two decades in New Orleans, Fagaly has been responsible, particularly, for

25. New Orleans *Times-Picayune*, April 25, 1966.

the Museum's collections and exhibitions of ethnographic and contemporary art. His expertise has helped build a collection of African tribal art of national importance. Equally significant, Fagaly has been responsible for organizing the Museum's periodic surveys—annuals, then biennials, now triennials—of contemporary art in the thirteen southern states, the oldest and most prestigious such exhibit in the region.

Byrnes had spent June in Paris, examining the collection of Mr. and Mrs. Stafford, and had arranged for an exhibition of those art works. The show was to be entitled Odyssey of an Art Collector. The director informed the board that the Stafford pieces were an "exceptional art collection which covers virtually the entire history of art from pre-classical to contemporary." [26] Mr. and Mrs. Stafford had assembled in the previous fifteen years more than two hundred items spanning five thousand years of art history. Byrnes wrote, "I felt that perhaps some of our citizens who have modest collections or some who have given thought to beginning a collection might be inspired further by the Staffords in their creation of the equivalent of a small private museum."

Byrnes wanted the show to teach the viewer something of what inspires a person to become a collector. He explained,

> Mr. Stafford states that his interest in art collecting began with a curiosity about the past, stimulated by a passage in the Bible, which referred to the Hittites. He was fascinated to learn that a powerful empire, one of seven tribes overcome by the Israelites, could seemingly come to prominence, flourish and disappear in the short period of four hundred years. In the early 1950's, Mr. and Mrs. Stafford, while on a trip through Italy, were offered an Etruscan ladle which was for sale at a very modest price. Recalling that, as with the Hittites, there was little known about the Etruscans, they risked the purchase, regarding it as a souvenir of their journey. On bringing their heavily patinated ladle back to Paris, they first thought it to be a common household utensil of little artistic interest and with some hesitancy, they showed it to a dealer in antiquities, who immediately offered them more than ten times the price they had paid. This spurred on their curiosity and they decided to learn more about it. After talking to a number of experts they decided to have the piece cleaned, after which process they discovered that the forked handle was topped by two beautifully carved hounds' heads, and on the reverse side of the handle where it joined the bowl, there was the standing figure of an athlete in shallow relief. This exciting "find" led to the acquisi-

26. Minutes of the Board of Trustees, Isaac Delgado Museum of Art, July 20, 1966.

tion of books on Etruscan and other arts, and thence to the acquisition of objects from other civilizations and cultures. It is not surprising that at one point the Staffords' growing involvement prompted them to attend a course on African and Primitive Art where, to their amazement, the professor, in discussing masterpieces of African art, used a slide of an Ibo mask, which they had recently added to their collection.[27]

The exhibition was a major milestone for the Museum, for not only did it emphasize the truth of Byrnes's contention that fine collections could still be built in the mid–twentieth century but it also brought the Staffords fully into the Museum family. They were quite pleased with Byrnes and considered themselves "soul mates over the years." As regards the show, Mrs. Stafford recalled, "We trusted him entirely in his proposed presentation, and it was stunning. Both my husband and I said we would never see it assembled again in so fabulous a way under one roof."[28] In March, 1967, Mr. Stafford gave the Museum two thousand dollars in recognition of the achievements of the director; the funds were to be used on any project the director chose. A grateful Museum board elected the Staffords lifetime honorary board members. Since then, they have been ever-generous patrons of the Museum, donating many works of art from their extensive collection. Among them are a sixfold Japanese screen of the Kanō school from the Muromachi period entitled *Birds and a Marshy Stream*, an eastern Wei-dynasty Buddhist stele, a Bengali Nolanda *Vishnu* stele, paintings by Pierre Bonnard and Joan Miró, and Georges Rouault's great print series *Miserere*.

The Stafford exhibit opened with a gala fund-raising event called the Odyssey Ball. Repeated annually, the ball continues to serve the Museum to the present day. Proceeds of the first Odyssey Ball were committed to the fund for the Freeman matching grant. Of course, the Women's Volunteer Committee was heavily involved in the event. The orchestra of René Louapre was engaged, and the women hoped to sell eight hundred tickets at twenty-five dollars each, and to realize another five dollars per guest for the buffet and drinks. The first Odyssey Ball was a great success, for according to Mrs. Muller, the evening brought a profit of over fourteen thousand dollars.[29]

27. James B. Byrnes, *Odyssey of an Art Collector* (1966), vii, xi.
28. Mrs. Stafford, interview with author, November, 1983.
29. Minutes of the Board of Trustees, Isaac Delgado Museum of Art, November 16, 1966.

The Ella West Freeman matching grant challenge not only prodded the board members to exert their capabilities in fund raising but also required them to make decisions on how to spend wisely what they raised. They soon had on hand more money than they had ever spent for acquisitions. The director and board had to formulate an acquisitions policy. For years Byrnes had favored an Arts of the Americas program in both acquisitions and exhibitions. Works from the western hemisphere could be top-quality objects at the same time that they were readily available and relatively inexpensive. Initially suggested by Lansford, the focus on the art of the Americas was popular during the administration of Mayor deLesseps S. Morrison, when the port was viewed as the Gateway to the Americas. Byrnes had acquired many objects from the Indian and Spanish cultures of Latin America, and had secured numerous donations of other such pieces.

As early as March 16, 1966, a trustee, Arthur Q. Davis, himself a collector of Pre-Columbian art, suggested that "a clear statement regarding the policies of the museum regarding acquisitions should be formulated and presented to the Board for approval."[30] The director drafted an acquisitions policy during the next several months, but after he presented it to the accessions committee, it was a half year before the committee adopted it. Achieving a quorum at the committee meetings seems to have been a major problem. In the end, the board approved the report unanimously, asking that the director proceed by reviewing the art market and recommending to the committee and board objects desirable for acquisition.[31]

Mrs. Francis, chairman of the accessions committee, made the proposal

> that a recommendation be made to the Board that they consider the possibilities of obtaining, perhaps on permanent loan, the collection of Middle America Research objects, which are owned by Tulane University, and the pursuit of the objective of creating a new wing in which these objects would be housed at Delgado, not, however, prejudicing the present new proposed wing, but completely in addition to that, and that, if the Board agrees in principle, we go ahead to see if the money is available and if Tulane would be willing to offer the collection to us on a lease or loan basis.

> It was also suggested by Mrs. Stern, approved by the Committee, that

30. *Ibid.*, March 16, 1966.
31. *Ibid.*, December 21, 1966.

if this acquisition of the Middle America Research Collection becomes a reality, the museum could use it as an incentive for further enhancement of Latin American Art and Archaeology.[32]

After much discussion the board voted that a committee be appointed to investigate this proposal and determine its feasibility. Carrere, the board president, appointed Davis, Mrs. Stern, and George B. Montgomery to the committee. At this meeting it was further reported that Mrs. Stern's son-in-law, Thomas B. Hess, a prominent voice in American art circles, would speak to board members on December 28, 1966, on the subject of acquisitions policies. Fagaly, the newly appointed museum registrar, later recalled,

> Asked by his mother-in-law to meet with the Museum's trustees to give his suggestions for a policy, Tom pointed out he had noticed a large sign on the airport, "Gateway to the Americas" when he got off the plane. Because of New Orleans' historic and economic ties and geographic proximity to Central and South America, the relatively low prices for works of art from that area, and the fact that no other American museum had a similar focus, this suggestion of an Arts of the Americas program was received with interest and ultimately adopted by the trustees. Edith was so enthusiastic about the plan and lent her support to Jim Byrnes in his desire to begin acquiring art from the Pre-Columbian period. She became friends with Alphonse Jax, a leading dealer in Pre-Columbian art, who sold a number of fine pieces to the Museum. She brought Ramon Osuna, who was then curator at the Pan-American Union in Washington, D.C., to New Orleans to consult and advise on the Museum program.[33]

On March 22, 1967, Mrs. Francis reported to the board on the policy finally approved by the accessions committee. She read to those present an excerpt from the foreword of the 1948 edition of *Art News Annual*, in which a phrase occurred that, the committee suggested, the board might consider as identifying the area of future acquisitions: "Paintings and other objects of the recent and distant past forming a complementary body of material showing the sources in history of the arts of the Americas today."[34] Mrs. Francis explained that the policy the committee recommended was a very broad-based one, for it included acquiring not only art produced in the Americas but also that of countries and cultures that here influenced hemispheric art. She pointed out that the committee recommended this

32. *Ibid.*,
33. Fagaly, "A Woman for All Causes," 33.
34. Minutes of the Board of Trustees, Isaac Delgado Museum of Art, March 22, 1967.

policy with respect to purchases and that it would not apply to objects offered as gifts. Mrs. Stern, however, was displeased with that exemption. According to Fagaly, she had come to hope "that the entire Museum [might] be converted only to the art of Latin America."[35] In her enthusiasm to turn the Delgado into a Latin American museum, she wanted to get rid of both the Kress Collection and the Billups Collection.

Mrs. Stern set out single-mindedly to transform the Museum, aided by her ally and fellow board member Davis. Together they promoted the Museum's purchase in June, 1967, of a nucleus collection of paintings of the Cuzco school, from José San Palo.[36] Furthermore, Mrs. Stern had in mind to donate a wing to the museum to house a collection of Pre-Columbian and other art of the Americas if the board committed $200,000 for the purchase of art works for the addition.[37] Such an agreement would have had the effect of spending most of the Freeman grant on art from the Americas. Mrs. Stern's boundless enthusiasm for that idea created a reaction among other board members. Most were opposed to dedicating the Museum exclusively to the art of the Americas.

In 1967, Mrs. Stern, joined by Davis and her longtime friend Barbara Hunter, made a six-week tour in search of art works in Columbia, Ecuador, Peru, and Brazil. The trip was a great success. According to Mrs. Stern's biographer, "in one sweep, a vast 'buying spree,' they managed to acquire a goodly number of valuable and worthwhile paintings, in addition to some extremely unusual furniture. The collection of the Delgado Museum grew by leaps and bounds, becoming what Edith had determined it should become, a treasure trove of Latin American art."[38] As many New Orleanians had learned, once Mrs. Stern made up her mind, it was difficult to divert her from achieving her goal.

In the meantime, for the approval of the board, the director assembled a number of objects for acquisition. The items presented at the board meeting of October 26, 1967, included a Costa Rican "flying panel" metate, a Zapotec stone lintel, a Mochica necklace of gold beads, a Guatemalan limestone wall panel, a Mayan painted cylinder vase, a Toltec/Aztec head of a feathered serpent, and an Olmec axe—

35. William A. Fagaly, interview with author, May 5, 1985.
36. Fagaly, "A Woman for All Causes," 34.
37. Minutes of the Board of Trustees, Isaac Delgado Museum of Art, September 20, 1967.
38. Klein, *A Passion for Sharing*, 349–50.

all Pre-Columbian objects of high quality. It was thought that all of these could be obtained for fifty thousand dollars. Byrnes arranged the items he recommended in one of the Museum galleries, along with some other new finds of his. He did this to show what "one gallery of first-rate Pre-Columbian objects would look like." In the other gallery he placed the eleven Cuzco-school paintings that Mrs. Stern and Davis had found, and a large sofa and silver throne that Mrs. Stern had acquired on her South American trip and had shipped to the Museum. The director informed the board that Mrs. Stern "hoped that they will be acceptable to the Accessions Committee and be purchased from Museum funds." [39]

The following month the board approved the purchase of ten of the items on display, at a total price of sixty-three thousand dollars. Mrs. Stern's sofa and silver throne were not among the accessions; their purchase was to be postponed until January 24, 1968. Furthermore, thirty-four objects from the pre-Columbian and Spanish colonial periods were purchased with funds from the Ella West Freeman Matching Fund. This fund also made possible the acquisition of a number of Richard Clague's and William Buck's oils of Louisiana scenes and personages, as well as a number of African pieces and works by American artists. Among the latter were Robert Henri's large oil, *The Blue Kimono*, which had been lent by the artist to the Museum's 1910 inaugural exhibition, and Reginald Marsh's *Taxi Dancers*.

The frantic activity of acquiring works for the Arts of the Americas Collection during a period of eighteen months culminated in a major exhibition in May, 1968. The Arts of Ancient and Modern Latin America, organized by Byrnes, was a huge assemblage of 337 objects from 1500 B.C. to 1965. It combined the Delgado's recent acquisitions with important loans from American museums and private collections. Byrnes intended the show to serve as a comprehensive model to which the Museum could aspire in its future acquisitions for the Arts of the Americas Collection. Certainly the works already purchased by the Delgado stood out for their high quality. The exhibition purposely coincided with the 1968 annual convention of the prestigious American Association of Museums, which was meeting in New Orleans for the first time. With nearly two thousand museum professionals viewing the show, the Delgado achieved national recognition of its commitment to the Arts of the Americas.

39. Minutes of the Board of Trustees, Isaac Delgado Museum of Art, October 26, 1967.

The efforts of the board had proved more than adequate, and the total raised to meet the requirements of the Freeman Foundation matching grant of $200,000 reached above $400,000. Since that money was for art acquisitions, it was up to the city of New Orleans to come through with adequate funding for the new wing. Dealing with a city bureaucracy is at best frustrating, at worst maddening. The city proposed the expansion funds in its budget of 1967 but at the same time cut back the Museum's operating budget; in 1967, the operating budget was reduced to $100,000. Staff salaries at that time amounted to $90,000. Consequently, the museum board had to apply for emergency funds to the city council for operating expenses. In June, 1967, the city Planning Commission authorized the Museum board to pass a resolution requesting funding for an education-and-service wing. The amount of $1,615,000 was approved in a bond-issue election on May 7, 1968, and the Museum received money for expansion.

Before that occurred, however, two proposals for expansion were placed before the trustees. The first was introduced on November 15, 1967, when Newman, the board president, reported that J. Ray Samuel, the new president of the Louisiana Landmarks Society, had offered the restored Pitot House, home of the first mayor of New Orleans, to the museum for the exclusive exhibit of Louisiana and New Orleans art. Newman added, "Knowing that our collection is small, three collectors, Ray Samuel, Felix Kuntz and Leon Huber, have agreed to promptly and immediately loan whatever is needed to insure that the exhibits planned for the house are of the highest quality. There is also a serious possibility that they will arrange to have the loans eventually become the property of the museum."[40]

This was an exceptionally handsome and generous offer. The Pitot House, one of the city's oldest, was just a few blocks away from the Museum on Bayou St. John. It would have been an attraction for tourists who seldom come to the Museum. The annual operating cost of about $1,200 could have been offset by an admission fee, and it might even have been possible to employ a live-in curator for the facility. In the discussion, Davis objected on the ground that the house was too far from being a fine arts museum and that the Louisiana State Museum already operated houses as museums. Feitel and Mrs. Muller argued that the project would be too costly. But Newman pointed out that for years the trustees had been trying to find a place in the

40. *Ibid.*, November 15, 1967.

Quarter for a museum facility. The director added that many other museums operate such houses, in which they exhibit appropriate paintings, furniture, and artifacts.

Finally the board passed a motion to approve in principle the proposal of the Louisiana Landmarks Society and to appoint a committee to look into all aspects of the offer. Some urgency was felt, for Samuel, Kuntz, and Huber had offered to "promptly and immediately" lend what might be needed to furnish the house. James J. Coleman, Jr., was chairman of the committee. At the board meeting of March, 1968, he had no report. But Newman said that he had spoken to Mrs. Sigmund Katz, whose excellent porcelains had been a significant addition to the decorative arts collection of the Boston Museum of Fine Arts, and that she was willing to "make a donation of truly magnificent furniture for the house."[41]

Not for six months was the matter of the Pitot House discussed. On September 18, 1968, Coleman reported that he had ascertained that the renovation was not complete and that the cost of completing it would exceed $31,500. The committee, therefore, did not recommend acceptance of the Louisiana Landmark Society's offer. The board concurred.

The second proposal for museum expansion under another roof came right after the board declined the offer of the Pitot House. Mrs. Francis, now the board president, had called a special meeting for October 3, 1968, to discuss the potential gift to the Museum of the house owned by Mr. and Mrs. Richard W. Freeman, Jr., at 1132 Royal Street. The structure, which had been built in 1857, is known as the Gallier House. It had been meticulously restored by the Freemans. Mrs. Norman had discussed with Mrs. Freeman the idea that the house might be given to the Museum. It was explained that because the Freeman Foundation was to meet that week to determine the disposition of the house, it needed to know the degree of the Museum board's interest in the building.

Byrnes commented that the Gallier House would be a perfect site for a museum branch devoted to the display of decorative art works and the Louisiana Collection, but Davis and Mrs. Stern questioned the need for that much additional space. They pointed out that the Museum was already in the midst of expansion. Mrs. Norman disagreed, saying that "she felt that the branch would attract visitors and

41. *Ibid.*, March 20, 1968.

tourists who might not otherwise get out to the Park, and that people would be encouraged to support such a facility who would not be interested in supporting the Delgado." Mrs. Francis and Newman agreed. Finally, Mrs. Logan moved to indicate the board's interest once details of financing and budgeting were reviewed. The motion carried "with Mrs. Stern casting a 'No' vote." [42]

Nothing ever came of the proposal, however. The Freeman Foundation, after much review, decided that the foundation itself should maintain the property as a historic site. When Mrs. Norman, on learning of the foundation's decision, asked Carrere why it had changed its mind, he told her, "Sunny, you oversold the idea and they are going to do their own museum." [43]

During this time, the museum expansion project was developing with no definite plan apparent. For example, on December 18, 1968, Davis, chairman of the special building committee, reported

> that the original planning had been for exhibition galleries, auditorium, storage space and relocation of certain offices within the new wing being provided by the City. The committee would like to recommend that this planning be modified and that the City Wing be entirely devoted to exhibition and storage areas and that the auditorium, with the administrative offices below, be placed in an additional wing to the side of the present structure. This would mean that the donation which has been announced by Mrs. Stern would be for the separate wing and that therefore the entire sum which has been provided by the City could be used for exhibition and storage area, and would provide more than double the exhibition space.

Davis further informed the board that the special committee had under advisement but without readiness to make a recommendation, the "proposed modification of the entrance to the new wing by changing the staircase in the Great Hall." Mrs. Stern suggested ripping out the grand staircase there. Fortunately the special building committee rebuffed that idea. Mrs. Norman pointed out that in the City Wing no areas had been provided for children's art classes. Davis replied that classroom space there would be inadequate and that his committee was of the opinion that yet another wing would house a children's museum and instructional facilities. [44]

The addition of a children's wing was a cause that Mrs. Norman

42. *Ibid.*, October 3, 1968.
43. Mrs. P. Roussell Norman, interview with author, May 23, 1985.
44. Minutes of the Board of Trustees, Isaac Delgado Museum of Art, December 18, 1968.

was to take up with efficiency, humor, and dedication. She was credited by Peneguy, a fellow board member, with influencing his aunt, Elizabeth Wisner, to help secure funding for the wing. On April 16, 1969, the director informed the board that through Miss Wisner's efforts, the Edward Wisner Fund, a New Orleans philanthropy established by her late father, would provide funds for a children's wing. A letter from Miss Wisner and Peneguy to the city council, whose approval was necessary for distributions from the Wisner Fund, read,

A bond election of 1968 provided approximately $1,600,000 for the construction of an addition to the Delgado Museum of Art in City Park. Further, Mrs. Edith Stern has made available the sum of $200,000 for a wing to the north of the building. Both of these new additions will be constructed simultaneously, beginning this year.

The Museum Board has, for many years, realized the necessity and practicality of the construction of a Children's Wing for the purpose of educating that segment of our population on works of art. We understand that in completing the plans for the former additions, this wing was contemplated, but the lack of funds indicated that the construction thereof would have to await future appropriations.

We have been approached by Museum officials with a view to making available the sum of $200,000 from the Wisner Fund for the proposed Children's Wing. This sum is available immediately, and to construct this Wing along with the other additions would not only save costs of planning, but would measurably reduce costs over-all.

In view of Edward Wisner's great interest in things cultural and humanitarian, and in view of the City's and Wisner Family's agreement in 1967 to direct Wisner Funds toward capital projects, we feel that this appropriation would be in order. We earnestly urge your favorable consideration thereof and action when the matter comes to a vote. We are certain that you can see the relative merit of such an undertaking for such an urgent need. Thank you for your consideration in this matter.[45]

On May 1, 1969, the city council passed an ordinance appropriating the money from the Wisner Fund to finance construction of a children's wing. In June, Mr. and Mrs. P. Roussel Norman offered to pay the salary of a curator of children's education. Mrs. R. V. Platou was hired and immediately began developing a children's program that eventually achieved national recognition.

At the board meeting of April 16, 1969, Byrnes suggested that the "Stern Wing," then planned to be a gallery, be laid out instead as an auditorium with permanent seating and an inclined floor. He rea-

45. *Ibid.*, April 16, 1969.

soned that the Museum badly needed a permanent auditorium with stationary accommodations rather than the usually less comfortable movable ones. Moreover, he pointed out that the walls of such a room could still be used to exhibit paintings. Barbara Neiswender, the Museum administrator, added that a fully appointed auditorium would attract to the Museum many businessmen's groups, women's clubs, and the like. The board unanimously approved a motion to discuss the proposed change with Mrs. Stern.

Mrs. Stern's response was received on June 18, 1969, and was read into the minutes of the board meeting by the president, Mrs. Francis:

> If possible and practical, it is my preference that the floor of the new auditorium be level. I envision that this room be furnished with armchairs that can be stacked; these chairs to be left in place until such times that it will be necessary to remove them, so that the auditorium may be part of the existing building.
>
> Should this prove to be impractical that, at my expense, a new floor be installed.
>
> However, should the Board deem it necessary to make this room a permanent auditorium, I will abide by their decision.[46]

After a brief discussion the trustees voted unanimously to have a permanent auditorium with a slanted floor and fixed seating. "Edith hated like anything having the Stern name on an auditorium," recalled Mrs. Norman.[47]

The final donation to the Museum for expansion was announced on December 17, 1969, when Mrs. Francis read a letter from the Dreyfous family indicating their desire to honor the memory of their father, Felix J. Dreyfous, by contributing funding for the Museum library. They offered common stock valued at about thirty thousand dollars "to finish and furnish the Library Reading Room planned for the museum addition."[48] The family asked that the room be named the Felix J. Dreyfous Art Library to memorialize their father's many years of work in behalf of the Delgado as a founding trustee and board president.

The arrangements for the library were not completed without difficulty, however. The Dreyfous family and Byrnes did not see eye to eye on the location of the room within the Museum facility, and there

46. *Ibid.*, June 18, 1969.
47. Mrs. Norman, interview with author, May 23, 1985.
48. Minutes of the Board of Trustees, Isaac Delgado Museum of Art, December 17, 1969.

was well-justified concern that the costs of the project would sky-rocket, as various alternatives were discussed.[49] Finally, almost a year after the announcement of the Dreyfous gift, all parties agreed to place the library on the basement level, where an exhibition area and meeting room had previously been planned. With that decision, the additions to the Museum were at last fully planned, and construction soon began.

On Tuesday, February 24, 1970, groundbreaking ceremonies took place, despite the rain, for the $2,095,000 expansion. Mayor Schiro officiated. The additions would add 18,278 square feet of exhibition space to the Delgado's original 9,932 square feet. The foundations of the back wing, the City Wing, were constructed to permit support of an eventual third-floor addition.

The construction inevitably triggered a renewal of the debate over whether to change the Museum's name. Many months went by as the legal committee, which had been charged with investigating the question, sat on the matter. Finally, at the meeting of September 19, 1971, the board resumed its discussion of the issue:

> Mr. Dreyfous stated that he would object to changing the name since it is established in the community. Mrs. Muller replied that the name Delgado is not well known nationally or internationally, but that the name New Orleans is. It was also pointed out that there is constant confusion with Delgado College, and only a few people realize that Isaac Delgado provided no funds for operation and we receive no income from Delgado-Albania Plantation. Mrs. Kaufmann added that a change in the name would make it possible to recognize future benefactors.
>
> Several possible names were suggested. Mr. Byrnes put forth "New Orleans Museum of Art," and Mrs. Muller proposed "Fine Arts." Mr. Peyroux suggested that a committee be appointed to discuss possibilities and report back to the Board, but it was generally agreed that time was too short to allow this and meet printing deadlines for opening in November. After further discussion, it was moved by Mrs. Kaufmann, seconded by Mrs. Muller and unanimously carried that the suggestion, "New Orleans Museum of Fine Arts" with proper accommodation of the names, Isaac Delgado Museum, Stern Auditorium and Wisner Education Building, and any future wings or buildings we see fit to accept be approved, subject to the approval of the City Attorney and after consultation with the Public Relations firm. Mr. Dreyfous asked to be recorded as voting against the motion.[50]

49. *Ibid.*, March 18, 1970.
50. *Ibid.*, September 15, 1971.

This was not the end of the matter, however. On October 20, 1971, the trustees voted to drop *Fine* from the new name. They felt that the word was unnecessary and that it made the Museum's name too long. The name of the Museum was the New Orleans Museum of Art, soon to be shortened by some to the acronym NOMA.

The sentiments of the press and of the community itself were split. Pie Dufour, a columnist for the *States-Item*, opposed the change, seeing it as a sacrilege on the memory of Isaac Delgado.[51] The *Times-Picayune*, on the other hand, fully backed the renaming.[52] The *Times-Picayune*'s longtime arts reporter, Alberta Collier, used the new name only under protest, however, referring to "the New Orleans Museum of Art, formerly the Isaac Delgado Museum of Art," in her column for several years. Even now some New Orleanians still view the change as illegitimate and continue to refer to the Museum as the Delgado, just as others still call the Fairmont Hotel the Roosevelt.

In an effort to reply to Pie Dufour's negative commentary on the name change, Newman, the board's president, pointed out that the name of the original Delgado building would not in fact be altered. He added, "What we are doing is changing the name of our association of individual members, chartered under Louisiana law, from Isaac Delgado Museum of Art Association to New Orleans Museum of Fine Arts Association. This conforms with Isaac Delgado's foresight when he wrote . . . , 'Nothing in this letter shall be construed as preventing the organization of an association having in view the preservation of the Isaac Delgado Museum of Art.'" Although the art association's name had been identified with one building for sixty years, Newman argued, "Now that there are four buildings, we face the necessity of having our name tell the more complete story." He recalled that the citizens of New Orleans had provided $1,590,000 for a new building twice the size of the Delgado building, and he remarked, "We feel it incumbent . . . to also perpetuate their generosity."[53] More than anything else, however, it is likely that the motive behind the name change was the desire to alter the Museum's image. To many of the board, the Isaac Delgado Museum of Art meant lack of space and art works, inadequate funding, insufficient programs, and internal disputes. A new name would help lay to rest the grimmer aspects of the

51. Pie Dufour, "A la Mode," New Orleans *States-Item,* October 1, 1971.
52. New Orleans *Times-Picayune,* November 21, 1971.
53. Pie Dufour, "A la Mode," New Orleans *States-Item,* October 6, 1971.

past. With three new wings, a growing collection, more money than ever before, a professional staff, new educational programs, and the supportive Women's Volunteer Committee, the Museum did indeed seem to be undergoing a rebirth. What better way to express its new vitality than with a new name?

Mrs. Muller, who in the past had chaired many important committees, was appointed chair of the committee for the opening of the new wings. Mrs. Muller and her committee organized a weeklong series of events to inaugurate them. First, on Sunday, November 14, there would be a sneak preview and open house for Museum members. On Wednesday, November 17, there would be a formal dinner for the mayor, city officials, trustees, major patrons, and national art personages. On Friday, November 19, the Women's Volunteer Committee would present the annual Odyssey Ball. And on Sunday, November 21, the Museum would be officially opened to the public with special activities throughout the building.

Byrnes, true to his goal of promoting the collection of art in New Orleans, planned an exhibition of New Orleanians' art holdings for the opening. He hoped that such a show would pique the interest of yet other potential collectors. The reinstallation of the Museum's permanent collection side by side with an exhibition of collectors' art was an exciting event.

At the time of the opening, Ms. Collier, the art critic, caught this sense of excitement: "Delgado director, James B. Byrnes, in planning for this climactic milestone in New Orleans art history, decided that the time was ripe for an evaluation of the total art resources of the community. An advance look at the 'New Orleans Collects' catalog indicates that the city, which grew out of a blending of cultures, has retained its cosmopolitan and varied tastes." She continued with a long list of the works of art being collected by New Orleanians: "A casual glance at the catalog shows that Orleanians are avid admirers of 19th and 20th century French art. The exhibit will have oil paintings by Gustave Courbet, Eugene Louis Boudin, Claude Monet, Jean Guillaumin, Henri Fantin-Latour and Pierre Bonnard; it will also have gouaches, watercolors and drawings by Ingres, Cezanne, Degas, Renoir, Seurat, Gauguin, Leger, Dufy, Picasso, Matisse, Archipenko, Dubuffet, Vasarely, Soulages and others."[54] Collier reported that

54. Alberta Collier, "The World of Art," New Orleans *Times-Picayune*, November 14, 1971.

there were numerous prints by Georges Braque, Marc Chagall, Edouard Manet, Joan Miró, and Georges Rouault, and many miniatures by English, Irish, and Continental artists. There was an El Greco of St. Francis, as well as sixteenth-, seventeenth-, and eighteenth-century paintings, prints, and sculptures from the Italian, Dutch, Flemish, French, and English old masters. Also included were many objects from "long gone epochs and exotic lands." In this category were Indian miniatures, Japanese Haniwa and Kamakura works, Byzantine icons, Pre-Columbian jades, and Spanish colonial paintings. There were oils by the expressionists like Ernst Kirchner, Paul Klee, Max Pechstein, and Karl Schmidt-Rottluff. American art was represented too by the likes of George Inness, Thomas Eakins, Frederic Remington, Winslow Homer, Maurice Prendergast, John Singer Sargent, Robert Motherwell, Andrew Wyeth, Larry Rivers, and Mark Rothko.

Indeed, it was an impressive assemblage of 411 works of art from many cultures and periods. The exhibition clearly demonstrated that New Orleans had come of age as an important center for art collecting. It is significant that all the collections represented in the exhibition had been formed during the most recent two decades. During the coming years many of the works in New Orleans Collects would be added to the Museum's permanent holdings.

After a visit to the Museum during the week of the opening, Luba Glade, of the *Vieux Carre Courier* wrote a feature story that summed up the high spirits surrounding the opening events:

> On the way home I was overtaken by a very real sense of elation . . . I tried to remember through to nearly five decades of living in this, my favorite of all places, when was the last time the City had opened (in its public sector) as meaningful a place as the new museum promises to be. Open to the public free of charge, geared now to appeal to the smallest child as well as the most sophisticated art lover, with a program to include both the visual and performing arts, it is probably one of the most life-enhancing projects which has happened during my lifetime.[55]

The excitement of the opening generated many outstanding donations to the Museum's permanent collection. The works accepted included a bronze sculpture by the Belgian surrealist René Magritte entitled *Les Travaux d'Alexandre*, from Muriel B. Francis; an epoxy

55. Luba Glade, "NOMA: The New Orleans Museum of Art," New Orleans *Vieux Carre Courier*, November 12–18, 1971.

sculpture by Frank Gallo entitled *Man in Rocker*, from Mr. and Mrs. P. Roussel Norman; an old Dutch-master painting by Willem Ormea and Adam Willaerts entitled *Fish Heaped on the Beach*, from Bert Piso; and a pair of Japanese screens of the seventeenth century, attributed to Kano Sanraku, entitled *Chrysanthemums* and *The Bamboo Wall*, and a Japanese late-Kamakura-period (fourteenth-to-fifteenth-century) wood sculpture, one of the *Judges of Hell*, from Dr. and Mrs. Kurt A. Gitter. Among the other gifts were an African tribal mask from Sierra Leone, given by Mr. and Mrs. Walter Davis, Jr.; an acrylic sculpture by Lillian Florsheim, given by Harris Hyman; and a papier-mâché sculpture by Carol Anthony entitled *Three Little League Players*, given by the children of Mr. and Mrs. Richard W. Freeman, Jr.

A major event of the opening festivities was the dedication dinner on November 17. More than three hundred art patrons attended the buffet dinner, at which Newman, the board president, presided as master of ceremonies. Byrnes, who "ignored his paltry allotment of three minutes at the banquet rostrum to make special note of the friends the museum has been favored with over the years," remarked that New Orleans finally had in its new wings and new accessions a firm base upon which to build to new stature as an art center for the region.[56] Mayor John Lindsay, of New York, was the featured speaker. Introduced by Mayor Moon Landrieu, of New Orleans, he spoke on the role of both the politician and the artist as a harbinger of change. He said, "I do not know which is most difficult—art or politics. I do not know which is hardest to achieve—beauty or change—the cathedral of Chartres or the Bill of Rights. But I do know that today there is a hunger for both beauty and change."[57]

The following night about 1,200 art patrons attended the Odyssey Ball, dancing to the music of Count Basie and his band and viewing the new wings for the first time. The ball raised more than thirty-five thousand dollars in profits. On Sunday, November 21, there were public ribbon-cutting ceremonies at the Museum, at which Congressman Hale Boggs spoke to a crowd of five thousand, saying, "We are learning that the arts are an important part of our national identity which can enrich the lives of our people. We are shedding the old notion that the arts are frivolous and not a proper concern of the business of government."[58] The ribbon was cut by a two-year-old boy,

56. New Orleans *States-Item*, November 18, 1971.
57. Baton Rouge *Morning Advocate*, November 18, 1971.
58. New Orleans *States-Item*, November 22, 1971.

Chris Souquet, and the new Museum was officially open to the public.

Most were well pleased with what had been wrought. By and large, the newspapers extolled the new wings, and the art critics praised the new additions to the collections as well as the exhibit New Orleans Collects. A few, however, were willing to say that all was not perfection. Among these was the gadfly reporter Bill Rushton, who criticized the new wings:

> The old Delgado Museum was a bit goofy, but at least it had a personality. The new "New Orleans Museum of Art" (NOMA) is irredeemably grotesque: how can anything that insensitive be presumed to be a house of art?
>
> For the last two weeks now, everyone has been doing this lets-pretend number about what a monumental social achievement we have built in City Park. It's a sloppy, ill-defined, mis-designed travesty, and polite self-delusions to the contrary make it just that much worse.

Particularly appalling to him were "those pebble-crusted panels" on the exterior of all three wings, which "have absolutely nothing in common with the color, texture or proportion of the original structure."[59] Rushton wrote that the Museum merited the *Vieux Carre Courier's* Golden Girder Award as the worst building of 1971, with August Perez and Arthur Feitel sharing in the prize as associated architects. He viewed the building as an example of "rank incompetence, contemptuously and gratuitously grafted onto a beaux arts building whose spatial inadequacies were at least compensated for with a profound sensitivity to art."[60] Still, if the new wings did not compare favorably with the original Delgado building on the outside or in architectural detail, they functioned well and provided the Museum with desperately needed space for special exhibitions, the permanent collection, and the education programs.

Whether the wings were criticized or celebrated, the Museum board had before it the task of settling back down to the business of their growing institution. At the final board meeting for the year, on December 15, 1971, new officers were elected: Mrs. Muller, president; Carrere, first vice-president; Shirley B. Braselman, second vice-president; Robert A. Peyroux, treasurer; and Mrs. Richard B. Kaufmann, secretary. The new officers were soon to face a transition in the ad-

59. Bill Rushton, "Cityscape," New Orleans *Vieux Carre Courier,* November 26–December 2, 1971.
60. New Orleans *Vieux Carre Courier,* December 31, 1971–January 6, 1972.

ministration of the Museum, for on May 8, 1972, it was announced to the executive committee that Byrnes had resigned the directorship effective the following February.

Ironically, it has become almost a tradition in American art museums that upon the successful completion of a building program, the director of the institution moves on, either willingly or unwillingly. There are a number of reasons. The director often has had to push and cajole his trustees and patrons over an extended period to get the building completed. Developing a program, selecting an architect, raising the money, overseeing the construction, preparing the opening exhibits—the entire process of museum expansion can cause stress and antagonisms to develop between the board and director which are exhausting to both. If the expansion is a great success, the director becomes an attractive candidate for a job at another museum. He may feel that he has accomplished all that he can with the opening of the new building and may seek new, fresh challenges elsewhere. In some cases, the board may feel that they need a bright new director to lead their museum into the era of growth they see the new building heralding.

Byrnes's resignation hit the front page of the *Times-Picayune* on May 14, 1972. The newspaper reported,

> Byrnes stated in his letter to the board that, having played a role in bringing the museum to its present state of accomplishment, he feels the need for time to pursue personal professional projects which he has had to set aside in favor of the tasks at hand.
>
> Mrs. J. Frederick Muller, board president, and the trustees, in making the announcement, say that Byrnes's request has been accepted with regret.
>
> They add that they recognize that, since 1962, when Byrnes took over, the museum has prospered and grown to the point where it not only has become a vital cultural force in this region, but has attained prominence in national and international circles.
>
> The board also cites the highlights of Byrnes' tenure:
>
> He is credited with reorganizing the museum's gifts and acquisitions to form the nucleus of the present permanent collection; he is also named as the man responsible for locating the Edgar Degas, *Portrait of Estelle Musson.* . . .
>
> Byrnes, in addition, created a number of important exhibitions which were designed to promote knowledge and interest in the history of art from its earliest beginnings to the present.
>
> Among these were a 1962–63 *Fetes de la Palette* exhibition, which brought 16th, 17th and 18th century painted tributes to the table to a city

noted for its cuisine; a 1965, *Degas, His Family and Friends in New Orleans*, which was built around the newly acquired *Portrait of Estelle Musson*, a 1966 *Odyssey of an Art Collector*, which inspired the Delgado's annual fund-raising Odyssey Balls and resulted in gifts and extended loans from collector Frederick Stafford and Mrs. Stafford; and a 1968 *Arts of Ancient and Modern Latin America*, which laid the foundation for a Pre-Columbian collection which is becoming widely recognized.[61]

Ms. Collier wrote on May 21, 1972, after the announcement of Byrnes's resignation, that he had been an excellent professional when the Museum needed one. She evaluated his successes and credited him with many achievements. She noted that the Museum "had just become a fully-accredited museum; is now considered one of the finest in the South." She said she regretted his resignation but noted the need for the search committee to find a new director who "will be a museum professional trained to shoot for the stars."[62] Byrnes left the city at the end of 1972 to take the position of director of the Newport Harbor Museum, in southern California.

The final exhibition of the Brynes era was Peruvian Colonial Painting, held from April 15 to May 28, 1972. That show embodied Mrs. Stern's final attempt to induce the board to commit itself to a wholly Pre-Columbian and Latin American museum. Nearly half of the works came from the permanent collection of the Brooklyn Museum of Art, which has one of the finest collections of the type in the United States. The rest of the paintings in the show came from Mrs. Stern and Arthur Q. Davis. William A. Fagaly explained that a number of years earlier, Mrs. Stern had brought to New Orleans Luis Lastra, a representative of Celsor Pastore, the Peruvian ambassador to the United States, "to make a presentation to the Museum's trustees of Señor Pastore's collection of Cuzcanian painting which was being offered for sale. They turned the offer down and consequently, Arthur Q. Davis and Edith bought the collection, had it restored, and arranged for a large exhibition at The Brooklyn Museum, followed by a showing at NOMA. Arthur and Edith realized this collection would be an important addition to the Museum and, rather than let it go elsewhere, they acquired it to keep in the city."[63]

The Peruvian Colonial Painting exhibition was an especially appropriate ending to Byrnes's decade as director of the New Orleans Mu-

61. New Orleans *Times-Picayune*, May 14, 1972.
62. *Ibid.*, May 21, 1972.
63. Klein, *A Passion for Sharing*, 238.

seum of Art. His development of the concept of the Arts of the Americas Collection was an important step in securing for New Orleans a unique permanent art collection of national distinction. During the 1960s, Byrnes worked with the staff and trustees to bring the Museum up to established professional standards; accreditation by the American Association of Museums came in 1970. The Museum's physical plant in City Park was sufficiently expanded to allow for the proper historical display of the permanent art collection, which had grown significantly in quality and size during Byrnes's directorship. The Museum was now prepared to play a much expanded role in the cultural life of the city and the region.

XV

E. John Bullard

At the meeting of the board of trustees of the Museum on May 17, 1972, after James B. Byrnes's resignation was accepted, the board's president, Mrs. J. Frederick Muller, appointed a committee to begin the search for a new director. The committee consisted of Muriel B. Francis, as chairman, and Ernest A. Carrere, Arthur Q. Davis, Mrs. Richard B. Kaufmann, Percy H. Stitges, and Mrs. Muller herself.

Two candidates came clearly to the fore: Stanton Catlin, then curator at the Center for Inter-American Relations, in New York, who was an authority on Latin American art and the candidate of Mrs. Edgar B. Stern's choice; and E. John Bullard, then assistant to J. Carter Brown, director of the National Gallery of Art, in Washington, D.C. Bullard became the candidate favored by Mrs. Francis and Mrs. Kaufmann.

Bullard had applied for the job after learning of the opening from Adelyn Breeskin, curator at the National Collection of Fine Arts and a friend of Mrs. Kaufmann's. Bullard had previously met Mrs. Walter Davis, Jr., a NOMA trustee, in Los Angeles in 1971 and had talked with her about the Museum. He was sufficiently impressed to take Breeskin's suggestion and apply for the directorship. Shortly thereafter, Mrs. Francis invited him to New York to meet her and Mrs. Kaufmann for an interview.

Both young and experienced, Bullard made an excellent impression at his initial interview. A native Californian, he received his B.A. and M.A. degrees in art history from the University of California at Los Angeles, specializing in American art. From 1965 to 1967, he was an assistant curator at the J. Paul Getty museum, in Malibu. In 1967, he received the Samuel H. Kress Foundation Fellowship to study for one year at the National Gallery of Art. The next year he joined the staff of the National Gallery, first as assistant curator of American art. He went on to serve as curator of exhibitions, curator of special projects,

and assistant to the director at the gallery. In Washington, he was responsible for organizing major retrospectives of Mary Cassatt and John Sloan.

In the fall of 1972, Bullard flew to New Orleans for an interview with the full search committee. He also talked with the staff and assessed the facility and collections. "There was great potential for sustained growth," recalled Bullard, "the new wings were completed, there were good private collections, and the city was moving forward under the administration of Mayor Moon Landrieu."[1] The fact that the New Orleans Museum of Art was a medium-sized museum appealed to Bullard, for he had learned that in a larger museum there is not as much opportunity for the director to be creatively involved in the art programs. If Bullard appreciated the potential of the Museum, it was no less the feeling of the board that there was a great deal of potential in the youthful Bullard.

On January 29, 1973, the board held a special meeting at which they met again with Bullard and then voted to employ him as Museum director "on such terms and conditions as the President may work out with Mr. Bullard in accordance with the laws of the City of New Orleans, and in consultation with the Chairman of our Legal Committee and the Chief Administrative Office of the City."[2] Bullard was to assume his duties in April, 1973. He recalls, "I thought the Museum a tremendous challenge and New Orleans a fascinating city. Also the Trustees were willing to give the new director great authority."[3]

From the outset it was apparent that Bullard was confident of his authority and that he knew the direction he wished to go. In an article in *New Orleans* magazine, Linda Bonner later wrote of Bullard that "the energy powering this Gucci-belted, cowboy-booted young dynamo has never seen neutral gear."[4] In this she was correct. From the moment he was hired, Bullard began to work tirelessly in behalf of the Museum.

Flying in from Washington, D.C., the new director attended the board meeting on February 21, 1973. There he reported that he had arranged for a group of paintings to be lent to NOMA from the J. Paul Getty Museum. He discussed the need for a monthly calendar an-

1. E. John Bullard, interview with author, August 5, 1985.
2. Minutes of the Board of Trustees, NOMA, January 29, 1973.
3. Bullard, interview with author, August 5, 1985.
4. Linda Bonner, "What's Happened to the Little Museum in the Park?" *New Orleans*, March, 1980, p. 57.

nouncing Museum events for the membership and gave printing cost estimates for it. He advised the board of various rearrangements of the galleries he had completed, as well as of the fact that he had formulated an acquisitions policy that was being reviewed by the accessions committee. Bullard reported that he had applied on behalf of the Museum for a $10,000 matching grant from the National Endowment for the Arts for the purchase of contemporary American art, and that he had settled the "division between the Wisner Education Wing and the rest of the Museum."[5] In the area of acquisitions, Bullard recommended the purchase of an oil painting by Marsden Hartley, *The Ice Hole, Maine*. For a man still living in Washington, D.C., he had accomplished quite a lot in twenty-odd days.

The statement that Bullard drafted concerning acquisitions served as a general policy for the next two years, although the board never officially adopted it. Bullard's document was careful to outline both the strengths and weaknesses of the existing Museum collections, and it also took into account the nature of local holdings that might become acquisitions. As a further step in formulating a practical and progressive policy, Bullard commented on the state of the art market and the overall pricings typical of various categories of works. Balancing all these considerations against the NOMA's financial resources, the new director produced a statement that included a specific summary of the acquisitions policy he was recommending:

> The New Orleans Museum of Art should concentrate its acquisition funds in several diverse areas: American art from the 18th century to the present; 20th century European art, particularly Surrealism; Pre-Columbian and African art; Spanish Colonial Painting and Sculpture; and Prints and Photographs. Serious consideration and study should be given to the possibility of broadening the collection of the decorative arts, particularly if exhibition space outside the Museum becomes available. At the same time the Museum should keep abreast of developments in the art market for old master paintings and sculpture, drawings, and oriental art, so to be prepared to acquire quality works in these areas when available and within our financial range.[6]

This set of acquisitions guidelines recognized as the collection's strengths Pre-Columbian and Spanish colonial art, nineteenth- and twentieth-century Louisiana works, twentieth-century European and

5. Minutes of the Board of Trustees, NOMA, February 21, 1973.
6. E. John Bullard, "A Report on Art Purchases, 1973–1983, New Orleans Museum of Art" (1983; typescript in archives, NOMA), 3–10.

American paintings and sculpture, surrealist works, and creations by constructionist and geometric artists. It acknowledged that NOMA held some fine African sculptures, a range of oriental art works, the excellent Billups Glass Collection, the nineteenth-century French academic paintings of the Hyams Collection, a modest number of works by Degas, and a few other significant French items. It saw the Museum's weaknesses to be in the areas of European paintings and sculptures from the Renaissance through the eighteenth century, in the Flemish and Dutch schools, in the ancient, classic, and medieval periods, and generally in the decorative arts. Bullard thought NOMA deficient in the impressionists as well, in early American works, and in drawings, prints, and photographs.

The new director appreciated the uniqueness of the Museum's Arts of the Americas Collection but believed that the purchase of Pre-Columbian works would not continue to be possible. The 1960s had seen an enormous influx of Pre-Columbian objects onto the world art market from Mexico and Central and South America. New Orleans' was one of many American museums that formed major collections of such material during that period. Nearly all Pre-Columbian works, however, were illegally exported from their countries of origin, through a collusion involving everyone from local grave robbers, who destroyed entire archaeological sites in securing salable objects, to conniving government officials. A UNESCO treaty of 1972 that limited the exportation of cultural patrimony was effectively stopping American museums from purchasing important Pre-Columbian objects.

The Museum, through the early and astute purchases by Byrnes, had already acquired a wide selection of Pre-Columbian art, and it was especially rich in Mayan artifacts. After 1973, NOMA purchased only an occasional Pre-Columbian object, if it could be proved to have entered the United States prior to 1972. Because the Museum also accepted donations from private collectors under the same restriction, it obtained during the 1970s important pieces from western Mexico and Costa Rica. Bullard also felt that the Arts of the Americas Collection needed to be broadened to include works by major United States artists from the colonial period through 1945, an area neglected by Byrnes. But that would prove to be increasingly difficult in the years following the American bicentennial of 1976, owing to the significant rise in the prices for American art.

Judging photography the "art form of our age"—and an art form

for which prices for high-quality works were still low—Bullard began guiding the Museum into an important area of future excellence.[7] At the meeting of the board on March 21, 1973, he recommended, with the approval of the accessions committee, the purchase of a portfolio of fourteen photographs by Walker Evans. That was the first among the thousands of photographs that would eventually become a permanent part of the Museum's holdings. Luba Glade, the art columnist for the *States-Item*, wrote on the direction the Museum was taking under the accessions policy laid out by Bullard:

> The important new direction Mr. Bullard is giving the museum collection can be summed up in one word—photographs. To those interested in talking to him about this subject, one bit of advice. Don't mention the word unless you have an hour or more to spare.
>
> For it brings forth a torrent of information and soon you've seen every photograph he's selected for the museum in the last six months and received a short course in the 20th century development of photography as an art form.
>
> John Bullard is as enthusiastic over this new direction in museum collecting as a boy with his collection of bottle caps. But behind all this enthusiasm there is a sensible, logical plan with achievable goals. He is no dreamer. His ideas are based on the cold realities of the art market as well as on what he conceives to be the function of a provincial museum like NOMA.[8]

Glade pointed out that in concentrating on photography, NOMA would be in the vanguard of museums, though some, like the Museum of Modern Art, in New York, had developed significant photography collections over the past thirty years. She quoted Bullard: "Photography is one of the new art forms of our century. Its development is so relatively recent that art scholars have given it short shrift. The literature is just beginning to develop."[9]

Ronald Todd, the Museum's first curator of photography, started in 1976 to organize small, changing exhibits of newly purchased photography, as well as lectures and seminars featuring famous photographers like Barbara Morgan and Henry Holmes Smith. These events substantially expanded the Museum audience for photography. In 1978, a matching grant from the Ella West Freeman Foundation and a bequest from Estelle Hyams made possible the construction of a new photography storage and study center within the Museum. It had its

7. *Ibid.*
8. New Orleans *States-Item*, November 10, 1973.
9. *Ibid.*

own self-contained climate-control system and berths for twelve thousand prints, as well as study space for staff and students.

Five years after the purchase of the Evans portfolio, a major exhibition of the photographs that the Museum had collected in Bullard's tenure was organized by Tina Freeman, then curator of photography. The show Diverse Images: The Photography Collection from the New Orleans Museum of Art ran from November 3 to December 17, 1978, and proved to be extremely popular with Museum visitors. It was the first major photography show of NOMA's collection. At the opening night preview for members, Anne Tucker, curator of photography at the Houston Museum of Fine Arts, commented on Bullard's foresight in initiating the collection of photographic works at NOMA. Standing before Alfred Stieglitz' *The Steerage*, she said to me, "At today's prices the cost of buying that and a good Ansel Adams is what my whole purchase budget for photography for an entire year at the Houston Museum of Fine Arts is. And think how little you paid. John Bullard was very right and this amazing show proves it."

At the time of the exhibit, Bullard reflected on the almost meteoric development of the photographic art market:

We began to collect photography just before the incredible transformation of this field into the art growth market of the late 1970's. While all areas of art collecting have soared in price in the last decade, photography has been ballyhooed as the last undiscovered, undeveloped art to be collected. While the oldest gallery in New York devoted exclusively to photography was founded only in 1969, during the last few years more than 130 galleries dealing in photography have opened in the United States. Today scores of institutions—museums, universities, corporations, banks and foundations—together with hundreds of private collectors, both great and small, are actively competing in the photography marketplace. Fortunately this boom did not really get started until 1975, giving the New Orleans Museum a two-year start.

The photography collection began cautiously enough with the purchase in March 1973 of a portfolio of fourteen images by Walker Evans. This was quickly followed by the purchase of portfolios by Henry Holmes Smith, Diane Arbus, and Lartique. Being a neophyte in this field, I had to depend on my own eye to judge esthetic quality and on the expertise of the few dealers then actively involved in photography.

From the beginning, our goal was to build a comprehensive collection of photography that would survey the history of the medium from 1839 to the present. New Orleans is fortunate to have had a long history of photographic activity. One of the earliest daguerreotype studios in America was established here in 1840. During the rest of the 19th cen-

tury numerous portrait photographers flourished in New Orleans, then as now one of the largest ports in the world. During the 20th century many of the masters of American photography—such as Lewis Hine, Arnold Genthe, Walker Evans, Edward Weston, and, more recently, Jerry Uelsmann and Lee Friedlander—have passed through New Orleans long enough to focus their cameras on this unique city. Of greater importance, since the 1930's photographer/writer Clarence John Laughlin has lived and worked in New Orleans. Although long neglected, Laughlin is now accorded the recognition his work deserves and he is rightly considered the greatest visual artist Louisiana has ever produced. Although not of Laughlin's stature, other resident photographers during the 20th century have done important work here that deserves attention: E. J. Bellocq's photographs of Storyville prostitutes are now widely known, but of equal interest is the work done at the same time by Mother St. Croix and Pops Whitesell. The inclusion of work by all these photographers who have worked in New Orleans, both transient and resident, has given our collection a special focus.

In 1973 and 1974 we concentrated on acquiring works by key historical figures of the 19th century and vintage images by 20th century artists. While certain famous images, such as Stieglitz's *The Steerage* and Adams's *Moonrise*, had to be included in the collection, an attempt has always been made to acquire unique or unusual examples of a photographer's work. An outstanding example of this policy is the marvelous group of eighteen vintage, postcard size images done in Paris in the 1920's by Andre Kertesz. To stay ahead of the market, we also have sought the work of European photographers not yet known in this country. Of particular interest to me are the photographers who worked in Germany and Central Europe between the World Wars. We now recognize some of the major artists of this period—Sander, Sudek, Funke, Mantz, and Renger-Patzch—but there must be many more to discover whose work, hopefully, escaped the disasters of the last War.

While it has not been possible, due to the skyrocketing prices and scarcity of fine material, to collect in depth the work of the 19th century masters, we have tried to acquire numerous examples by important 20th century photographers so that the range and development of their art can be studied and exhibited. We are approaching this goal in our holdings of Abbott, Adams, Coburn, Cunningham, Doisneau, Walker Evans, Feininger, Genthe, Gilpin, Hine, Kertesz, Laughlin, Sander, Uelsmann, Van Der Zee, and Weston.[10]

The majority of the board continued to be committed to photography, though according to George Leake, a board member, "some members . . . severely criticized the photography, saying it is not real

10. E. John Bullard, "Preface," in *Diverse Images: The Photography Collection from the New Orleans Museum of Art*, by Tina Freeman (1979), v.

art."[11] Between 1979 and 1983, the Museum spent $279,160 on photographs. In addition to making purchases, the Museum also received numerous gifts, the most significant of which came from the internationally known New Orleans photographer Clarence John Laughlin in 1982. Valued at over a quarter of a million dollars, the collection he gave comprised 350 photographs by both famous and unknown American and European photographers he had known personally during his long career. It included important vintage photographs by Edward Weston, Imogen Cunningham, Ruth Bernhard, Wynn Bullock, and Brassai. There were also many works by younger photographers who considered Laughlin their inspiration and teacher. Many of the photographs were portraits of Laughlin himself.

Bullard had long had his eye on Laughlin's outstanding collection of his own and others' photographs. He saw them as the potential capstone to the Museum's photography section. Early in 1976, when I was chairman of the accessions committee, Bullard confided to me his desire to obtain Laughlin's ten thousand master prints of his own work, his collection of other photographers' works, and his library and collection of memorabilia. As a stunning addition to the Museum, they would be the core of the Clarence John Laughlin Center for Photography. Bullard envisioned Laughlin's collection as constituting a focal point in the South for the study of photography and for photographic scholarship. I was in total agreement.

The idea was appropriate, for the New Orleans Museum of Art had enjoyed a long relationship with Laughlin. The first one-man exhibition of his photographs was held at the Museum in 1936. In 1974, the largest exhibition of his work yet presented, The Personal Eye of Clarence John Laughlin, which had been organized by the Philadelphia Museum of Art, was exhibited at NOMA. Two years later, the Museum presented another show of Laughlin's work, Ghosts Along the Mississippi: Photographs by Clarence John Laughlin. And in 1981, still another exhibit was presented by the Museum, Clarence John Laughlin: Louisiana Plantations. Bullard pointed out, however, that there were impediments to establishing the center he dreamed of, not the least of which was the formidable Laughlin himself. Bullard described Laughlin as one who "possessed an extraordinary personality. He was in turns fascinating, exhausting, maddening, illuminating, and always unique. Through his travels and reading, he had a

11. New Orleans *Times-Picayune*, January 18, 1981.

vast knowledge in many specific areas—including, but not limited to science fiction, comic books, Victorian architecture, Art Nouveau, and all things concerned with the strange, fantastic, surreal and mysterious—which he was happy to share with you at great length. He also had definite opinions on nearly every subject and many specific likes and dislikes." [12]

The director and I agreed that we had to arrange a meeting with Laughlin to discuss the ideas of the center. If he was interested, we would devise a plan to pay for the collection and to convince the board of the worthiness of the project. On the appointed evening, Bullard, my wife, and I trudged up four flights of creaky stairs to Laughlin's attic apartment in the historic Upper Pontalba. I had never seen the eminent photographer in person and was not prepared for the image that greeted us at the door. He was in a faded Hawaiian sport shirt and baggy shorts, with socks sagging about his ankles. His apartment was just as amazing. It was jammed with bookshelves made from planks and bricks. The floor, uneven under the weight it bore, acclaimed the craft of its builder by not collapsing. In the center of the room there was a large table stacked with papers, books, and photographs. Laughlin led us to stand there for a harangue about his health, his diet, and the dangers of preservatives in food. When he noticed my wife's advanced pregnancy, he offered a chair. His mood changed, and he told us about his work and showed us some work of other photographers. We broached the idea of establishing a center for photography with his collection as the centerpiece. Laughlin was receptive, knowing how much the collection could bring, but he was uncertain of the tax consequences and of other legal technicalities. Bullard explained that those problems could be resolved over the coming months. We were even able to suggest a suitable lawyer.

As Bullard had predicted, it was not difficult to develop a plan for the purchase of the Laughlin collection that was both manageable for the Museum and advantageous to Laughlin with respect to taxes. With a modicum of effort we laid the groundwork among various board members and brought the proposal through the accessions committee to the full board in the fall of 1976. Bullard explained to the trustees that it would cost between $150,000 and $200,000 and that the purchase could be completed over a ten-year period. The board au-

12. E. John Bullard, "Clarence John Laughlin, 1905–1985," *Arts Quarterly*, VII (April–June, 1985), 17.

thorized the committee to pursue the matter further and to report to them.

Nevertheless, the idea was destined never to come to fruition. In January, 1977, the chairmanship of the accessions committee changed. The new chairman, Mrs. Kaufmann, was not enthusiastic about the Laughlin acquisition, knowing from personal experience that the photographer was difficult to deal with. Dr. Richard W. Levy, a newly elected board member, also opposed the idea, feeling that NOMA's limited accessions funds would be better spent in other areas.[13] To avoid a division of the board on the question, Bullard after careful consideration decided to postpone the discussion of the purchase. The accessions committee voted unanimously to defer the matter until after the upcoming Tutankhamun exhibition. In a letter of February 27, 1977, to Laughlin, Mrs. Kaufmann wrote,

> After extended discussion, the Acquisitions Committee of the New Orleans Museum of Art has decided to postpone until the Spring of 1978 consideration of the purchase of your collection of master prints and your photography library and archives.
>
> This decision was necessitated primarily by the tremendous work involving the staff and Trustees in mounting the Tutankhamun exhibition in the Fall of 1977. This project will literally occupy the Museum's total time and energy for the next twelve months. In addition, there are difficult questions of storage and exhibition space and staffing, as well as financing, involved in the acquisition of your collection which the Trustees and staff do not have the time and attention to properly consider until after the close of the Tutankhamun exhibition.
>
> I am sure that you can appreciate our reluctance to undertake such an important acquisition, with all its inherent responsibilities for the Museum, without thorough consideration and thought by both parties.
>
> The Acquisitions Committee looks forward to resuming our discussions on this subject next year. Let me assure you that we have the greatest respect for you and your work and we are anxious to have your work as well represented as possible in the Museum's Collection.[14]

The plan was never revived, owing to a change in acquisitions priorities. In 1981, the Historic New Orleans Collection purchased Laughlin's collection of master prints of his own photographs, together with his manuscripts and correspondence. Later HNOC purchased from the University of Louisville all of Laughlin's seventeen

13. Minutes of the Accessions Committee, NOMA, January 19, 1977.
14. Mrs. Richard B. Kaufmann to Clarence John Laughlin, February 25, 1977, in archives, NOMA.

thousand sheet-film negatives, thereby creating a permanent repository for Laughlin's work. Bullard was able to persuade the photographer to offset the sizable taxes he would have had to pay on the sale to HNOC by donating his large collection of other photographers' work to NOMA in 1982. At his death, Laughlin bequeathed small collections of his own photographs to seven American art museums, the largest going to the New Orleans Museum of Art. So in the end Laughlin became the greatest benefactor to date of NOMA's photography collection.

The building of the Museum's collection was Bullard's major concern in his first eventful years at the New Orleans Museum of Art. There was a great deal of hard work involved, and also a bit of luck. In 1973, after Bullard's presentation of his draft acquisitions policy, the director and trustees spent $180,000 on 136 works of art. The Museum received 120 gifts of art works as well. Among the outstanding purchases was a large oil painted in 1704, *Adoration of the Magi*, by Nicholas Colombel, a disciple of Nicolas Poussin. Also of note was the painting *Romeo and Juliet*, by the American master Benjamin West, commissioned in 1778 for the duke of Courland.

The remaining money from the Freeman Foundation matching grants was expended in 1973 to purchase two early American modernist works for the collection: *The Ice-Hole, Maine*, an oil painted by Marsden Hartley in 1908; and *Pitcher and Three Croissants*, a still life painted by Alfred Mauer in 1912 in Paris while studying with Matisse. A matching grant from the National Endowment for the Arts for the purchase of works by living American artists enabled the Museum to acquire a gouache by the African-American artist Jacob Lawrence from his Builders series. Other additions to the American collection came from Edgar William and Bernice Chrysler Garbisch; three of their gifts depict southern scenes. Mr. and Mrs. Richard B. Kaufmann gave two drawings, one by Louis Guglielmi and the other a self-portrait by Joseph Stella, both from the collection of Edith Halpert. By far the most important addition to the twentieth-century American collection was a 1937 New Mexico landscape, *My Backyard*, by Georgia O'Keeffe, that the Museum purchased directly from the artist with funds from the city of New Orleans. During this period a number of Pre-Columbian and African objects were given to the Museum as well.

The Museum received some outstanding gifts of Japanese art from the noted New Orleans collectors Dr. and Mrs. Kurt A. Gitter. Dr. Gitter first came to the attention of the trustees at the board meeting

of November, 1972 when the president, Mrs. Muller, announced that she had received a letter from "Dr. Kurt Gitter, a local physician who is also an authority on Oriental Art, offering his services as an honorary curator. He also indicated that he is willing to donate works from his own collection to the Museum, and has suggested the establishment of an accessions fund for the purchase of oriental art." [15] After some discussion by the trustees, they decided that Gitter's gifts would be considered by the accessions committee but that his offer of lending expertise on oriental art would have to await the appointment of a new director.

In 1972, the Gitters made their first gifts to the Museum: four hanging scrolls and an eightfold screen. Their nascent commitment blossomed in 1973, nurtured by a close friendship with Bullard, and it resulted in the Museum's building a collection of Japanese art with special strength in paintings from the Edo period. The Edo period, one of the richest and most diverse in the history of art, was a time of peace and prosperity in a deliberately isolated Japan, then under the firm rule of the Tokugawa shogunate. Between 1615 and 1868, nearly a dozen different schools practiced distinct art styles, from the monochromatic, abbreviated ink paintings of Zen monks to the colorful depictions of courtesans by the ukiyo-e artists of the capital. The thousands of artists who worked during this 250-year period were just becoming known in the West when the Gitters began to collect in the early 1960s. They were among the pioneers of American collectors, specializing particularly in works of the Zenga and Nanga schools.

The Gitters' great interest in building a collection of Edo-period painting at NOMA illustrates how a trustee can influence the development of a museum's art collection. Gitter was elected to the board in 1975, and over the years the Gitters gave dozens of works to NOMA and encouraged family and friends to donate Japanese works, as well. Their example prompted gifts from other collectors. Eventually the director convinced the board of the necessity of committing the Museum to purchase important Japanese paintings from dealers in New York, London, and Japan, in order to enhance the collection the Gitters' gifts had initiated. Over seven years, NOMA spent $324,000 in the field of Edo painting, building depth in its Japanese collection.

The New Orleans Museum of Art "has the finest Japanese collection in the Southeast and more important, one of the best Edo collec-

15. Minutes of the Board of Trustees, NOMA, November 22, 1972.

tions in the country," Bullard boasted in 1983.[16] NOMA's reputation
in this area had been spread throughout the country by a number
of traveling exhibitions organized by the Museum and documented
by scholarly catalogs the adjunct curator of Japanese art, Professor
Stephen Addiss, of the University of Kansas, had written. The first of
these exhibitions, Zenga and Nanga: Paintings by Japanese Monks
and Scholars—Selections from the Kurt and Millie Gitter Collection,
was presented in 1977 and then toured to museums in Cincinnati,
Honolulu, San Diego, Ann Arbor, and Portland, Oregon. In 1980, Ad-
diss organized for NOMA A Japanese Eccentric: The Three Arts of
Murase Taiitsu. Mounted to mark the hundredth anniversary of the
artist's death, it was the first exhibition of the work of the eccentric
Nanga painter and Confucian scholar ever presented outside Japan.
In 1983, the Museum presented a second exhibition drawn from the
Gitters' extensive collection, A Myriad of Autumn Leaves: Japanese
Art from the Kurt and Millie Gitter Collection. It traveled to the Wal-
ters Art Gallery, in Baltimore. In conjunction with it, the Museum
sponsored an international symposium, "The Arts of the Edo Pe-
riod," in November, 1983. Thirteen scholars from Japan, England,
and the United States presented papers, later published by NOMA,
to a distinguished audience of academics, museum curators, collec-
tors, and dealers from all over the world. After ten years of building
strength in Edo paintings, the Museum had a collection worthy of ex-
hibition at other museums. In 1982, a selection of scrolls and screens
was presented at the Birmingham Museum of Art and at the Brooks
Memorial Art Museum, in Memphis; in 1983, a group of NOMA
screens was shown at the Lowe Art Museum, in Miami.

A phenomenal wealth of art donations came to the New Orleans
Museum of Art in 1974. The first gift was a nearly $5-million bequest
of works from Victor K. Kiam, of New York City. The stunning dona-
tion was announced by the director to the board of trustees at its
meeting on May 22, 1974. The collection's contents were virtually a
curator's wish list of twentieth-century art, with ninety-one paintings,
sculptures, and graphics by such artists as Pablo Picasso, Georges
Braque, Joan Miró, Fernand Léger, and Marc Chagall. The Kiam be-
quest also included 181 African and Oceanic objects of superb quality,
among which was a rare Hawaiian sculpture originally collected by
the English explorer Captain James Cook. Altogether, Kiam's collec-

16. Bullard, "A Report on Art Purchases, 1973–1983," 39.

tion was the most important art acquisition to be offered the Museum since the Kress Collection. But it was to take three years of negotiation before the Museum received the Kiam bequest, and by then the collection was considerably reduced in size.

Kiam was a prominent financier and lawyer who had lived in New York City for nearly forty-five years. Born in Houston in 1896, he had been reared and educated in New Orleans. He received his A.B. in 1915 and his LL.B. in 1917, both from Tulane University, and maintained law offices in the Canal Bank building on Baronne Street for several years before moving to New York, where he achieved considerable success on Wall Street.

On February 24, 1973, soon after Bullard was hired as director, Kiam wrote to him requesting a meeting: "I have something to discuss with you as Director of the Museum which I think would be of interest and importance to the Museum." [17] Though no one at the Museum had heard of Kiam, Bullard traveled to New York from Washington to meet him on March 14. The elderly man, nearly blind, graciously conducted Bullard on a tour of his astonishing collection of twentieth-century paintings and sculptures, complemented with African and Oceanic artworks, all elegantly installed in his Park Avenue duplex. Among the highlights were nine paintings by the great Spanish master Joan Miró, a personal friend of Kiam's. Kiam confided to Bullard that a number of New York museums were interested in his collection but that he was tremendously disenchanted with the New York art world, largely because of the controversial deaccessioning and sale of works from the Adelaide de Groot Collection by the Metropolitan Museum of Art. Besides that, Kiam was incensed that William Rubin, curator of paintings at the Museum of Modern Art, had asked his friend Miró to suggest to him that he give his most important painting by the artist to the museum. Kiam had come to the conclusion that if he gave his collection to a New York museum, only a few of his works would ever be on display, the majority remaining in storage or being sold.

At the conclusion of the visit, Kiam asked Bullard if the New Orleans Museum of Art would be interested in his collection. Bullard replied enthusiastically that New Orleans would be eternally grateful for such a splendid donation and that the collection, since it included major works by masters not already represented in the Museum,

17. Victor K. Kiam to E. John Bullard, February 24, 1973, in archives, NOMA.

would be prominently displayed. Kiam made no definite promise but assured Bullard that he would give a donation to NOMA considerable thought.

During the next twelve months, Bullard corresponded regularly with Kiam and visited with him on several occasions. He also arranged for two Museum trustees, Mrs. Stern and Mrs. Francis, to visit Kiam to see his collection, hoping that they might help persuade him. As part of Bullard's campaign of cultivation, he informed Kiam of the promised gift of Mrs. Francis' collection of twentieth-century art, then kept in her New York town house. Bullard proposed that on his next visit to New York, Kiam come for cocktails at Mrs. Francis' house, where he might see her collection. A date was set for May 14, 1974.

Bullard has recalled that on the appointed night he and Mrs. Francis waited for Kiam and his companion. When the always-punctual Kiam did not arrive, the director telephoned his apartment and learned from the housekeeper that her employer had died of a heart attack on the street that morning. Bullard and Mrs. Francis were shocked and discouraged. But the following day Kiam's attorney informed an amazed Bullard that the collector had bequeathed his entire art collection to the New Orleans Museum of Art under the terms of a will he had made in October, 1972—several months before first discussing the possibility with Bullard.

The announcement of the Kiam bequest was applauded on the front and editorial pages of New Orleans newspapers on May 30 and 31. Bullard expressed the hope of having the collection on display by the early fall. The director's hope was a vain one, however, for the negotiations to settle the Kiam estate proved to be long and delicate. The great problem was the decline in the value of all the property in the estate, including stocks, real estate, and art, as a result of the 1974 recession. For example, Sotheby Parke-Bernet made two appraisals of the art collection, as required for probate. The first, setting the value at the date of death, amounted to $4,817,000; the second, six months later, came to $3,730,000. Worse, the decline in the estate's cash assets made it difficult to pay out Kiam's specific bequests.

As a result, Victor K. Kiam II contested his father's will on behalf of his two minor children, who were the residuary legatees of their grandfather's estate. Victor Kiam II, a resourceful and successful businessman, who later became famous for his commercials for Remington shavers on television, was then chairman of the Benrus Corporation. Through his lawyers, he let it be known that his father's will

was a recent one and that the elder Kiam had not been in good health in recent years. In his last will, Kiam had left to his friend and companion, Chen Ing Chang, his Park Avenue duplex and considerable wealth. His son's implication was one of undue influence. After the bequests to the Museum and Miss Chang and once legal fees and taxes had been paid, there would, because of the fall in the estate's assets, have been practically nothing remaining to create residuary trusts for the Kiam grandchildren.

The Museum's legal committee, chaired by Carrere, considered the chances of winning a court battle against the Kiam family to be slim. They reasoned that the New York courts would have little sympathy for an out-of-state museum and that the court would not favor a public institution over minor relatives. Consequently, the Museum's attorney advised the trustees that the wisest path would be to reach a settlement. He believed that a court battle could be lengthy and costly and that in the end the Museum might lose the entire collection. In a settlement, he thought, the Museum would receive a fair portion of the collection, with a choice of the best works.

The trustees agreed to let the legal committee negotiate. Because of the delicacy of the transaction and the diplomacy required, the resolution of the matter took years. Finally, in May, 1977, the necessary papers were signed, and the Museum came into possession of its portion of the bequest. It received seventeen paintings and sculptures, and 182 African, Oceanic, and American Indian objects, as well as a group of illustrated books. These works arrived in October, 1977.

In the final settlement, the Museum received most of the finest works in Kiam's collection. The seventeen paintings and sculptures by European and American masters included four works by Joan Miró, all major paintings from different periods; three works by Pablo Picasso, two paintings and a sculpture; two paintings by Georges Braque, including a rare fauve landscape from 1906; two works by Alberto Giacometti, a painted sculpture and a painting; three works by Jean Dubuffet, two paintings and a sculpture; a drip painting by Jackson Pollock; a painting by Sam Francis; and a mobile by Alexander Calder. The group of African objects gave the Museum, when they were combined with its own holdings, the finest collection of such material in the South. Although some fine works had been included in the art ceded to the family—including paintings by Miró, Picasso, Marc Chagall, Wassily Kandinsky, Fernand Léger, and Georges Rou-

ault—the Kiam bequest was still one of the two greatest art donations in the Museum's history.

A month after the first announcement of the Kiam bequest on June 29, 1974, the *Times-Picayune* related that a collection of 347 English and Continental miniatures had been given to the Museum. "The donation, which is an anonymous one," it said, "places the New Orleans Museum among the top six American institutions in this field." Quoting an elated Bullard, the newspaper reported that "auction prices at recent London miniature sales indicate that this collection should be valued in the half million dollar range." [18]

The donation, known as the Latter-Schlesinger Collection, was the gift of Mrs. Richard B. Kaufmann, née Latter, and her children, Lee H. Schlesinger II and Mrs. Mark B. Herman, in memory of Harry and Anna Latter. The collection, contrary to the director's expectations, was not placed on view until five years after its presentation. Miniatures are rather delicate, often painted on vellum or ivory, and they require constant light and temperature control in order to maintain their beauty. Thus, Mrs. Kaufmann wanted the Museum to house the collection in a specially designed gallery whose display cases were equipped with scientifically engineered climate control and lighting. Moreover, each of the over three hundred objects had to be researched for a major scholarly catalog of the collection, which was underwritten in part by a grant from the National Endowment for the Arts. The arrangements took five years to complete, but in the end the Museum had another outstanding and unusual collection, as well as a beautiful new gallery and a learned catalog.

The significance of miniatures is often lost on the modern world, since the invention of photography has afforded a convenient alternative to the use of these tiny paintings. From the Middle Ages until the nineteenth century, miniatures were important, however, as a means of keeping a loved one's image at hand. It was a Hans Holbein miniature of Anne of Cleves that persuaded Henry VIII to marry the ill-fated princess. Mrs. Kaufmann recalled that "one of the Georges, I think it was George IV, had a portrait painted of his mistress, and when he died it was buried with him." [19] The greatest painters of the day practiced the art of creating miniatures, and the small images were often encased in frames decorated with precious and

18. New Orleans *Times-Picayune*, June 20, 1974.
19. New Orleans *States-Item*, November 23, 1979.

semiprecious jewels. Many included a lock of hair of the person represented.

The extensive Latter-Schlesinger Collection concentrates on the period in which the art of miniatures was at its height in England and on the Continent, from the Renaissance through the mid-eighteenth century. The collection contains works by many of the greatest miniaturists, such as Samuel Cooper, Richard Cosway, Nicholas Hilliard, John Hoskins, and John Smart. In the handsome catalog *English and Continental Portrait Miniatures: The Latter-Schlesinger Collection,* Mrs. Kaufmann wrote about collecting:

> The history of collecting is a very exciting subject. Volumes have been written on this topic. *The Taste of Angels,* by Henry Francis Taylor, *A Collection in the Making,* by Duncan Phillips, and Aline B. Saarinen's, *The Proud Possessors,* are only a few. The private collections chronicled in these books are similar in their development to the background of this collection.
>
> In 1921, my parents, Harry and Anna Latter, made their first trip abroad. Along the way, they bought a few objets d'art: antique watches, ivories, miniature silver pieces, and portrait miniatures. On many subsequent trips until World War II, they added to each of these enticing groups. Over the years, these pieces became four different collections.
>
> President Eisenhower in late 1957 requested my Father spend a year in Europe in order to evaluate an existing Government Project. My children and I accompanied my parents. We arrived in London, which was to be his headquarters, in January 1958.
>
> During that year, my Father continued to add to the collection but soon realized he was most attracted to the English miniatures. No doubt, his English birth, his love of history as well as their artistic beauty, contributed to his specializing. At this point, I, too, became interested in the miniatures. His enthusiasm and energy was infectious. We accumulated reference books, read sales catalogues. We met collectors and dealers. We spent hours studying miniatures in London museums, particularly those in the superb collection of the Victoria and Albert Museum.
>
> The whole experience was exciting and educational, but as any collector will tell you, knowledge alone is not a sufficient guide to collecting. I remember the day we went to a tiny shop outside of London and got into a heated discussion on the attribution of a miniature. I was sure that my new found knowledge supported my belief that the artist of the miniature was other than the dealer claimed. My Father agreed with the dealer. I left the shop hoping my Father would follow without this rather expensive portrait. He followed but with his precious miniature. Driving back to London, I gave him my reasons for disbelieving the attribution.

"That's all well and good," he said. "Nevertheless he looks good to me." His practiced eye and innate good judgment later proved his point when the miniature was duly authenticated.[20]

The next extension of the Museum's holdings came through Mrs. Stern's unique purchase-donation plan whereby the Museum acquired the Stern-Davis Collection of Central Andean Colonial Art. The collection consisted of twenty-eight paintings and one sculpture, *Archangel Michael*. These works had been on long-term loan to the Museum ever since they had been shown at the Museum in the 1972 exhibit Peruvian Colonial Painting. Many trustees thought that the collection would eventually be given outright to the Museum, but Mrs. Stern conceived a plan. Arthur Q. Davis recalled, "I was prepared to give the paintings to the Museum, but Edith Stern had other ideas. She said she would like to give the paintings on the assumption that after a proper appraisal had been made the Museum would match our contribution dollar for dollar, and by this method raise considerable funds."[21]

The plan as presented to the trustees in 1974 was that the Museum would purchase the art objects for $224,000, with a $10,000 payment in 1974 and the commitment of 50 percent of all future undedicated acquisition funds. The final stipulation was that 100 percent of all proceeds in the future from the sale by deaccession of any Peruvian colonial art in the Museum's collection also would go to pay for the collection.

One trustee was inspired to ask, What is the donated portion of this acquisition if the Museum purchases the collection for $224,000? After all, the amount was more than the Museum had ever spent for either an art object or a single collection. Bullard explained that Mrs. Stern's foundation and Davis would split the $224,000. They would then donate to the Museum the appreciated value of the collection, including the costs, since its purchase, of insurance and restoration, and of the antique framing of many of the paintings. In that way, the cash payment would cover the costs of maintenance of the collection, making the real cost of the paintings not so high as at first appeared. After lengthy discussion, the board, with only one dissenting vote, agreed to buy the collection. Many trustees may have concurred in the pur-

20. Shirley Latter Kaufmann, "Foreword," in *English and Continental Portrait Miniatures: The Latter-Schlesinger Collection*, by Pamela P. Bardo (1978), 7–8.
21. Klein, *A Passion for Sharing*, 239.

chase mainly so as not to upset the delicate negotiations that were then in progress over the gift of Mrs. Stern's home to the Museum for use as a branch center for the decorative arts. Because of the heat of the board discussion concerning the purchase of the Stern-Davis Collection, the Museum was requested to sign a chattel mortgage securing the $224,000 owed Mrs. Stern's foundation and Davis, which was "due December 31, 1985, payable in annual installments commencing December 31, 1974."[22]

The NOMA board took a momentous step on March 20, 1974, when it voted to accept the recommendation of the development committee, headed by William E. Burkenroad, to hire a fund-raising firm to implement a major capital campaign. It had been one of Bullard's fervent hopes that the board would commit itself to a drive, for the Museum was in dire need of certain acquisitions, particularly in the areas of early American art and of French art prior to the nineteenth century. With the Ella West Freeman Matching Fund exhausted, the Museum's only source of funds for acquisitions was the annual Odyssey Ball. What it generated, however, was not sufficient for the major purchases Bullard contemplated.

As a first step, representatives of Ketchum, Inc., a national fund-raising firm, undertook a feasibility study that elicited widely differing opinions about which of the Museum's needs a drive ought to address. Some felt the endowment should have priority; others were more interested in supporting a campaign that would help the Museum expand its physical facility. After all, NOMA's collections were still rapidly growing and in need of space.

In June, the development committee recommended to the board that it "proceed with the planning, organization and implementation of a drive to raise from three to five million dollars primarily for acquisitions funds and, possibly, for capital funds to provide an addition to the new wings for the Kiam Collection"[23] There was much discussion, at this time, of constructing the third-floor addition to the City Wing that had been anticipated when the wing was added. Undecided, the board took no vote concerning the purpose of the drive. It did vote, however, to allow a chairman for the drive to be selected and to get the preliminaries under way. Upon the completion of the development committee's report, Mrs. Francis announced on behalf

22. Minutes of the Board of Trustees, NOMA, December 18, 1974.
23. *Ibid.*, June 19, 1974.

of the accessions committee the gift of the Latter-Schlesinger Collection, bringing home the need for additional space.

It was not until February 15, 1975, that James J. Coleman, Jr., reported that the development committee recommended a drive with a goal of $2.5 million for acquisitions, and the engagement of the firm of Ketchum, Inc., to see NOMA through the campaign. In March, Robert A. Peyroux, the board's president, announced that Mrs. Francis and Coleman would chair the fund drive (the latter resigned in September). At the March meeting the board approved the contract with Ketchum, Inc., as well as the $2.5 million goal. Contributions to the campaign were to be either cash, for art purchases, or actual works of art appropriate to the collection.

Aware that a formal acquisitions policy for the Museum would be of great importance for the success of the campaign, the director presented a draft to the full board at its April meeting. Based on Bullard's statement of 1973, the revised and expanded policy was developed in consultation with the accessions committee and the staff. The final draft was approved unanimously by the full board:

Nearly ten years ago the New Orleans Museum of Art, realizing that it could not possess a totally comprehensive collection of world art, decided to specialize in a few areas in which outstanding and unique collections could be formed. Matching a generous grant from the Ella West Freeman Foundation in 1967, the Museum began to form an Arts of the Americas Collection, which would survey the art of North, Central, and South America from the Pre-Columbian period to the present.

By the time the Freeman Matching Fund was exhausted in 1973, the Museum had fulfilled its original goal of forming a unique, specialized collection, as well as acquiring important art works from other cultures and periods. With Freeman purchases and the recent acquisition of the Stern-Davis collection, the New Orleans Museum of Art now owns the finest and most comprehensive collection of Latin American Colonial Art in the United States. This collection is complemented by an outstanding selection of objects from the various Pre-Columbian Indian civilizations of Central and South America.

Now, contemplating a major drive for art acquisition funds, what should be the future direction for the New Orleans Museum of Art?

Due to the new national and international regulations prohibiting the illegal exportation and sale of artistic patrimony, it is no longer possible to acquire significant Pre-Columbian and Latin Colonial works. Fortunately the Museum already has formed [a] collection in these areas. However, there is one aspect of the Arts of the Americas Collection which the Museum neglected in the past, namely painting and sculpture

by United States artists, particularly of the 18th and 19th centuries. So, in the immediate future, it would be most appropriate, particularly during the American Revolution Bicentennial, for the New Orleans Museum of Art to acquire a comprehensive collection of American Art, which would balance and complement its Latin American and 19th century Louisiana art collections.

While the Museum attempts to present a survey of European art from the Renaissance to the present, there are a number of gaps in its collection of old master paintings and sculpture. Rather than attempting to fill all of these lacunae haphazardly, it would be wiser to identify its current strength in this field and specialize in that area. Combining present holdings and anticipated gifts from local collectors, the Museum is far richer in works of the French School than any other. Considering the historic cultural ties of New Orleans and France, this is not surprising.

The Museum owns fine French paintings of the 17th and 18th centuries and is particularly strong in works of the 19th and 20th centuries. The Hyams Collection of Barbizon and Salon painting and the Degas Collection provide a strong foundation for further development of a 19th century French collection. Past gifts and purchases, together with the anticipated bequest of the Victor Kiam collection, give the Museum an outstanding survey of the 20th century School of Paris. Two private New Orleans collections, rich in works by French artists, have been promised to the Museum, thereby eventually broadening and complementing its existing French holdings.

For nearly four hundred years, the French consistently have produced scores of great masters. Even lesser known artists have created works of great beauty and significance. Fortunately works by French artists of every period are still readily available within financial reason. It would be appropriate then for the New Orleans Museum of Art to concentrate its efforts in forming a comprehensive collection of French Art from the 16th through the 20th centuries.

While the New Orleans Museum of Art will concentrate its resources in acquiring American and French art, some funds should be spent in those other areas in which the collections are already strong.

First, during the past two years, the Museum has begun to form a significant collection of photography. This new area of collecting has received considerable support and the Museum now has the best photography collection in the South. The Museum should continue to add steadily to this collection in the future.

Second, due to gifts and loans, the Museum now possesses a small, but fine collection of oriental art, particularly Japanese painting. While the Museum cannot collect actively in this field, it should from time to time acquire important objects to augment the existing collection, thereby encouraging future gifts.

Third, the Museum already owns, in the Melvin Billups Collection,

one of the finest and most comprehensive glass collections in the country. The contemplated conversion of Longue Vue House into the New Orleans Museum of Art's decorative arts branch would provide galleries for the exhibition of glass, porcelain, and silver, as well as period furniture rooms. The Museum should support this new facility and collection by purchasing outstanding works of different types in the decorative arts field.

Fourth, the Museum now owns a fine collection of African art. The bequest of the Victor Kiam Collection will triple our African and Oceanic holdings, giving New Orleans the finest collection of such material in the South. Occasionally, when available, an important piece should be acquired to fill any gaps in this area.

Fifth, the Museum should continue to add to its small collection of old master and modern prints and drawings. Such works complement the painting and sculpture collection; therefore, logically, the Museum should concentrate on acquiring graphics by American and French artists.[24]

For the purposes of the fund drive, the campaign literature offered a condensed version of the acquisitions policy. To achieve brevity, clarity, and impact, the literature emphasized works by North American artists from the colonial period to the present, and works of the French school from the sixteenth, seventeenth, and eighteenth centuries.

During the summer, the drive got under way. The director presented a talk and slide show about the Museum's collections and the Museum's goals for the fund drive at the homes of thirty-odd hosts and hostesses who had agreed to invite friends to attend the dinners. In September, solicitation of the staff and the trustees themselves began. By December, Mrs. Francis, now sole chairman of the drive, could announce to the board that the amount taken in already was $550,000, from pledges totaling $800,000. She asked that other trustees make their pledges by the end of the year so that the largest amount possible could be in hand when the campaign went to the public in January, 1976. Paul Stephani, of Ketchum, Inc., reported that the money promised and received represented eight pledges. He "added that he was encouraged and that there [was] an outstanding prospect of exceeding" the goal.[25]

Early in January, 1976, the newly elected board president, Moise S. Steeg, Jr., announced to the board that he had met with Mayor Moon

24. *Ibid.*, April 16, 1975.
25. *Ibid.*, December 17, 1975.

Landrieu to discuss various needs of the Museum. The very day after this meeting, the city released fifty thousand dollars as its contribution to the fund drive. Mrs. Francis reported that divisional heads had been recruited for the fund campaign. Frederick M. Stafford was to be honorary chairman of the drive. Richard A. Peneguy was to head the committee on initial gifts; C. C. Clifton, Jr., that on primary gifts; Shirley B. Braselman, that on major gifts; Francis Doyle, that on special gifts; and Mrs. Muller, that on metro gifts. Percy H. Sitges was to serve as treasurer. Mrs. Francis remarked that nineteen trustees had pledged $694,240 in cash or gifts in kind.

As the funds from the drive came in, Bullard and the members of the accessions committee began to consider what high-quality works might be available for purchase. He and the committee concentrated on American artists such as Frederick E. Church, John Singleton Copley, Ralph Earl, Martin Johnson Heade, Charles Willson Peale, John Singer Sargent, and John Trumbull. Success was soon to come. By February, two paintings by a great American artist, Gilbert Stuart, entered the Museum's ownership. One was a *Portrait of Major Peter Fort*, done around 1818, and the other was *Mrs. George Williams*, an unfinished portrait limned in Boston in 1819. Both were purchased out of the fifty thousand dollars the city had contributed to the fund drive, and Mayor Landrieu announced their purchase. It was hoped that tangible early results would stimulate generous impulses as the campaign penetrated the public sector. Bullard said, "It seems particularly appropriate . . . to acquire two important American paintings during the Bicentennial Year."[26] The purchase of the *Portrait of Major Peter Fort* was especially fitting, for the subject had lived in New Orleans from 1808 to 1816 and had fought in the Battle of New Orleans.

In a few months another fine colonial portrait joined the new Stuarts. A work of the English-born artist John Wollaston, *General Staats Long Morris*, was a gift in kind to the fund drive. The artist had been one of the most active painters on the Atlantic seaboard. He was highly regarded by the colonial gentry, and he influenced American artists such as Benjamin West, Matthew Pratt, and Gustavus Hesselius. He spent more than a decade in America, painting over three hundred works.

26. New Orleans *Times-Picayune*, February 19, 1976.

General Staats Long Morris, the subject of the painting, was from one of the oldest families in Westchester County, in the New York colony. His brother, Lewis Morris, signed the Declaration of Independence. His half brother, Gouverneur Morris, was a famous American statesman and diplomat. Staats Long Morris remained a Tory; indeed, he became an expatriate as a young man. After graduating from Yale, he left for England in 1755 and became a member of the Gordon Highlander Regiment, in which he eventually attained the rank of general. He served as a member of Parliament from 1774 to 1784 and in 1797 was appointed governor of Quebec, where he died in 1800.

The board was considering the purchase of John Singleton Copley's *Portrait of Colonel George Watson*. The painting was offered for $285,000, a price Bullard considered excellent. He explained to the board that Copley was the most skillful artist practicing in the American colonies prior to the Revolution. Trained in America, he had moved to England in 1774 because of his loyalist sympathies. There he became a member of the Royal Academy and enjoyed a distinguished career as a portraitist and history painter. Colonel Watson, like Copley, was a loyalist, but he remained in America, where he was a resident of Plymouth, Massachusetts. Copley painted Watson's portrait about 1768. In 1774, a crowd appeared late one night at the artist's home in Boston, where they believed the "villain" Watson was visiting. Their quarry had actually left Boston earlier that day, so Copley's home escaped destruction by the mob. But it is believed that this event triggered Copley's permanent departure from the colonies.

I was serving during this time as chairman of the accessions committee, and I brought the Copley to the attention of the director. I had received a telephone call from the art dealer Steven Straw offering my wife and me a magnificent Copley for our collection. Straw said that he had remembered my remarking that we would like to have one. "I have a fabulous one," he said. He explained that the portrait had descended in the family of Colonel Watson and was now being offered privately for sale by the owner, who needed the funds for his children's education. The price was reasonable, because the owner needed the money quickly.

I replied that Mrs. Dunbar and I had recently purchased a Copley and were not interested but that the Museum was in the process of a campaign for acquisitions funds and might be. I explained to Straw that I would discuss his painting with the director. Bullard was de-

lighted, and he agreed that I should go to Boston to see the portrait with Straw and then present my recommendation on it to the accessions committee at its next meeting, in June.

When Mrs. Dunbar and I met Straw in Boston, he introduced us to Henderson Inches, the painting's owner, who took us to view it. It was breathtaking, and we knew that the trustees would want it for the Museum. As we took photographs for presentation to the board, I asked Straw how he had come to find the picture. He admitted that it had been pure luck. Reviewing the catalog of a Copley show held in the 1920s at the Boston Museum of Fine Arts, he had noticed that several of the paintings were owned by one person, Henderson Inches. An unusual name like that, he reasoned, should not be hard to trace in Boston. Indeed, the city telephone directory listed a Henderson Inches, who turned out to be the son of the owner recorded in the catalog. The younger Inches was amenable to discussing the sale of the portrait.

The members of the accessions committee, upon seeing the color photograph, agreed that the painting was magnificent. It represented just the kind of quality they wished to buy, and they recommended its purchase to the board. The board was a little hesitant, for the painting was the most expensive one the Museum had ever considered. Moreover, the owner wanted full payment of $285,000 by October. Bullard told the board that there were cash pledges of $608,000 that could be used to secure it. Mrs. Stern remarked that she did not believe that an American colonial painting could be so expensive. Finally, the trustees approved purchasing the painting if the funds could be obtained.[27]

We left the meeting with a feeling of exhilaration. That night Bullard, Mrs. Stern, Mrs. Maurice Stern, and I dined together at Marti's Restaurant, in the French Quarter. Bullard hoped that Mrs. Edgar Stern might be one of the persons who fulfilled their pledges quickly so that funds would be available. We spoke of the beauty of the Copley, and of how wonderful it was to obtain it at such a reasonable price. Mrs. Stern would have none of it. She just could not believe that a single American colonial painting could cost so much.

I was certain that Bullard would find the money to buy the painting. The board was so excited by the prospect of its acquisition that it seemed impossible to fail. But failure did indeed await us. In August,

27. Minutes of the Board of Trustees, NOMA, June 16, 1975.

Bullard called to say that Mrs. Stern had informed Moise Steeg, the board president, that she expected to be paid for the Stern-Davis Collection before she remitted her pledge. Consequently, there were not the resources to purchase the Copley. With great disappointment, Bullard notified Straw, who sold the painting to a group of dentists seeking an investment. He told Bullard that if they ever decided to sell, he would offer the painting to the Museum for first refusal. It was small consolation.

On April 8, 1977, I received a long-distance phone call from Peter Findlay, a New York City art dealer, who offered me Copley's *Portrait of Colonel George Watson*. I was dumb struck. I asked him to send me a photo of it and a cover letter. Then I called Bullard and told him that the painting was available from another gallery. We recalled Straw's verbal commitment to offer the Museum first refusal, and I suggested Bullard get in touch with him. Straw told the director that he did not know the investors had offered it for sale but that he would investigate.

In the meantime, the letter arrived from Findlay, explaining, "The painting belongs to a friend of mine who purchased it from the Inches family to whom it descended from the Watsons. He is asking $350,000 for the painting, less a commission for me, but as I said, I am sure I can get him down to $325,000, which seems to me to be about the right price in today's market." Bullard learned that Straw had talked to the painting's owners and that, indeed, they would let Straw handle the sale to the Museum for $325,000, a $40,000 increase over the price we had considered eleven months earlier.[28]

Bullard thought the Museum could deaccession some small paintings in storage to make up the difference. Straw agreed to that proposal and offered to come to New Orleans for the board meeting on May 18 to make the selections. He was to bring the Copley with him. Would the board again agree to buy the Copley? By this time the Stern-Davis Collection had been paid for, but now Steeg seemed opposed. But when Bullard presented the plan to the trustees in April, they approved further negotiations. The accessions committee was to vote on the acquisition in May.

Before the May meeting, Steeg sent a memo to the members of the committee saying, "The possibility of buying the Copley has raised a

28. Peter Findlay to Prescott N. Dunbar, April 8, 1977, in present author's possession.

question that has been in my mind since I read the [acquisitions] policy [for the fund drive]." The Steeg memo continued,

First, to you on the Accessions Committee who were not on it previously, or who may not have been at the Board meeting when the Copley was first discussed, it was decided at that time that this would be a very fine acquisition for the purpose, hopefully, of stimulating interest in the Drive as well as having a fine painting. It was also decided at that time as matter of policy, that the Museum should select quality paintings rather than go out and buy a quantity of items.

All of this appears to me to be good policy, except that the need of the Copley as a stimulation of interest in the Museum is now gone. The Drive is over for all intents and purposes, and there may be at the most two or three items remaining to close it out. On the other hand, I think we have to look to what this Museum wants to accomplish by its acquisitions.

Succinctly and possibly stated in such a way to create a controversy, the issue is fairly simple:

Are we buying paintings to enhance the reputation of the New Orleans Museum of Art among other Museums, or

Are we buying paintings that will assist the New Orleans Museum of Art in attracting more interest and more people to the Museum as members as well as in its attendance?

As I can see it, the Copley will do much to enhance our reputation among Museums; however in my opinion, and I can be perfectly wrong on this but it is still my opinion, the Copley will not do much to enhance our position in the Community and bring people to the Museum.

The next question is going to be, then if a great Copley won't do it, what will, and my answer is that we should try to find this out before we start spending the money that we have. . . .

I think as members of the Accessions Committee this is an issue which you must determine before approval of the purchase of the Copley is given. . . .

I submit this to you before it gets to be an issue before the Board because I think it is something that should be seriously considered before the expenditure of $325,000 for this one painting is made.[29]

Despite the memo, the accessions committee decided to recommend to the board the purchase of Copley's *Portrait of Colonel George Watson,* for $325,000. Straw agreed to accept $283,500 and five paintings valued at $41,500. If the board approved the transaction, the paintings that would be deaccessioned were *Harbor Scene,* by Frank M. Boggs; *Morning California,* by William Keith; *Port Donnant,* by

29. Moise S. Steeg, Jr., "Memo: All Members of the Accessions Committee" (May 9, 1977; archives, NOMA), 1.

Henri Moret; *Autumn in the Garden*, by Robert Reid; and *Still Life*, by Maurice de Vlaminck.

During the board's discussion of the Copley purchase, Steeg questioned whether "such a large sum of money should be committed when we are incurring major expenses in connection with the King Tut exhibition." Bullard replied to the president that he felt there was no problem, for group tours and special evening events would generate enough income to meet the show's expenses. Steeg persisted, reiterating the line of opposition he had expressed in his memo to the accessions committee. Eventually the question was called, and the vote was unanimous in favor of purchasing the Copley. Mr. Steeg, who as president did not vote except in the instance of a tie, "asked to be recorded as opposed to the board's action." [30]

The Museum was lucky, in more ways than one, to get this Copley from Steven Straw and Company. On July 29, 1980, before Judge Andrew Linscott, of the Massachusetts Superior Court, Straw pleaded guilty to each of ten allegations of securities fraud, larceny, embezzlement, obtaining signatures by false pretenses, and credit fraud. According to *Art News*, "Straw's guilty plea was the latest chapter in the tangled story that has shaken art circles since Straw filed a massive bankruptcy petition on July 18, 1979. At that time, Straw claimed unaudited assets of $1.7 million with liabilities of $16.2 million and listed more than 90 creditors."

It seems incredible that such a pleasant, quiet fellow could pull off a multimillion-dollar art fraud. But he did, and this is his story:

> Steven Straw was on a very fast track, amassing millions of dollars from the sale of art. According to Straw's professional colleagues, he had a remarkable eye despite his lack of formal education beyond high school and his smiling references to being color blind. Fond of the grand gesture, he was as persuasive as he was personable. He could propel a modest investment made on behalf of his fellow dealers and investors from the various professions—doctors, lawyers, business executives—into impressive profits. But because his whole strategy depended on a pyramid of ever greater investments to pay off investors—it all amounted, in the end, to little more than investments in investments—the empire Steven Straw built came tumbling down.
>
> He would sell paintings he didn't even own, offer paintings that didn't exist or sell the same ownership of legitimate paintings to credulous buyer after buyer. Straw even got investors to put up funds to buy from a "private collector" a Gauguin that actually had been owned and dis-

30. Minutes of the Board of Trustees, NOMA, May 18, 1977.

played by the National Gallery of Art for two years. It was only a matter of time before the inevitable occurred. In the end, three of Straw's investors claimed staggering losses—$1.9 million, $3 million and $7 million each. Not only are they out their money, but the pride and the reputations of these men and women have been shattered by their pursuit of a quick, albeit honest, buck.

Straw was extremely clever:

It was always the same. Straw would hook his investors by delivering big profits; then he would swindle them. One of several well-to-do professionals who invested in art with Straw through dealer Douglas James of Signal Mountain, Tennessee, was textile manufacturer Lewis Card, Sr. Straw admitted taking $500,000 from him as a one-third investment in *The Invocation* by Gauguin, which Straw claimed to have already sold to multimillionaire collector Daniel Ludwig for $2 million—despite the fact that the painting was then hanging in the National Gallery in Washington and was most definitely not for sale.[31]

The purchase of the Copley portrait for the Museum set a "standard of the highest quality for future acquisitions."[32] Consistent with that standard, the trustees bought only the finest paintings available with the remaining money from the fund drive. Among the high-quality paintings purchased were Jean Baptiste Greuze's *Portrait of Madame Gougenot de Croissy*, Charles Willson Peale's *Portrait of Robert Morris*, John Singer Sargent's *Portrait of Mrs. Asher B. Wertheimer*, and a landscape, *Ideal View of Tivoli*, by Claude Lorrain, which was acquired for $385,000.

The gift that pushed the fund drive over its goal came from the Emile N. Kuntz family. Early in the drive, Mrs. Francis and I made a call on Kuntz at his antique-filled office. We asked him to consider giving his James Claypoole painting of the artist's wife, which we told him would be a fine addition to our growing American collection. James Claypoole, Jr., was born in Philadelphia in the mid-1740s and was trained by his father who was also a painter. The younger Claypoole moved to Kingston, Jamaica, and became a noted portraitist of the English gentry. Historically, Kuntz's painting was very important, for it "is possibly the earliest neoclassical painting done by an American."[33] We told Mr. Kuntz that we knew he could get an appraisal of

31. *Art News*, October, 1980, p. 101.
32. E. John Bullard, "Five Years of New Acquisitions: 1973–1977," *Arts Quarterly*, I (January–March, 1978), 3.
33. H. Parrott Bacot, "The Rosemonde E. and Emile Kuntz Rooms," *Arts Quarterly*, V (April–June, 1983), 17–18.

$250,000 for the painting, since Larry Fleischmann, of the Kennedy Galleries, in New York City, who was familiar with the painting, had told me that he would appraise it at that value. Kuntz seemed surprised at the figure, thinking it far too high. He told us he would consider our proposal, but it was clear he was not yet convinced.

In the follow-up call to Kuntz, Fleischmann confirmed the painting's value. Nonetheless, Kuntz did not make a commitment to the drive at that time. Several months later, however, he informed Bullard that it was his intention to give the furnishings for two rooms: one, a Louisiana bedchamber of the federal period, and the other, a federal-period salon of the New Orleans residence of an East Coast emigrant's family. At the time, Kuntz told Bullard that the things to be placed in the rooms would have to be worked out between them. Not until 1980 was it known that the fine Claypoole painting would come to the Museum as an addition to the furnishings of the federal-period salon.

The handsome collection of American paintings and furnishings that Kuntz donated was originally assembled by his older brother Felix. The story is aptly told by H. Parrott Bacot:

> In New Orleans, Felix Hurwig Kuntz (1890–1971) was the unquestioned dean of collectors of Americana. Like all great collectors, Kuntz was born with that "special eye" that leads a collector instinctively to recognize that a given object is either of the best quality or is merely good or is mediocre. . . . Kuntz was consumed with collecting the best of everything related to America. Where many collectors limit their interest to one phase of American decorative arts or paintings, Felix Kuntz went that step beyond and amassed significant holdings in prints, books and manuscripts. He gave the greatest part of these manuscripts and books to Tulane University's Special Collections as a memorial to his parents, Rosemonde E. and Emile Kuntz.
>
> Felix H. Kuntz's interest in American antique and period rooms was heightened by his association with Joseph Downs, an early curator of the Metropolitan's American wing. Mr. Downs later became Mr. du Pont's curator and mutual collecting interest of Felix Kuntz and H. F. du Pont brought them together. The Downs–du Pont relationship influenced Felix Kuntz to want to do something similar for New Orleans.
>
> In the meantime, Felix Kuntz was nurturing and encouraging an interest in the fine and decorative arts in his younger brother, Emile Nicholas Kuntz (1906–1980). Emile N. Kuntz became a knowledgeable collector in his own right. While the donation of an American decorative arts collection to the New Orleans Museum of Art as a memorial to his parents was Felix Kuntz's idea, failing health led him to charge his brother with the realization of the project. Emile Kuntz brought new enthusiasm

into the endeavor, and he expanded his brother's ideas to include more fine art in the room. Following Emile Kuntz's untimely death, his widow, Julia Hardin Kuntz, and his daughters, Karolyn Kuntz Westervelt and Rosemonde Kuntz Capomazza di Campolattaro, have honored her husband and their father in completing the rooms.[34]

One of Bullard's first priorities in 1973 after becoming director was strengthening and enlarging the Museum's professional staff. There were already a number of experienced and dedicated professionals at the Museum, headed by two Delgado veterans of many years experience. Barbara Neiswender joined the staff in 1958, serving as Sue Thurman's assistant and as secretary to the board. In 1973, she was NOMA's administrator, responsible for supervising security, maintenance, accounting, and the museum shop. William A. Fagaly was brought to the Museum in 1966 by Byrnes to serve as registrar. By 1973, he was chief curator of collections, responsible for all the permanent collections and special exhibitions. He served ably as acting director during the interim between Byrnes and Bullard.

The new director immediately hired several staff members to fill vacant or newly created positions. First to be hired was Jacqueline Sullivan to serve as the Museum's chief accountant and comptroller. A native New Orleanian, Sullivan had as a C.P.A. the ideal training for a demanding job, with the responsibility, among others, of preparing annual budgets and timely financial statements. Pamela P. Bardo, from the Frick Art Gallery, at the University of Pittsburgh, was hired as the new registrar and would later become curator of decorative arts. The city of New Orleans under Mayor Landrieu was extremely cooperative and increased the Museum's operating appropriation in 1974 to $311,000 to permit the filling of nine new security and maintenance positions. Through the city's federally funded CETA employment program, Bullard was able to add in the same year curators of photography, prints and drawings, and research, as well as an assistant registrar and a librarian.

In the late 1960s, the Museum's trustees and staff had perceived a need for an enlarged education program, particularly focused on children. In 1969, in conjunction with plans to expand the Museum, the Edward Wisner Land Trust pledged the funds for a new education wing. Mr. and Mrs. P. Roussel Norman immediately provided two years' funding for a curator of children's education to demonstrate to

34. *Ibid.*, 16.

the city the importance of such a position. Mrs. Ralph V. Platou, an artist active in many community activities, was hired in 1969 to fill the post. With the anticipation of three floors of space, Mrs. Platou engaged the confidence of influential community leaders and got them to work with her to develop the conceptual groundwork for a variety of children's interactive arts programs aimed at bringing art into their everyday lives. Programs were to include participatory exhibitions, art classes, teacher training, and school tours. The Wisner Education Wing opened in 1971 with an imaginative exhibition, The Wit of It, that demonstrated that serious art could be fun, imaginative, comprehensible, and enjoyable. To assist in developing programs and to train the volunteer docents, Platou hired as assistant curator of education a young woman, Bonnie Pitman, who would become an innovator in the field.

Pitman's docent program, combined with Platou's exhibitions, brought NOMA's education department national acclaim. Pitman used an experimental technique, based on the Socratic style of teaching, known in the museum-education field as the inquiry method. It embodied the philosophy of the museum as an alternative learning space which was then gaining popularity throughout the country in the late sixties. Based on the study of the Museum's permanent art collection, docents and students were encouraged to explore art works through movement, sound, and visual games, with a focus on the artist's vocabulary of line, color, texture, form, and shape, as well as to make cultural associations of what they saw with what they knew. In developing NOMA's program, Pitman produced three teacher workbooks: Watermelon, which applied improvisational teaching methods to a museum setting, and Africa and Ancient and Colonial Latin America, which integrated two of NOMA's strongest collections with the curricula of the New Orleans public schools. A permanent relationship was established with the local school systems through preparatory teacher training and classroom study materials.

When Bullard arrived in 1973, the program of the Wisner Education Wing was one of the most successful in the country. As often happens in art museums, however, the education department seemed isolated from the collections staff. In an attempt to integrate the education department with the rest of the Museum, Bullard reorganized it, elevating Platou and Pitman to higher positions that placed them on the level of senior art curators. He hired a new assistant curator of education, Chester Kasnowski, a computer artist, to arrange pro-

grams for the Stern Auditorium and to develop new audiovisual and video capabilities.

On January 16, 1974, Peyroux, newly elected as president, advised the trustees that he would charge each board committee with specific tasks that year. The legal committee was to revise the Museum's by-laws; the community-involvement committee was to seek out ways to increase public participation and attendance; the history committee was to review documents pertaining to the development and growth of the Museum and to consolidate them into a single format to be considered for publication; the budget-and-finance committee, in addition to overseeing the budget, was to investigate insuring the permanent collection; and the development committee was to formulate a plan of action to initiate a major fund drive for new acquisitions. This was the first time that a board president had set forth to the board members specific goals. In the past, trustees had dealt with problems more or less after the fact. A new era was at hand.

Indeed, 1974 was a period of intense and meaningful activity at the Museum. The director has said, "It was also a period of growth in which the Museum continued to fulfill its role as the major visual arts resource in Louisiana as well as the Gulf South." [35] A number of important programs in that year came out of the education department. For example, a ten-week course on the Museum's collection was given to gallery docents in training. For the first time, the course was opened to all interested Museum members. Another innovative program was Nancy Staub's Puppet Playhouse, which performed in the Stern Auditorium for 3,800 children, parents, and teachers. There was a special performance for adults of the play *The Love of Don Perlimplin and Belisa in the Garden*, by the Spanish dramatist Federico García Lorca. Also presented in the Stern Auditorium that year were two performances of Gertrude Stein's opera *Four Saints in Three Acts*, a New Orleans premiere produced and directed by Gay Sperling.

In connection with the Museum's acquisitions policy on photographic works, the education department mounted its exhibition The Camera. Organized by Mrs. Platou, this show was designed to portray visually the history and development of the camera and to demonstrate, through a multiscreen slide presentation, some of the basic technical aspects of the camera's use. Along with a selection of the

35. E. John Bullard, "Director's Report: Two Years in Review" (1975; typescript in archives, NOMA), 2.

Museum's recently acquired photographs, the exhibition included many old cameras, as well as a mock-up of a photographic darkroom that suggested the type of equipment and environment necessary to develop film and make prints.

In May, NOMA's education department played host to the national conference "Arts in the Schools." The New Orleans Parish School Board and the Council of Arts for Children sponsored the project. During the summer, the department presented Kenneth Clark's acclaimed thirteen-part series "Civilisation." The films for the series were the gift of Mr. and Mrs. Walter Davis, Jr., in honor of her parents, Mr. and Mrs. Louis Fry, of Natchez, Mississippi.

Much of the summer's activity at the Museum focused on programs for children. In June, 150 young people were guided by Museum staff in a program relating the youngsters' own visual creations to language, poetry, dance, and music. The Museum also offered a number of projects to more than 2,500 children from thirty special day camps in the city. That program was part of an effort called the Council for Arts for Children's Summer in the City. As an added attraction, special kabuki theater performances for children from four to eight years of age were presented on the second floor of the Wisner Education Wing. Serving both children and adults, the Museum also initiated the first in a series of visits by the handicapped.

Making use of the news media, the Museum reached out to the community as never before. In November, 1974, WYES-TV initiated two Museum-oriented programs. "This Week" focused on various art works, with the curatorial staff giving in-depth interviews about the objects. Later that month, the Museum presented a series of five programs for the Spanish-speaking community centering on the Pre-Columbian and Latin colonial collections; this series was produced by Jack Sawyer and hosted by Justine McCarthy, a NOMA docent. In fact Bullard from the beginning of his directorship realized the importance of the news media in raising public awareness of the Museum and its programs. He saw his job as extending beyond the Museum's walls into the community. As NOMA's principal spokesman, he became a well-known personality, attending gallery openings, symphony concerts, charitable benefits, and private parties all over the city, often escorting Mrs. Francis. His activities would in succeeding years prove successful in attracting new patrons and donors to NOMA.

XVI
Treasures of Tutankhamun
and After

The presentation of the international blockbuster exhibition Treasures of Tutankhamun, the single most momentous event to occur at the New Orleans Museum of Art, took place between September 15, 1977, and January 15, 1978. The exhibition made NOMA an everyday, household word familiar to tens of thousands of New Orleanians. It made taxi drivers aware for the first time of the Museum's location. Despite the debate in the museum world about the value of blockbuster exhibitions, there is no doubt that NOMA benefited tremendously from this, the biggest of all. The show became a watershed in the cultural history of New Orleans, with people speaking of "before Tut" and "after Tut."

How Tut came to New Orleans is a story familiar to most New Orleanians. In the wake of the 1973 Israeli-Egyptian conflict, New Orleanian urban planner Jake DiMaggio was asked by his influential Egyptian friend Dr. Hadi Salem to organize a group of architectural and construction firms that would participate in the rebuilding of Egypt. An article in the New Orleans newspaper *Figaro* recounts that

> the businessman piled up a lot of goodwill for New Orleans during his time in Egypt. He made friends with both the current Egyptian Ambassador and the Minister of the Organization of Egyptian Antiquities, the branch of Cairo's government that takes care of the country's pyramids, sphinxes, temples and museums.
>
> Jake DiMaggio was also instrumental in clearing the Suez Canal of the mines, bombs, rockets and hand grenades that had fallen into it during the war. The exact nature of DiMaggio's assistance is something of a State Department secret. Suffice it to say that the Egyptians were so pleased with his performance that they offered to send the *Treasures of Tutankhamun* exhibit to his hometown.
>
> At the time, a smaller Tut exhibit was finishing up an international

tour in London. Nixon, Kissinger and Thomas Hoving, the director of New York's Metropolitan Museum of Art, were all angling for a larger *Treasures of Tutankhamun* to tour the United States as part of the bicentennial celebration. The Egyptians were in agreement with the principle, but the details—including the places the exhibit would visit—were a long way from being ironed out.

DiMaggio didn't realize what a big deal the Tut exhibit was when the Egyptians first offered it to him. When he came back to New Orleans and told Mayor Moon Landrieu about it, people started jumping on the bandwagon.

DiMaggio's wife, Dolly, had previously been appointed to the Louisiana Bicentennial Commission by Governor Edwards. She got Verna Landrieu, the mayor's wife and the chairman of the New Orleans Bicentennial Commission, involved in the Tut project. When the bicentennial year ended, the two commissions were succeeded by the Tutankhamun Committee of New Orleans, which Mrs. DiMaggio co-chairs.

In the course of lobbying to get the Tut exhibit sent to New Orleans, Dolly DiMaggio started talking to State Department officials, beginning with Elliot Richardson, then Secretary of State.

Eventually, a state department official told Mrs. DiMaggio that the tour's itinerary would be chosen by the Egyptians. Since Mr. and Mrs. DiMaggio were friends with prestigious Egyptian citizens like Dr. Salem, the Egyptian Ambassador and the Minister of Antiquities, the official suggested that she direct her lobbying efforts toward them.

The Tutankhamun lobby in New Orleans continued to mushroom. Verna Landrieu made her own visits to the State Department. John Bullard, the director of the New Orleans Museum of Art, sent copies of the Museum's blueprints and budgets to the Egyptians. Congressman David Treen flew to Cairo. Congresswoman Lindy Boggs and Senator J. Bennett Johnston also got involved.

Then, almost a year ago, Dolly DiMaggio got the word from Dr. Salem.[1]

E. John Bullard informed the board of trustees of the New Orleans Museum of Art on October 15, 1975, that in the fall of 1977 the Museum would show the Treasures of Tutankhamun. Little more was said at the time about the exhibition, though many wondered about the cost of transportation, packaging and crating, insurance, cataloging, and installation, and of the curator who would accompany the exhibit. Indeed, there were a thousand unanswered questions, but the board ignored these at the time, in the sheer joy of being one of the host museums. It was assumed that if this American tour of Tutan-

1. New Orleans *Figaro*, June 29, 1977.

khamun's treasures drew the capacity crowds that it did in Europe, earnings from the tour would more than suffice to cover expenses. It never occurred to the NOMA board that the expenses of the four-month show would amount to twice the Museum's annual budget.

In the initial agreement between the Metropolitan Museum of Art and the Cairo Museum it was determined that Egypt would send on loan fifty-five artifacts from the tomb of Tutankhamun, twenty-two of which had never before left Egypt. The participating museums would be the National Gallery of Art, in Washington, D.C. (November 15, 1976–March 15, 1977); the Field Museum, in Chicago (April 15–August 15, 1977); the New Orleans Museum of Art (September 18, 1977–January 15, 1978); the Los Angeles County Museum of Art (February 15–June 15, 1978); the Seattle Art Museum (July 15–November 15, 1978); and the Metropolitan Museum, in New York (December 15, 1978–April 15, 1979). There would be no special fee for the exhibition, although each museum could continue to impose its regular general admission charge. The Metropolitan Museum of Art would serve as manager of the consortium of the six American museums, and it would be responsible for all financial and administrative aspects of the tour in the United States. Local installation costs would be the responsibility of each of the participating museums.

The expenses for the American tour were underwritten in part by the National Endowment for the Humanities, with a grant of $325,000. Exxon pledged $150,000, and the Robert Wood Johnson, Jr., Charitable Trust pledged $100,000. Each of the participating museums put up $20,000.

Meanwhile, in June, 1975, more than a year before King Tut was to come to New Orleans, it was reported to the trustees that the city's chief administrative office had requested that the Museum look into ways of generating new funds, and it suggested the Museum charge an admission fee. Several trustees were opposed to the idea, fearing that a fee would cut down on attendance. Nevertheless, the board recognized that in recent years museums all over the country had instituted admission charges. Since the city's chief administrative office had suggested it, the board felt that it had to give the matter serious consideration.

On September 24, 1975, Bullard presented a recommendation for a general admission charge: "Beginning on the first Tuesday in October, General Admission for adults over 18 years old, $1.00; students 12 to 18 years of age, $.50; children under 12 and adults over 65 years

of age, free; and all members free. Regularly scheduled school tours would also be free, and admission would also be free to all on Wednesdays."[2] Discussion revealed strong sentiment against initiating any admission fee. William E. Burkenroad thought it an inappropriate action when the Museum was in the middle of the acquisitions fund drive, and Mrs. Jesse W. Cook asserted that a fee would be particularly discouraging to the black community. It was agreed that Robert A. Peyroux, board president, would inform the city administration that the board was reluctant to impose an admission charge.

The admission fee was brought up before the board again the following month in a proposal that differed from the earlier one in that Saturdays were to be free days. Richard A. Peneguy convinced the board that the city fathers believed there was no choice. In light of the fact that the Tut exhibit was coming to NOMA, there was little that could be done. A general admission charge was passed.

In December, 1976, a little over a year later, Peneguy recommended a change in the admissions policy. He proposed eliminating the Saturday free admission and free admission for senior citizens as well. The motivation behind his suggestion clearly lay in the looming Tut exhibit—now a scant nine months away. With the expected expenses of the show, the Museum could not afford the loss of revenues on Saturdays, especially since weekends would likely be the time of greatest attendance.

The alteration of the admissions policy became a tempest in a teapot when an editor of the *Courier* pointed out, in opposition to the move, that NOMA attendance dropped in 1976, the first full year under the admission-fee policy, to 91,000 visitors from an estimated 140,000 to 150,000 the preceding year. Against the figures of other museums that had imposed fees, this statistic revealed that for NOMA the effect of charging for entry had been more severe than it was, on average, for other institutions. Using data prepared by Bullard, the editor revealed that 29,000 of the total 91,000 visitors the previous year had come to the Museum on the free Saturdays. But with only 3,000 members contributing dues amounting to seventy thousand dollars annually, NOMA could no longer afford, Bullard asserted, to allow free Saturday admissions. Citing the upcoming King Tut exhibition, the director spoke of the change in policy as vital, and the editor suggested alternatives:

2. Minutes of the Board of Trustees, NOMA, September 24, 1975.

"We expect $200,000 in increased in-house expenses" for the total show, he says, including 15 security guards and a seven-day operation including two hours per night. If Saturdays are free during King Tut, NOMA could lose $50,000 to $60,000. . . .

Well, then, why not charge a special admission fee for entrance to that part of the museum containing King Tut's 50-piece show?

The six-museum consortium buying the show has agreed to provide the Egyptian government with $3 million to renovate the Cairo museum, in exchange for the loan of Tut, and the contract specifies that all "special fees" go directly to the Egyptian government.

Well, then, what about temporary discontinuance of free admissions during that three-month show only? That would be rude, says Bullard, finally revealing a major apparent reason for stopping free Saturdays now, but would not necessarily violate the contract.

What about a "pay whatever you wish" policy for Saturdays now with "free" Saturdays restored after King Tut and paid for by a special endowment for that purpose generated from Tut show profits? Well, Bullard admits ruefully, the NOMA board's finance committee never considered that particular option.[3]

Others exercised by the board's decision wrote angry letters to the editor of the *Times-Picayune*. One commented,

It is citizens to whom admission at $1 is either not worth the price or beyond their means, that such an institution should aim to serve, as well as those financially or culturally more fortunate. Or is this a museum for the elite?

The attempt to laugh off the cancellation of free admission to senior citizens is in poor taste. It is, in addition, untrue that no visitors have admitted to being over 65, I know of many; yet if the proportion is so small that the guards cannot recall it, why not continue free admission to senior citizens?[4]

Bullard bore the brunt of the criticism from angry citizens. At no other time in his career had he been the object of so much criticism. One senior citizen wrote,

Unquestionably it is much too early in the year to nominate E. John Bullard, director of the New Orleans Museum of Art, for the Public Relations Lackwit Award of 1977. However, this wunderkind of museum management gets my vote. . . . [His reasoning is] as beautiful a display of non-thinking as I have read in the new year. Here it is: " . . . the removal of free admission for senior citizens should make no appreciable

3. New Orleans *Courier*, January 13–19, 1977.
4. Laura Bodenbender to the editor, New Orleans *Times-Picayune*, January 12, 1977.

difference, as guards say they have had no visitors admitting to being over 65."

On a public relations level, Master Bullard should not be allowed out without his Nanny. He cites the reason for suddenly charging senior citizens a dollar to enter the museum is because they haven't been coming for starters. If no senior citizens visit the museum, . . . I would say that he and the overall management of the museum haven't made any real effort to attract senior citizens. . . .

. . . maybe Childe Bullard should ask a few of us old folk how come we stay away. We might suggest a series of informal, informative and midweek, daylight look-listen sessions for senior citizens. Not geared to make us art experts but to give us a chance to catch up on a few things. . . . Many of us seek inexpensive means of not only entertainment but on-going education.[5]

Peneguy, the board secretary, was angry at Bill Rushton who, as managing editor of the *Vieux Carre Courier*, had contributed substantially to the public uproar. He wrote Rushton a curt letter, noting the embarrassing fact that Rushton was not among the dues-paying members of the museum. Peneguy enclosed a membership application for Rushton's use and suggested further that Rushton recruit an additional five thousand members, which would have yielded enough revenue to restore free admission on Saturdays.[6]

A number of concerned citizens attended the January board meeting to protest the change in admissions policy. Moise S. Steeg, Jr., the board's president, welcomed the visitors and asked for a suspension of the regular order of business in order to address the problem of an admission charge. He explained that $30,000 had been budgeted from admissions in 1976 for operating expenses, but that only $26,000 had been realized. After receiving from the city a general-fund allocation of $360,000, the Museum had prepared a revised estimate indicating the need for an additional $74,000. The projection was that Saturday admissions would bring in $10,000.

City councilman Joe DiRosa requested that the Museum maintain a weekly free day, and he promised to try to get an additional $10,000 from the city. Adele Borncastle, the director of VIGOR and formerly with the Council on Aging, spoke in favor of free admission for senior citizens. Rushton, whose opinions were, of course, well known, suggested that a citizens' committee be appointed to study the problem.

5. Clint Bolton to the editor, New Orleans *Times-Picayune*, January 12, 1977.
6. Richard A. Peneguy to Bill Rushton, January 20, 1977, in archives, NOMA.

In the end, Steeg appointed a special committee on free days at NOMA. Members of the committee were Turner Catledge, Mrs. J. Frederick Muller, Steeg himself, and I. It was this committee's recommendation that the free day be on Saturday, although the board might make exceptions for functions, such as Tut, that were of substantial cost to the Museum. The committee recommended a charge of fifty cents for persons over sixty-five. The board approved the committee's recommendations.

In January, 1977, the board appointed a Tutankhamun exhibition executive committee. It comprised Mrs. Moon Landrieu, honorary chairman; Mrs. Walter Davis, Jr., and Mrs. Jake DiMaggio, co-chairmen; Steeg, president of the board of trustees; Bullard, director of the Museum; Barbara Neiswender, administrator of the Museum; and Jay Handelman, assistant director of public relations for the city. The committee also included Betty McDermott, who had been hired by the Museum as exhibition coordinator for the Tutankhamun project.

On February 14, 1977, the executive committee met and selected committee heads for the exhibition: Mrs. Blake Arata, entertainment; Mrs. Thomas N. Bernard, publicity; Mrs. T. S. Buchanan, Jr., and Mrs. P. Roussel Norman, products and store promotion; Larry Case, exhibition construction; Mrs. David J. Conroy, general services; Mrs. T. Sterling Dunn, films; Mrs. Richard B. Kaufmann, food concessions; Richard McCarthy, Jr., logistics; Mrs. Richard McCarthy, Jr., lectures and universities, and speaker's bureau; Mrs. Robert P. Norman, facilitators; Mrs. Henry J. Read, volunteer processing; Mrs. Moise S. Steeg, Jr., hotels and tourism; William K. Turner, signs; Peneguy, parking; and Peyroux, security. I was in charge of special evening events. The length of the committee list is an indication of the complexity of the Tut exhibit. The Museum family pulled together as never before. They were aided in their efforts by more than 1,200 volunteers. All was done in a spirit buoyant with enthusiasm.

The biggest problem facing the Museum Trustees was raising the $800,000 the exhibit would cost NOMA. The trustees knew that hundreds of thousands had viewed the exhibit at the National Gallery and the Field Museum. They knew that many would want to see it in New Orleans, but the question was whether enough would come to meet the costs through entry fees. The board knew that the Museum would be out a great deal of money in the event of a shortfall. The state of Louisiana and the city of New Orleans had informed Museum

officials that they could not fund any aspect of the exhibit. Steeg formulated a plan whereby guarantors helped insure the Museum against any deficit. A number of persons agreed to act as guarantors, but the amount of such "insurance" was not large. The staff, however, developed a scheme to raise a portion of the $800,000 needed for the show. The National Endowment for the Humanities and the Metropolitan Museum permitted NOMA to arrange for a certain number of prescheduled group tours from 9 to 10 A.M. on Tuesdays through Sundays, before the Museum's regular morning hours, and from 3 to 9 P.M. on Mondays, when the Museum was normally closed. To participate, a group had to number at least 30 but not more than 150. Groups were scheduled at fifteen-minute intervals, so that six hundred persons could enter the Museum each hour. Each visitor on these tours paid a three-dollar admission-and-handling fee.

Earlene Guice, a staff member in charge of activities, and Ann Conroy, chairman of general services, made the arrangements for the tours. They began scheduling groups on March 15, 1977, and sold out by June 1, 1977. They booked 130,000 people for a total of $391,941. That sum, of course, went a long way in offsetting the massive expenses the exhibit incurred.

The other means of paying for the costs was through special evening events scheduled for nights when the Museum was not open. Each evening that the Museum was free, a private viewing party could be booked. Such nights sold for a minimum of ten thousand dollars. The New Orleans Museum of Art was the first museum of the consortium to come up with this fund-raising idea. I was the single-member committee in charge. The private events raised an astounding $499,000. That amount, combined with the revenues from the group tours, paid for the costs of the exhibition.

The *Times-Picayune* social columnist, Diane Sustendal, explained the special evening events in her column, "Vivant":

> If, when you're standing in line one evening waiting to see the "Treasures of Tutankhamun" exhibition, you spot elegantly-clad ladies and gents being taken 'round back of the museum, don't feel snubbed. Those people getting the VIP treatment have planned and paid for the privilege.
>
> The "Special Evening Events" project is one of the more imaginative ones undertaken by the New Orleans Museum of Art. The allowing of private individuals, corporations and organizations to book the museum for an entire evening is a first for any of the museums which the Tut

show visits. These private parties for groups of 250 to 800 were devised to provide a more relaxed viewing of the young king's treasures as well as to help, through the proceeds of such an evening, to offset NOMA's installation costs for this show (which are now about $800,000).

The affairs, according to the descriptions given by Prescott N. Dunbar, who serves as chairman of the committee as well as treasurer of the museum, run in an elegant vein. Whether a snappy black-tie dinner dance, a cocktail reception or just simply a wine and cheese party, all guests enter the pavilion which is being constructed adjacent to the building. It is, in fact, the same striped tent, flooring, tables and chairs used by President and Mrs. Ford when they entertained Queen Elizabeth II on the White House Lawn last year.

Once inside the yellow and white pavilion, guests may see flowers banked on every wall, or simply long bars set up for the soiree. They may sample hors d'oeuvres, Oysters Rockefeller and finger sandwiches or seven-course dinners all prepared by the Fairmont Hotel, which brought in the best bid for the events. The size, scope and elaborateness are up to the group booking the party.

"It's quite interesting to see not only the types of organizations booking these evenings, but also the types of parties they are giving," said Dunbar, who is justifiably proud of the fact that the committee has since March booked 44 of the 58 nights available for evening events. "For example, the Harvard Club of Louisiana is sponsoring an entire weekend around the showing. It is going to have two professors lecture, one in the morning and one in the afternoon, prior to the wine and cheese reception it will host in the evening.

"American Express is flying down a number of executives for the Super Bowl. As a change of pace from football, it is hosting a gourmet dinner, for 250 people. I understand that it has arranged to have a small ensemble play classical music throughout the evening; that should be a real change of pace from the usual razzmatazz which surrounds the game. Another of the terribly elegant evenings will be the black tie dinner-dance being hosted by the Associates of the Dallas Museum of Art. . . ."

. . . As one can imagine, art associations, historic groups and museum members make up the largest portion of those booking evenings. A listing from Dunbar's very fat "Special Evening Events" folder shows confirmation by such groups as the Pensacola Art Association, two evenings by art groups in Mobile, a party by the Historic Natchez Foundation, and any number of events which Dunbar coupled—an association from one city with an association from another, to provide enough people to offset costs. . . .

"What is truly appalling is the apathy from cities in Louisiana which have museums and art associations. We offered the evenings to groups in cities such as Baton Rouge, Lafayette and Shreveport first. To date,

there is not one museum group or art association from Louisiana that has even approached us for a special evening showing," said Dunbar.

If one expects museums' interest, one is surprised at the amount of interest shown by convention groups which will meet in New Orleans while the exhibition is on display. Such groups as The Associated Press Managing Editors, the American Society of Respiratory Therapy, American Association of Anesthesiologists, and the Louisiana Chapter of the American Society of Interior Designers have planned evenings around the show.[7]

As a result of revenues received from the special evening events and the group tours, the Museum's costs for the Tut show were earned before the exhibit ever opened. This meant that every paid admission, all profits from the Museum's shop, all fees paid for lectures from the speakers' bureau, and total earnings from tours of private homes arranged in conjunction with the exhibit would come to the Museum in the form of profits. The exhibition proved to be big business for NOMA and the city as well, as time would prove.

Because NOMA had no restaurant and the Casino in City Park was too small, another of the problems was how to feed so many visitors each day. The special evening events were often parties including elaborate food and drinks, and it was essential to provide some sort of large facility for the parties. Mrs. Kaufmann, chairman of the committee on food concessions, went to H.D.O. Productions, the nation's leading specialist in providing portable assembly pavilions. The Museum rented a 60- by 120-foot pavilion that could accommodate six hundred people seated and one thousand people standing. Three auxiliary tents were connected to the main tent, the largest one serving as a kitchen and the others as rest rooms.

The Fairmont Hotel won the bid for the exclusive right to food and beverage catering during the exhibit. It funded the cost of the restaurant and created a unique theme menu that reflected the "Tutomania" sweeping the country at the time. There were Sphinxburgers, Valley of the King hot dogs, Red Sea beans and rice, Egyptian dolmas, Ramses gumbo, and Lotus of the Nile salad. Under the direction of Jerry Ursin, the hotel handled all catering for the special evening events as well.

Assembling the pavilion was a major task. George Leake, cochairman of the Museum's committee for the purpose, and William

7. New Orleans *Times-Picayune*, June 14, 1977.

LeCorgne, representing the City Park Improvement Association, supervised the placement of the tent in the meadow in front of the Museum. The area was drained and filled with shells so that the tent could be firmly set in position without sinking. A delivery service area was built adjacent to the kitchen. Rear Admiral D. G. Iselin, of the United States Navy, lent 3,500 square feet of military matting at the request of Congresswoman Lindy Boggs, and with Mayor Moon Landrieu's guarantee of its being returned in good condition.

Leake and LeCorgne also oversaw the installation of a temporary transformer for electricity for the tents and for lighting in the bleachers that were built to seat the crowds awaiting entry to the Museum. The two men supervised the installation of sewage and water lines to the tents as well as the installation of air conditioning and heating for the tent. They also worked on arrangements for the trailer and refrigeration trucks needed for the food concession, and for obtaining twenty portable toilets, police barricades for crowd control, information and ticket kiosks, trash containers, bicycle racks, and temporary pay telephones. They assisted too in the work on external decorations for the Museum. A thirty-two-foot monumental obelisk, designed by Franklin Adams, was set up in the pond in front of the Museum. And in tribute to the Egyptian Nile, Emery Clark, a New Orleans artist, used Lelong Avenue as her canvas for a novel work, the *NOMA Nile*. The street was painted an ultramarine with center stripes of lapis, turquoise, emerald green, magenta, and gold. The Cook Paint and Varnish Company donated ten thousand dollars for paint, and the students of the New Orleans Center for Creative Art assisted Clark in the work's execution.

Because the New Orleans Museum of Art has no Egyptian collection, the staff of the education department sought to orient the public with a supplementary exhibition on the culture and civilization of ancient Egypt. The show was conceived by NOMA's new chief curator of education, Annabelle Hebert, who replaced Mrs. R. V. Platou in January, 1976, after Mrs. Platou had become chief curator at the Historic New Orleans Collection. Hebert headed an expanded education department staffed by Alice Yelen, in charge of docent and school programs with the departure of Bonnie Pitman in 1975, and David Swoyer, in charge of audiovisual programming and exhibit design. Hebert also hired Ann Henderson to assist with special Tut-related activities. Hebert and Henderson secured a $97,000 grant for its Egyptian exhibition from the National Endowment for the Humanities and

assembled eighty objects from the Boston Museum of Fine Arts and private collectors. They were aided in mounting the exhibition by Virginia Lee Davis, the guest curator of Egyptology.

This show, entitled Eye for Eye: Egyptian Images and Inscriptions, opened in the second-floor gallery of the Wisner Education Wing on April 2, 1977. It focused upon the influence of geography on ancient Egyptian religion, and upon the pyramidal structure of society in ancient Egypt. On opening night, 2,500 Museum members attended to view the show, eat Egyptian food, and dance to the New Leviathan Oriental Fox-Trot Orchestra, which featured Egyptian-inspired fox-trots from the 1920s, when Tut's tomb was opened. George Schmidt, a vocalist with the orchestra, did much of the research on the old songs and put together a record album of them entitled *Old King Tut*, which was sponsored by the Museum's education department. Diana Coleman, Mr. and Mrs. Richard W. Freeman, Jr., Mr. and Mrs. Richard S. Friedman, Mrs. P. Roussel Norman, Mr. and Mrs. David Oreck, Ann Strachan, and my wife and I underwrote the production costs, with profits from the sale going to the Museum's education department. The record sold well and got favorable reviews, with the performances and George Schmidt's vocals called impeccable by the New York *Times*.[8]

Coordinated by Betty McDermott, the Museum's staff, trustees, members, and volunteers for months worked unceasingly to prepare for the huge crowds that were expected to look at the boy king's treasures. There was no wish to relive the National Gallery's problems of crowd control or the Field Museum's improper choice of display cases, which the Egyptians required them to rebuild at vast expense. Every detail pertaining to the show was gone over and double-checked. The staff of the Museum, as well as of City Park, was proud of the way work was proceeding. But Jake DiMaggio was not. His feelings were summarized in an article in the *Courier*:

> Is the mummy's curse causing a rumble? If not a rumble, at least a mild quake or irritation from one Orleanian who's had more than just a passing connection with the exhibit.
>
> The Oct. 3 issue of *Time* Magazine quotes New Orleans contractor Jake DiMaggio as being displeased with the trappings of the exhibit at the New Orleans Museum of Art. "The civic and cultural leaders are ridiculing the Egyptian deity," DiMaggio is quoted by *Time* as saying, "Why can't we do something with a little class?"

8. New York *Times*, January 7, 1979.

DiMaggio, however, says he was not contacted by anyone from the *Time* staff, and he believes that they probably picked up his quote from the September issue of *New Orleans Magazine*. But, DiMaggio told *Courier* that although he is more than pleased that the people of New Orleans are getting to see the exhibit, he is more than miffed with the city's appreciation of his part in the exhibit. He has friends and associates in the Egyptian government who helped book Tut into New Orleans.

"I haven't gotten a letter of thanks from the Chamber of Commerce or anybody," he says, claiming that his due credit has been denied. "There are some people in this town who are upset that a Sicilian fruit peddler's son got this thing here. I bet you if I lived on the other side of Jackson Avenue between Prytania and St. Charles, I would have been treated to a testimonial dinner or two."

But DiMaggio insists he is glad that the exhibit is a rousing success. "But this is for the people of this city, not for the patrons of the arts. And it's not for the museum board. They are just a custodian."

The contractor is unhappy with certain aspects of the show outside of the museum, including the blue street. "The Nile doesn't look blue. It's got as much shit thrown in it as the Mississippi." He doesn't like the term "Tutlets," which the museum staff dubbed the outside toilets, and he says he is upset about the New Leviathan Oriental Fox Trot Orchestra's version of "Old King Tut."

At a time when everyone else is awestruck with positive response to the Boy King's goodies, DiMaggio's opinion is a diverging jolt. Is that reaction merely revenge for being left out of the glory? "Hell no. The only way to get anywhere in this world is to beat the shit out of any bastard who competes with you."

Next question?[9]

As early as August, 1977, DiMaggio had expressed displeasure with not being credited adequately for his role in bringing Tut to New Orleans. He felt that way despite several earlier newspaper articles recognizing both his and his wife's parts in the achievement. He told Steeg that he was tired of reading articles like Betty Guillaud's column on August 9, 1977, in the *States-Item*, crediting Muriel B. Francis with charming the Egyptian government into sending the King Tut exhibit to New Orleans.

In an effort to set things straight, Steeg dashed off a friendly letter to Guillaud correcting the error.[10] He sent a copy to Mrs. Francis, who, however, took serious offense. Mrs. Francis asserted that it was not she who was being erroneously credited with the Tut coup but

9. New Orleans *Courier*, October 6–12, 1977.
10. Moise S. Steeg, Jr., to Betty Guillaud, August 12, 1977, in archives, NOMA.

Bullard. But what was worse was that she interpreted Steeg's letter as implying that it was a disservice to the Museum that her name was associated, mistakenly or not, with NOMA and its projects.[11] Of course, Steeg's reference to the harm that Guillaud's error caused the Museum had been intended to refer only to the resultant alienation of Mr. and Mrs. DiMaggio, and the board president quickly wrote Mrs. Francis a letter of explanation and apology.[12]

But the DiMaggio flap was not over. Late in August, DiMaggio invited the NOMA board to join him in a lawsuit against *New Orleans* magazine for "defamatory remarks" in their forthcoming article on the exhibition, claiming that he was misquoted. The Museum declined, hoping that DiMaggio would become more conciliatory. Though Mrs. DiMaggio worked hard as cochairman of the executive committee for the exhibition, her husband continued to feel that his original efforts in securing Tut for New Orleans were being slighted. In the end, after publicly venting his anger at a luncheon for the Egyptian ambassador during the week of opening ceremonies, he boycotted the other official events inaugurating the exhibition.

At the time of the Tut exhibit, Franklin Adams, professor of art at Newcomb College, was hired by the Museum as exhibition designer. He traveled to Washington, D.C., twice in this connection to consult the National Gallery staff. All six museum designers had agreed that in their presentation of the show they would try to simulate five chambers of the original tomb. The Museum's registrar, Charles L. Mo, worked with Adams as Tutankhamun project supervisor. He was responsible for overseeing matters like construction, installation, packing, and climate control. Mo spent ten days in Chicago in April, 1977, observing the unpacking of the objects. After that trip, he wrote a report that became the manual not only for NOMA but for all the remaining museums on the tour.

The entire first floor of the Museum had to be transformed to accommodate the exhibition itself, the movements of the expected crowds, and the traveling museum shop as well as NOMA's own shop. The massive job of implementing the restructuring of the first floor was handled by Adams, Bullard, and Mo, along with William A. Fagaly, the chief curator of NOMA; Gillard Ravenel, the head of the exhibition design department at the National Gallery of Art; and

11. Muriel B. Francis to Moise S. Steeg, Jr., August 29, 1977, in archives, NOMA.
12. Moise S. Steeg, Jr., to Muriel B. Francis, August 30, 1977, in archives, NOMA.

Larry Case, chairman of the exhibition construction committee. This team managed to hold construction costs to a minimum. The key in the effort toward economy was Case's success in soliciting donations of over fifty thousand dollars' worth of construction materials.

The exhibit design, approved in advance by Dr. El-Sawi, of the Egyptian Museum, set aside the Great Hall as the crowd control area from which people were directed to the exhibit. Located there was an island for catalog sales and for the rental and return of portable tape-recorded guides. In the Downman Gallery was housed the Tutankhamun orientation room and the first section of the entrance passage. The adjacent elevator foyer contained the final passage of the entrance. The Ella West Freeman Gallery housed the antechamber, the burial chamber, the two treasury rooms, and the annex. The Kress Galleries were turned into a one-room rest area and a two-room gift shop operated by NOMA. The first-floor gallery of the Wisner Wing accommodated the traveling Metropolitan Museum Shop.

The complex planning paid off. The Tut objects arrived safely, soundly, and secretly in New Orleans, and under the direction of Mo they were carefully placed in their climate-controlled cases. To celebrate the arrival of the exhibit, the Women's Volunteer Committee organized a three-day celebration for Museum members, whose numbers had burgeoned from about three thousand in 1976 to more than twenty thousand in 1977. Tickets for the various events were highly prized.

Kicking off the three days of festivities was a formal dinner on Thursday, September 15, 1977. Arranged by the Museum board, the dinner honored the ambassador of Egypt, Ashraf A. Ghorbal, and Mrs. Ghorbal. After a sumptuous meal, the guests entered the Museum to see the exhibit. On the following night, the Museum's annual Odyssey Ball took place in the Great Hall. During the ball the exhibit remained opened. After dancing in the Museum to the music of the Jubilation, guests enjoyed breakfast in the tent. On Sunday of that memorable weekend, the partygoers gathered for a *thé dansant* aboard the newly built paddle-wheeler the *Mississippi Queen*. The weekend sponsored by the Women's Volunteer Committee brought the Museum a profit of $178,000 for the acquisitions fund. That was the largest amount yet raised by the ball.

In the final analysis the financial figures indicate that Treasures of Tutankhamun was a bonanza for the Museum and the economy of New Orleans alike. The 870,595 visitors to the city, which was 40,000

more than saw the show in Washington, D.C., generated an esti-
mated sixty to seventy million dollars in tourist revenues during the
four-month period. The gross revenue for the Fairmont Hotel Pavil-
ion Restaurant exceeded one million dollars; the Museum's share of
the gross, after initial expenses, was thirty thousand dollars. NOMA's
operation of the Tutankhamun Museum Shop and the Acoustiguide
Audio Tour on behalf of the Metropolitan Museum of Art and the
Egyptian government grossed over $2.7 million and under half a mil-
lion respectively.

Direct exhibition income to the Museum totaled just under
$1,382,000 from general admissions, special nights, group tours, and
the Fairmont's restaurant. Out of that total, the Museum retained
profits of $617,000. The profit from NOMA's own museum shop was
$180,000. The board added that amount, in addition to a miscellane-
ous $85,000, to the $617,000 to establish a reserve fund for the Mu-
seum of $882,000, which was dedicated to the Museum's education
programs—as was the rental fee paid to the Museum by the Seattle
Art Museum for the Eye for Eye exhibit. Museum membership of
19,433 at the time of Tut brought in $432,787 for the Museum's activi-
ties fund. And the Hotel and Motel Association presented the Mu-
seum with $50,000 for the acquisitions fund for the ten thousand tick-
ets they had sold for five nights at NOMA. The grand total of profits
garnered by the Museum during Tut was $1,485,787.

Once the Tut exhibition was over, the Museum board commis-
sioned a study on the economic impact of the event on the commu-
nity. The report, by E. C. Nebel II, director of the School of Hotel,
Restaurant, and Tourism Administration at the University of New Or-
leans, in collaboration with Bullard, was one of the first of its kind
nationally to assess the impact of a blockbuster exhibition on the
economy of a host city. Published in the *Louisiana Business Survey* (and
reproduced in full in Appendix 3), it revealed some remarkable statis-
tics that would strongly influence NOMA's board to support the pre-
sentation of international exhibitions later.

Of the total 870,595 visitors to the Tut exhibition in New Orleans,
Nebel's survey showed that 613,169 were from out of town: 540,445
coming as individuals and 72,724 as members of 1,149 group tours.
All together the out-of-towners spent $89,028,271 during their stays
in New Orleans, on lodging, food and beverage, retail merchandise,
entertainment, and ground transportation. The Nebel survey esti-
mated that 76.5 percent of all individual out-of-town visitors came

mainly to see Tut, as did the great majority of the group tours. Nebel concluded that $69,432,364 was the lowest possible estimate of specifically Tut-generated tourist revenues. The exhibition had been a boon to local hotels, restaurants, and stores that serviced the upscale visitors. By applying the appropriate tax rates to the various expenditure categories, Nebel determined that approximately $4,067,314 in local and state sales taxes came in because of the Tut-attracted spending. Nebel concluded his published report by writing,

> Culture in any community is necessary, in and of itself, for the benefit of the local citizens. This study reinforces, in a rather dramatic way, another simple truth—that people's travel motives are influenced by opportunities to learn, to be entertained, to explore new worlds, and to experience unique and different things. New Orleans has always had a rich and varied cultural heritage, which is one of the main reasons why it has prospered as a primary tourist destination. The King Tut phenomenon shows us another way to both culturally and economically enrich our community.[13]

The Museum experienced benefits beyond the monetary gains. Museum memberships remained at a high level, about three times what they had been previously. The prestige of NOMA was enhanced as never before locally and statewide, and throughout the country as well. Expertise in handling the crowds and providing them entertainment and other creature comforts favorably impressed the visitors who had had unfortunate experiences at other museums where the show had been. The experience gained from this exhibit was invaluable for the staff, trustees, and volunteers. In every way there were gains.

Not everyone involved with the Tut exhibit was satisfied, however. The City Park Improvement Association, which had received a state grant to redo the sidewalks and lighting on Roosevelt Mall and for conversion of a parking area on the Old Driving Range, claimed severe losses in revenues from their golf courses and tennis courts as a result of Tut. The City Park's liaison committee asked NOMA to consider reimbursing the association for the seventy thousand dollars it claimed to have lost during Tut and the next exhibit, Peru's Golden Treasures.[14] Its request was tabled indefinitely.

Treasures of Tutankhamun was the major blockbuster exhibition of

13. E. C. Nebell III and E. John Bullard, "The Economic Impact of King Tut," *Louisiana Business Survey*, IX (October, 1978), 2–3.
14. J. Garic Schoen to Donna Banting, October 11, 1978, in archives, NOMA.

the 1970s. Such shows have caused much controversy in the museum world because of the costs, profits, deficits, crowds, burdens, and commercialization that sometimes result. Museum directors and trustees are careful to assess their advantages and disadvantages. They are not necessarily money-makers, and their spectacular proportions can become "addictive" for the public. "You get hooked, to a certain extent," Bullard was quoted as remarking. "Your audience says, 'Well, when's the next one going to come along?' And they wait for it; why go out just for a small show?"[15] Indeed, in the wake of Tut, New Orleanians developed a classic case of blockbuster fever.

The first of the subsequent blockbuster exhibitions, Peru's Golden Treasures, was a show of a dazzling and priceless collection of 225 gold artifacts of the Pre-Columbian period. The exhibition ran from January 14 to April 15, 1979. Attendance at the show, which was sponsored by a $30,000 grant from J. Ray McDermott, Inc., reached 135,411. The Museum realized a profit of $83,000 from entrance fees and $52,000 from the museum shop. The Odyssey Ball, held in conjunction with the show, added $86,464 to the total gains.

The Museum's second blockbuster of the year was Africa in Antiquity: The Arts of Ancient Nubia and the Sudan. It was open from May 20 through August 12, 1979. The cost was $275,000, but only 39,900 persons attended it. There were shop profits of $62,000, but overall the show lost more than $150,000. The exhibit, though impressive for the new knowledge it diseminated about ancient and medieval Nubia and the Sudan, lacked the wide appeal of Tut. The artifacts were esoteric. They did not have the iconographical recognition of Tut's death mask, for example. There were few gold objects, mostly stone carvings and pottery vases, bowls, jars, and such.

From May 24 through July 20, 1980, Treasures from Chatsworth: The Devonshire Inheritance, was shown at the Museum. This magnificent collection, owned by the duke of Devonshire, was not as popular as the exhibit's organizers expected. Only 28,299 visitors attended. The income generated was $32,043; costs ran to $80,000. The Museum was fortunate that the show had been underwritten in the amount of $20,000 by Morton's Auction Exchange and that a grant of $10,000 from the National Endowment for the Arts covered the costs of transportation. The Women's Volunteer Committee sponsored a

15. "Blockbuster Exhibitions: Hype or Hope for Museums?" *Cultural Post*, September–October, 1979, p. 8.

champagne preview party, which raised an additional $12,000. But the exhibit ended with a deficit of $5,957. The exhibit's failure may well have been due to scheduling. Summer months are hot and rainy in Louisiana. Most people try to get away, and seldom are there large numbers of tourists in the city then. The show was breathtaking in the depth of artifacts exhibited. It included eighteenth-century English furniture, porcelain, silver, and gold objects of the ducal collection. There were paintings by Pompeo Batoni, Thomas Gainsborough, Edwin Landseer, Claude Lorrain, Bartolomé Murillo, Nicolas Poussin, Joshua Reynolds, Sebastiano Ricci, Anthony Van Dyke, Velázquez, and numerous drawings by Vittore Carpaccio, Ghirlandajo, Jan Gossaert, Leonardo daVinci, Andrea Mantegna, and Raphael, to name but a few.

The next major exhibit came on December 16, 1980, and stayed for about three months. The show, Gold of El Dorado: The Heritage of Columbia, was another outstanding exhibit of Pre-Columbian gold artifacts. This show cost only $18,000. The Odyssey Ball held in conjunction with the exhibit yielded a profit of $139,520, one of the largest ever made by that function. The exhibit still failed, however, to live up to projections. Only 50,605 people attended, for a revenue of $47,229. But at least the show ended in the black, with a gain of $29,229.

A popular exhibit was Art of the Muppets, which ran at NOMA from September 13 through October 25, 1981. The show cost $113,903 and was visited by 126,184 people. It brought in $227,305, for a profit of $134,402. The museum shop had a $21,000 profit as well. The exhibition presented the details of the making of those fantasy television and movie creatures, the Muppets. It was well attended by adults as well as children.

The Search for Alexander, from June 27 through September 19, 1982, was the next blockbuster that the Museum was host to. A major exhibition of Greek antiquities from the time of Alexander the Great, it was sponsored nationally by Time, Inc. The participation fee for the exhibit was $100,000; funding for participation was underwritten locally by a $100,000 gift to the Museum by J. Ray McDermott, Inc., of New Orleans, which also spent the same amount to advertise the show throughout the Gulf South. Ten thousand dollars was granted by the Louisiana State Arts Council for Transportation. The Museum's cost was $600,000, and the show turned a profit of $256,593. The gala opening state dinner honoring the Greek ambassador Nik-

daos Karandreas, Governor and Mrs. David C. Treen, Mayor and Mrs. Ernest C. Morial, and Donald Wilson and Zachary Morfogen, of Time, Inc., made a profit of $63,773. Acoustiguide sales netted a profit of $19,309 for the Museum, and shop sales grossed $357,274.

In the final analysis, blockbuster exhibitions, despite the loss on Africa in Antiquity, proved successful for the New Orleans Museum of Art. They helped keep membership at very high levels, and they helped stimulate community interest in areas totally untouched before. The exhibits brought new friends to the Museum family, and they increased the prestige of the Museum throughout the country. Not least, they were for the most part extremely profitable. The Precious Legacy: Judaic Treasures from the Czechoslovak State Collections, which closed on February 19, 1985, was no exception to the rule.

In the meantime, the NOMA staff itself organized a number of successful exhibitions other than the Japanese and photography shows: Richard Clague Retrospective, highlighting the work of one of Louisiana's major nineteenth-century landscape and portrait painters, with a catalog by Roulhac Toledano; German and Austrian Expressionism, introducing the field to the New Orleans audience, with a catalog by Sarah B. Dunbar; Designing A Nation's Capitol: The 1792 Competition, showing long-forgotten drawings of the architectural competition in 1792 for the Capitol building in Washington, D.C., from the Maryland Historical Society Archives; and Five from Louisiana, featuring works of the contemporary artists Lynda Benglis, Tina Girouard, Richard Landry, Robert Rauschenberg, and Keith Sonnier. Also of note were Five Years of New Acquisitions: 1973–1977, which exhibited the many masterpieces the Museum had acquired; Seventeenth-Century Dutch Painting from the Bert Piso Collection, which revealed the treasures the Museum received from Bert Piso; The Photographs of Mother St. Croix, which showed turn-of-the-century photographs of New Orleans by an Ursuline nun; and Art, Myth, and Culture: Greek Vases from Southern Collections, which brought together for the first time many very fine Greek vases from the Gulf South.

A number of significant innovations occurred at the Museum after the Tut exhibit. One of these was the formation of a statewide advisory council for the institution. A project initiated by Moise S. Steeg, Jr., the board president, the advisory council had the role of making recommendations and suggestions to aid in the development of the Museum's membership program and to broaden the base of

support throughout the state. Members of the council were appointed from the greater New Orleans Metropolitan area, Alexandria, Baton Rouge, Hammond, Lake Charles, Monroe, Shreveport, and other cities across the state.

The advisory council initiated the development of a statewide traveling exhibitions program in 1977, when it became apparent that such a program would be useful to position NOMA as the major visual-arts resource in Louisiana. A grant from the Louisiana State Arts Council helped defray the costs of preparing the works of art for travel, enabling the Museum to offer high-quality temporary exhibitions at minimal cost to exhibitors throughout the state. Another advisory council proposal was to establish a major NOMA periodical, as an aid in maintaining the interest of the thousands of new members who had joined the Museum during the Tut exhibit. The *Arts Quarterly* began publication in 1978 under the creative editorship of Dawn Dedeaux. Presented in a lively and crisply designed tabloid format, its articles focused on museum exhibitions, programs, and acquisitions, as well as on other cultural events in the city and around the state. Over the years the *Arts Quarterly* has proved its worth to the membership and has garnered many national design awards.

One April 18, 1979, Mrs. Muller presented a report from the special projects committee of the advisory council recommending that the trustees establish a new support group for NOMA to be known as the Fellows of NOMA. The group was to be similar to those sponsored by many museums around the country, with limited membership and dues of a thousand dollars a year. Fellows, in return for their gift to the Museum, would enjoy private planned art tours, an annual dinner with a special lecture from a luminary in the museum world, and lectures relating to the permanent collection. At the May meeting the board approved the concept of Fellows of NOMA. By November of 1981, 115 fellows had enrolled, adding ninety-eight thousand dollars to the NOMA treasury. The group has flourished and has been an invaluable means of support for various projects from catalogs to the funding of new curatorial positions.

In recent years, other groups have been established: Partners in Art (for those under forty-five), Advocates for the Arts (for those under thirty-five), and six Friends of the Collection groups (for prints and drawings, ethnographic art, contemporary art, oriental art, photography, and the decorative arts). Members of these groups pay smaller dues than the Fellows of NOMA; they have accordingly brought new

members to the Museum's growing family. The Friends of the Collection encourage private collecting and support the curators in building the Museum's holdings.

After a decade of rapid expansion in what the museum owned, it had become clear to the trustees and staff that it would be good collection management to prune works that were no longer relevant or that fell below existing standards of quality. NOMA's staff carefully selected 419 works for deaccession and sale at public auction. At the meeting of September, 1981, the board approved the accessions committee's recommendation. Morton's Auction Exchange, of New Orleans, produced an illustrated catalog, and the sale took place on December 12. The auction was a success, with all items sold and a realized profit of $172,000 to apply to purchases.

In 1972, the Museum had organized the exhibition Treasures by Peter Carl Fabergé and Other Master Jewelers: The Matilda Geddings Gray Foundation Collection. This was one of the most popular shows held at the Museum before King Tut, and it was the first public exhibit of an important Louisiana collection. The Gray Foundation Collection is one of the three most significant Fabergé holdings in the United States—the Forbes Magazine Collection, in New York City, and the Pratt Collection, at the Virginia Museum of Fine Arts, in Richmond, being the other two. After the New Orleans show, the foundation began a tour of the collection to museums throughout the country that lasted for many years, in keeping with the educational purposes that the organization pursued.

In October, 1980, three imperial Easter Eggs and six other objects from the Gray Foundation Collection were stolen while they were on exhibit at the Paine Art Center, in Oshkosh, Wisconsin. The theft included a gold-and-moonstone imperial cigarette case and matchbox, a gold-and-crystal perfume flacon, and a silver Russian cigarette case. The director of the Paine Art Center, Ralph Bufan, said, "The eggs have a total worth of more than $1 million." An article about the incident reported, "He refused to speculate on the value of the six other stolen pieces, saying, 'It's better that that not be known.'"[16] Eventually the FBI, working with the Minneapolis Police Department, tracked down the thieves. They were paid an insurance ransom, but a daylight car chase ensued before the culprits were caught with the objects in hand.

16. New Orleans *Times-Picayune*, December 1, 1980.

After the robbery and recovery, Bullard talked with Mr. and Mrs. Harold H. Stream, directors of the Matilda Geddings Gray Foundation, and longtime patrons and trustees of NOMA, suggesting that since the tax laws required the foundation to exhibit the objects publicly, a permanent installation in a gallery at NOMA might be appropriate. He explained that in that manner the foundation could meet its educational requirements and that the arrangement would cut down on the wear and tear that constant touring inflicted on delicate objects. In addition, Bullard observed, his plan would reduce paperwork and staff time. The Streams agreed, and a specially designed gallery, resembling the czar Nicholas II's study, was constructed at NOMA to exhibit the Gray Foundation Collection. It opened on May 15, 1981, and has become especially popular. The Fabergé collection seemed especially appropriate for the Crescent City, for New Orleans claims a deep affection and historical indebtedness to the imperial Russian court. The visit to the city of His Imperial Highness, the grand duke Alexis Alexandrovitch Romanoff, in 1870, prompted the organization of the now-traditional pageant of Rex, King of Carnival, in New Orleans' famed Mardi Gras celebration. Moreover, it was appropriate for the collection to reside at NOMA, since Matilda Geddings Gray had been a member of the Arts and Crafts Club, one of the first private art organizations in the city,. She also had taken an interest in the Delgado Museum in the 1950s.

Miss Gray was a talented artist in her own right, having worked with the Greek sculptor Apartis, a follower of Emile Bourdelle. She sculpted, in bronze and terra cotta, figures and portrait busts of her friends, family and devoted servants. She had studied in the School of Art at Newcomb College, where she decorated Newcomb pottery, ceramics in the famous arts-and-crafts style. Miss Gray also painted floral subjects in watercolors and did bookbinding.

In 1933, Miss Gray visited Chicago's Century of Progress Exposition and encountered some examples of Fabergé's works that Armand Hammer had just brought to America from Russia. Soon she began to acquire Fabergé items herself. Her collection was a very personal one, reflecting her own training as an artist. In addition to the three imperial eggs, she obtained a variety of functional objects such as cigarette cases, matchboxes, a pair of opera glasses, frames, clocks, perfume flacons, and desk equipment. Although there are only a few hardstone carvings of animals by Fabergé in the collection, there are eighteen exquisitely realistic floral creations. These held a special appeal

for Miss Gray because of her great interest in nature and gardening. Also included in the collection is Fabergé's masterpiece, the imperial basket of lilies of the valley created for the empress Alexandra. Altogether, the Gray Foundation collection of Fabergé's objects de lux gives the modern viewer a rare glimpse of the vanished life-style of the Russian imperial court.[17]

The 1980s began with an unusual addition to the Museum's art collection—the bequest of Bert Piso, a trustee and chairman of the accessions committee, of his collection of seventeenth-century Dutch little masters. The twenty paintings he left to NOMA went on view on November 22, 1981. They included marines, still lifes, landscapes, tavern interiors, and farm subjects by such artists as Cornelis Bega, Aelbert Cuyp, Anthonie Palamedesz, Hendrick Pot, Michiel Simons, and Jan van de Velde.

Piso was born of Dutch parents in 1915 on the island of Java, in the Dutch East Indies, now Indonesia. He showed an early interest in art, and he studied to be a painter. Prior to World War II, he was a teacher in Java. After service in the Dutch army and imprisonment during the war, he in 1949 emigrated to the United States. Having settled in New Orleans, he was for many years the regional salesman for Consolidated Trimming Company, for which he traveled throughout the South. He began collecting in the 1960s, searching out on his travels works by the Dutch little masters, so called because they formed the broad base of Dutch art in the seventeenth century from which emerged giants like Rembrandt and Vermeer. With limited funds but a keen eye and sound scholarship, Piso assembled a collection of quality that added depth to NOMA's small Dutch collection.

Before Piso's bequest, the Museum had only a few works by Dutch and Flemish artists. NOMA acquired one important Dutch painting in a highly unusual way. In June, 1979, Dr. Richard W. Levy, a Museum trustee, spotted in the Sunday *Times-Picayune* a classified advertisement headed "Hang a Dutch Master." On personal inspection, Dr. and Mrs. Levy and Bullard discovered the painting to be a large original work by the seventeenth-century artist Jan Mytens of a prosperous Dutch family in a landscape setting. Owned by a Dutch sea captain retired and living in Marrero, the Museum agreed to purchase the painting for the modest asking price, which turned out to be a fraction of the work's value. Research showed that the painting was

17. William A. Fagaly, *Treasures by Peter Carl Fabergé and Other Master Jewelers* (1972).

well documented, with a full history of the family it depicted, and that it had been exhibited at the Rijksmuseum, in Amsterdam, in the 1940s.[18] It is often the case that the acquisition of an art work in a particular area prompts donations in the same category. In 1979, Dr. and Mrs. Levy gave the Museum a large painting by the Dutch mannerist artist Abraham Bloemaert, *Landscape with Tobias and the Angel.* Two years later, Mr. and Mrs. Henry H. Weldon, of New York, donated three seventeenth-century Dutch works to NOMA, the most important being the Rembrandtesque *Portrait of an Old Man,* by Jan Lievens.

In 1980, the Museum accessioned over 570 works of art. Among the most important gifts was Auguste Renoir's late oil *Seamstress at the Window,* donated by Charles C. Henderson in memory of Margaret Stevenson Henderson. Another major acquisition was Jean Metzinger's cubist *Still Life with Box,* done in 1918, a gift of Richard M. Wise and Mrs. John N. Weinstock in memory of their aunt Madelyn Kreisler. Mrs. Kreisler, a New Orleanian who had lived in New York for many years, was at one time married to Victor K. Kiam. Upon Mrs. Kreisler's death in 1976, her nephew and niece placed her collection of sixteen impressionist and school of Paris paintings, sculptures, and drawings on long-term loan to NOMA.

During the early 1980s, the Museum made a concerted effort to expand its historical survey of eighteenth-century French painting by making several major purchases. This was an area of the art market that was undervalued, and works of high quality by both famous and lesser-known artists were available. In 1982, NOMA bought, with funds from the Women's Volunteer Committee, a self-portrait by Nicolas de Largillière. The purchase was in memory of Frederick M. Stafford. In 1983, it purchased a rare religious subject, *Noli Me Tangere,* by Carle Vanloo; the charming *Portrait of a Mother and Child,* by François André Vincent; and a portrait of a Napoleonic officer done in Rome in 1805 by J. B. J. Wicar, a student of Jacques Louis David. In the same year, two out of five old-master paintings donated by the Azby Art Fund in memory of Herbert J. Harvey, Jr., and Marion W. Harvey were by French artists: the small, late *Head of an Old Man,* by Jean Baptiste Greuze, which complements the Museum's earlier portrait by the artist; and the *Portrait of the Artist,* by the nineteenth-century academic master Thomas Couture. These new acquisitions by French artists allowed the Museum to present a historical survey of this impor-

18. Joan Caldwell, "New Acquisition: Portrait of the Martini Family by Jan Mytens," *Arts Quarterly,* II (October–December, 1979), 22.

tant national school. The quality of NOMA's holdings in this area was confirmed when the Museum was requested to lend forty-four French paintings from the seventeenth through twentieth centuries to inaugurate the new Musée des Beaux-Arts, in Orléans, France, in September, 1984. NOMA's then–curator of European painting, Edward P. Caraco, wrote a detailed catalog, published in Orléans in French and English.

The efforts to expand the French collection reached a high point in 1984 and 1985 with the purchase of paintings by two of the greatest artists of the eighteenth century: François Boucher and Elisabeth Vigée-Lebrun. The Boucher, acquired in France, is an early work by the artist, painted around 1730–1732. Titled *The Surprise*, it charmingly depicts a young woman in her boudoir, a cat in her lap, startled by a male intruder. The painting has all the verve and lightness associated with the rococo style. Immediately after purchasing the painting, NOMA agreed to lend it to a major Boucher exhibition that was to hang in Paris, New York, and Detroit.

In 1985, the director and trustees began searching for a major work to purchase to celebrate the Museum's seventy-fifth anniversary the following year. After considering a number of possibilities, Dr. Levy, president of the board, learned that a portrait by the great portraitist Vigée-Lebrun might be available from a private collector. The painting was the life-size *Portrait of Marie Antoinette, Queen of France*, measuring nearly twelve feet in height with its original, elaborately carved frame. Painted in 1788, just before the French Revolution, the portrait was commissioned by Louis XVI's youngest brother, the Comte d'Artois, who later reigned as Charles X, the last Bourbon king of France. The Trevor family, of New York, had owned the painting since 1951, and it had been included in the exhibition of the artist's work in 1982 at the Kimbell Art Museum, in Fort Worth.[19]

Under the auspices of the New York art dealer Richard L. Feigen, Bullard, together with a conservator from the Metropolitan Museum of Art, was able personally to inspect the painting at Bronson Trevor's Oyster Bay estate. After seeing it, Bullard was convinced that it was the ideal acquisition for commemorating the Museum's seventy-fifth birthday. Though the price of $500,000 was the highest NOMA had ever paid for a work of art, it was reasonable in view of the importance of the artist and the fame of the sitter. The size of the painting

19. Edward P. Caraco, "Seventy-Fifth Anniversary Purchase: Portrait of Marie Antoinette," *Arts Quarterly*, VIII (January–March, 1978), 3–6.

made it impractical for most private collectors, and works by Vigée-Lebrun had sold recently for considerably more. The board agreed with the director and voted at the meeting on June 26, 1985, to purchase the portrait.[20] The Women's Volunteer Committee enthusiastically agreed to raise the funds necessary, as their contribution to the anniversary. The painting, installed on the stair landing in the Delgado Great Hall, was unveiled at a gala party on December 9, 1985. The portrait of Marie Antoinette, an eminently appropriate acquisition for a museum in the American city with the strongest French heritage, dominates the Great Hall and regally greets all visitors to the Museum.

20. Minutes of the Board of Trustees, NOMA, June 26, 1985.

XVII

Expansion

Because of the accelerated pace of art accessions and the Museum's expanded exhibition programs, NOMA's staff and trustees realized in the late 1970s that there was a critical need to expand the institution's physical facility in City Park. In number of items, the collection had more than doubled since 1960 and was growing at an increasing rate. The *Arts Quarterly* reported the situation to the Museum's members and friends in 1979:

> The present Museum is now inadequate to house both its growing permanent collection, as well as an ever-increasing number of major, and at times disruptive, international exhibitions. To fulfill its cultural responsibility to the community and the region, the Museum must be expanded. With this end in mind, the President of the Board of Trustees, Mrs. Richard B. Kaufmann, appointed an Expansion Committee in January 1979. Since then, this committee, chaired by Prescott N. Dunbar, has worked diligently in formulating concepts and researching ways to make this expansion a reality.[1]

The expansion committee and the Museum staff went to work immediately to outline the needs of the Museum in an expansion. Their preliminary conclusions were given to James R. Lamantia, Jr., of the Tulane University School of Architecture, who assigned the Museum expansion as the project for his design platform class. The students reviewed programs of other museums that were planning expansion, arranged meetings with E. John Bullard, the Museum's director, and members of the expansion committee, and interviewed Museum staff, to learn more about the needs that a design had to meet. From brainstorming sessions the students moved on to make blueprint drawings and construct site models. Of these the director and the ex-

1. Betty McDermott, "NOMA 1985: Will Expansion Dreams Come True?" *Arts Quarterly*, II (October–December, 1979), 15.

323

pansion committee selected the most feasible, which were shown to the trustees and to members of the board of commissioners of City Park. The models went on exhibit at the Museum for several months for the edification of the public.

Many of them were excellent. In most cases the new additions completely enveloped the three wings added to the building in 1971. All of the models doubled the size of the Museum's exhibition area and expanded existing facilities, such as the education wing, the restaurant, and the museum shop. It had been hoped that the expansion could be completed by 1986, in time for the Museum's seventy-fifth anniversary. That goal proved unattainable, however, and plans for expansion proceeded at a slow but steady pace during the early 1980s, with several diversions into dead ends along the way.

After the exhibition of the Tulane models, the staff asked the National Endowment for the Arts to fund a feasibility study of the Museum's expansion. The idea was that a regional urban-design assistance team of five experts, including architects, urban planners, and environmentalists, would come to New Orleans and study the Museum's needs. The proposal, however, did not win funding.

As a consequence, Betty McDermott, hired by the Museum to serve as expansion project director, outlined a three-phase program at the board meeting in September, 1979: a management study, a feasibility study, and a design competition. The second and third of the phases were eventually funded by NEA grants and the first by the Museum. Three professionals from the Loyola University School of Business Administration—Claire Anderson, Robert McGillivray, and Ernest Nordtvedt—working closely with a trustee and staff committee chaired by Mrs. J. Frederick Muller, completed the management study between January and June, 1980. The frantic expansion of the Museum's staff and programs, particularly exhibition, during the previous eight years had occurred without advance planning. It was time for the Museum to examine seriously its organizational structure, both board and staff, as well as its total operations, to prepare for anticipated growth. The resulting in-depth management study, numbering fifty pages, set general policies, made specific recommendations, and proposed procedures of implementation. Besides setting up a new financial system for the Museum, the study led to the reorganization of the staff into three divisions—art, administration, and development—each headed by an assistant director reporting to the director. In the reorganization, three long-term staff members were

promoted to assistant director: William A. Fagaly, for art; Jacqueline Sullivan, for administration, and Barbara Neiswender, for development. For the first time NOMA had a professional development department charged with raising both operating and capital funds.

In a memorandum to the members of the policy and growth committee of the management study on April 15, 1980, Bullard succinctly described the priorities for Museum expansion:

> On Saturday, April 12, 1980, the Policy and Growth Committee met to discuss and define policy and priorities for the physical expansion of the New Orleans Museum of Art. The following policy was agreed to by the Committee for the use of the Architectural Feasibility Study.
>
> The *first priority* of Museum Expansion is the need for considerably more public exhibition space for the permanent art collection. During the past ten years NOMA has made great strides in expanding the quality and quantity of its collection, both in established areas and in new areas. Unfortunately, significant portions of the various areas of the collection are in storage for lack of gallery space. Also, additional gallery space must be found for future growth of the collection in the 1980's, by purchase, gift, and bequest.
>
> The areas of the permanent collection have been prioritized into three sections: (1) areas of the collection which are not exhibited at all; (2) areas of the collection which have a significant portion in storage; (3) areas of the collection in which future growth is anticipated.
>
> (1) Photography
> Prints and Drawings, Old Master & 20th Century
> Spanish Colonial Paintings, Sculpture, & Decorative Arts
> Louisiana Painting, 19th century and contemporary
> Decorative Arts (Newcomb pottery, silver)
> (2) Glass
> Japanese Painting
> African, Oceanic, North American Arts
> Pre-Columbian Arts
> (3) 17th Century Dutch Painting & other Old Masters
> 19th & 20th Century European and American Paintings & Drawings
> Oriental Ceramics
> Costumes and Textiles
>
> The *second priority* for Museum Expansion is increased non-public spaces. Such expansion is crucial for more efficient use of the Museum's human resources: staff, volunteers, trustees. The following list of areas for expansion is arranged in order of priority.
>
> (1) Staff offices, lounge area, and lunch room. At present staff offices are over-crowded, with two and three persons in rooms intended for

one. The location of the offices in the basement of the Stern Wing is not the essential problem, but sufficient space for each person, with departments grouped together, is essential for high productivity and morale.

(2) Meeting rooms. There are not meeting rooms available in the Museum. Space is found on a catch-as-catch-can basis—the gallery bay, the library, an office—disrupting activity normally occurring in that area. There need to be one to three meeting rooms of varying size for Board of Trustee meetings, staff meetings, volunteer meetings and docent training. These rooms should have built-in audio-visual capabilities.

(3) Unpacking-storage areas for special exhibitions. While gallery space for special exhibitions (first floor City Wing) is sufficient, the staff needs a secured area for the unpacking of special exhibitions, where objects can be examined for condition and prepared for mounting in the exhibition gallery. Packing crates for special exhibitions would be stored in this area.

(4) Security office. The security office, which houses the chief of security and all centralized security monitoring panels, needs to be enlarged. Office should be large enough for a number of attendants to be present at one time. Space should be anticipated for television monitors for future expansion of surveillance system.

(5) Mail room. Separate room to house all mail handling activity, as well as duplicating and copying machines.

(6) Photography studio. Separate, secured space for Museum's photographer to photograph works from the collection and on loan.

(7) Library. Additional space for library expansion in 1980's should provide for at least a doubling of the size of the collection.

(8) Art storage. Storage areas for the permanent collection should be expanded with special attention given to creating storage spaces tailored to the needs of the objects. For example, prints and drawings may be separated from the photography collection; costumes and textiles would require specialized storage; decorative arts storage needs more cubic feet than paintings.

(9) Basement work areas. Both preparators and engineers/maintenance need additional space for storage of supplies and materials and space to work.

The *third priority* for expansion comes in the non-art exhibition, public areas of the museum.

(1) Museum Shop. The Shop needs to at least double, if not triple, its present size if it is to generate the income needed by the Museum in the 1980's.

(2) Auditorium. The Stern Auditorium is the most underused space in the present building because of its physical inflexibility. The lack of stage space (both depth and wings) limits its use primarily to films and

lectures. More limiting is the fact that there is no separate entrance to the auditorium. Auditorium users must enter through the Museum's front entrance and have access to the restrooms in the first floor elevator lobby. This means that during non-public museum hours, security staff on overtime are required to open the auditorium. Ideally, the auditorium should have a separate entrance and lobby with restroom facilities attached, so that the auditorium can be completely closed off from the museum during non-public hours. In this way community groups could use the auditorium on a regular basis.

(3) Restaurant. Ideally the Museum should have a restaurant facility that services both museum visitors and the general public. Entrances both from the museum and directly from the outside would allow the restaurant to function during non-public museum hours. Such a restaurant could be run by a franchised operator, generating income for the museum. The present location of the restaurant, opening off an art gallery and with the kitchen located on a different floor, is unacceptable.

(4) Orientation Gallery. The Education Department needs a multipurpose gallery space, possibly one on each floor, to provide public orientation exhibitions and audio-visual presentations related to both the permanent collections and special exhibitions.

The Feasibility Study also must give careful consideration to the Museum's relationship to City Park, particularly the questions of parking and traffic circulation. All expansion must conform to Federal guidelines for the handicapped. In addition to recommendations for expansion, consideration must be given to the more efficient utilization of existing space within the Museum.[2]

In late 1979 the Museum received an NEA grant in the amount of ten thousand dollars for a "study for the expansion of the New Orleans Museum of Art." The New Orleans architect and artist Grover Mouton was the project counsel and the architect Jean Paul Carlhian, of the prestigious architectural firm of Shepley, Bulfinch, Richardson and Abbott, of Boston, wrote up the study. The conclusion was that the expansion could best be carried out in three steps. The first would involve the addition of a third floor above the rear wing. The second was the erection of a pair of four-story structures on either side of the existing building, along the north sides of the Wisner and Stern wings. The third was the construction of two three-story annexes at the rear of the building.

The Carlhian study provided the trustees and staff with a clear idea

2. E. John Bullard, Memorandum to Members of the Policy and Growth Committee and Expansion Committee, April 15, 1980 (Archives, NOMA).

of how to proceed with the expansion of the Museum in City Park, but two proposals for museum expansion that involved decentralizing the Museum's collections and operations to other sites were made at the same time. The first was to place some of the Museum's operations at Longue Vue, Mrs. Edgar B. Stern's house and gardens; the second was to use Gallier Hall, the former City Hall in the central business district. The board seriously considered both of these proposals. Thus progress on the expansion of the City Park facility suffered a delay.

As early as 1972, Mrs. Stern had proposed to Mrs. Muller, then the board president, that her home at the end of Garden Lane be given to the Museum as an adjunct facility if zoning restrictions could be resolved. At the time, Mrs. Stern did not know exactly how the Museum could use her home, but board members were interested in the proposal. Ernest A. Carrere, Jr. reported to the board on November 22, 1972, that the city council had at its most recent meeting expressed approval of the city Planning Commission's proposal for zoning changes at Mrs. Stern's house to permit additional parking for visitors to the gardens, which had been open to the public for several years. The board unanimously approved action to seek city approval for the other zoning changes that the Museum's use of the site would require, and from that point on the trustees were committed to some arrangement for the Stern house. But exactly what arrangement remained unclear.

The first of Mrs. Stern's many schemes for the use of her house by the Museum came shortly after Bullard's selection as director, when on May 14, 1973, she revealed her plan at an informal meeting at Longue Vue. Mrs. Stern envisioned a museum at Longue Vue that would put to advantage and augment NOMA's collections in various areas of the Latin American visual arts. Generally, she hoped that "collecting activity would first be directed toward graphic works of the past 200 years concerned with the rediscovery and exploration of the Middle and South American continents."[3] But she had in mind a facility that would collect and display works illustrative of Latin American flora and landscapes as well as of the human scene. She foresaw the development of such a museum to take place over three to five years, and her longer-term plan included the establishment of a foundation whose goal would be to maintain the museum while

3. Klein, *A Passion for Sharing*, 281–82.

expanding its activities outward, fostering study, publication, and exhibits.

Clearly, in this elaborate plan, Mrs. Stern was still trying to influence the direction of the Museum toward an emphasis on Latin American art. Bullard, the new director, had other plans for the house: he saw it as an ideal center for the decorative arts. For the most part, the trustees of NOMA considered the gift of the Stern home helpful; most envisioned it as a facility comparable to Bayou Bend, of the Houston Museum of Fine Arts. Because Mrs. Stern had no decorative-arts collection comparable to that of Ima Hogg, however, the trustees were aware that some of the Museum's holdings would have to be placed at Longue Vue. After the informal meeting at Mrs. Stern's, there was very little further mention of her proposal of a center for the Latin American arts. She herself eventually stopped pushing the idea as more of the board spoke out against the Museum's going in that direction.

Other problems concerning Longue Vue took precedence. The first was the matter of zoning. The *Vieux Carre Courier* explained the tangle in November, 1972, under the headline "The Battle of Garden Lane":

> Art and politics collided before a special meeting of the City Planning Commission recently, the minutes of which finally have been published. Mrs. Edith Stern, the city's wealthiest person, and its only philanthropist of national note, is attempting to give her estate, Longue Vue, as a branch of the New Orleans Museum of Art, specializing in the decorative arts. The city has devised a special addition to the zoning ordinance to accommodate her bequest. Mrs. Stern has previously given the city some of its most important paintings and sculpture, a recital/hall auditorium, during NOMA's recent expansion, and the gardens of the estate, Longue Vue Gardens, where ballet performances and public tours are conducted regularly. The crunch of all this comes from the neighbors' claims that Mrs. Stern's husband signed a restrictive covenant to keep the property residential.[4]

Mrs. Stern could not understand her neighbors' objections. She reasoned that since her gardens had been open to the public on a day-to-day basis for years and that since she had notified her neighbors of her intentions and at that time there had been no objections, there should not be any now. Stanley M. Diefenthal, Mrs. John P. Labouisse, Max Nathan, Shepard Latter, Paul J. Leaman, Jr., Mrs. Per-

4. Linda Bonner, "What's Happened to the Little Museum in the Park?" *New Orleans*, March, 1980, p. 57.

cival Reniers, and L. M. Williams, who brought suit to enjoin the use of Garden Lane as an access route to the proposed Museum branch, feared that their neighborhood would be overcrowded with museum goers in private cars and buses. They anticipated that the traffic would invade the quiet of their homes.

Of course, the neighbors' suit arrested progress toward the Museum's expansion into the Stern house, but the delay worked somewhat to the advantage of the parties involved. Despite the plan Mrs. Stern had announced, she herself was not sure how her home should be used. A number of trustees began to have serious doubts about accepting the house; Frederic Ingram in particular was concerned that the proposed $5-million endowment would not be sufficient to manage the property. Even Bullard vacillated about Longue Vue.

Many of the board members knew that much of what Mrs. Stern had in her house was not of museum quality. Mrs. Stern knew it too. She told Pamela P. Bardo, NOMA's curator of decorative arts, "You see, here, because almost everyone I find who left their homes to be a museum have had fabulous collections to start them off. We have not. And we haven't specialized in anything. We haven't . . . as I say, we have good, bad and indifferent." [5] Consequently, the trustees worried. Would one or two rooms be compiled from the best furnishings in the house? Would the remaining rooms then be turned into period rooms with the furnishings coming from other collectors? Could Mr. and Mrs. Frederick M. Stafford be asked to furnish two rooms of eighteenth-century French furniture from their magnificent collection? Would the Kuntz family be interested in establishing rooms from their extensive store of eighteenth-century American furniture and paintings? Would the Matilda Geddings Gray Foundation allow its Fabergé collection to be placed on permanent loan?

Mrs. Stern's idea on the use of Longue Vue were evolving. Two years after her proposal of a center for the Latin American arts, she set forth some of her thinking in a rough-draft memorandum to the Museum committee handling the matter. The Latin American theme behind her, she now ruminated, "That it should be a Museum of the decorative arts still seems to me to describe its destiny, but that phrase encompasses such unlimited possibilities." In a very personal way, she seemed particularly concerned with the effect that the facility, her former home, would have on the individual visitor: "It must

5. Mrs. Edgar B. Stern, interview with Pamela P. Bardo, July 3, 1977, p. 24.

not be formal and cold. It must not be forbidding. It must not be os-
tentatious, filled with treasures no longer obtainable. Hopefully, it
will give forth a message, 'I could do something like that.' Most of all,
I do want it to be original, vital and living." In keeping with her desire
that the museum preserve the warm qualities of a living home, she
proposed that the project be taken on by the Women's Volunteer
Committee. She hoped that a woman would serve as curator and
pointed out that although Longue Vue would remain under the gen-
eral supervision of the Museum director, its management by the
Women's Volunteer Committee rather than by the board would
lighten the load on that already burdened group.[6]

On September 22, 1976, the trustees of the Museum entered into a
very loosely drawn agreement with Mrs. Stern and the Longue Vue
Foundation:

(1) The parties hereby formalize their joint intent that the house at 11
Garden Lane and certain of its contents (except, of course, such items
selected by Mrs. Stern [for] her personal use, and as designated by her)
presently owned by Mrs. Stern, plus a minimum of surrounding
grounds but not to interfere with Longue Vue Gardens, will be operated
by Museum as a Museum of Decorative Arts.

(2) The property will be legally owned by Mrs. Stern or by Founda-
tion, though its operation will be under the control of the Museum.

(3) Mrs. Stern will furnish a total endowment of $5,000,000 for
Longue Vue Gardens and the Museum of Decorative Arts. From that
amount will be deducted the cost of converting the house into a Mu-
seum of Decorative Arts. Whatever is left from the $5,000,000 will be di-
vided into two equal parts, to be held and administered by Foundation,
one part for the benefit of Longue Vue Gardens and the other part for
the benefit of the Museum of Decorative Arts.

(4) Paid admissions to the house may be charged, and the upkeep
thereof, plus the operation of the Museum of Decorative Arts shall be
paid out of the admission charges (if any), endowment income, invasion
of the endowment funds if available, and such other funds as may from
time to time be provided for this purpose.

(5) Foundation will be responsible for financial management and divi-
sion of land between Longue Vue Gardens and the Museum of Deco-
rative Arts.

(6) This Agreement shall become effective not less than thirty (30) nor

6. Mrs. Edgar B. Stern, Rough Draft Memorandum on Longue Vue, (1975; archives,
NOMA), 1–2.

more than sixty (60) days after Mrs. Stern announces she has vacated the premises, and shall continue indefinitely. Provided, however if the Board of Trustees of the Museum determined by a vote of not less than two-thirds (2/3) of its members, that the income as defined in paragraph 4 above is not sufficient properly to operate the Museum of Decorative Arts, and that it is unable to obtain any additional funds for this purpose, it may then terminate this agreement and transfer all of its rights herein to Foundation.[7]

Because the legal battle over access on Garden Lane was still pending, however, the board made no public announcement about the tentative agreement at the time. There were still many details to be worked out between Mrs. Stern, the Longue Vue Foundation, and the museum committee. At a fall meeting at Mrs. Stern's house, members of the Longue Vue Foundation met with members of the Museum's Committee on Longue Vue. Mrs. Stern, Bullard, and Miss Bardo were also present. At that lengthy meeting, Mrs. Stern distributed copies of notes that she said reflected her thoughts about her home. She outlined her specific wishes on a number of matters, ranging from the use of various portions of the house to the hours the facility would be open, and she reiterated some of the questions that had plagued the project from the beginning, such as how much material at the Museum would be moved there and whether there would be "any costs such as those covered by [the] City as at NOMA: such as guards."[8]

Mrs. Stern's concerns and questions were extensive, and from this and other conversations it was becoming more and more apparent that she was ambivalent about the extent to which she wanted the Museum's participation in her home. Needing additional space badly, Bullard believed the board should convert many of the rooms into galleries for the exhibit of the Billups glass, the Howard Roman glass and Greek vases, the Harrod silver, and the Newcomb pottery, to name a few collections. If that was not possible, he believed the Museum should disengage from the agreement. A stalemate existed until Mrs. Stern determined her direction. Finally, in 1977, Bullard charged Miss Bardo with the task of working closely with Mrs. Stern in an effort to ease relations and move the project along. After all, in the rough-draft memorandum, Mrs. Stern had written that she wanted a woman cu-

7. Minutes of the Board of Trustees, NOMA, September 22, 1976.
8. Mrs. Edgar B. Stern, Memorandum on Foundation Meeting and LVF Meeting (1977; archives, NOMA).

rator for Longue Vue. Perhaps Miss Bardo's personality and winning ways would fit hand in glove with Mrs. Stern's and the disposition of Longue Vue could be resolved.

On April 19, 1977, the *States-Item* informed its readers that "an out-of-court settlement of a civil suit has cleared the way for Mrs. Edith R. Stern to donate her famed Longue Vue estate to the City of New Orleans."[9] The article reported that Garden Lane would remain private and that another road would be built within two years to provide access to parking when the house opened as a museum. The road would be constructed by Mrs. Stern or by the city of New Orleans or by the New Orleans Museum of Art. It now seemed that matters could go forward and, Moise S. Steeg, Jr., the board member and attorney representing the Museum in the negotiations, said at the time, "The new museum is expected to open in about two years."[10]

There followed another legal brouhaha when residents of Bamboo Road, which would now take the brunt of the bus traffic instead of Garden Lane, objected to the prospect of fumes, crowds, and congestion. They obtained a restraining order against the project from the civil district court.[11] But the delay they caused was not a long one. Unlike the residents of Garden Lane, they were not successful in their suit, and buses were permitted to approach the Stern home by way of Bamboo Road.

At the meeting of the board on February 22, 1978, the regular order of business was suspended to allow consideration of several important matters that Mrs. Richard B. Kaufmann, the board's president, presented. One was the final agreement between the Museum, Mrs. Stern, and Longue Vue Foundation concerning the administration of the Stern home as an adjunct wing to the Museum. As approved by the board, the agreement read;

THIS AGREEMENT, entered into by the New Orleans Museum of Art (Museum), Edith R. Stern (Mrs. Stern), and Longue Vue Foundation (Foundation), witnesseth that:

(1) All prior agreements and understandings between the parties concerning the use of the house at 11 Garden Lane are hereby cancelled and superseded.

(2) For a period of two years from the effective date of this agreement, the house at 11 Garden Lane and certain of its contents (except of course,

9. New Orleans *States-Item,* April 19, 1977.
10. *Ibid.*
11. New Orleans *Vieux Carre Courier,* August 18–24, 1977.

such items selected by Mrs. Stern for her personal use, and as designated by her) presently owned by Mrs. Stern, plus a minimum of surrounding grounds but not to interfere with Longue Vue Gardens, will be operated by Museum as a Center of Decorative Arts with space for the Museum's collection of glass, jade, and other decorative arts.

(3) The property will be legally owned by Mrs. Stern or by Foundation, though its operation will be under the control of the Museum.

(4) Mrs. Stern or Foundation will pay all necessary costs of converting the house into a Center for Decorative Arts. Mrs. Stern or Foundation will in addition underwrite the operations of the Center of Decorative Arts and Longue Vue Gardens, not to exceed $250,000 per annum, the allocation between the two operations being determined by Foundation. Neither the City of New Orleans nor the Museum will be obligated for any deficit that may result from operations.

(5) Foundation will be responsible for financial management and division of land between Longue Vue Gardens and the Center of Decorative Arts.

(6) The effective date of this agreement shall be the opening of the Center for Decorative Arts and its term shall be two years from such date. Provided, however, if the Board of Trustees of the Museum determines by a vote of not less than two-thirds (⅔) of its members that the income as provided for in Paragraph (4) above is not sufficient properly to operate the Center for Decorative Arts, it may then terminate this agreement and transfer all of its rights herein to Foundation.[12]

The *Times-Picayune* reported, "After several years of verbal volleys the New Orleans Museum of Art and art patron Mrs. Edith Stern have reached an agreement; and talks about a decorative arts center will become a reality in June." The article also mentioned that "NOMA director, John Bullard, said it is difficult to say whether the endowment will be adequate."[13] Bullard and the board hoped that during the two-year trial period stipulated in the agreement there would be time to iron out all difficulties. Mrs. Stern had come to realize that certain rooms in the house would have to be revamped to form galleries for exhibition of the Museum's collections and for loan exhibits. As to the idea of creating period rooms, such as an eighteenth-century French room, she told Miss Bardo, "No, I'd hate it for this house. I think it's been done. . . . My own feeling is that there are plenty of those to be seen. But if people could learn something, could adapt it to their living . . . We're in such an era of bad taste that I

12. Minutes of the Board of Trustees, NOMA, February 22, 1978.
13. New Orleans *Times-Picayune*, February 23, 1978.

would love to influence people."[14] Mrs. Stern's hope that her house would function in a didactic way for people decorating their own homes led one trustee, weary after years of negotiating, facetiously to suggest that she give the house to a local university for its home-economics department.

Mrs. Stern moved out of Longue Vue in May, 1978, and Miss Bardo moved her office in to oversee the creation of gallery spaces out of the kitchen and the servants' rooms. Miss Bardo also undertook a full-scale inventory of what remained in the house. Because the objects did not belong to the Museum, Bullard insisted that every object be recorded and that a number be assigned to it and a sticker affixed.

The inventory procedures were an irritation to Mrs. Stern from the first. She was to experience many annoyances, but the real problem was that the move from her home to the Pontchartrain Hotel was much more traumatic for her than she had ever realized it would be. Longue Vue was a symbol of everything she loved: her devoted husband, her adoring children and grandchildren, indeed, life itself. In the twilight years of her life, the move was heartrending. She frequently visited the house and seemed unable to let go. She still wanted things her way. If a ripped curtain in need of replacing was pointed out to her, she insisted that it just needed sewing up.

The trial period ended in mid-1979 without much fanfare. Betty Guillaud, the social columnist for the *Times-Picayune*, sensed the reality: "But the museum, which is now doing a feasibility study on turning the home into a decorative arts center, may tell long-time matriarch of the museum, Edith Stern, 'No, thank you,' after all."[15] It was true that the trustees felt that there simply was not enough of an endowment to run the house and gardens; moreover, they did not think it wise to have separate entities running the gardens and the house. But above all, they realized that they could not come to an agreement with Mrs. Stern concerning the function of the house. Bullard reported to the board of trustees on September 19, 1979, that "a meeting was held in July of the Executive Committee of the Longue Vue Foundation to try and develop a set of guidelines under which NOMA would operate. We agreed that the Billups Collection would not be installed at Longue Vue at present due to financial and aesthetic considerations."[16] Mrs. Stern had felt that the cost of con-

14. *Ibid.*
15. New Orleans *States-Item*, November 30, 1979.
16. Minutes of the Board of Trustees, NOMA, September 19, 1979.

structing security cases for the glass would be too great. Bullard in addition informed the trustees that he had met with Mrs. Stern's grandson Bill Hess, director of the Longue Vue Foundation, on the previous day. At that meeting Hess told Bullard that "Mrs. Stern cannot come to an agreement to give NOMA the necessary authority to run the house at this time." [17] There were no comments from the trustees with the exception of Mrs. P. Roussel Norman, who asked what the house would be called. Mr. Bullard replied that it would probably be known as Longue Vue House and Gardens. Thus ended seven years of negotiations.

Longue Vue opened to the public on January 15, 1980, as a house museum under the administration of the Longue Vue Foundation. The first exhibit was organized by Lamantia, the professor of architecture from Tulane University whose design class had worked up models for the Museum's expansion. The exhibit featured antique furnishings from Mrs. Stern's collection and examples of decorative arts from the Cooper-Hewitt Museum and the Metropolitan Museum of Art. "The borrowed objects are intended to complement Mrs. Stern's belongings and to illustrate the range of her eclectic taste," the art critic Roger Green reported.[18] He aptly described the Stern home as a "monument to the lifestyle of an affluent New Orleans family during the 1940's." [19]

A feature story that appeared in the travel section of the New York *Times* on Sunday, April 27, 1980, described the home in a way that must have pleased Mrs. Stern greatly:

> Tours of the house take place each hour. If the oyster-gray stucco facade is slightly forbidding, the interior conveys an impression of comfortable warmth and elegance not usually associated with a house-museum of such grandeur.
>
> The house has 45 rooms, and area of 21,646 square feet, and 80 tons of air-conditioning—statistics that boggle a contemporary energy-conscious mind. Yet the feeling of a family home pervades. Flower-print chintzes cover antique chairs and sofas; the walls are covered with tapestries and needlework, mirrors, verre eglomise, clocks, botanical prints and silhouettes; there are a few oil paintings. Personal touches abound—monogrammed towels in the Art Deco bathrooms, monogrammed linens on the banquet-size dining table, fresh flowers everywhere.

17. *Ibid.*
18. New Orleans *States-Item*, January 15, 1980.
19. *Ibid.*

Upstairs, the formal drawing room somehow retains a certain comfortable flavor despite its proportions; the room is 30 feet wide, 46 feet long and has 14½ foot ceilings. The bedrooms, baths—even a sleeping porch complete with Murphy beds—are included in the house tour, giving a thorough view of a home of a family of wealth and taste.

A two-story exhibition gallery has been created from the upstairs servants' quarters and the kitchen directly below. Changing exhibits—focusing on selected pieces from the Stern collection and augmented by loans relating to the house's philosophy of decorative arts—are displayed here.[20]

Mistakenly, the reporter informed the reader that Mrs. Stern "left the house to the New Orleans Museum of Art."[21] That error would be made again and again. Even Mrs. Stern's obituary on the front page of the *Times-Picayune* in September, 1980, recounted the gift of her home to the Museum among her many philanthropies. Eventually the paper corrected its account: "The money, house, and the property were given to Longue Vue Foundation, which manages the building and adjoining Longue Vue Gardens."[22]

In May, 1981, Mayor Dutch Morial proposed that, instead of enlarging the Museum facility at a cost of at least six million dollars, the board of trustees give consideration to taking over Gallier Hall. The mid-nineteenth-century former City Hall, a magnificent Greek-revival building designed by James Gallier, had been used for various purposes since the construction of the new City Hall in 1956. Mayor Morial had taken a special interest in the building, expending capital funds for repairs and beginning a total restoration, with the top two floors already carefully renovated. Carrere, then chairman of the expansion committee, after touring the building with Bullard and seeing the restored rooms, was enthusiastic about the possibilities for three reasons. First, as a national landmark, Gallier Hall might be eligible for federal funds for historic restoration. Second, the building's downtown location would be convenient to workers in the central business district and, especially, for tourists. Third, some of the restoration work had been finished and the mayor was willing to commit city funds toward its completion.[23]

Carrere secured the board's permission for the expansion committee to investigate further the possibility of adapting Gallier Hall to an

20. New York *Times*, April 27, 1980.
21. *Ibid.*
22. New Orleans *Times-Picayune*, December 11, 1980.
23. Minutes of the Board of Trustees, NOMA, May 21, 1981.

expansion of the Museum. At the September meeting, J. Thomas Lewis, the president of the board, stated that the use of Gallier Hall was still under review and that it looked feasible. The next month the board learned that the Museum had applied to the National Endowment for the Arts for two grants for Gallier Hall, totaling $150,000, and that it had prepared a capital request of two million dollars for the renovation of Gallier Hall for inclusion in the city's capital request to the state for 1982. Not one of NOMA's three requests was granted.

Meanwhile, the expansion committee had heard a detailed report on Gallier Hall. The report reiterated the advantages that had appealed to Carrere and added the considerations of a financial saving and of potential donor support to the arguments favoring the use of the building. Moreover, proximity to the site of the 1984 World Exposition and to public transportation made the proposal the more attractive. But the board had to reckon with serious disadvantages as well. Gallier Hall offered room for expansion that was less expensive than new construction, but the space was only half the desired amount. The square footage was cut up inconveniently, and that would impose inflexibilities upon the Museum; problems with lighting and decorative detail also threatened NOMA's use of Gallier. Other claimants to portions of the building—the Arts Council of New Orleans, the NORD Theater, and the mayor himself—seemed likely to complicate the situation for the Museum, and lack of parking space nearby was a real drawback. But the overwhelming argument against the use of Gallier Hall was financial: the full study showed that renovation and operating funds would be difficult to raise and that there were significant hidden costs in splitting the Museum operation between two locations.[24]

As a result, the expansion committee voted to recommend against the use of Gallier Hall, as not practicable. The trustees concurred, and the matter of Gallier Hall was dropped.

In October, 1982, with both Longue Vue and Gallier Hall eliminated as sites for museum expansion, Carrere, now the board president, appointed a new expansion committee, chaired by Arthur Q. Davis, a trustee and distinguished architect. The committee recommended to the board a design competition to select an architect for the new addi-

24. Special Report on Gallier Hall (September 29, 1982; archives, NOMA).

tions to the City Park building. The committee believed that a competition would generate the most creative approaches to an expansion on what was a limited and restricted site. It would generate good publicity about expansion, which would be useful in a future fund drive. And it would avoid the result that had impaired the expansion of 1971—a mediocre design by a politically selected architect. Too, a competition would memorialize the method by which an architect had been selected for the Delgado building in 1910.

The staff prepared and, in December, 1982, submitted a grant application to the National Endowment for the Arts' design program for funds to support the competition. The full amount they requested, thirty thousand dollars, was approved the following spring. Architectural competitions were popular in the early 1980s, encouraged in part by generous grants from the NEA. The NEA felt that NOMA's proposal was well prepared and decided to cosponsor the competition with the Museum.

Grover Mouton was project director for the competition, and Ronald C. Filson, dean of the School of Architecture at Tulane, was the professional adviser. The Tulane Architectural Coalition served as the support team. It worked out all the details of location and site for the expansion with City Park officials, and it developed the guidelines for the competition and prepared the information packets for the competitors. The Museum reviewed the architectural feasibility study prepared by Carlhian and the management study. It conducted extensive interviews with the staff of the Museum. In the end, it called for a 55,000-square-foot addition. Henry C. Cobb, the head of the Department of Architecture at the Harvard Graduate School of Design, was selected chairman of the jury. The other jurors were Bullard and Davis, and Lawrence Halprin, a landscape architect and author; William LeCorgne, a member of the board of commissioners of City Park; Harry Parker, the director of the Dallas Museum of Art; John Pecoul, a representative of the mayor; and Jacqueline T. Robertson, the dean of the School of Architecture at the University of Virginia.

The guidelines stipulated that architects interested in participating were to register before June 30, 1983, to be eligible for an entry deadline of August 31, 1983, for the first round of the competition. The jury was to meet in early September to select six finalists for the second round. Each finalist was to receive a stipend of two thousand dollars and expenses to attend a site-and-project research meeting in

New Orleans. Final designs were to be due December 5, 1983, and the jury's selection was to be announced on December 15, 1983, with the winner receiving thirty-five thousand dollars and a contract. Competition announcements were distributed at the annual meeting of the American Institute of Architects, which was held in New Orleans in May, 1983, and they were mailed all over the country. More than three hundred architects paid fifty dollars apiece to register for the first round, and nearly two hundred submitted proposals, including such prominent figures in the field as Charles Moore and Robert Venturi.

The six finalists were Emilio Ambasz, of Emilio Ambasz and Associates, in New York; W. G. Clark, in association with the Charleston Architectural Group, in South Carolina; Julio Grabiel, of Spillis Candela and Partners, in Coral Gables, Florida; Ralph Lerner and Richard Reid, of Lerner and Reid Architects, in Cambridge, Massachusetts; Barton Myers, of Urban Innovations Group, in Los Angeles; and Patrick L. Pinnell and Heather Willson Cass, of Cass and Pinnell Architects, in Washington, D.C.

After lengthy discussion and deliberation, the jury selected the design of Clark. Its decision, however, was not unanimous. LeCorgne, the City Park commissioner, voted against Clark's plan, objecting to the envisioned incursion into the lagoon. The dramatic winning design called for a separate, adjacent three-story, L-shaped structure connected to the existing building by an elevated public walkway at the second-story level and by an underground service tunnel. The building was to rise from a podium surrounded on all sides by water from the lagoon adjacent to the Museum. To the jury, one of the most attractive aspects of the plan was that it included features that created new outdoor spaces, enhancing rather than detracting from museum visitors' experience of the park. There was a terraced garden surrounded by an outdoor cafe, from whose tables visitors could enjoy a view, over the lagoon, of the park. There was also an outdoor amphitheater for concerts and other events. The design was to provide City Park with a new outdoor facility, bringing a closer union between the Museum and the park.

The newspaper reported, "Members of the jury praised Clark's design for responding 'brilliantly to both the Museum's institutional program and its extraordinary location in City Park.' The park location is the crucial consideration since the City Park Board is concerned about the addition's effect on the 1,500 acre oasis that contains the

present Museum."[25] The competition was deemed a great success by the jury and the National Endowment for the Arts. The Yale architectural journal, *Perspecta 21*, published the winning design in 1984; other finalists' proposals appeared in the *Architectural Record*, the *Princeton Journal*, and the Tulane School of Architecture's *Review.*

Still, the architectural competition possessed a fatal flaw that eventually doomed Clark's winning design. In the rush to prepare the guidelines for the competition, the Museum came to only a tentative agreement with the board of commissioners of City Park about the site of the expansion. For purposes of the competition only, the commissioners agreed that two theoretical locations could be mentioned in the information packets for the two rounds: one expanded the existing circular site, and the second was to the right of the Museum, between the street and the lagoon. Offering a choice of locations to the competitors meant that the jury ended comparing two totally different approaches to expansion—one of a structure that wrapped around and was fully attached to the present building, and another of a completely separate building connected by a bridge over the street.

Once the proposal for a building on the lagoon site was presented to the board of City Park, objections multiplied. Many felt that the proposed building was too large, overwhelming the adjacent structure. More important, Clark's building required the elimination of an existing street and bridge and an encroachment into the water of the lagoon, substantially altering the shoreline. The board of commissioners was quick to point out that the lagoons by the Museum were originally designed as scale models of Lake Pontchartrain and Lake Bourne and therefore their configurations could not be changed. In any case, the commissioners reminded the Museum that they had never given approval for an expansion site, which would require negotiation. They also reminded NOMA of its own stated intention: "Through this competition the Museum seeks to find the most appropriate and progressive approach and designer."[26] The Museum, in offering assurances to City Park before the competition, had repeatedly said that the competition was meant to select an architect, not a final design.

During 1984, Clark modified his lagoon design, slightly reducing the bulk of the building to fit more easily on the site, in the hope that

25. New Orleans *Times-Picayune*, April 7, 1984.
26. Phase One Information Packet, Design Competition for the Expansion of the New Orleans Museum of Art (June 30, 1983; archives, NOMA).

the board of City Park could be convinced of its merits. Meanwhile, the Museum was moving ahead on other fronts. In June, Davis, the new board president, along with the director, met with city officials to inform them of the selection of Clark and to show his winning design. To fund the expansion, the Museum requested and received a $100,000 grant from the Zemurray Foundation through the good auspices of Mrs. Roger T. Stone, a longtime NOMA supporter and an honorary trustee. A topographical survey of the existing Museum site and of possible areas of expansion was completed by Gondolfo Kuhn.

In February, 1984, Robert A. Peyroux, president of the board of City Park and a former president of the Museum's board, wrote to Davis;

> Several times over the past year the (then) President of City Park's Board of Commissioners, Mr. Frank J. Stich, Jr., pointed out in letters to the (then) President of NOMA, Mr. Ernest Carrere, the position of the City Park with regard to Museum expansion.
>
> Since the Boards of both City Park and NOMA have changed officers for 1984, I thought it would be advisable to reiterate City Park's position on this matter so that all parties are properly informed on such an important subject.
>
> City Park's Board of Commissioners has not approved any specific site or any design concept for possible expansion of NOMA within the park. It is our understanding that the alternative proposals and designs submitted to NOMA by various architects over the past year were for the purpose of selecting an architect and were not for the purpose of designating a site or producing any particular design.
>
> City Park wants to cooperate to the fullest in consideration of the possibility of NOMA expansion. It is crucially important that the NOMA Board and staff understand clearly that City Park has not approved as yet any site or design for such expansion.
>
> We recognize NOMA as a major asset to City Park and pledge our cooperation in efforts to improve the Museum within the park.[27]

The gentlemanly language did not veil the commissioners' unshakable position. A similar confrontation had arisen several years earlier in New York between Central Park and the Metropolitan Museum of Art over that museum's wish to build on park land. Obviously park boards have their own agendas and priorities, one of the prime ones being the preservation of green space. The New Orleans Museum of Art, needing to expand, found itself landlocked within a traffic circle, surrounded by park land it did not control. What is more, the financially strapped board of City Park, seeking new sources of income,

27. Robert A. Peyroux to Arthur Q. Davis, February 28, 1984, in archives, NOMA.

expressed its determination to require payment in some form for any land that it might make available to the Museum for expansion. Lease conditions advantageous to the park had been incorporated into a draft contract between City Park and the Louisiana Children's Museum, which was contemplating building a new facility in the park. NOMA trustees were appalled by the idea of any kind of payment.

After much dancing around during 1984, the board of City Park finally rejected the site Clark had counted on for the Museum's expansion. In a letter dated December 27, 1984, and read to the Museum board at their January meeting, Peyroux stated that the only location available for NOMA's expansion was the one that enlarged the Museum's existing circular site. The circle's inner edge could be pushed out to the present sidewalk across the road, with the understanding that all mature trees would be preserved and the Museum would bear all costs of relocating the road, which would have to conform to the same circular pattern.[28]

The park commissioners' decision meant that Clark had to scrap his plan and start anew. After considering the costs and problems of expanding the circle to provide additional land for the expansion, the Museum trustees decided that that was impractical. Rather, the expansion committee instructed Clark to develop a design that provided the desired square footage but that fitted within the existing traffic circle, on the land the Museum controlled. In that way, the Museum could avoid any more protracted negotiations with the commissioners of City Park over the questions of site boundaries and compensation for additional land.

During 1985, as a follow-up to the earlier management study, the Museum's trustees and staff worked together for eight months to compose a long-range plan projecting growth for the next five years. A long-range planning committee of ten board members and staff, chaired by Mrs. Muller, submitted a thirty-six-page report to the board, which adopted it at its meeting on November 20, 1985.

The report, after stating the Museum's mission and general goals, was divided into six sections—on governance, administration and personnel, art collections and programs, budget and finance, facility, and development. In each section it enumerated specific five-year goals it believed to be realistic and essential, and it recommended how each goal might be achieved. The most important objectives for the

28. Robert A. Peyroux to Arthur Q. Davis, December 27, 1984, in archives, NOMA.

five years were the expansion of the facility in City Park with an addition of at least forty thousand square feet and the increase in the program and art endowment funds to a total of five million dollars.[29]

Before 1984, the Museum's endowment for operations totaled little more than $100,000. Recognizing the great importance of increasing that substantially for the future financial stability of NOMA, the trustees in February, 1984, established the Seventy-Fifth Anniversary General Endowment Fund for program expenses, by permanently dedicating the proceeds from the Tutankhamun exhibition, which totaled over a million dollars. In establishing that fund, the board stipulated that the principal was never to be invaded and that only the interest was available for operations.[30] By the end of 1985, with the addition of the net income from the fellows, the General Endowment Fund totaled $1.55 million. The long-range plan set a goal of at least doubling the endowment to three million dollars by the end of 1990.

The size of NOMA's endowment for art purchases was also pitiful before 1984, only sixty thousand dollars. Since 1966, the Museum had depended on the Odyssey Balls as a continuing source of funds for art purchases. They yielded a not inconsiderable amount. In the first twenty years, the Women's Volunteer Committee had raised over $1.3 million from the balls. In addition, in the same period, the Museum had had two major fund drives for art acquisitions: in connection with the Ella West Freeman Matching Fund in 1966, netting $400,000; and for the Art Acquisitions Fund in 1975–1978, netting $1 million in cash and $1.5 million in art donations. The long-range plan, recognizing the great need for a permanent endowment for art purchases, set a five-year goal of two million dollars. The fund was initiated even before the completion of the long-range plan, with a surprise bequest of over $400,000 from Carrie B. Heiderich, a New Orleans woman without any previous connection with the Museum beyond an individual membership.

The completion of the long-range plan coincided with the resumption of work on expanding the Museum. After protracted negotiations, requiring Clark to associate with a New Orleans architect, the board in January, 1986, approved a contract with him for the first phase of the architectual program, to provide schematic drawings of an expanded building within the existing circular site. Clark selected

29. New Orleans Museum of Art Long-Range Plan, 1986–1990 (Archives, NOMA).
30. Minutes of the Board of Trustees, NOMA, February 22, 1984, p. 4.

as his associate Eskew, Vogt, Salvato, and Filson, a new architectual firm headed by Allen Eskew. At the same time, the Museum hired David Scott as a consultant for the expansion. Scott was an art historian with extensive museum experience who had overseen the construction of the new East Building of the National Gallery of Art.

Work began in earnest on the schematic design. During the spring of 1986, the architects drew upon the experiences of the staff to refine the space and program requirements for the new building. The first phase was completed in July when the board of trustees enthusiastically accepted Clark and Eskew's schematic designs for a 55,000-square-foot addition. The architects had come up with a brilliant solution to the problem of expanding the Museum within the constricted and confined site of the existing circle. Their plan kept the central focus on the original 1910 Delgado building by retaining the main entrance in the grand neoclassic facade. New space was added on the sides in two new wings curving with the circle, like arms embracing the three wings built in 1970. In addition a third floor was added to the City Wing at the rear. Nearly half of the new space was to be devoted to the display of NOMA's art collections, and there were to be public spaces of the sort that had long been needed, including a restaurant, meeting rooms, and an expanded shop. An outstanding feature of the design was the two entry courtyards, one on each side, that would provide separate entrances for the auditorium and the education wing so that either could be in service when the rest of the museum was closed.

With a five-year long-range plan and an approved architectual concept, the Museum, after eight years of false starts and delays, was ready to embark on an expansion program that would totally alter its future. The celebration of its Diamond Jubilee in 1986 would provide the Museum with an ideal opportunity to inform the citizens of New Orleans and Louisiana of its accomplishments, its great art collections, and its plans for expansion. Trustees, staff, volunteers, and patrons were united in their efforts to ensure that the New Orleans Museum of Art would remain what, on the day of its opening, the *Daily Picayune* had described it as being, the "City's splendid possession."

Afterword

The concern of this history has been the first seventy-five years of the New Orleans Museum of Art. Unlike mere mortals, museums, one can hope, do not cease to exist after a certain period of years, but move on into the future, continuing to grow and serve their constituencies. Since much has happened at NOMA during the past three years, it is appropriate to review here the most important events and developments.

The seventy-fifth anniversary of any organization or individual is a momentous event, worthy of celebration. In true New Orleans fashion, the Museum joyously celebrated its diamond jubilee with a year-long series of special events, exhibitions, and art acquisitions. It seemed especially appropriate that the diamond-jubilee year began and ended with public events that fulfilled Isaac Delgado's expressed wish that the Museum be a "temple of art for rich and poor alike." NOMA realized its hope that all the citizens of New Orleans should have a chance to visit the Museum during its seventy-fifth year, through a grant from Latter and Blum that funded free admission on Thursdays in 1986. The first jubilee celebration was a Door Jam on January 9 to inaugurate the new open-admission policy. As a result, the culmulative attendance on Thursdays increased nearly threefold in 1986, from twelve thousand visitors to over thirty-five thousand. The jubilee celebration ended in grand style with an all-day Birthday Bash on Sunday, December 14, that attracted over six thousand visitors, who feasted on seventy-five artistically decorated cakes inspired by works in the collection.

The Women's Volunteer Committee, working with the seventy-fifth anniversary committee, which I chaired, staged a glittering series of events to celebrate the jubilee and to raise funds. A Day at the Races attracted many Museum members to the fairgrounds on January 24.

A Thé Dansant on April 13 was inspired by Isaac Delgado's famous Pink Dinner in 1892. The Women's Volunteer Committee presented the twenty-first Odyssey Ball on November 15, with more people in attendance than ever before. A lasting memento of the anniversary celebration, and a continuing source of revenue, was the Museum's first cookbook, *The Artist's Palette Cookbook,* another example of the imaginative and unceasing work of the Women's Volunteer Committee in behalf of the Museum.

In addition to six major exhibitions, including the Thyssen-Bornemisza Collection of American Masters and a survey of neoimpressionism, the Museum organized two yearlong exhibits to celebrate its anniversary. The first, the Diamond Jubilee History Exhibition, presented in two parts, documented the persons and events crucial in the growth of the Museum. Relying on the research for this history, I was curator for the exhibition, with the help of E. John Bullard, the Museum's director. The exhibition was a resource for WWL-TV when it prepared a half-hour documentary on NOMA, "Our Living Legacy," which aired on stations throughout the state.

The second yearlong jubilee exhibition was held not in New Orleans but in six other Louisiana cities: Baton Rouge, Shreveport, Alexandria, Monroe, Lafayette, and Lake Charles. As a birthday present to the entire state, Freeport-McMoRan provided funds to organize a display of twenty-five of NOMA's finest paintings and to circulate it. The exhibition, Celebrating Seventy-Five Years of Excellence: European Paintings from the New Orleans Museum of Art, generated considerable enthusiasm in each of the six cities it visited and publicized NOMA's importance as a state cultural resource.

Through gifts of art works and purchases, the Museum made a number of important acquisitions to commemorate the seventy-fifth anniversary. Certainly the most spectacular was the life-size *Portrait of Marie Antoinette, Queen of France,* painted in 1788 by Elisabeth Vigée-Lebrun, purchased for the Museum with funds to be raised by the Women's Volunteer Committee. Among other major art purchases were a *table de milium,* made in France around 1690 and, appropriately, the *Portrait of Louis XVI,* by Antoine Callet. The great variety of gifts included a seven-foot-high twelfth-century Chinese *Bodhisattva,* from Jun Tsei Tai of New York; a painting, *Vase of Flowers,* done by Maurice de Vlaminck, in 1910–1912, from Dr. and Mrs. Max J. Miller; a bronze sculpture, *Neapolitan Fisherboy,* by J. B. Carpeaux, from Mrs. Seymour Weiss; and a Louis XVI–period mantel clock, from Dr. and

Mrs. Richard W. Levy. In addition to these works of earlier periods, a number of important contemporary pieces were donated, including an early welded steel sculpture by David Smith, from Mr. and Mrs. Walter Davis, Jr., and an oil painted by Lee Krasner in 1957, from Mrs. P. Roussel Norman. The enrichment of the Museum's art collection was a lasting legacy of the jubilee celebration.

The Museum lost one of its most loyal and generous benefactors during the seventy-fifth year, with the death of Muriel B. Francis on May 1. She had been an active member of NOMA's board since 1961, chairing many important committees and serving as president in 1968–1969. In recognition of her extraordinary services to the Museum, Mrs. Francis was elected an honorary life trustee in 1985.

During her years as a trustee, Mrs. Francis regularly donated art works to the Museum. In November, 1985, NOMA organized an exhibition of nearly one hundred works from her extensive collection and accompanied the exhibit with an illustrated catalog. In a final magnificent gesture of support, Mrs. Francis bequeathed nearly her entire collection to the Museum. Her bequest of 171 works, together with her previous gifts, constitutes one of the most important art donations in NOMA's history. Particularly rich in drawings, her collection included beautiful works by Joseph Cornell, Edgar Degas, Hans Hofmann, Henri Matisse, Pablo Picasso, Odilon Redon, Auguste Renoir, and David Smith.

Plans to expand the Museum have moved ahead rapidly and with great success since 1986. In December of that year, the board reversed the order of its architects, naming Allen Eskew as principal architect, with W. G. Clark as associate architect for design. Eskew and Clark proceeded with the commencement of design development in February, 1987. They completed the first half of design development in June and made an architectural model of the expanded building. The architects then stopped work while preliminary fund-raising efforts were begun.

In April, 1987, the Museum engaged an experienced fund-raising consultant, Irving Warner, of Los Angeles, to conduct a feasibility study to assess realistically NOMA's ability to raise fifteen million dollars to fund an expansion. The trustees felt that such a study was essential in view of the continuing depression of the Louisiana economy that resulted from the collapse of oil prices in the early 1980s. NOMA's development department was reorganized and expanded at the same time in anticipation of a major capital campaign. Barbara

Pate, assistant director for development and a longtime NOMA employee, retired in the spring of 1987. Bullard hired Sharon Litwin, a television producer, journalist, and community activist, to head the development department and direct the capital campaign.

The first step in the campaign to raise expansion funds was taken in August, 1987, when Bullard, along with Richard W. Levy, president of the Museum's board, and Kurt A. Gitter, chairman of the expansion committee, met with Mayor Sidney Barthelemy to ask for the help of the city of New Orleans. With the mayor's full support, the staff of the city Planning Commission recommended that five million dollars be included for Museum expansion in the city's next bond election. Miraculously that proposal moved smoothly through City Hall channels, easily gaining approval from the city Planning Commission and the city council. On November 1, 1987, the citizens of New Orleans overwhelmingly approved Purpose C of the city bond issue, which included, together with money for parks and police and fire stations, five million dollars for Museum expansion. The campaign had begun with a big bang, which was to reverberate in the succeeding months. In December, three New Orleans foundations, the Zemurray, Rosamary, and Ella West Freeman foundations, pledged a total of $2.75 million to the expansion program.

By February, 1988, when Warner submitted his completed feasibility study, which concluded that the Museum could successfully proceed with a $15-million capital drive, half that amount had already been raised. With Warner's advice, the development department began to structure the fund drive, officially named "Campaign 2000: The Face of the Future." Of crucial importance for its success was securing dynamic campaign leadership. Thomas C. Keller, the Museum board's president, was successful in recruiting two NOMA trustees to head the campaign: Louis M. Freeman as chairman, and Jack Aron as honorary national chairman. Freeman quickly formed a campaign cabinet and began soliciting leadership gifts in May, 1988.

By the summer of 1989, the Museum had received additional pledges from the private sector—foundations, corporations, and individuals—of $5.5 million. In addition, after a year and a half of active lobbying in Baton Rouge, NOMA received the commitment of a million dollars from the state of Louisiana in the capital outlay bill passed in July, 1989. With just over fifteen million dollars raised of an expanded campaign goal of eighteen million dollars, the Museum went public with its capital fund drive in the autumn of 1989. It was

planned that after completion of the architectual plans, the removal of asbestos from the 1970 wings, and the successful conclusion of the fund drive, ground breaking would take place at the end of 1990. Construction of the new wings and total renovation of the existing building was scheduled to take approximately two years. These will be exciting times for the New Orleans Museum of Art, and they hold great promise as NOMA looks forward to its centennial in 2010.

Appendix 1
A Chronology

1839

November 23 Isaac Delgado is born in Kingston, Jamaica.

1853

Isaac Delgado immigrates from Jamaica to New Orleans.

1910

February 26 Isaac Delgado gives $150,000 to the City Park Improvement Association for the erection of an art museum for the city of New Orleans to be located on land in City Park.

April 26 A board of administrators from the City Park Commission and the Art Association of New Orleans is formed by Isaac Delgado to implement the establishment of the Museum. Pierre Antoine Lelong is elected first president of the Museum board.

July 1 The prize for the architectural design of the Museum is awarded to Samuel A. Marx, of Chicago.

The construction contract is awarded to Julius Koch, of New Orleans.

1911

March 22 The cornerstone dedication ceremony takes place at the Museum.

December 6 The New Orleans City Council accepts, by ordinance, the gift of the Isaac Delgado Museum of Art to the city.

December 16 The Isaac Delgado Museum of Art opens to the public at 2 P.M., with the opening ceremony attended by Mayor Martin Behrman and three thousand others.

The inaugural exhibition organized by the Isaac Delgado Museum of Art comprises over four hundred paintings and plaster casts of antique sculptures lent by local collectors.

1912

January 4 Isaac Delgado dies, bequeathing to the Museum the collec-

tion of decorative arts assembled by his aunt Virginia McRae Delgado.

September Major Benjamin M. Harrod bequeaths twelve paintings.

1913

The Museum receives the Morgan Whitney bequest, the Whitney Jades, a collection of 145 pieces valued at fifty thousand dollars.

The Museum makes its first purchase from admissions monies: *Frozen River,* by Charles Rosen.

1914

The Museum receives a bequest from Eugenia Ulhorn Harrod, wife of Major Benjamin Harrod, consisting of fifty-six pieces of English and American silver.

1915

The Museum receives a bequest from Mrs. Chapman H. Hyams, a collection of thirty-six paintings by artists of the French salon, the Barbizon school, and the Munich group.

A collection of bronzes and porcelains, and five thousand dollars, come to the Museum as a gift from the estate of Eugene Lacosst.

The Museum receives a gift in the memory of William Agar from his son John G. Agar.

Charles Wellington Boyle becomes first curator of the Museum.

1916

The Museum receives a bequest from Eugenia Ulhorn Harrod: an art-purchase endowment in the amount of five thousand dollars and a collection of the decorative arts.

The Fine Arts Club of New Orleans makes a gift to the Museum: *Forenoon,* by Asher B. Durand.

The Museum receives Alvin P. Howard's gift of ninety-one ancient glass vessels and vases from Middle East excavations.

1923

Chapman H. Hyams gives an endowment of sixty thousand dollars, the income from which is to be used for upkeep and maintenance of the Museum building and of his wife's collection.

1925

An anonymous donation of ten thousand dollars for expansion comes to the Museum. Expansion does not occur for forty years.

Charles Wellington Boyle, first curator of the Museum, dies.

Ellsworth Woodward becomes unpaid acting director of the Museum, a capacity in which he serves until 1939.

1926

The Art Association of New Orleans organizes a memorial exhibition: Paintings by Charles Wellington Boyle.

1928

The Museum purchases Chinese bronzes owned by I. M. Cline for $3,135, the funds coming from the Lacosst bequest.

1930

The Museum purchases its first painting by an African-American artist: *The Good Shepherd*, by Henry O. Tanner.

The Art Association of New Orleans organizes the show Post Modern French Paintings. This is the first exhibit of modern art at the Museum.

1931

A first gift from Samuel H. Kress—*Madonna and Child*, by Giovani di Biondo—begins a long relationship between the Museum and the Samuel H. Kress Foundation.

The Museum is almost forced to close because of budget cuts by the city of New Orleans. An uproar in the city's newspapers forces the city to reinstate the funds.

1933

The Art Association of New Orleans organizes the show Fifty-Two Italian Old Master Paintings, lent by Samuel H. Kress.

1934

Samuel H. Kress gives *Portrait of Pope Clement XIII*, by Anton Raphael Mengs.

1936

October 1–22
The Art Association of New Orleans conducts the exhibit Photographs by Clarence John Laughlin. This is Laughlin's first one-man show.

1938

April
Samuel H. Kress makes a gift of *The Blessing Savior*, by Vittore Carpaccio in 1510.

1939

February 28
Ellsworth Woodward dies.

Arthur Feitel becomes unpaid acting director of the Museum as well as president of the Art Association of New Orleans.

Physical changes are made within the Museum. Galleries are rehung following a chronological or historical approach. Pieces are cleaned and relabeled. The ventilating system of the Museum is improved. Storage racks are constructed in the basement for works not on display.

1940

The Museum purchases *The Toilette of Psyche*, by Charles Joseph Natoire, using the bequest of Judge Charles F. Claiborne.

December 20–
January 17, 1941

The show Picasso: Forty Years of His Art, organized by the Museum of Modern Art, includes *Guernica*.

1941

March

The Art Association of New Orleans mounts the exhibit Paintings Lent by Mrs. Hans Hofmann and Mrs. Muriel Francis. This is the first exhibit of Hans Hofmann's work in the United States.

1943

November 20

The show Refugee French Art Treasures opens. It has been organized by René Batigne and the Museum.

1945

A bequest by Kate P. Jourdan, an art-purchase endowment in the amount of four thousand dollars, is the second such endowment the Museum receives.

1947

January 11

Arthur Feitel becomes president of the board of administrators of the Museum and contributes as unpaid acting director of the Museum.

The New Orleans City Council quadruples the annual funding for the Museum.

The Helis family's patronage begins with cash prizes to art students for meritorious art work.

1948

December

Alonzo Lansford, the first professionally trained director, is hired by the Museum's board of administrators.

1949

The Museum purchases *Hercules the Archer*, by Antoine Bourdelle, from his widow for seven thousand dollars.

1950

February 28

Michael Musson, nephew of Edgar Degas, gives that artist's *Bronze Horse* to the Museum.

1951

William E. Campbell gives *Dream*, by Adolph Gottlieb, to the Museum.

1952

August 9

Mr. and Mrs. Isaac Heller give *Everyone Here Speaks Latin*, by Max Ernst, to the Museum.

Muriel B. Francis gives *Sleep*, by Bazoites, beginning her important patronage.

1953

Anonymous gift of *Head of an Oba*, the first African piece to enter the collection, is made to the Museum.

April

Announcement is made of the Samuel H. Kress Foundation's long-term loan of twenty-nine old-master paintings to the Museum. Members of the board of the Kress Foundation and the director of the National Gallery of Art are special guests at a luncheon at the Roosevelt Hotel. A gala reception is held at the Museum in connection with the announcement.

October 17–
January 10, 1954

An exhibit of masterpieces, Fench Painting Through Five Centuries, 1400–1900, from the Louvre, is held. It has been organized to celebrate the bicentennial of the Louisiana Purchase. Attendance for the year 1953 is a record 104,000.

1954

July

Arthur Feitel designs plans for museum expansion and tries to get support for expansion but is not successful.

1955

Alonzo Lansford begins successful negotiations with Melvin P. Billups for the Billups Glass Collection. Ultimate donation of this collection is made in 1969.

The board of administrators of the Museum attempts a $575,000 museum fund drive, which is unsuccessful.

March 27–
April 20

The Museum organizes and holds the show Vincent Van Gogh, 1853–1890.

1956

October

First painting of the Cuzco school enters the collection: *St. Jerome*, from John Jay Cunningham.

1957

March 28

Alonzo Lansford is dismissed as director of the Museum. This action begins a period of conflict between Lansford, the Museum board, and the New Orleans City Council, which culminates in the board's rewriting the charter to expand community representation.

1958

Sue Thurman is named director of the Museum with new responsibility to determine the exhibitions and control the educational and developmental thrust of the institution.

Renovations begin in some of the galleries.

The registration and cataloging of the permanent collection and a cardex system are begun.

1959

May	Mrs. E. James Koch and Mrs. Olivier Billion make a gift of ten thousand dollars for remodeling of the Downman Room, in honor of their father, Robert H. Downman.
June	The Junior League of New Orleans gives two-year funding for a curator of education.
	Curators of education and collections are hired.
November 2	Renovations to the Museum are completed.
November	Announcement is made that the Samuel H. Kress Collection will become a part of the permanent holdings of the Museum.

1960

November 15– December 31	The Museum shows The World of Art in 1910, which it has organized as part of its fiftieth-anniversary celebration.

1961

February	The Knoedler Gallery, of New York, exhibits a New Orleans private collection of impressionists to raise accession funds for the Museum.
	The Museum receives the Jeanette Waugh Lapèyre bequest of fifty thousand dollars.
June	Sue Thurman resigns.
November 22	James B. Byrnes is named director of the Museum.

1962

The city of New Orleans allocates $135,000 for renovations.

The Museum organizes the show Fetes de la Pallette.

The Museum shows A Decade of Glass Collection from the Melvin Billups Collection, organized by the Corning Glass Museum.

1963

Mrs. Edgar B. Stern gives twentieth-century European works to the Museum.

December	A name change for the Museum is suggested.

1964

The theme for the year is "Bring Estelle Home."

A public fund drive raises $190,000 for purchase of *Portrait of Estelle*, by Edgar Degas, painted in New Orleans in 1870–71.

1965

January	A name change for the Museum is again suggested to Board.
May 2– June 16	The show Edgar Degas: His Family and Friends in New Orleans, organized by James B. Byrnes, commemorates the purchase of *Portrait of Estelle Musson*.
June	The Women's Volunteer Committee is formed.

September	Hurricane Betsy hits New Orleans.
October 25, 26, 27	Deaccession and auction of surplus art nets thirty-eight thousand dollars for the accessions fund.

1966

	The Ella West Freeman Foundation gives a $200,000 matching grant to the Museum for art purchases.
November 13	First annual Odyssey Ball premieres exhibition Odyssey of an Art Collector: The Frederick Stafford Collection.

1967

	The sum of $200,000 is raised to match the Freeman Foundation grant.
March 22	Accessions policy is established with emphasis on the Arts of the Americas.

1968

May	Voters in the city of New Orleans approve a bond for $1,615,000 for Museum expansion.

1969

	The Museum receives by bequest the Melvin P. Billups Glass Collection.
	The Edward Wisner Fund gives $200,000 for the children's wing.
	The Stern Family Fund gives $200,000 for the auditorium-and-office wing.
	The Dreyfous family gift of $30,000 is received for the library.

1970

February 18	James B. Byrnes proposes a name change for the Museum.
February 24	The ground-breaking ceremony for the expansion of the Museum is held.

1971

October	The board of trustees changes the name of the institution to New Orleans Museum of Art.
November 14– January 9, 1972	The Museum holds the exhibition New Orleans Collects. A shower of gifts occurs in response to the new facilities.
November 18	The Odyssey Ball is held.
November 21	The expanded and renamed New Orleans Museum of Art officially opens.

1972

February 18	The Museum is accredited by the American Association of Museums, Washington, D.C.
May	James B. Byrnes resigns.

April 15–
May 28
: The show Peruvian Colonial Painting takes place, organized by the Brooklyn Museum and NOMA.

October 20
: The Museum receives its first gifts of Japanese art from Dr. and Mrs. Kurt A. Gitter.

November 3–
December 31
: The Museum shows Treasures of Peter Carl Fabergé and Other Master Jewelers—The Matilda Geddings Gray Foundation Collection, which it has organized. This is the collection's first public exhibit.

1973

January 29
: E. John Bullard becomes fourth director of the Museum. He begins the photography collection.

December 7–
October, 1974
: Henry Moore bronzes from the Norton Simon Foundation and the Norton Simon Museum of Art are placed on long-term loan.

1974

May 22
: Victor K. Kiam dies, leaving the Museum a bequest of thirteen paintings and four sculptures by twentieth-century masters. Included in the bequest are 180 African and Oceanic objects. The Museum receives items from the Kiam bequest in 1977, after legal maneuvering.

June
: The Shirley Latter Kaufmann gift of 347 English and Continental miniatures given in memory of her parents, Harry and Anna Latter.

1975

February 15
: The Museum launches a fund drive to raise $2.5 million for art acquisitions.

April 16
: A new acquisitions policy is adopted that emphasizes six areas of collecting specialization.

October 25
: General admission is charged for the first time.

1977

The Victor K. Kiam bequest is placed on exhibit.

September 15–17
: Odyssey Weekend raises $178,000 for acquisitions.

September 18–
January 15, 1978
: Treasures of Tutankhamun opens at the Museum and is seen by 900,000 persons in four months

1978

The acquisitions fund drive, begun in 1975, is successfully completed with the gift of the Kuntz Collection, two period rooms of eighteenth-century furniture and decorative arts in memory of Rosamonde E., Emile, and Felix H. Kuntz.

An advisory council is established.

November 3–
December 17
: Showing is held of Diverse Images: The Photograph Collection of the New Orleans Museum of Art, organized by NOMA.

A Chronology

1979

January 14– April 15	Peru's Golden Treasures opens at the Museum.
April 18	The Fellows of NOMA is formed at the Museum, with annual dues dedicated to endowment.

1980

The first handbook of the Museum's permanent art collection is published.

Loyola University, working with the trustees and staff, produces a management study for the Museum.

May 24– July 20	The show Treasures from Chatsworth: The Devonshire Inheritance is held. It is organized by the International Exhibitions Foundation.
December 16– March 29, 1981	The show Gold of El Dorado: The Heritage of Columbia is held. It is organized by the American Museum of Natural History.

1981

September 13– October 25	The exhibit Art of the Muppets is held at the Museum.
December	A bequest by Bert Piso of a collection of seventeenth-century Dutch paintings is received by the Museum.

1982

The gift of Clarence John Laughlin's collection of photography is received by the Museum.

June 27– September 19	The exhibit The Search for Alexander is held at the Museum.

1983

May 15	The Matilda Geddings Gray Foundation's collection of Fabergé objects is placed on long-term loan in a specially designed gallery.

A nationwide architectural competition is held to select the design of the future expansion of the Museum. The winner is W. G. Clark, of Charleston, South Carolina.

1984

February 22	The trustees establish a seventy-fifth anniversary general-endowment fund of over $1.5 million out of the reserve fund from the Tut exhibit and income from the Fellows of NOMA.
May 12– November 11	The show Treasures of the Vatican is held. It is organized by the archdiocese of New Orleans and cosponsored by the Vatican Museums and NOMA at the Louisiana World Exposition.
December 16– February 10, 1985	The show The Precious Legacy: Judaic Treasures from the Czechoslovak State Collections is held. It is organized by Smithsonian Institution Traveling Exhibition Services.

1985

A bequest by Carrie B. Heiderich in the amount of $400,000 establishes a new endowment fund for art purchase.

The trustees and staff complete the first five-year long-range plan for growth (1986–1990).

The Museum purchases *Portrait of Marie Antoinette,* by Elisabeth Vigée-Lebrun, for $500,000 in observance of NOMA's seventy-fifth annivesary.

Appendix 2
Presidents and Trustees of the New Orleans Museum of Art, 1910–1986

PRESIDENTS

Pierre Antoine Lelong, 1910–1912
Gustave R. Westfeldt, 1913–1915
Henry Fay Baldwin, 1916–1919
Charles F. Claiborne, 1920–1933
Ellsworth Woodward, 1934–1938
Felix J. Dreyfous, 1939–1946
Arthur Feitel, 1947–1958
Charles E. Whitmore, 1959–1960
Herbert Jahncke, 1960–1961
Robert J. Newman, 1962–1963
F. Julius Dreyfous, 1964
A. Q. Peterson, 1965

Ernest A. Carrere, Jr., 1966
Robert J. Newman, 1967
Mrs. Muriel B. Francis, 1968–1969
Robert J. Newman, 1970–1971
Mrs. J. Frederick Muller, 1972–1973
Robert A. Peyroux, 1974–1975
Moise S. Steeg, Jr., 1976–1977
Mrs. Richard B. Kaufmann, 1978–1979
J. Thomas Lewis, 1980–1981
Ernest A. Carrere, Jr., 1982–1983
Arthur Q. Davis, 1984–1985
Richard W. Levy, 1986–1987

TRUSTEES

Mrs. Gerald L. Andrus, 1962
Hon. Wayne Babovich, 1982–1985
Hon. Brod Bagert, 1978–1980
H. F. Baldwin, 1913–1919
Hon. Sidney Barthelemy, 1981–1986
Z. W. Bartlett, 1974–1976
Beauregard L. Bassich, 1983–1985
I. J. Becnel, 1972–1973
Mrs. Edward B. Benjamin, 1957,
 1960–1963, 1965–1968
Joseph Bernard, 1910
Thomas N. Bernard, 1975–1977
Dr. Frank Birtel, 1978–1980, 1984–1986
Mrs. Harry J. Blumenthal, 1980–1983
Dr. Joseph Bonin, 1978–1982
John F. Bookout, 1970
Norman Boothby, 1972–1974
Shirley B. Braselman, 1970–1975
Kenneth Broadwell, 1986–1988

Mrs. Theodore S. Buchanan, Jr.,
 1984–1985
A. Fred Bultman, Jr., 1943
William B. Burkenroad, Jr., 1972–1977
Paul Capdevielle, 1910–1921
Mrs. Roberta Capers, 1961–1962
Mrs. Carlo Capomazza, 1984–1988
Ernest A. Carrere, Jr., 1961–1966,
 1971–1975, 1982–83, Honorary Life
 Member, 1977–1981, 1984
Larry H. Case, 1973–1977, 1983–1988
Hon. Fred J. Cassibry, 1958–1960
Turner Catledge, 1972–1977
Mrs. Clayton Charbonnet, 1964–1967
Mrs. Edgar Chase, Jr., 1977–1982
Hon. Philip C. Ciaccio, 1971–1976
Charles F. Claiborne, 1910–1933
Duralde Claiborne, 1924–1958
John Clemmer, 1960–1961

361

Lloyd J. Cobb, 1940–1950
Dr. Isidore Cohn, 1962–1964
James J. Coleman, Jr., 1968–1971,
 1973–1975
Mrs. George E. Conroy, Jr., 1978
Mrs. Jesse W. Cook, 1974–1979
Walter G. Cowan, 1981–1986
David S. Cressy, 1981–1983
Hon. Henry B. Curtis, 1960–1961
Camille A. Cutrone, 1976–1981
Hippolyte Dabezies, 1934–1957
Valeton J. Dansereau, 1982–1984
John Dart, 1941
Arthur Q. Davis, 1964–1968, 1971–1976,
 1982–1987
Wallace M. Davis, 1960–1962
Mrs. Walter Davis, Jr., 1971–1974,
 1976–1981, 1984–1987, Honorary Life
 Member, 1989
Charles I. Denechaud, 1942–1956
Edward J. de Verges, 1954–1957
Mrs. Joseph A. Diaz, 1960–1961
Hon. Joseph V. DiRosa, 1977
F. Julius Dreyfous, 1925–1962,
 1964–1966, 1968–1971, 1973–1974
Felix J. Dreyfous, 1910–1946
Hon. Walter M. Duffoure, 1957–1958
Prescott N. Dunbar, 1974–1979,
 1981–1986
Hon. Clarence O. Dupuy, Jr., 1966–1968,
 1971–1976
Tom W. Dutton, 1965–1966
Mrs. C. J. Eagan, Jr., 1979–1982
Mrs. Leslie J. England, 1985
H. Mortimer Favrot, 1985–1990
Mrs. Edward Feinman, 1979–1982
Arthur Feitel, 1933–1965, Honorary Life
 Member, 1966–1982
Hon. James E. Fitzmorris, Jr., 1957–1962
Norris V. Fitzmorris, 1980–1985
Mrs. Muriel B. Francis, 1961–1969,
 1971–1976, 1978–1983, Honorary Life
 Member, 1985–1986
Dr. Norman Francis, 1972–1973
Richard W. Freeman, Honorary Life
 Member, 1968–1985
Mrs. Richard W. Freeman, 1960–1962,
 1964–1965, Honorary Life Member,
 1968

Richard W. Freeman, Jr., 1972–1975,
 1976–1977
Sandra D. Freeman, 1983
Frank Friedler, Jr., 1977–1979
George S. Frierson, Jr., 1965, 1966–1968
Bro. Gebhard Frohlich, 1976–1978
Fernand Charles Gandolfo, 1968–1971
Allan H. Generes, 1952–1953
James H. Gibert, 1977–1982
Dr. Kurt A. Gitter, 1975–1980, 1983–1988
Lewis Gottlieb, 1960–1961
Mrs. Ford M. Graham, 1970–1975
Charles L. Graves, 1980–1983
George Grundman, 1947
Dr. Alfred J. Guillaume, 1986–1989
Major Benjamin F. Harrod, 1910–1912
H. Edward Heiny, 1955
Mrs. William G. Helis, 1954–1959,
 1960–1962, 1964–1966, 1968–1969,
 1971, Honorary Life Member,
 1969–1980
Mrs. Charles C. Henderson, 1960–1963,
 1967–1969
Hunt Henderson, 1916–1928
William Henderson, 1975–1977
Mrs. William H. Hodges, 1985
Dr. Edward J. Howell, 1985–1986
Mrs. Killian L. Huger, 1977–1982
Frederic B. Ingram, 1972–1975
J. Norcom Jackson, Jr., 1982–1983
Herbert Jahncke, 1959–1962, 1965–1966,
 1968
Rev. M. V. Jarreau, S.J., 1971–1973
Norman Johnson, 1978
Mrs. Norman Johnson, 1979–1980
Joseph M. Jones, 1961–1963
Richard G. Jones, 1954
Thomas Jordan, 1945
Arthur L. Jung, 1982–1983
Paul R. Kalman, Jr., 1964–1966,
 1968–1969
Mrs. Nolan Kammer, 1962
Mrs. Richard B. Kaufmann, 1962–1965,
 1970–1975, 1977–1980, 1982–1987,
 Honorary Life Member, 1988
Thomas C. Keller, 1984–1989
Dr. Fred Ketchum, 1953–1954
Nat B. Knight, 1961–1966
Richard Koch, 1936–1941

James H. Stone, 1984–1987
Mrs. Roger T. Stone, 1971–1974,
 Honorary Life Member, 1977
Harold H. Stream, 1971–1974,
 1976–1981, Honorary Life Member,
 1983–1988
Mrs. Harold H. Stream, Honorary Life
 Member, 1983
Joseph T. Sylvester, 1979–1984
Louis J. Torre, 1964
Pat Trivigno, 1966, 1968, 1971
William E. Trotter II, 1985
Samuel Adams Trufant, 1921–1935
Eli W. Tullis, 1971–1972
W. O. Turner, 1964
William K. Turner, 1975–1977
Hon. Bryan Wagner, 1980–1981
Dr. H. W. E. Walther, 1928–1935,
 1938–1942

Milton H. Ward, 1986–1991
John N. Weinstock, 1977
Mrs. John N. Weinstock, 1977–1982
Samuel Weis, 1913–1921, 1936–1937
Alfred Wellborn, 1927–1956
Gustave R. Westfeldt, 1910–1915
Charles E. Whitmore, 1955–1960
Wilmore W. Whitmore, 1986–1989
Hugh M. Wilkinson, 1948–1951
Mrs. C. S. Williams, 1960–1962,
 1964–1965
J. Barbee Winston, 1972–1977, 1982–1987
John M. Wisdom, Jr., 1966
Leon M. Wolf, Jr., 1960–1961
Ellsworth Woodward, 1910–1939
Dr. William Thomas Young, 1974–1979
Dr. Edwin L. Zander, 1958
William G. Zetzmann, 1944–1947

Appendix 3
The Economic Impact of King Tut

E. C. NEBEL III and E. JOHN BULLARD

The works of art found in an Egyptian boy king's tomb have caused excitement throughout our nation. The Treasures of Tutankhamun first opened to record crowds in Washington, D.C., maintained its momentum in Chicago, and then traveled to New Orleans where a total of 870,595 people viewed some of the contents of Tut's tomb.

Long before the exhibition opened in New Orleans, advance hotel bookings were running very high and large numbers of group parties were making plans to visit the New Orleans Museum of Art and spend additional time sightseeing in New Orleans. Once King Tut opened, it was clear to the New Orleans Museum of Art (NOMA) and to leaders of the tourism industry that significant economic benefits were resulting from this exhibition. But there have been no firm figures as to exactly how important in dollar terms this cultural event was to the city. To determine this, the New Orleans Museum of Art commissioned a survey to estimate the dollar expenditures of visitors attracted to New Orleans by the King Tut exhibition.

SURVEY METHOD

Two types of out-of-town visitors were identified: (1) individuals who on their own visited New Orleans to see King Tut and (2) those who came as part of a group that made special arrangements with the New Orleans Museum of Art to view the exhibition. Of the total of 613,169 out-of-town visitors who attended the exhibition, 540,445 were separate individuals and 72,724 were members of 1,149 group tours.

A total of 8,000 individuals either signed postcards requesting additional information about Museum gift shop merchandise or were out-of-town Museum members who visited the exhibition. Questionnaires were sent to each of these 8,000 individuals and to each of the 1,149 group leaders. The response rate was 22.5% for group leaders and 17% for individual visitors.

From *Louisiana Business Survey*, IX (October, 1978).

SUMMARY OF FINDINGS

Table 1 presents average daily per capita personal outlays for the various categories of spending by Tut visitors.

TABLE 1
AVERAGE EXPENDITURES PER PERSON PER DAY

	Individuals	Groups
Food and beverages	$19.80	$19.72
Lodging	17.44	18.40
Retail merchandise	15.42	19.12
Entertainment	6.67	11.89
Ground transportation	2.19	5.35
	$62.19	$74.48

The average length of stay for individual travelers was 2.42 days, giving a total expenditure of $150.50 per person. Since 540,445 visitors came individually to view King Tut, expenditures for them totaled $81,336,864. The average length of stay for group visitors was calculated as 1.42 days, for a total of $105.76 of spending per person during their visit to New Orleans. For all 72,724 group visitors, total expenditures were thus $7,691,407. Adding individual and group expenditures together gives a grand total of $89,028,271 expended in New Orleans by out-of-town visitors who attended the King Tut exhibition.

The economic importance of the exhibit must be viewed in terms of the number of visitors who came to the city primarily to see King Tut, however, excluding those who, while in New Orleans for other reasons, also attended the King Tut exhibition. Table 2 gives the results of a survey conducted by researchers from Tulane University of 401 non-group out-of-town visitors waiting to get into the Tut exhibition.

TABLE 2
MAIN PURPOSE OF TRIP TO
NEW ORLEANS

	Response
See King Tut	76.5%
Work-related	10.3
Tourism besides Tut	6.3
Visit relatives	5.8
Other	1.1

If 76.5% of all the individual visitors came mainly to see Tut, then specifically Tut-generated individual expenditures totaled $62,222,701. For all 72,724 group visitors, total expenditures were $7,691,407. However, NOMA records indicate that 3,555 group visitors were in New Orleans for either the Super Bowl or conventions and therefore were drawn to the city primarily for reasons other than seeing King Tut. For the remaining 68,169 group tour visitors, were expenditures of $7,209,663. Total specifically Tut-generated expenditures would then be the sum of such individual and group expenditures, which is $69,432,364. It is the authors' judgment that this figure probably represents the lowest possible estimate of the economic impact of King Tut. An upper-level estimate is $75,264,217.

Where did the massive number of Tut visitors come from? In Table 3, the state of origin for individual visitors is taken from the Tulane study, while group tour data reflect Museum records.

TABLE 3
STATE OF ORIGIN OF KING TUT VISITORS

| | Individual | | | | Group | |
State	%	Rank	State	%	Rank
Louisiana outside New Orleans	21.8	1	Louisiana outside New Orleans	25.6	1
Texas	15.8	2	Texas	15.4	2
Mississippi	8.8	3	Mississippi	10.6	3
Alabama	6.8	4	Alabama	7.2	4
Georgia	3.1	8	Florida	5.7	5
Arkansas	1.6	9	Missouri	2.8	6
Tennessee	3.5	7	Tennessee	2.6	7
Florida	6.4	5	Georgia	2.1	8
Oklahoma	3.9	6	Arkansas	1.7	9
Ohio	1.2	10	Oklahoma	1.2	10

As would be expected, visitors from Texas, Mississippi, and the remainder of Louisiana outside the New Orleans SMSA dominated the statistics. These three areas accounted for 46.4% of the individual travelers and 51.6% of the group travelers. Add in the other Southern states of Alabama, Florida, Tennessee, Georgia, and Arkansas, and 67.8% of all individual and 70.9% of the group travelers are accounted for.

This is an important finding—that the primary origin of the overwhelming majority of Tut visitors was nearby Southern states. The marketing implications are obvious. For greatest results, advertising and promotion of cultural

attractions should be concentrated in nearby Southern states around New Orleans.

Overall, who were the major recipients of the primarily Tut-related tourist? As shown in Table 4, it is not surprising that food-and-beverage and lodging ranked first and second. In terms of retail expenditures, King Tut had the same impact as if every man, woman and child in Orleans Parish had gone downtown and spent $35 apiece. The $7.8 million spent on entertainment can be likened to a half million people each spending about $15 in some New Orleans night club. One million people taking taxicab rides at an average fare of $3.40 gives some idea of the economic impact of the ground transportation component. (Note that these are conservative estimates.)

TABLE 4
EXPENDITURES BY CATEGORY
(MILLIONS)*

Food and beverage	$21.7
Lodging	19.2
Retail merchandise	17.3
Entertainment	7.8
Ground transportation	3.4
Total	$69.4

*Conservative estimates

IMPACT ON TAX REVENUES

By applying the appropriate tax rates to the various expenditure categories, we can determine approximate levels of tax collections basically resulting from King Tut. Table 5 gives sales tax rates applicable to each expenditure category.[1]

TABLE 5
TAX RATE STRUCTURE

Expenditure Category	Total Tax Rate	State	City	Superdome	School Board	City Welfare
Food and Beverage	6%	3%	2%	—	1%	—
Lodging	6	—	1	4%	1	—
Retail Merchandise	6	3	2	—	1	—
Entertainment	11	3	2	—	1	5%

1. Because sales taxes are not collected by taxicabs and because it is impossible to apportion ground transportation expenditures among the various modes of transportation, we bypass the tax implications of this category of expenditures.

TABLE 6
TAX REVENUES

Category	Visitor Expenditures (Millions)	Total Tax Revenues	State	City	Superdome	School Board	City Welfare
Food and beverage	$21.7	$1,228,302	$614,151	$409,434	—	$204,717	—
Lodging	19.2	1,086,792	—	181,132	$724,528	181,132	—
Retail merchandise	17.3	979,246	489,623	326,415	—	163,208	—
Entertainment	7.8	772,974	219,811	140,541	—	70,270	$351,351
Total	$69.4	$4,067,314	$1,314,585	$1,057,522	$724,528	$619,328	$351,351

Multiplying tax rates by total expenditures by category results in an estimate of total tax receipts due to the lure of King Tut (Table 6). A total of $4,067,314 in local and state sales taxes were collected because of Tut-attracted spending, of which approximately one-third went to general state revenues.

CONCLUSION

Culture in any community is necessary, in and of itself, for the benefit of the local citizens. This study reinforces, in a rather dramatic way, another simple truth—that people's travel motives are influenced by opportunities to learn, to be entertained, to explore new worlds, and to experience unique and different things. New Orleans has always had a rich and varied cultural heritage, which is one of the main reasons why it has prospered as a primary tourist destination. The King Tut phenomenon shows us another way to both culturally and economically enrich our community.

In the near future NOMA will host Peru's Golden Treasures exhibition, which also promises to bring record numbers of visitors to our city.

Selected Bibliography

JUDICIAL RECORDS

Louisiana Reports, 142.

NOTARIAL RECORDS, NEW ORLEANS NOTARIAL ARCHIVES

A. E. Hebert. Inventory of the Estate of Isaac Delgado, January 13, 1912.
Felix J. Puig. Inventory of the Estate of Hunt Henderson, November 23, 1934.

NEWSPAPERS

New Orleans *City Item*, 1911–16.
New Orleans *Daily Picayune*, 1881–1916.
New Orleans *Daily Tropic*, 1845–47.
New Orleans *Figaro*, 1976–77.
New Orleans *Item*, 1916–58.
New Orleans *Item-Tribune*, 1925–32.
New Orleans *Morning Tribune*, 1930–36.
New Orleans *Old French Quarter News*, 1948–49.
New Orleans *States*, 1923–54.
New Orleans *States-Item*, 1911–60.
New Orleans *Sunday Item-Tribune*, 1939–42.
New Orleans *Times-Democrat*, 1911–13.
New Orleans *Times-Picayune*, 1912–85.
New Orleans *Times-Picayune States*, 1957–58.
New Orleans *Vieux Carre Courier*, 1970–77.

CATALOGS AND REPORTS

Bardo, Pamela P. *English and Continental Portrait Miniatures: The Latter-Schlesinger Collection*. 1978.
Byrnes, James B. *Edgar Degas: His Family and Friends in New Orleans*. 1965.

————. *Odyssey of an Art Collector*. 1966.

————. *The Samuel H. Kress Collection at the Isaac Delgado Museum of Art*. 1966.

Fagaly, William A. *Treasures of Peter Carl Fabergé and Other Master Jewelers*. 1972.

Freeman, Tina. *Diverse Images: The Photography Collection from the New Orleans Museum of Art*. 1979.

Hawkins, A. *Creole Art Gallery Catalogue*. No. 13. 1892.

Kaufmann, Shirley Latter. *English and Continental Portrait Miniatures: The Latter-Schlesinger Collection*. 1978.

Thurman, Sue M. *The World of Art in 1910*. 1960.

Isaac Delgado Museum of Art. *Catalogue of Etchings, Lithographs, Paintings, and Drawings by James McNeill Whistler*. 1917.

Isaac Delgado Museum of Art. *Catalogue of Inaugural Exhibit*. 1911.

Isaac Delgado Museum of Art. *Masterpieces of French Painting Through Five Centuries*. 1953.

New Orleans Museum of Art. *1977 Artists' Biennial*. 1977.

New Orleans Museum of Art. *Catalogue of N.O.M.A. Deaccession Auction: Saturday, December 12, 1981, at 11:00 A.M., Morton's Auction Exchange, New Orleans*. 1981.

"Annual Report, for the Year Ending December 31, 1911, of the Metropolitan Museum of Art." 1912.

Catalogue of Art Auction Presented by the Women's Volunteer Committee of the Isaac Delgado Museum of Art: A Selection of Objects Surplus to the Collection, October 25–27, 1965, Gallier Hall. 1965.

Catalogue of the Collections of Paintings and Other Works of Art Belonging to James Robb, Esq. 1859.

First Annual Exhibit of the Artists' Association of New Orleans. 1887.

"New Orleans Museum of Art 1986–1987 Biennial Report." 1988.

Paintings by Andres Molinary Exhibited at the Isaac Delgado Museum of Art, May 30, 1915. 1915.

"Twenty-Seventh Annual Report of the Art Association of New Orleans." 1930.

UNPUBLISHED MATERIALS

Bullard, E. John. "A Report on Art Purchases, 1973–1983, New Orleans Museum of Art. 1983. Copy. Archives, NOMA

Feitel, Arthur. "Confessions of a Frustrated Museum Enthusiast." [1967.] Typescript. Archives, NOMA.

Garthwaite, Elloyse, and Tom Ireland. "Isaac Delgado: His Life and Impact on New Orleans and the State of Louisiana." Louisiana Committee for the Humanities, New Orleans, June 30, 1980. Typescript.

Kohlmeyer, Charles, Jr. Letters and Memorabilia Pertaining to Isaac Delgado Museum of Art, 1958–1962. Archives, NOMA

McDermott, Betty, and Charles L. Mo. "Final Report by New Orleans Mu-

seum of Art on Exhibition of Tutankhamun." 1978. Copy. Archives, NOMA.

Stern, Mrs. Edgar B. Interview with Pamela P. Bardo. July 3, 1977. Typescript. Archives, NOMA.

Instructions for Architects in Competition for the Isaac Delgado Museum of Art. 1910. Archives, NOMA.

Letters and Memorabilia Pertaining to Isaac Delgado Museum of Art, 1910–1984. Archives, NOMA.

Minutes of the Regular Meetings of the Board of Administrators/Trustees of the Isaac Delgado/New Orleans Museum of Art, 1910–1986. Archives, NOMA.

New Orleans Museum of Art Long Range Plan, 1986–1990. Archives, NOMA.

New Orleans Museum of Art Management Study. January–June, 1980. Archives, NOMA.

Phase One Information Packet, Design Competition for the Expansion of the New Orleans Museum of Art. June 30, 1983. Archives, NOMA.

Phase Two Information Packet, Phase Design Competition for the Expansion of the New Orleans Museum of Art. September 26, 1983. Archives, NOMA.

Scrapbooks of Newspaper Clippings, Photographs, Magazine Articles, etc., Pertaining to the Isaac Delgado/New Orleans Museum of Art, 1910–1986. Archives, NOMA.

SECONDARY SOURCES

BOOKS

Appleton's Cyclopedia of American Biography. N.s. Vol. V of 20 vols. New York, 1888.

Behrman, S. N. *Duveen.* Boston, 1972.

Birmingham, Stephen. *The Grandes Dames.* New York, 1982.

Boughman, James P. *Charles Morgan and the Development of Southern Transportation.* Nashville, 1968

Burt, Nathaniel. *Palaces for the People.* Boston, 1977.

Carter, Hodding, ed. *The Past as Prelude: New Orleans, 1718–1968.* New Orleans, 1968.

Christovich, M. L., ed. *New Orleans Architecture: The Cemeteries.* Gretna, La., 1974.

Christovich, M. L., S. K. Evans, and R. Toledano. *New Orleans Architecture: The Esplanade Ridge.* Gretna, La., 1977.

Clark, John G. *New Orleans, 1718–1812: An Economic History.* Baton Rouge, 1970.

Cohn, Isidore. *Rudolph Matas: A Biography of One of the Great Pioneers in Surgery.* Garden City, N. Y., 1960.

Davis, John H. *The Guggenheims: An American Epic.* New York, 1978.

373

Finley, David E. *A Standard of Excellence.* Washington, D.C., 1973.

Fortier, Alcée. *History of Louisiana.* Vol. II of 3 vols. New York, 1904.

Guggenheim, Peggy. *Out of This Century.* New York, 1979.

Hoving, Thomas. *Tutankhamun: The Untold Story.* New York, 1978.

Huber, Leonard. *New Orleans: A Pictorial History.* New York, 1971.

Jackson, Joy J. *New Orleans in the Gilded Age: Politics and Urban Progress, 1880–1896.* Baton Rouge, 1969.

Kemp, John R. *New Orleans.* Woodland Hills, Calif., 1981.

Kendall, J. S. *History of New Orleans.* Vol. II of 2 vols. New York, 1922.

Klein, Gerda Weissmann. *A Passion for Sharing: The Life of Edith Rosenwald Stern.* Chappaqua, N.Y., 1984.

Ormond, Suzanne, and Mary E. Irvine. *Louisiana's Art Nouveau: The Crafts of the Newcomb Style.* Gretna, La., 1976.

Poesch, Jessie. *The Art of the Old South.* New York, 1983.

Reeves, Sally K. E., et al. *Historic City Park, New Orleans.* New Orleans, 1982.

Searing, Helen. *New American Art Museums.* New York, 1982.

Stephens, Suzanne, ed. *Building the New Museum.* New York, 1986.

Tindall, George B. *The Emergence of the New South, 1913–1945.* Baton Rouge, 1967.

Tomkins, Calvin. *Merchants and Masterpieces.* New York, 1970.

Towner, Wesley. *The Elegant Auctioneers.* New York, 1970.

THESES

Barkmeyer, Estelle. "Ellsworth Woodward: His Life and Work." M.A. thesis, Tulane University, 1942.

Heidelberg, Michelle Favrot. "William Woodward." M.A. thesis, Tulane University, 1974.

Patureau, Stephen. "A History of the Isaac Delgado Central Trade School." M.A. thesis, Tulane University, 1939.

ARTICLES

Bullard, E. John. "Celebrating Seventy-Five Years: A Review of the Jubilee Year." *Arts Quarterly,* IX (January–March, 1987), 16–21.

———. "Five Years of New Acquisitions: 1973–1977." *Arts Quarterly,* I (January–March, 1978), 1, 3–5.

Chamberlain, Betty. "How to Get and Spend a Million Dollars for Art." *Art News,* LV (April, 1956), 37–39.

Fagaly, William A. "A Woman for All Causes, Including Art." *Arts Quarterly,* VI (October–December, 1984), 31–34.

Hutson, Ethel. "The Art Association of New Orleans." *Warrington Messenger,* October, 1936, pp. 8–12.

———. "The Southern States Art League." *American Magazine of Art,* XXX (February, 1930), 86–92.

Woodward, Ellsworth. "Advice to the South." *Art Digest,* X (December 1, 1935), 9.

Index

375

Index

Clapp, Mrs. Emory, 23, 24, 33
Clark, Emery, 306
Clark, W. G., 340–45, 348
Clasen, Glenn P., 129, 145, 148, 152, 165–66
Claypoole, James, Jr., 290–91
Clemmer, John M., 133, 138, 139, 140, 156, 185, 193, 194, 198–99
Clerck, Hendrick de, 103
Clifton, C. C., Jr., 284
Cline, I. M., 26, 50, 78
Coates, R. H., 96
Cobb, Henry C., 339
Cobb, Lloyd, 83, 86, 89, 90
Cohn, David L., 73n
Cohn, Isidore, 202, 225
Cole, Thomas, 4
Coleman, James J., Jr., 248, 281
Coleman, Laurence, 158
Collas, Louis A., 3, 95, 96, 144
Collier, Alberta, 108, 111, 120, 146, 166, 210, 213, 231–32, 253–55, 259
Colombel, Nicholas, 271
Conroy, Ann, 303
Constable, John, 219
Constantini, Battista, 33–34
Cook, James, 273
Cook, Mrs. Jesse W., 299
Cooke, George, 3, 4
Cooper, Irene, 67
Cooper, Samuel, 278
Copley, John Singleton, 284, 285–90
Cornell, Joseph, 348
Corot, Jean Baptiste Camille, 35, 92
Cosway, Richard, 278
Coulon, Goerge D., 95
Courbet, Gustave, 92, 254
Couture, Thomas, 320
Creighton, S. G., 165
Cunningham, Imogen, 267, 268
Cunningham, John Jay, 125
Cuyp, Aelbert, 319

Dabezies, Hippolyte, 59, 84–85, 88, 89, 126, 128, 134, 136
Dabo, Leon, 50n
Daen, Lindsay, 111
Daum, Joseph, 133, 142–43
Daumier, Honoré, 60, 92
David, Jacques Louis, 5, 77, 115, 320
Davies, Arthur B., 31, 53, 60
Davis, Arthur Q., 222, 243–49, 259, 261, 279, 280, 338, 339, 342
Davis, Mrs. Arthur Q., 231

Davis, Mary, 222
Davis, Mrs. Walter, Jr., 256, 261, 295, 302, 348
Davis, Walter, Jr., 256, 295, 348
De Kooning, Willem, 233
de Verges, Edward J., 126, 128, 130, 136, 144, 145–46, 159, 181
Dedeaux, Dawn, 316
Degas, Achille, 228
Degas, Edgar, xii, 49, 60, 64, 64n, 70, 83, 95, 96, 115, 117, 212, 226–230, 234, 254, 258, 259, 282, 348
Degas, René, xii, 96, 228, 230
Delacroix, Eugène, 60, 115
Delgado, Isaac, xiii, 7–12, 9n, 20, 23, 24, 28, 42, 65, 86, 144, 153, 179, 181–84, 346
Delgado, Samuel, 8, 9
Delgado, Mrs. Samuel, 9, 23, 71
Delgado Museum of Art. See New Orleans Museum of Art
Delgado Room (NOMA), 10, 10n, 23
Demesse, Maximilien Felix, 77
Derain, André, 61, 72, 82, 97, 98
Derby, George M., 97
Deutsch, Herman, 131–32
Diaz de la Peña, Narcisse Virgile, 35
Dick, J. M., 3
Diefenthal, Stanley M., 329
DiMaggio, Jake, 296–97, 307–309
DiMaggio, Mrs. Jake, 297, 302, 309
Dinkins, Lynn H., 69, 70
DiRosa, Joe, 301
Donson, Jerome Allan, 161, 165
Doolittle, Amos, 30
Doughty, Thomas, 4
Doweal, Ed, 30
Downman Room (NOMA), 185
Doyle, Francis, 284
Dreyfous, F. Julius, 52, 70, 75, 85, 89, 90, 111, 126, 128, 136, 159, 178, 185, 221, 233, 251, 252
Dreyfous, F. Logan, 202
Dreyfous, Felix J., 13, 16–17, 22, 52, 59, 75–76, 85, 87, 221, 251
Drysdale, Alexander J., 54–55
Dubuffet, Jean, 254, 276
Ducros, Hilda, 176
Duffoure, Walter M., 129, 148, 152
Dufour, Pie, 107, 108, 253
Dufy, Raoul, 61, 72, 83, 92, 97, 98, 188, 254
Dunbar, Charles E., Jr., 179
Dunbar, Prescott N., xii, 285–88, 302, 304, 307, 323, 346, 347